FR18 2

T4-ADM-627

Selling Collectibles
for Profit
& Capital Gain

Also by Richard H. Rush

Art as an Investment (1961)

The Techniques of Becoming Wealthy (1963)

Antiques as an Investment (1967)

Techniques of Becoming Wealthy (1977)

Investments You Can Live with and Enjoy (1974, revised 1975, 1976)

Automobiles as an Investment (1981)

Shown in the living room of Julia and Richard Rush's Palladian villa is an Italian table for which they paid $1,400 in Italy in 1974 and which would value at $5,000 today. The Venetian carved and gilded Louis XV bench-settee was purchased for $350 in New York in 1966 at Plaza Art Auction and would bring $3,500 today. The Italian Louis XVI armchairs were purchased in an apartment sale in Washington, D.C., a decade ago for less than $100 each and would sell for over $1,000 each today. (Fototecnica)

Selling Collectibles for Profit & Capital Gain
Richard H. Rush

HARPER & ROW, PUBLISHERS, New York
Cambridge, Philadelphia, San Francisco
London, Mexico City, São Paulo, Sydney

SELLING COLLECTIBLES FOR PROFIT AND CAPITAL GAIN. Copyright © 1981 by Richard H. Rush. All rights reserved. Printed in the United States of America. No part of this book may be used or reproduced in any manner whatsoever without written permission except in the case of brief quotations embodied in critical articles and reviews. For information address Harper & Row, Publishers, Inc., 10 East 53rd Street, New York, N.Y. 10022. Published simultaneously in Canada by Fitzhenry & Whiteside Limited, Toronto.

FIRST EDITION

Designer: C. Linda Dingler

Library of Congress Cataloging in Publication Data

Rush, Richard H.
 Selling collectibles for profit and capital gain.
 Includes index.
 1. Collectibles as an investment—United States.
2. Selling—Collectibles. I. Title.
AM237.R87 1981 700'.68'8 81–47358
ISBN 0–06–038008–X AACR2

81 82 83 84 85 10 9 8 7 6 5 4 3 2 1

Contents

Acknowledgments **ix**

Introduction **1**

1. Collectibles: An Era of Phenomenal Growth **9**
2. Criteria for Selecting Collectibles **22**
3. Determining the Market Value of a Collectible **27**
4. The Auction Houses: What They Want and What They Can Sell **43**
5. Marketing Collectibles to and Through Dealers **64**
6. Selling Locally and on Premises **91**
7. Collectors' Clubs as a Sales Medium **100**
8. Advertising in Newspapers and Magazines **112**
9. The Donation of Appreciated Collectibles **125**
10. Contacting the Museum Market **140**
11. Preparing the Collectible for Market **150**
12. What Type of Collectible Are You Selling? **173**
13. Contemporary Works of Art **178**
14. Arts and Crafts **193**

Appendix A Selected North American Auction Houses, Associations, and Dealers **205**

Appendix B Price Trends in Collectibles **234**

Index **251**

Acknowledgments

Over the years there have been a number of people who have assisted my wife, Julia, and me in our art and antique collecting activities. Over the years, too, they have contributed to the knowledge of selling that led to the writing of this book. Some of them we talk to almost weekly, some less frequently, but all have combined to make this book possible.

First we would like to thank our close friends Robert and Bertina Manning, as well as the late William Suida, Mrs. Manning's father. Dr. Suida, Austria's most illustrious art historian as well as curator of the Kress Foundation and the Kress Collection of paintings, gave us the guidance and the encouragement that we needed to launch us on a career of collecting.

The two major painting dealers whom we call on regularly for assistance, no matter how busy they are, are Clyde Newhouse and Spencer Samuels, both of New York. Mr. Samuels's late father, Mitchell Samuels, devoted many hours to educating us in the collection of antiques when he was the largest antique dealer in America, if not in the world, and we were first starting our collecting activities.

At Sotheby Parke Bernet in New York we want to thank Liz Robbins particularly for her constant help in supplying us with information on each auction as it took place over a span of ten years. We also thank Old Master Director Brenda Auslander and Director of the Silver Department Kevin Tierney, as well as the heads of the other departments.

In Christie's, New York, we take occasion to thank Perry Rathbone, former director of the Boston Museum of Fine Arts, Christopher Burge, in charge of painting sales, and Ian Kennedy, director of the Old Master department, the heads of the other departments, and Elizabeth Shaw, head of the Press Office.

In Christie's, London, Gregory Martin, Old Master director, Michael Broadbent, wine director, and John Herbert, public relations director,

have always been extremely cooperative in supplying facts and opinion on the market.

We thank New York art dealers Herbert Roman, Herman Galka, and Walter Altschul for the many paintings we purchased from them over the years and on which we made substantial capital gains. We thank Messrs. Roman and Galka for their appraisals, which stood up so well when reviewed by the Appellate Staff of the Internal Revenue Service.

Addy Bassin has spent many many hours reviewing the international wine market with us, and we thank him for this advice as well as for supplying us with excellent investment wines.

The O'Reilly brothers, Edward and William, have long supplied us with both collectibles from their auction and an outlet for things we wanted to dispose of when they owned Plaza Art Galleries.

Nick Soprano has made a very real contribution by citing dealers, auction houses, and publications of use to the seller of classic automobiles.

Cintra Huber, public relations director of Phillips, New York, has always stood ready to supply us with any information we needed on the sales of her gallery.

Last, but certainly not least, we take occasion to thank John Marion, president of Sotheby Parke Bernet, New York, for his splendid help in selling our paintings at his auction. He personally auctioned the ones which we sold in New York at his gallery and certainly secured for us commendable prices.

Perhaps we should have placed at the head of this list of acknowledgments Roger Jellinek and Leonard F. Schwartz, who asked me to write this book in the first place, as well as the many people who have written to me over the years to ask how to determine the value of their art, antiques, or other collectibles and how to sell them.

Selling Collectibles for Profit & Capital Gain

Introduction

Never before have collectibles sold in such volume and at such prices as in the decade from 1970 to 1980. In the latter year Sotheby's in New York sold one picture—a J. M. W. Turner Venetian scene—that brought over $7 million with premium.* Less than two decades earlier, in 1961, the same gallery's *total* sales for the entire year amounted to $8,430,306.

Very conservatively, prices of collectibles across the board, all the way from classic automobiles to European paintings of the nineteenth century, rose on the average six times in price in the 1970's. In 1960 a Mercedes-Benz cabriolet of 1955 vintage was offered for sale in Washington, D.C., for $1,900. The owner might well have taken somewhat less. In 1980 the Phillips auction house sold a comparable car for $33,000, and in late 1980 two such cars were advertised for sale—one for $40,000, one for $60,000. As late as 1972 a large Georgian tray of the eighteenth century sold at auction in Canterbury, England, for about $750. It weighed 155 ounces, and the price realized per ounce was $4.80. In 1980 the same tray would have brought about $50 an ounce—more than $7,500.

Less than two decades ago the editor of *Art News* at a meeting of the Collectors' Club in New York stated, from the speaker's platform, "Art as an investment? What a horrible idea!" The club members applauded him.

The editor of *Art News* today, a different editor,† broadsided the art, antiques, and collectibles world with flyers on his November 1980

* "Juliet and Her Nurse," by J. M. W. Turner, sold for $6.4 million plus 10 percent buyer's premium in May 1980 at Sotheby Parke Bernet, New York. This was an auction record for any work of art.

† Milton Esterow is publisher and editor of *Art News* and its sister publications *Antiques World* and the *Art Newsletter*.

Consigned to Sotheby's for sale by Flora Whitney Miller, J. M. W. Turner's Venetian painting "Juliet and Her Nurse" brought the highest price ever paid at auction for a painting or work of art when it sold for $6.4 million in May 1980. The painting brought about three times expectations in a month of record-breaking painting sales in New York, where million-dollar prices almost became commonplace. It is doubtful that such a price could have been achieved (or asked) privately.

Collectors' Conference. The "Opening Session for All Participants" was chaired by the editor himself. The theme was: "Antiques as an Investment." This followed the March 1980 World Art Market Conference featuring "Art as an Investment" sponsored by *Art News* and its sister publications. In January 1981 they featured "Antiques as an Investment" in the opening session of their conference in Palm Beach.

There is little doubt that unless the concept of art, antiques, and collectibles as investments had not been generally accepted over the past several years, there would have been much less of a boom in collectibles than there was. The most systematic spreading of the word is done by the big New York auction house Sotheby Parke Bernet. Members of the staff of this organization take the opportunity to lecture virtually anywhere and everywhere on art as an investment.

Art, antiques, and collectibles are no longer considered solely decorations or simply works of art; they represent legitimate *investments*. If one is investing in a 1965 Rolls-Royce convertible, not simply buying

Introduction

a fine and fancy automobile, his whole attitude toward such a purchase is different. The $100,000 price is not a cash outlay that will gradually decrease in value as the car gets older. One has made a choice of investing in an automobile instead of, say, IBM stock. If we look back on the history of price increases in such cars in the past decade, the Rolls-Royce may well in the future rival IBM common as an investment, and one's $100,000 may well turn into $150,000 or $200,000 over the next five years or so. Collectibles, almost all of them, have moved into the investment category. The result of this new concept of collectibles has been greater demand, which in turn has resulted in a steep rise in price for many investment collectibles.

Today there are far more art and antique investment funds than most people realize, as there are more investments of trust funds in art, antiques, and collectibles, from the trust fund investment program of Citibank and Sotheby Parke Bernet to the British Rail Pension Fund that put $1,250,000 into an early candlestick.

Ten years ago many collectibles were sold by buyer to seller via newspaper advertising. Many collectibles were also sold directly by seller to dealer. In fact, direct buying from owners was the source of most collectibles for many dealers. Over the past ten years the auction houses have become a major, if not *the* major, factor in the art, antique, and collectible distribution system. The big worldwide auction houses, with Sotheby's and Christie's in the lead, have grown* by leaps and bounds and now dominate much of the auction business. In certain areas, like antique and classic cars, coins, and stamps, specialized auctions dominate, and their combined volume of sales probably rivals the entire auction business of the major houses.

Most of the literature on collectibles deals with *collecting*, particularly as an investment. My own previous books on the subject were entitled *Art as an Investment* (1961), *Antiques as an Investment* (1967), and *Investments You Can Live with and Enjoy* (1974, with later revisions). The emphasis was obviously on *buying* for investment, and other than price histories and trends, there was very little on *selling* in order to realize on one's investment. There has been little or nothing written on how to sell, when to sell, and where to sell. When do you send your collectible to

* Christie's worldwide auction total in the 1969–70 season was 20 million pounds sterling ($48 million), and in the 1979–80 season its worldwide total was $362,057,040. Christie's doubled its volume in America in the 1979–80 season compared to the previous year. The 1979–80 total *in America* of $113 million was four times the worldwide total for Christie's fifteen years earlier. In a twenty-year period worldwide sales rose from $10,360,000 to $362 million.

Sotheby Parke Bernet has the largest worldwide total. In the 1979–80 season it came to $573,089,700. Ten years earlier, in 1969–70, it was a little more than 45 million pounds ($108 million). In North America the volume rose from $38,524,966 to $249,832,000 in the decade. Sales of Parke Bernet in the 1963–64 season, before acquisition by Sotheby's, totaled $10,820,242.

auction? When do you try to sell to a dealer? Should you sell to a dealer or consign your collectible to a dealer to sell for you? Should you advertise what you have for sale in a newspaper or a specialist magazine?

Even before the collector thinks of where, when, and how to sell, he should think of what to buy as a collectible, for what he buys determines where, when, and how he can sell it, and with how much of a prospect for a satisfactory profit.

What is a collectible? There are essentially two types. The first is something that is established as a collectible, collected by a number of people who may be organized into a club, like the Sports Car Club of America or the American Numismatic Association.

"Collectibles" has a second meaning, at least those bought simply because one likes to own such things: minor collectibles such as old barbed wire, toys, telephone pole glass insulators, beer cans, match packs, cards with the picture of a prominent baseball player on each, and so on. Many of these have acquired and risen in value, but in this book we will be focusing on investment collectibles, with an established market today, bought with an eye to investment value and appreciation over a period of months or years.

Thus, Jim Lehrer (of the *MacNeil/Lehrer Report*) owns bus memorabilia, like signs from the sides of old Greyhound buses, which are certainly collectibles, but are not truly investment collectibles likely to appreciate in value. He did not buy the bus memorabilia to realize an appreciation in value; his father was a bus company employee, and Lehrer formed his collection for nostalgic reasons rather than for eventual profit. Impressionist paintings, on the other hand, are frequently, if not almost always, bought with an eye to appreciation in value.

Many collections started simply as amassments of items of relatively little value have turned into investment collections as the years went by—as values increased and as the collections were refined. As prices rise, people come to look on their collections as investments.

To collect deliberately for investment there are two requirements. First, the marketing technique must be carefully thought out. Secondly, there must be considerable emphasis on liquidity. I would very much like to own one of the last steam engines used on the New York, New Haven & Hartford Railroad. It would take up considerable space on my property, and I would have to build some kind of structure to house it. But such a locomotive as an investment? I doubt whether it would meet any of the criteria of investment collectibles. Where would I sell it? To whom? How would it be moved to the seller—provided there was any means of moving it to my property after I had bought it in the first place?

Is such a collectible as a locomotive liquid? The question might

be rephrased: Is such a collectible even remotely liquid? How long would it take to find a buyer—any buyer!

Of all liquid markets the auction market is the most liquid—and the most viable. Not all collectibles are salable at auction. Some highly competent contemporary artists cannot easily or profitably be sold at auction. There is no auction market for such artists because the market for their works is not broad enough—the auction sale at which one or more works of such an artist are offered for sale will not automatically attract several buyers willing to bid on the paintings *offered at that sale.*

Some things are naturals to be sold at auction—automobiles in great demand, like Ferraris; Impressionist paintings by Renoir; Tiffany lamps; American gold coins. If you collect such items, you have great liquidity and at a fairly determinable price.

The Washington real estate developer Robert Wolpe recently stated, "I really don't want to consider my own home as an investment. Certainly it goes up in value every year, but what does it cost per year to own it and operate it—repairs, insurance, and all the rest?" The same principle applies to any collectible. What does it cost to own it over a period of time? One of the most desirable collectibles I ever owned was a 1952 Bentley coupe with body by the master Swiss body builder Graber. I paid $2,500 for the car, plus import duty and transportation from Switzerland. When the car landed, certain repairs to its mechanics and paint were required.

For three years I tried to sell the car. Several hundred dollars was spent on advertising. Repeated repairs had to be made. Insurance and registration had to be purchased every year. The garage for the car cost a fair amount. Three years after I bought it I sold the car for $2,800. Was this a good investment? If I had added to the original cost all the expenses along the way, my loss would have been sizable. Profit on collectibles can be more apparent than real.

On the other hand, this year I made a $5,000 down payment on a Lamborghini Miura, one of the most desirable collector cars in the world. The purchase price was $20,000, so I owed $15,000. The seller, Stanislaw Zagorski, was a leading illustrator located in New York, and I located the car from an ad he had placed in *The New York Times.*

The car required small repairs to the paint, which Mr. Zagorski agreed to take care of. He sent the car to the shop of Sal Marinello in Brooklyn. While the car was in the shop, one of the customers came in, saw the car, and asked if it was for sale.

Mr. Marinello said he understood the car had been sold—for $30,000. Whether the $30,000 figure, rather than the actual sales price of $20,000, was a legitimate mistake or whether he wanted to see the effect of such a price quotation on his customer I do not know. However the customer was still interested, and he said, "I would be glad to pay

thirty-two thousand for the car if the new owner would care to sell it or if the deal hasn't yet been consummated."

Mr. Marinello immediately called the owner of the car, Mr. Zagorski, to tell him of the $32,000 offer. Mr. Zagorski then called me and informed me of the offer. He said. "I will be glad to refund your deposit of five thousand dollars and give you another five thousand dollars profit. I can then sell the car to the man who made the thirty-two-thousand-dollar offer. If, however, you are not interested in this offer, then perhaps you will want to resell the car to this prospective customer as soon as you have paid off the balance due me."

I took neither offer, but it made me feel very comfortable in my "investment" that someone had offered me an immediate and substantial profit. It is not always easy to realize a profit quickly—before expenses to maintain the car mount up.

The purchase of investment collectibles is really a form of saving. If chosen well, collectibles in this generally rising market increase in value each year. Sometimes they decline in value, but the price trend in almost every collectible is up. One has only to calculate the appreciated value of his car or whatever collectible he owns to determine how much he has "saved" each year.

There may, of course, come a time for selling the collectible because one wants to put the cash into something else. The sale of an *investment* collectible results in a capital gain (if sold at a profit), not ordinary income. Simply, the profit is not added to the owner's income for the year before the income tax rate is applied on Form 1040. Only 40 percent of the gain is added to the rest of his income. It works out that no matter what method of determining capital gain one employs, and the determination will be gone into later, the tax is never more than 28 percent of the gain. Ordinary income can result in a tax of up to 70 percent. This is certainly a plus for buying strict investment collectibles.

This book should do several things for you:

1. Indicate the best methods and the best channels to use in order to sell a particular kind of collectible—the best one to use or a choice of good methods and channels.
2. Point out what methods and channels should be used with caution—or not used at all.
3. Show how to establish the value of a collectible that you contemplate selling.
4. Suggest how to protect yourself against the many risks of selling.
5. Advise how to prepare the collectible for sale so that it will be shown off to its best advantage.

Being able to sell a collectible at a satisfactory price is as important to a collector as being able to buy at a satisfactory price, and it is usually

Introduction

far harder to sell than to buy. When one has funds with which to buy (or invest), it is not hard to buy, not even hard to buy at a satisfactory price. It is often very hard to sell, and certainly at a price that will return a satisfactory capital gain.

Any meaningful and helpful book on selling collectibles not only should list and describe methods of selling and channels to use to reach the potential buyers but should also indicate the advantages or disadvantages of using one method or channel as against another. This we have tried to do, indicating what we consider the best ways to reach potential buyers. Many have worked for us in the past. Where we have had experience we are in a position to give advice.

If you acquired a collectible, almost any collectible, of quality, over

Often used as a flower vase on the family sideboard, and thought to be worth about £200 (under $500) by the owners who took it to Phillips fine art auctioneers in England, this Chinese vase was recognized as an object of great worth by the auction officials, who arranged for it to be included in a special sale in July 1980 of Oriental ceramics. Photographs were mailed to prospective buyers throughout the world. The vase, which dated from the sixteenth century, sold to a Japanese collector for £220,000 (about $500,000).

the past decade or, for that matter, over a good part of the past decade, the chances are that you will have seen a growth in its value. If you simply owned an investment collectible over that time, whether you inherited it, purchased it, or received it as a gift, no matter how you came by it, you will no doubt have seen an increase in its value, unless it is of poor quality.

Over the past several years dealers and auction houses alike have continually emphasized, "Buy the best. That is what will appreciate in value the most."

I might start this book by quoting the very last sentence of my book *Art as an Investment*, written two decades ago: "In the end the investor-collector always arrives back at the same question in his selection of works of art: Is the quality there?"

If the items which you have purchased for investment have been selected with an eye to quality in a rising market, you are well on your way to making a capital gain on the sale of your investment collectibles.

This Renaissance credenza was purchased in 1965 at Savoy Art and Antique Auction Galleries in New York for $150. When offered for sale in 1978 through a dealer in Venice, Italy, it sold for a net to the author of $2,500. (Fototecnica)

1

Collectibles: An Era of Phenomenal Growth

It is difficult to realize the rapidity with which many collectibles—or investment collectibles—have grown in value. On December 28, 1979, the New York Diamond Exchange reported these values for one-carat "investment grade" diamonds:

D Color, Flawless (the best)	$38,000
E Color, Flawless	23,500
F Color, Flawless	17,300
G Color, Flawless	13,000
H Color, Flawless	9,500
H Color, VVS2 (lower investment grade)	6,500

These were the reported values on February 29, 1980:

D Color, Flawless	$61,000
E Color, Flawless	42,000
F Color, Flawless	31,000
G Color, Flawless	22,500
H Color, Flawless	17,500
H Color, VVS2	10,000

Between these two dates the finest grade diamond rose 60 percent; the E color rose 79 percent, as did the next grade, F color. G color stones rose 73 percent, H color 84 percent, and the lower-grade investment diamonds rose 53 percent—a phenomenal rate of growth at the time gold and silver were in the process of entering a debacle!

Isaac Jaroslawicz of the New York Diamond Exchange tells a story that emphasizes the dramatic growth in the value of diamonds:

"During the Conference on Diamonds that the New York Diamond Exchange conducted at Fort Lauderdale, Florida, a woman came up to me with a rather smug smile on her face and said to me, 'The diamond that I am wearing is worth seventeen thousand dollars. I know it is!' My brother examined the stone under the analyzer. He looked up after he had finished making his examination. 'Your diamond is worth nineteen thousand dollars *a carat*, and it weighs four and a quarter carats,' he said."

In the mid-1950's New York's Metropolitan Museum of Art deacquisitioned some of its paintings and drawings—art it felt it didn't need to keep. One of the deacquisitions was a monochromatic drawing of the Prodigal Son by the Italian artist G. B. Castiglione. The drawing was bought by the New York dealer Herman Galka, who offered it for sale for $80. This writer saw the drawing, bargained on the price a little, and finally bought it for $60.

At an exhibition of Italian paintings in the Finch College Museum of Art in the late 1960's, an "unknown buyer" inquired if the drawing was for sale. I quoted him a price. He paid $2,250—by cashier's check, so that I never knew who he was. Shortly thereafter the drawing appeared in the Hazlitt Galleries in London priced at something above $10,000. It was sold to David Rust of the National Gallery, Washington, D.C. Mr. Rust regularly displays the drawing in exhibitions. It was sold at public auction in the mid-1950's, so it can be considered as having achieved "market price."

In mid-1978 a 1966 Ford Mustang convertible was bought from a repair shop. It had been put in fine condition, with new paint, brakes, bumpers, tires, etc. This writer purchased it for $1,600. In early 1980 the superintendent of the building I lived in offered $3,500 cash for the car—after it had been driven several thousand miles with a minimum of repairs or additional investment.

One final example of growth: In 1972 this writer went to London to survey the art and antique market and to make an investment in wine. At Christie's wine auction he bought a case of twelve bottles of Lafite-Rothschild 1959 vintage French Bordeaux for $205. The next year he put the same case right back in the same auction—and received $775 for it. The profit on the twelve bottles of wine was enough at the time to pay the air fare over and back (to and from London) plus the bill at the Ritz Hotel.

Collectibles of all kinds, or almost all kinds, have risen in value in recent years at a phenomenal rate. Still, there are some collectibles that have not kept pace with the front-runners and some that have moved little or not at all. In periods of rising prices for most collectibles, there are others that actually counter the trend. In the same period even the "growth collectibles" at times move down in price as well as up.

Not every collectible that a person has is now a great treasure, and there are probably more things owned by people who would like to sell them, but who have something of much less value than they believe, than people who have treasures that have appreciated materially over the years. We will try to indicate where the prospective seller can go to get an idea of what he has and what he can expect to receive for it.

Collectibles—A Decade of Growth

When one talks about a "decade of growth," the implication seems to be that growth took place fairly steadily over the decade. In fact, one of the main reporting firms dealing with the art and antique market (a leading Wall Street brokerage house) each year puts out a report indicating the rate of compound growth of a number of collectibles (and other investments). Collectibles, however, do not move the way compound interest builds up. They differ in two ways: They move up at very different rates in different years—they did just this in the decade from 1970 to 1980—and some major collectibles at times move down as well as up. The French Impressionists in some years moved down in price as sharply as they moved up in other years. Then, over the decade, some things didn't move much at all, medium-grade eighteenth-century British portraits, for instance—not the finest ones, but the medium-grade ones.

When you try to calculate the rise over a period of years, it sometimes makes a difference which *month* you choose for the beginning of the period and which as the cutoff date. If we cut off the diamond decade of growth in December 1979, we would get less of a rise in the decade than had we cut the decade off just two months later. The rise in diamond prices in just two months was enormous.

The same applies to American paintings. They increased in price greatly to the end of 1979, but by April 1980 they had risen to vastly higher levels.

Finally, it should be cautioned that even though you may have a western painting by Charles Russell, it may be worth far less than the $250,000 that one brought in New York at auction on April 25, 1980. The $250,000 painting was one of his best and most valuable. Relatively few such great paintings come onto the market.

It is convenient to consider "a decade"—ten years. It is more "usual" to think in terms of a decade than, say, seven or eight years. In the case of collectibles this past decade has far more significance than simply the fact that a decade is a convenient time span over which to measure price rise. The decade from 1970 to 1980 is, in many ways, *the decade*—much more important than, say, 1968 to 1978 or 1969 to 1979.

In many ways 1970 was Year One. In 1970 art, antiques, and many

collectibles were in the doldrums. The art business in New York and London, as well as in many other cities, was at a low point. Dealers were not overwhelmed with sales. A number of auctions of art and antiques went very poorly and far under expectations. For example, consider the Consuelo U. Ford and the Prince estates, which came onto the market offering everything from paintings to Italian antiques to Venetian glassware to French porcelain.

In the Ford sale, many sessions of which were conducted in Sotheby Parke Bernet's "lesser auction" P.B.84, many things went dirt cheap. Robert Manning, the Italian art authority, sitting in on a session of glassware and other items being sold at P.B.84, remarked, "They might as well give the things away." A very large set of green Venetian glassware, perhaps fifty pieces in all, brought just $15. A Renaissance armchair of the period brought $55. Magnificent French glassware went for 59 cents a glass.

In 1970 we bought all we could afford and had space to house— Old Master paintings from the best London galleries, antique furniture from Italy and New York, glassware, porcelain, etc.

By 1973 things had literally "taken off." Old Master paintings were in a new and great boom. Impressionists were at a new high. English furniture, which was certainly not high in 1970, was moving up well. So was Georgian silver. In 1970 a price for Georgian silver of under $5 an ounce was not unusual.

Nineteenth-Century Traditional Paintings—Up to Twelve Times

One of the biggest risers over the decade of the 1970's has been traditional paintings of the nineteenth and early twentieth centuries. A few months ago we placed English paintings of this period at the very top of the growth list, followed by Continental paintings and then American paintings. We feel now that American paintings show as steep a growth pattern as European paintings, including both English and Continental paintings.

In early April 1980 a large (50- by 60-inch) English painting entitled "Antonius Caesar on Caracalla" brought the equivalent of $315,000. Its painter, Sir Lawrence Alma-Tadema, was a traditional British artist of the nineteenth century. Ten years earlier this painting could hardly have brought as much as $25,000. If you go back to my 1961 book, *Arts as an Investment*, on page 108 you find the statement ". . . in 1958 a good example of his work brought around $700 in London." On page 239 there is the additional statement "Few of the paintings of Alma-Tadema have appeared on the market in recent years, and there is no general demand for them."

The same holds for Continental paintings. In 1979 a painting of

a "mother and child" by the French artist William Bouguereau brought $62,500 at auction. This is a traditional subject of this artist. Ten years earlier the same painting might have done well to reach $6,000, and twenty years ago $1,000 was a good price for a Bouguereau, many of which came up at the minor auctions and sold for under $1,000.

American nineteenth-century paintings are something like oil company stocks in the year 1980—only very much more so. In April 1980 Sotheby Parke Bernet held one of the most spectacularly successful sales of all time—a sale of traditional nineteenth- and early-twentieth-century American paintings. A Thomas Moran, 22 by 15¾ inches (not a large painting), was estimated by the gallery in advance of the sale at $40,000 to $50,000, a reasonable estimate in light of past prices of Morans. The painting actually brought $135,000.

An Albert Bierstadt (the painter of Yosemite National Park and the West), 20 by 28 inches, estimated to bring a fairly high $100,000 to $150,000, realized $300,000.

In 1970 neither of these paintings could have been estimated at over 10 percent of these figures.

The *Encyclopedia of Painting*, issued in 1955, has this to say about Thomas Moran: "His later huge canvases . . . achieved, like those of Bierstadt, a monumental dullness." And *Art as an Investment* said in 1961:

This was the feeling in the early twentieth century about both Bierstadt and Moran and about the so-called Hudson River School which painted views of the Hudson River and the nearby Catskill Mountains. The group fell into disfavor. But times change, and art opinion likewise changes, and these artists are now showing some strength in the market. Large Bierstadts are no longer a drug on the market, and art critics are wiping their glasses for a new look.

Still, hardly anyone could have foreseen the gigantic rise that this school of art has experienced in recent years.

Paintings by such artists as Moran and Bierstadt are bringing in six figures privately and at auction. A record for Moran was reached at Christie's in May 1980, when "Children of the Mountain," a large mountainous landscape, sold for $650,000—which, with the buyer's 10 percent premium, was $715,000. A record at auction for an American western painting was established in the same sale, when a Frederic Remington "Apache Scout" sold for $320,000 premium, and higher Remington prices are reported in private sales.

English Antique Furniture—Up to Eight Times

A growth of eight times in price level over the past decade is a conservative estimate for English furniture of the eighteenth and early nineteenth centuries—Queen Anne, Chippendale, Hepplewhite, Sheraton, and Re-

This Mercedes Benz 500K, dating from 1936, brought $400,000 plus premium ($440,000) at Christie's auction in Los Angeles in 1979, an auction high for *any* automobile at that time. Ten years earlier the car would have been valued at about $50,000, and twenty years earlier in the neighborhood of $10,000.

Fine antique carpets and rugs have increased in price in recent decades, as shown by this example of a Persian Heriz carpet, 18.8 by 11.8 inches, which would have been valued in the early 1960s at $4,500 and today would fetch $40,000. (Vojtech Blau)

gency antiques. In early 1980 a set of eight English chairs of the early eighteenth century brought an unusually high price at Christie's auction in New York. The eight chairs, made by Giles Grendey, were part of a set of twenty-eight chairs owned by the Rosen Foundation, owners of Caramoor, located in Katonah, Westchester County, New York. They are beautiful chairs, and we have had the pleasure of sitting on them at a banquet at Caramoor. We felt that if the Rosen Foundation were very fortunate, the chairs might reach a price at Christie's auction of $10,000 a chair—$120,000 in all. They brought $319,000 for the eight—almost $40,000 a chair. Back in 1970 $4,000 per chair might have been a very good price. Four armchairs and sixteen side chairs are still owned by the foundation!

In 1970 a simple late-eighteenth- to early-nineteenth-century commode could have been purchased for the equivalent of $100, or even less, in London and elsewhere in England. Today such a commode can rarely be purchased at under $1,000, and the same degree of rise holds for sets of chairs, particularly Hepplewhite, Sheraton, and Regency chairs. The top-grade pieces, as well as the moderate-price pieces, have risen dramatically in the past decade. A grandfather's clock in perfect working order, made in the late eighteenth century in Canterbury, England, was purchased by this writer in Canterbury in 1971 for $72. Today it would easily bring ten times that sum.

Classic Automobiles—Up to Eight Times

The statement that classic automobiles have increased in price up to eight times is a conservative estimate of activity in this area in the past decade. Some classic cars have increased less, but some have increased more than eight times. In 1970 a Mercedes-Benz 300 S cabriolet was offered to me for sale in Washington, D.C. It was in good but not prime condition. The car new, in 1955, had cost $13,250. It was a luxury car, and its price reflected that fact. By 1970, when it was offered for $1,900, it had declined in price about as far as it was going to decline. Then the rise started. (This is the pattern—price drop and then rise—for many collectibles. First they are simply secondhand and "getting older" all the time. Then it is [sometimes] realized that they are collectibles, and a rise in price takes place—not for all luxury cars but for a number of them.)

In 1979 a fine Mercedes-Benz 1936 Model 500 K roadster was offered for sale in California by Christie's. It was a rare beauty and in excellent condition. It brought the large sum of $400,000. Ten years earlier by no stretch of the imagination could this car have brought more than $50,000.

Overall, classic cars (those made after 1922 and particularly those made in the postwar years) have risen in value eight times.

The Vintage Wines of France—Up to Seven and a Half Times

The Bordeaux dry red wine Lafite-Rothschild, of the vintage year 1961, is one of the greatest of all investment-quality wines. This writer bought it by the bottle at retail for $19 in 1970. He bought thirteen bottles in all. In 1978 the Washington wine wholesaler and dealer Addy Bassin offered him $100 a bottle. In March 1980 D. Sokolin Co., Inc., of New York offered the wine at retail for $255 a bottle—more than thirteen times its original purchase price.

In 1970 the top French sweet white wine, Château d'Yquem, 1961, was offered for sale for $8.79 a bottle retail. This writer bought some and put it away in his wine cellar. In 1980 retailers were charging $150 a bottle for this very much wanted vintage year wine.

Some vintage wines of France have gone up even more than these two wines. Some have gone up less, but a very careful statistical study arrives at a growth of seven and a half times in the decade.

Tiffany Lamps with Leaded Glass Shades—Up to Seven Times

Tiffany lamps were extremely popular in the late nineteenth and early twentieth centuries. They retailed for up to about $500 a lamp.[*] In 1978 the New York dealer in Art Nouveau Lillian Nassau sold a particular model of Tiffany lamp for $70,000. In early 1980 an identical lamp sold at Christie's auction for $360,000.

In 1973 Mrs. Nassau sold another model Tiffany lamp for $38,000. In 1979 a similar Tiffany lamp sold for $150,000 at auction.

Not all of the many Tiffany lamps made are such high risers, nor do they all cost in the hundreds of thousand dollars today; but a rise in the decade of seven times is conservative. The colored pieces of glass set in lead in a dome-shaped lampshade represent a high point in the art of American glass.

Middle Eastern Carpets—Up to Six Times

There is an enormous retail and auction business in Middle Eastern carpets, also called Orientals. These carpets are classified as Persian, Caucasian, Turkestan, Anatolian, and Turkish. Those under fifty years old are considered modern, those from fifty to one hundred years old, semiantique, and those over one hundred years old, antique.

The carpets are colorful, generally with a low pile. Many are made with silk, and all are handmade. Some are almost works of art, and almost all are durable. The major New York rug and carpet dealer

[*] One model sold for as much as $750, but $500 was about top of the line, and the majority sold for considerably less.

Vojtech Blau placed an Oriental Bijar carpet in the lobby of the Sotheby Parke Bernet Galleries in New York in 1970. Dirt, water, sleet, ice, and snow were tracked over the carpet by the thousands of visitors to the auction house over a number of years. Yet there was no visible wear on the carpet.

In a period of fifteen years the value of this carpet rose almost ten times. In 1960 the value would have been $1,500. In 1964 the value would have risen to $3,500. By 1975 the value was about $9,500, and in 1980 it was well above $15,000.

If anything is a "standard collectible," Middle Eastern carpets are. They are used both as ornamental elements for the home and as investments by many people, including Middle Easterners themselves. Overall, in the past decade their price level has risen about six times.

Drawings—Up to Five Times

As recently as a decade ago drawings were not extremely popular and did not command huge prices. Many good ones could be collected on a limited budget. In the past decade the prices of all drawings have risen, from Old Masters by Italian and Dutch artists to Impressionist to modern drawings, including Picassos. Fairly recently Christie's in New York sold a Picasso drawing of the head of a woman done in the artist's Classic Period for the very large sum of $210,000.

Among the record auction prices for drawings by Old Masters, a drawing by Albrecht Dürer sold in the Robert von Hirsch Collection sale at Sotheby's in London for 300,000 pounds ($552,000). In that 1978 sale a watercolor by Dürer brought a little over $1 million. An auction high for a Rembrandt drawing was established at Christie's in London in 1980, when a pen-and-ink drawing with brown wash brought 190,000 pounds (the equivalent at the time of $444,000). The drawing measured approximately 7 by 9 inches. There is almost no limit to what is paid for top-quality drawings by great masters.

Not all drawings bring extremely high prices, and although interest in them is increasing, it is still possible to make some good buys. People who collected drawings ten and twenty years ago, however, are indeed fortunate and should see a good capital gain in the sale of their collections.

Drawings in all schools of art have risen conservatively five times in the past decade.

American Antique Furniture—Up to Five Times

American furniture of the eighteenth and early nineteenth centuries belongs about here in the growth table. It did not rise as rapidly as English furniture of the same period because it was very much higher

in price than English furniture a decade ago. American furniture is based on, and is sometimes confused with, English furniture, but it is very much scarcer than the latter and in greater demand, mostly by American collectors and investors. A growth rate of five times in ten years is a conservative estimate.

In 1970 a fine Sheraton foldover side table, made in Salem, Massachusetts, was sold by Weschler's auction in Washington, D.C. It was bought by this collector for $250, a good buy, but not far under the market at the time. Today the piece would bring at auction perhaps $1,500, possibly a little more. This is the low end of the price scale.

At the high end of the scale a very good foldover American table recently sold for $21,000 at retail, the retail market price for a quality table. Such a piece might have sold for $3,000 a decade ago.

A great highboy with elaborate top, once owned by the family of Benjamin Franklin, made circa 1770 and attributed to the great cabinetmaker Thomas Affleck, was offered for sale slightly more than a decade ago by a New York dealer for a little in excess of $75,000. Today the piece should bring an easy $250,000, perhaps more, and there are great pieces of American furniture that can top $1 million.

The Finest Jewelry—Up to Four Times

The finest jewelry is that containing fine-quality stones, mainly diamonds, sapphires, emeralds, and rubies. These four stones are the investment stones. The value of such jewelry lies in the gemstones themselves, not in the mountings. The value of the mountings in general depends on the scrap value of the metal out of which they are made—platinum, gold, or silver. Very few mountings have any intrinsic value in addition to the weight of the metal.

Although at times jewelry prices seem sky-high, such prices depend on the large stones or the large number of stones of top quality.

Most jewelry does not have much antique value except for a relatively few fine Victorian pieces; eighteenth-century pieces, including Georgian items; Renaissance objects; and perhaps some unusual Art Nouveau and Art Deco pieces from the latter nineteenth century to the mid-1920's.

Jewelry rises and falls perhaps more with business conditions than other collectibles do. It has, nevertheless, increased in price level about four times in ten years.

Fine jewelry reached new highs in 1980 with a record for a jewelry sale in mid-November at Sotheby's in Geneva which totalled over $30 million—which was about double the previous high. In that sale there was a new auction high for any lot of jewelry sold at auction when a pair of diamond earrings brought $6,647,069—more than the J. M. W. Turner $6.4 million record for any work of art sold at auction. An auction

record for a single stone was set a few days later at a Christie's sale in Geneva when a 41.28 carat diamond brought $4,651,162. Before November 1980, the record for a single lot of jewelry sold at auction had been $1.6 million, which had been reached for an emerald and diamond tiara which was sold at Sotheby's the previous year in Switzerland.

American Folk Art—Up to Four Times

The term "folk art" covers items made from the late eighteenth century up through the early part of the present century. It comprises:

Simple country furniture, much of it painted
Primitive American paintings, mainly portraits, many by unknown artists
Pewter
Weather vanes
Scrimshaw—carved whalebone (and other natural materials)
Coverlets
Simple silver
Glassware
Folk sculpture
Ceramics of American interest, including Chinese export porcelain.

After a recent sale of American folk art at Sotheby Parke Bernet, the gallery's president, John Marion, telephoned his father, the former head of the Parke-Bernet Galleries. John said to his father, "We have just auctioned off a metal weather vane. What do you think it brought—your wildest guess?" The weather vane had sold for $25,000!

American folk art, or Americana, sales are becoming more and more numerous, and they are including more and more things for sale. They include not only folk art but fine American antique furniture, fine American silver, and other quality offerings in addition to the "quaint" folk art. The May 1980 sale held by Sotheby Parke Bernet in New York offered 1,340 lots for sale. There were two very large sales catalogues for this auction. Other auction houses are also staging enormous American folk art sales. Prices in the last decade have risen at least four times.

American Silver—Up to Four Times

With the tremendous rise in the price of silver bullion, from a level of $1.50 an ounce not very long ago to more than $50 for a brief period, American silver of high silver content tended to rise in price in relatively equal steps with bullion. This was the silver with more silver in it than historical and antique importance. It was for the most part that of the nineteenth century. It tended to drop with the decline in silver bullion but showed a rise for the decade.

Rare fine silver from the early- and mid-eighteenth century, in some

cases through the end of the century, to the early years of the nineteenth century also saw a big rise. There were some setbacks, particularly for Paul Revere, the American patriot who was also a leading silversmith. His work, which had risen in value at the end of the 1960's, boomed and then slackened off in the 1970's. It came back to new auction highs in 1980 with the sale of a Revere coffeepot at Sotheby Parke Bernet for $64,000 plus premium. The record for any piece of American silver was $105,000, reached at the same auction house in 1979 for a presentation punch bowl of historical importance. The maker was Hugh Wishart, and it was made in New York, circa 1799. In 1970 it would probably not have been valued at more than $20,000, and even Sotheby Parke Bernet's silver specialist, Kevin Tierney, was surprised at the price it brought.

Very early American silver was, and is, scarce. A fine rare teapot, circa 1725, by Peter van Dyck, brought $47,000 at auction toward the end of the decade.

Over the decade fine American silver, particularly eighteenth-century pieces of quality and historical importance, not necessarily simple items, has risen about four times in value. It is scarce and not likely to be more plentiful.

Fine French Furniture of the Eighteenth Century—Up Three and a Half Times

French furniture is some of the finest-designed and finest-constructed furniture made in the world in any era. It is the height of luxury and elaborate design and workmanship. The finest French furniture is the highest in price of any furniture.

A Louis XV corner cabinet by Dubois, an important and elaborate cabinet with exceptional ormolu and surmounted by a clock, holds the auction record for any piece of furniture. It sold in June 1979 in a Sotheby's sale in Monaco for approximately $2 million with the buyer's premium included. It is now in the Getty Museum in California.

The rise in price of fine examples of furniture of the Louis XV and Louis XVI eras together was about three and a half times in the past ten years. It does not rank near the very top in price increase because it was already high ten years ago. In fact, Louis XV furniture was high in price twenty years ago. Over a twenty-year period Louis XV furniture increased in price only four times, but the later Louis XVI furniture increased about ten times. In the past ten years Louis XV furniture probably no more than doubled in price, overall, while Louis XVI better than tripled. Twenty years ago Louis XV furniture was the great favorite of the supermillionaires, including J. Paul Getty, and its price rose so high that people turned to the less expensive, but fine, Louis XVI.

Collectibles: An Era of Phenomenal Growth

A Sample of the "High Risers" Only

It would take an entire book to compute the price rises of the majority of collectibles, even of those used as investments. We have not even mentioned the area of Old Master, Impressionist, and French modern paintings, prints, postage stamps, and coins, among many, many other things. It is enough to point out, however, that the above price increase estimates do represent a sample of how collectibles in general have risen in recent years. There has, in fact, never been a period in American history in which collectibles, overall, have increased so markedly in value.

The objective, at least one objective, is to sell the collectibles or at least to *be able* to sell them should the proceeds be needed for something else, and we will proceed to indicate those that can be most expeditiously marketed as well as advise how to select collectibles that can in the future be marketed satisfactorily and, one hopes, with a resulting capital gain.

This painting sold in a garage sale in Alabama for under $100 ten years ago. It brought $310,000 at Sotheby's American painting sale in April 1981, an auction record for the artist, Martin Johnson Heade. The work, which measures 13 by 26 inches, is signed M. J. Heade at the lower right.

2

Criteria for Selecting Collectibles

The time to start selling art, antiques, and other collectibles is when they are *bought*. If something salable is bought, the job of selling it is relatively easy. If one collects items like an enormous Flemish marble mantelpiece, the selling job is by no means easy—at least at a satisfactory price. If, on the other hand, you invest in American gold coins, you can sell them about as fast as it takes to get them out of your pocket and onto the counter of a coin dealer. Between these extremes are all shades of marketability. Marketability of your investment collectible may not be the only criterion to use in deciding what to collect, but it is extremely important since we are talking about *investment* collectibles, not simply collectibles. The word "investment" implies increase in value and probably also eventual sale.

These are some criteria for selecting investment collectibles—those that stand a good chance of turning out to be good investments, while they provide other benefits to the collector:

Place some emphasis on *liquidity*. Liquidity may not seem important when one is collecting, but it may be very important when one wants to sell. It simply means ease of selling. It might well be placed at the head of the list of desirable characteristics of a collectible—provided you haven't yet picked the collectible or collectibles. To sell a very high-priced painting may require waiting until a very important sale is scheduled by an auction house.

Collectibles in a *rising price trend* are desirable. In the spring of 1980 American and European nineteenth-century paintings were in an up price trend. One can, in this type of collectible, look forward to a probable (or at least possible) price appreciation in the not-too-distant future.

A *determinable market price* is a good characteristic for a collectible to have. If a Vermeer painting should come onto the market, it would certainly sell at a high price, but how high? *There is no easily determinable*

Prices of fine Old Master paintings have risen greatly in the last fifteen years. This important painting by Jacopo Vignali, "Hagar and the Angel," was purchased by the author from French & Company, New York, in 1966 for $3,200. Less than ten years later, it was sold at Christie's in London for $21,000. If one purchases quality items, selling them is not difficult.

market price for such a masterpiece. On the other hand, there is a fairly definite market price for a Venetian scene by Canaletto—at least a market price in a particular range. For postage stamps the market is even more readily determinable. For many coins the market is almost absolutely determinable.

If one has an idea of market price, he has an idea of how much he can realize on his collectible by selling it, of what it is worth even if he plans to keep it, and of the trend.

Collectibles with an *auction market* are desirable. When a new artist comes onto the retail market, he usually does not have an auction market. Only after a dealer "builds up" the artist can his paintings arrive at auction. When his paintings arrive at the auction market and sell regularly, then they become very desirable as an investment. Auctions "move" collectibles, and without an auction market, collectibles may not move well when the owner wants to sell—and at a profit.

The next step is to see if the collectible has an *auction price*. A great western artist sold at auction at Sotheby Parke Bernet in New York in late April 1980. His work had possibly never appeared at auction before. It was uncertain, in advance of the sale, what the price would be and even whether the painting would sell at all. It did sell, and at a good price. Thus, the works of this artist became much more desirable to a

collector-investor simply because they sell at auction and at a particular price. The more of an artist's works sell at auction, the more possible it is to determine market price.

The collectible should have, if possible, an *international market* and an *international market price*. When collectibles move from a particular local market to a national and finally to an international market, these works become definite investment collectibles. English Georgian silver sells all over—London, New York, Paris, Rome. So does fine French furniture. So do Oriental carpets.

An international market is a kind of broad insurance. If the local market won't "move" the collectible, the international market very well may. While one country may be in a recession and buyers may be reluctant to part with cash for collectibles, another country may be better off, and its buyers active. In recessions American buyers are often reluctant to buy. British, Swiss, and German buyers may be very much more positive, so that the market for the collectible is not limited.

An international market also assures a certain kind of mobility of investment. In the fairly recent Chilean crisis, albums of stamps were quietly spirited out of Chile and sold in New York, so the sellers could start a new life or at least weather the storm in their country.

The collectible should be *something the auction houses and dealers want*—and will even "reach for." Any auction house or major dealer would like to have for sale a Rembrandt landscape or a Gainsborough landscape, or a fine Tiffany lamp, or a fine French bombé commode by a leading maker like BVRB, or a painting by Guardi, or some Paul de Lamerie silver. These things auction houses and dealers can sell with little difficulty.

It is wise to *form a collection*. The Robert Scull Collection of Pop Art and other nonrealistic art was unique. Prior to its auction in October 1973, such a collection had never come onto the market. While a number of the works owned by Mr. Scull would have sold individually, the value to the auction house, and to the owner, of a whole collection was great—from the point of view of sales. A catalogue of the entire collection could be prepared. Many pieces could be illustrated in color. The sale could be publicized and advertised. From the viewpoint of the collector, building a collection is an intriguing project that may extend over many years. It is far more satisfying to build a collection than to buy a few pieces of this and a few pieces of that.

Collect things that can be *bought at auction and from dealers*. One collector specializes in memorabilia of old-time bus companies. It is not only hard to buy such collectibles at auction, but it is hard to sell them at auction. It is hard to buy from or sell to dealers, simply because the collectible is an extreme specialty, not widely collected. If a collectible is hard to buy, it is obviously hard to collect.

Some very much wanted collectibles, like fifteenth-century Italian Renaissance furniture, are simply hard to find anywhere. Every collector would no doubt like to be able to buy this early furniture, but he must be satisfied with sixteenth-century and probably even seventeenth-century items.

Follow *auction prices* of your collectible very closely—to see what you can buy at what price, what you can get if you sell, and what the price trend is: up, steady, or down. If the trend is sharply up, you may want to buy; if sharply down, you may want to sell. Auction prices are important to follow because dealer prices—prices a dealer receives when he sells—are almost always unavailable to you or anyone else.

Consider choosing collectibles to invest in that are *easy and relatively inexpensive to own.* An important New England collector of nineteenth-century American paintings used to collect classic and antique automobiles. He shifted to paintings. He said, "Every time I went out to start one of my cars the battery was dead or the tires were flat." In addition, he probably should have mentioned the difficulty of getting parts, the expense of repairs, insurance, licensing, and storage. Cars are a good investment, but one should know fully what he is getting into before he decides that they are for him.

Get to know the *characteristics that give a collectible value* and that detract from value. The auction catalogues and their descriptions will help you. So will auction house officials. So will dealers.

Cultivate dealers very early in your collecting activities. They will be your most valuable friends and allies in intelligent collecting. If you buy from them, they will be inclined to assist you in your collecting.

Early in your collecting activities it is wise *not to put too much money* into your collectible in toto. If you make mistakes (and you will early in the game) and you spend a great deal, you may be out of the collectible as rapidly as you went into it. As your expertise grows, so can your investment grow.

Early in your collecting you may want to *limit the amount* you spend *for any one item.* You may want to put, in all, $10,000 into a collection of, say, prints. If you put $5,000 into one desirable print, you have only an equal sum to put into the rest of the collection. If you make a mistake on a $500 print, it is far less serious than if you make a mistake on a $5,000 print. You might even buy a $5,000 fake!

You might want to set up a *collecting budget*—mainly so that your collecting does not get away from you. You can decide whether you want to buy out of income or out of capital. A rare-automobile collector will almost certainly have to buy out of capital. A beginning stamp collector might buy only out of income. It is, of course, wise to start by buying out of income. If your early collecting activities turn out to be unwise, at least your capital will not have decreased, and you will feel

far better than if you had depleted your capital to buy the wrong things.

Some consideration might be given to *buying the very best collectibles* that you can find—not necessarily the most expensive items, but the best of what you want to buy: the best condition gold coin, the finest foldover American card table, a perfect penny black stamp. The "best"— not the lesser and certainly not the worst item—is sought by collectors. Beauty, workmanship, authenticity, condition—all are important in determining what is the best.

In collecting, consideration should be given to the *interests and desires of the whole family.* Classic racing cars may be a good kind of collectible, but they cost a great deal of money, require constant repairs, are hard as well as costly to store, are of very limited use—and certainly of little use to one's wife!

Antiques, on the other hand, may satisfy both husband and wife as a collectible. Money outlay is involved in most collectibles—family money—and a collectible that interests the family might well be considered. Antiques, of course, enrich the home and enrich one's life, as do other collectibles like paintings, china, glass, and silver.

Assistance should be secured systematically.

1. Make friends with large dealers to help in collecting.
2. Cultivate small dealers who can be of more help as far as time devoted to you and your collecting activities go.
3. Consult experts, like those on Italian art, animalier bronzes, porcelain, etc.
4. Join clubs, particularly well-organized ones with periodical magazines, like the Sports Car Club of America, or even such an exclusive club as the Collectors' Club—of New York, if you can get into it!
5. Subscribe to periodicals like the magazine *Antiques, Art News,* or *Hemmings Motor News.* In exotic cars there are clubs for many makes—Rolls-Royce, Ferrari, Lamborghini, Maserati, etc.

Selling collectibles is a highly important consideration to any collector—at least at times when he may want to sell either for a capital gain or because he wants to refine his collection or because he needs to realize cash to put into something else. But the time to think about selling comes much earlier than the point at which you want the money. It is before you start collecting in the first place, so that you may select the collectible or collectibles that one day may be sold fairly easily and at a profit.

3

Determining the Market Value of a Collectible

On October 25, 1979, a monumental painting sale was held in New York. It was monumental because one painting in particular brought a monumental price. It was especially noteworthy because an *American* painting brought that price—greater than any American painting had ever before brought at auction: $2.5 million. It exceeded the price that the great Rembrandt "Aristotle Observing the Bust of Homer" had brought at the same gallery—$2.3 million. In advance of the sale everyone seemed to know the painting would bring a record price, but relatively few people thought it would reach $2.5 million. It was a traditional painting by the nineteenth-century landscape artist F. E. Church, and it was dated 1861.

In the same sale another F. E. Church, "Figures in a New England Landscape," dated 1852, was offered. It brought $40,000. Still another Church was offered in the same sale—"Magdalena River, Ecuador." It brought $27,000. Both of these lesser priced paintings are "quality" and pleasing to hang on the wall. The $2.5 million Church painting is very large and striking. It measures 64 by 112 inches and depicts icebergs. It is a masterpiece of the particular artist. Such a top example of the artist's work had never come up at auction before.

One of the questions to be answered in determining the value of what one has, and may want to dispose of, is: What is it worth and what can I get for it?

A person may have an unquestioned F. E. Church or he may have "an attributed F. E. Church," one worth a great deal and one worth far less.

Had the iceberg painting simply been "attributed to" F. E. Church and not definitely been the work of the artist himself, the price achieved would have been very problematic. It might have gone for one-tenth or more likely one-hundredth of the $2.5 million.

A painting by Thomas Moran sold in New York at auction in April 1980 for $135,000. Sometime ago a very large and imposing landscape, not unlike the one which had gone for $135,000, was offered for sale in Washington, D.C. It looked like a Moran, but there was little evidence that it was by this artist. It sold for something less than $1,000!

The determination of value (and probable price) is a technical matter, but some research by the owner of a collectible the value of which is unknown to him will certainly assist materially in arriving at value.

What Is in Style?

Fads in collectibles do not come and go as they do in women's clothing. In collectibles we might use the words "in style" rather than "fads." Ten years ago the postwar classic cars like the finest Mercedes were just beginning to come into style. There was little collector interest in such cars, and there were few collectors who would part with much money for them. Today classic cars seem to be all the rage, and a Mercedes has brought $400,000 at auction. Many classic cars are changing hands at more than $100,000 each.

Ten years ago Tiffany lamps were no great collectibles. Today they are, and many of them bring in five figures, and some six figures.

Ten years ago Italian Renaissance tables were more or less a drug on the market, and many of them sold for a few hundred dollars. Today a good Renaissance table sells in the thousands of dollars—and in the ten thousands.

In 1938 absolutely nobody would pay anything for the finest Louis XV furniture. Commodes sometimes went for $150, and armchairs for $50. Today we can add two digits to these figures—at least.

Collectibles that are in style tend to bring high prices, and they sell easily. A Tiffany "special order" lamp that sold new for less than $1,000 sold recently for $360,000. Tiffany lamps are at the pinnacle of their style cycle.

What Particular Items Are in Style?

My *Antiques as an Investment,* written in 1967, had this to say about Louis XV and Louis XVI furniture:

In the 1960's the furniture that consistently brings the highest prices are commodes of the Louis XV and Louis XVI Period. Chairs are of less importance *compared with commodes,* even though of comparable excellence and even though stamped by the same maker.

Prior to World War II, the exact opposite situation obtained. A set of chairs brought a great deal of money, and commodes were decidedly a secondary item.

Today we are back to the pre-World War II era as far as preference for French period chairs goes. In the past ten years interest and demand have shifted to chairs—not simply Louis XV and Louis XVI chairs, but all chairs, particularly those in large sets. Sets of twelve of almost any kind of antique chair sell quickly and at a high price, compared with what such a set would have brought even as recently as five years ago.

Ten years ago few people wanted a secondhand Rolls-Royce Silver Cloud III of 1963–65, and prices were low. Now these cars are very high in price, and the convertible body style can go into six figures.

Who Is the Maker or Artist?

A mid-eighteenth-century teapot of fine design and in good condition—American—can bring as much as $5,000. If the same teapot bears the stamp of Paul Revere, it can bring as much as $50,000 plus.

In paintings one of the big questions always asked is: Is it a Rembrandt? If the painting turns out to be not by Rembrandt, but by a follower, even a known artist in Rembrandt's circle, it may bring $50,000, but not much more and often much less. If it is definitely established that Rembrandt did paint the picture, the value can be ten times $50,000—or more.

The same holds true for French antique furniture—if made by "RVLC" or Joubert or any other of the great furniture makers. Just the fact that one of the great artisans made a piece adds tremendously to its value.

Size

A relatively few years ago large pictures were sometimes called outsize pictures. They were like oversize houses. Nobody wanted either. Now both large pictures and large houses tend to bring a great premium. The $2.5 million F. E. Church was not only a masterpiece but a very large masterpiece—64 by 112 inches.

A very large quality Italian Renaissance table will bring a disproportionately high price, compared to a smaller table. A large French armchair of the Louis XV period will bring more than a small armchair. While larger size does not always mean disproportionately higher price in collectibles, it often does, particularly in great paintings.

Does the Object Have Certain Characteristics Considered Good?

In the April 1980 auction of American paintings in New York, a Childe Hassam—a scene at Newport Harbor—brought $205,000. Another Has-

sam—of Union Square, New York—brought $190,000. A Hassam portrait of an attractive woman, estimated to bring $15,000 to $20,000, failed to find a buyer at all. Buyers want landscapes, not portraits, by Childe Hassam.

In British portraits of the eighteenth century, like those of George Romney, a 25- by 30-inch portrait of a man in a dark coat brings far less than the same-size portrait of a man in a red coat. A similarly sized portrait of a woman brings still more, and a portrait of a child brings the most.

The value of antique furniture is highly technical. An extremely well-carved Chippendale chair brings far more than a simple Chippendale chair. One of the most important books ever written on value-determining characteristics of American furniture is *Fine Points of Furniture—Early American,* by Albert Sack (New York: Crown Publishers, Inc., 1950). The book is a series of illustrations of various pieces of American furniture. On the same page there will be pictures of a "good" table, a "better" table, and a "best" table. One must train his eye to recognize characteristics in any collectible that determine value. When the slender, well-proportioned pieces bring the most, then one must learn exactly what constitutes "slender" and "well-proportioned." The recognition of these value-giving characteristics is not always simple. It is learned over a period of time—with study.

The Importance of Elaborateness

We have touched on elaborateness as a value-giving element. Almost across the board in collectibles the most elaborate collectible tends to be worth the most—from Chippendale chairs and highboys to carved Renaissance tables to carved antique frames to animalier bronzes to porcelain figurines to Oriental carpets.

Is the Object Beautiful?

The Mercedes-Benz 1936 Model 500K convertible that brought the record high price for any car at auction of $400,000 was one of the most beautiful roadsters ever built, and it has been known as a beautiful car through the years, even though ten years ago it would certainly not have brought an auction price of $400,000.

The F. E. Church that brought the $2.5 million was probably the most beautiful example of that artist's work in existence.

Still, beauty must be learned to a degree, and the great Bernard Berenson, the authority on Italian art, continually emphasized the elements of beauty in masterpieces. It is hard to fault the "Mona Lisa" by Leonardo da Vinci in any way—drawing, third dimension, coloring, landscape background.

In general, the piece of American furniture that brings the top price is the most beautiful piece.

There are beautiful paintings by Rubens and there are not-so-beautiful paintings by Rubens, and the less beautiful ones do not command the prices of the beautiful ones.

The Provenance of the Object

If a piece of French furniture that was once in Versailles Palace is offered, that provenance alone adds materially to its value. If a piece of American furniture once belonged to Benjamin Franklin, that background adds value. Many years ago a direct descendant of John Hancock lived in Greenwich, Connecticut. She owned much of the furniture and silver and several of the paintings once owned by Hancock. A clock actually had the bill of sale by the maker to Hancock with it. This provenance adds to the value of anything.

If there is no royal or historical provenance, the piece may have belonged to a great collector who obviously knew what he was about in his collecting activities. Paintings once owned by Henry Ford II or Baron Thyssen have their value enhanced somewhat by such a background.

If a Bugatti Royale should come onto the market, it should bring at least $500,000. Only seven of these unique cars were ever built—each was specially made and the history of each is recorded—and many, many people want one. The greater the background of the object and the person to whom it belonged, the more valuable the object—as a general rule.

Was the Piece Exhibited and Cited in Authoritative Works?

Was the painting once on display in the Metropolitan Museum of Art, or was the Chippendale chair once on loan to the American Wing of the Metropolitan? If so, the Metropolitan in a sense places its stamp of approval on the collectible—as both authentic and fine.

If the painting is reproduced in Bernard Berenson's book on Italian art, that is a recognition of its authenticity and quality.

Sales catalogues of auction houses often cite exhibition after exhibition and authoritative book after authoritative book on the painting, the piece of furniture, porcelain, or whatever it is. The more such recognitions, the greater tends to be the value.

Original Condition

Condition can be tremendously important to the value of a collectible. On April 11, 1980, Christie's auction in London sold Lot 163, a painting

of a gentleman by Pompeo Batoni, for 55,000 pounds sterling (about $121,000), a high price, but for a beautiful picture and apparently in excellent condition. The very next lot in the sale, Lot 164, was also a Batoni, and the subject looked as though it were the same man. Even from the photo in the sales catalogue this painting appeared to be in poor condition. In brought 2,600 pounds—$5,700. Maybe the high-priced picture was bigger and more colorful, but condition was all-important and probably the determining factor.

A Rolls-Royce firm in New York recently had two Silver Cloud II Rolls-Royce sedans for sale. One was priced at $12,500, and the other priced at $45,000—quite a difference in price for the same model car of the same year, 1961. The first car was in average condition—not bad—but the second car was in mint condition.

The question about almost any collectible is: How near to its original condition is it? Some antiques are in original condition, even to original lacquer. Some are so repaired, and with so many replacement parts, that little of the original condition is left. The latter are hardly antiques at all, and their value as antiques is problematic.

The older a collectible is, the more repairs and replacements are tolerated—without reducing the price much. A Chinese vase that was used as an umbrella stand several years ago was cracked in several places at the top. It brought $573,300 at auction. It was old, and in older items one must put up with damage—or do without the rare item!

In coins condition is everything. Coins are valued according to condition and are graded by their condition. This is an accepted grading of coins according to original condition, the most valuable obviously being at the top of the list:

Proof coin	Fine
Uncirculated	Very good and good
Extra or extremely fine	Fair and poor
Very fine	

These are official and determinable grades according to condition. A top-grade coin can easily bring ten times what a bottom-grade coin can.

How Rare Is the Piece?

Like anything else, price in collectibles is a matter of supply and demand. Some time ago a great Titian that hung in London's National Gallery was sold at auction in London. Nothing like this masterpiece had come up at auction in years. The painting was sold to the London dealer Julius Weitzner for $4,065,000. Before Mr. Weitzner even had time to pay for his purchase, J. Paul Getty bought it for his museum for more

than $4.3 million—a profit to Mr. Weitzner of $300,000 for several hours of work and no investment on his part.

But so rare was this Titian that the British government would not allow its export to the Getty Museum in Malibu, California. The government raised the money to buy the painting to keep it in England.

The antique dealer Robert Sack raised the question about how much the great Rembrandt "Aristotle Observing the Bust of Homer," which sold in 1961 for $2.3 million, would bring today if offered for sale by the Metropolitan Museum of Art, its present owner. He answered his own question by another question. "Twenty million dollars? More perhaps?"

A very good English sideboard with some inlay work can sell for $2,500 or $3,000. A comparable American sideboard can bring $10,000, $20,000, or even more. American is much rarer than English furniture of the same period.

Price History

A collectible can be valued on the basis of past price for comparable collectibles and for the particular piece, if such a price is available. Some paintings are sold several times at auction. Thus, there is a price history of the particular painting, and it does *influence* present value and present price. The more recently the collectible was sold at a published price, the more important is that price in determining its present value. In a 1980 sale of automobiles at Madison Square Garden a Duesenberg failed to sell. The reason, one dealer explained, was that the car had been offered three weeks earlier at another auction—and failed to sell. This "nonsale" militated against the sale of the car just three weeks later at any good price.

The trick is to find comparable items that sold in the recent past. These past prices in a way determine what the present value of a collectible is. It is the basis for the gallery's estimate of what the particular item is likely to bring at auction. Such estimates are included in most auction catalogues as a guide to buyers in their bidding.

Price history is a kind of takeoff point for the seller to use in arriving at a reasonable estimate of the worth of his collectible. When he knows the approximate present value of an item that he has, he knows what he has and whether its sale would be of financial interest to him. If the item is worth $10, its sale may not be worth his time. If the value is $1,000, it may be worth time disposing of it. If the value is $10,000, the sale might be very important to the owner.

All through this listing and description of value-giving elements in collectibles we assume that the collectible is something that somebody

(or somebodies) wants and is willing to part with money for. This is the demand side of the value-determining picture or equation. As regards railroad memorabilia, there is a good demand, and at a fairly high price, for china used in the dining cars, particularly of the old-time crack trains. On the other hand, there is very little demand for old railroad ties as collectibles, even antique railroad ties. The demand must be there for price to be significant.

We might repeat our list of value-giving elements in collectibles:

Demand Rarity
Quality Condition

Establishing a Probable Dollar Value of a Collectible

General principles on estimating the worth of a collectible are important, but they are a far cry from coming up with a specific value or range of values. One obvious way of finding out the value is to offer the piece for sale. This course of determining price is possible for some collectibles. A coin can actually be offered for sale to a coin dealer. If it is popular, like an American gold coin, the dealer will offer a dollar amount, usually on the spot. At the other extreme is a large unique Flemish mantelpiece on which almost no one can come up with a value. Between these extremes there are all shades of accuracy in determining value.

Like coins, postage stamps have verifiable value, and if one visits a major stamp auction, the auction house official will give a very good idea of what the stamp will bring. In many cases a dealer will offer to buy a stamp on the spot, like the coin dealer, but a dollar figure for stamps is harder to arrive at than for coins.

Offering to a dealer is one way of establishing value for some standard items with a very determinable market price, but not for certain other collectibles. Very often "Foreign Cars for Sale" ads contain the words "No dealers, please," meaning, "We want no dealers to make offers on this car." The reason is that dealers sometimes offer ridiculously low prices on cars and, in effect, would like to "steal" them from their owners.

Offering the collectible to a dealer is only one way of establishing or determining value. Some auction houses buy collectibles outright from their owners and are thus something like dealers. It might be well to see what these buying auction houses will pay for your collectible.

You might also look at advertisements of similar collectibles offered for sale. The main newspaper for advertising exotic cars is *The New York Times*, and often the kind of car you have is offered for sale there at a stated price.

There are also many specialist newspapers and magazines that carry such advertisements, publications like the *Bulb Horn* for antique cars and *Hemmings Motor News* for classic cars. The Customart Press of Westchester County, New York, has listings in sixteen publications for everything from jewelry to antiques and collectibles to hot-rod cars to antique motorboats. Their address is 525 North Barry Avenue, Mamaroneck, New York 10543. Telephone: 914-698-1500. The specialist club publications offer items for sale, all the way from watches to Lamborghini automobiles.

For many collectibles auction catalogues are the best source of values. The auction houses are a volume outlet for major investment collectibles, and their price lists cover each sale of the major collectibles they handle. Thus, if you have a half-length portrait of a man by the great American portraitist Gilbert Stuart, one done during his residency in London or in Ireland, you look at the catalogues for the London auction sales of English pictures by Sotheby Parke Bernet and Christie's and perhaps Phillips and Bonham's—two other auction houses located in London (and other cities as well). "English" and "Irish" Gilbert Stuarts come up for sale most frequently at auction in London, although they also show up from time to time in the New York auctions.

One simply finds out what library or museum (such as the Metropolitan Museum of Art and the Frick Art Reference Library, both in New York) has the auction catalogues of Sotheby Parke Bernet and Christie's, London. Price lists are usually attached to the catalogues.

The same procedure for price estimation can be used for many other collectibles: carpets, English antiques, Georgian silver, Gallé glass, Art Deco furniture, Chinese vases. Most auction house catalogues are specialized according to collectibles offered, so the collectible can be easily located. There are catalogues for Old Master, English, American, and European paintings; Georgian silver; English, American, and French furniture; English porcelain; Americana; musical instruments, and many other categories of collectibles.

For a fee the auction houses will make an appraisal of a collectible. Sotheby Parke Bernet states that it will appraise in the following categories for a minimum fee of $300: arms and armor, Art Nouveau and Art Deco, furniture, prints, jewelry, Oriental art, paintings, porcelain, rugs and tapestries, Russian works of art, and silver.

From time to time the major auction houses conduct what they call Heirloom Discovery Weeks or some such designation. A group from the auction house will travel to a smaller city and there review what collectibles anybody chooses to bring to them for identification and verbal appraisal. There is usually a small donation to the sponsoring organization but the auction house does not charge for verbal appraisals.

The auction officials, of course, hope to secure items for sale in their auction houses, and they often get valuable things to sell at auction in this way.

An owner can, of course, simply bring his collectible to the auction house and secure the same service. There will be no written, formal appraisal, but the owner is given an idea of what he has and what the auction house might secure for it at auction.

Sotheby Parke Bernet's Joseph Kuntz was making an appraisal for the nuns at Elizabeth Seton College in Yonkers, New York. The nuns were interested in having an appraisal made of the contents of a house they had received as a gift. Mr. Kuntz noticed that the nuns at luncheon had a rather unusual sugar bowl they were using. He asked if he might examine it. They agreed.

The bowl turned out to be one of the pieces of porcelain made by Francesco de' Medici in his Florentine factory about 1575. Fewer than sixty such pieces are known to exist today.

Sotheby Parke Bernet was permitted to auction the bowl. It brought $180,000! This was a major discovery, and an auction high for a single piece of European porcelain.

If one *knows* what he has and would like to value it, he is well on the road to securing a good valuation. When he does *not* know, the valuation task becomes harder. Very often people own things of little value that they think may be worth a fortune. On the other hand, a relatively few items turn out to be great treasures like the Medici bowl and the Chinese "umbrella holder" that Christie's auctioned for $573,300.

A first step might be to show the item to a dealer in the kind of things the owner of the collectible has—just to determine what it is and what a rough value might be. An antique obviously might be shown to a local antique dealer, a diamond to a jeweler.

If there is no major auction house in your city or town, you might take the item with you to a major auction house in a nearby city, if possible. If the distance to the auction house is too great, you should have a *professional* 8-by-10-inch *black-and-white glossy* photograph print made. On the back should be the description of the item—paper, wood, or what, the size, and what you know of the background of the piece. Send this to a major auction house in one of the cities in which the firm is located—preferably the main office of the auction house. You should also indicate that you might like to sell the item, not that you are simply idly curious to know what you have and its value.

At this point a decision can be made to go ahead with plans to sell, if a sale is contemplated. Right here *most* attempts to value things stop, as the owner's idea of the worth of his item may well not accord

with reality. On the other hand, there are, no doubt, many people who own items that have far more value than they think, and they might like to know this fact, even though they may never want to sell.

Professional Appraisers and Appraisal Societies

In order to donate art objects to museums, educational institutions, and charitable institutions and secure an income tax credit, a formal appraisal is an absolute must. Securing this appraisal is explained in detail in Chapter 9, "The Donation of Appreciated Collectibles." The better the appraisal and the better qualified the appraiser, the greater the chance that the appraisal will stand up under the scrutiny of the Internal Revenue Service.

In this chapter the use of appraisers and their professional associations or societies will be explained in connection with securing an estimate of what one's collectible is worth as a step to possible disposal of the collectible.

The Art Dealers Association of America

This association *itself* appraises works of art. It does not appraise for the purpose of supplying "general information to the owner or for insurance purposes."

The valuations of the association are made for income tax purposes in connection with donations to museums and other nonprofit institutions. In "exceptional situations [it] also appraise[s] art works in estates for estate tax purposes."

Its fields of appraisals are "paintings, drawings, sculpture, graphics and photographs. . . ."

Individual members can and do do appraisals, and here the range of expertise is broader—twentieth-century and contemporary American and European works of art, nineteenth-century works of art, Old Masters, drawings of all eras, etchings, lithographs, serigraphs, primitive art, sculpture, prints, photographs, pre-Columbian art, ancient art, illustrated books, print reference books, antique silver and porcelain, comic art, and works by famous illustrators, among other things.

There are approximately 105 members of the Art Dealers Association, most located in the East, and the headquarters are at 575 Madison Avenue, New York, New York 10022.

The organization, when it appraises as an association (not an individual member doing the appraising), charges a fee from $50 for a work of art worth up to $2,000 to $750 for a work of art worth between $75,000 and $99,999.

The Appraisers Association of America

This organization does not appraise *as an association*. Individual members appraise, and when they do, they prepare the appraisal on forms indicating that they are members of the association. The headquarters are at 60 East 42nd Street, New York, New York 10017.

The membership of this organization is very large and located all over the country. For $3 one can secure a list—of more than 120 pages—of its members listed geographically.

The American Society of Appraisers

This organization also does not appraise as an association. Individual members do appraise. The address is Dulles International Airport, P.O. Box 17265, Washington, D.C. 20041. The membership numbers about 5,000, but 300 of the members specialize in the appraisal of personal property, including collectibles. Many members do only real estate appraisal work.

The members who appraise personal property are rigidly tested and must meet high standards of knowledge and appraisal ability. Their areas of expertise are antiques, fine arts, gems and jewelry, African sculpture, rare books and manuscripts, coins, pre-Columbian art, Orientalia, and the contents of residences.

Members can charge only a flat fee or an hourly or daily fee for appraisal. They cannot charge according to the value of the thing appraised. Most of the members are not dealers, but specialists in appraisal.

The organization, membership, and appraisal activities of these associations are taken up more fully in Chapter 9. It is in the donation of collectibles that these associations make a very big contribution. Individual members, of course, can appraise on their own, and a list of the members can help one locate someone who can tell the owner of a collectible at least the approximate value of what he has and perhaps even prepare a formal appraisal for use for income tax or estate tax purposes, the division of estates among heirs, insurance, sales, and even, in some rare cases, the value of the object as collateral for a loan.

The "Quick" Price Guides

At one end of the spectrum of determining the value of one's collectible is a formal appraisal by a leading appraiser or by an association, an appraisal that takes time and study and can sometimes run to a good deal of money. At the other end are the "quick" price guides.

The Official Price Guide to Antiques and Other Collectibles is prepared by

Grace McFarland and published by The House of Collectibles, 773 Kirkman Road, No. 120, Orlando, Florida 32811. This "directory of prices" is more than 450 pages long and contains more than 20,000 prices. The main use of the *Official Price Guide,* as it is called, is to get an idea of the value of the unusual collectible that a person may have.

The number of categories of "collectibles" is immense and runs from *A*—almanacs, American eagles, etc.—to *W*—weather vanes and woodenware, to *Z*—zodiac.

These are some examples of entries from the *Price Guide:*

North American Almanac, S. Sterns, 1776—$35 to $38
White Springs arrowheads, 1½ to 2½ inches, 5000 B.C.—$1 to $2
Mahogany Belgian Art Nouveau dining room suite, 8 pieces—$2,800 to $3,400
Chevrolet deluxe roadster, 1931—$7,500
Barbed Wire, Gunderson, circa 1881—$2 to $5
Mickey's Malt Liquor Beer Can—$.50
Bicycle, Boneshaker, 1850—$1,600 to $2,000
Knives for trimming hooves, circa 1890–1910—$2 to $3

The Kovels' Complete Antiques Price List (New York: Crown Publishers, 1978), contains 45,000 prices and is revised regularly. It contains about 500 illustrations, some in color, and 300 factory marks. The price is $9.95. It is even more comprehensive in its coverage than the *Official Price Guide.*

There are other collectible price lists. These two are comprehensive and are kept up-to-date. All of the guides are helpful in establishing the value of your collectible.

In 1980 *Sotheby Parke Bernet's Price Guide to Antiques and Decorative Arts* was issued for items sold by that auction house. It is issued by Fireside Books, Simon and Schuster, 1230 Avenue of the Americas, New York, N.Y. 10020. Classification of the 33,000 items, with prices, are grouped under major headings like American ceramics, English furniture, and European silver. The price is $9.95.

The Art and Antique Market Price Reports and Summaries

International Art Market is a monthly publication covering "The Current World Auction Prices of Art and Antiques." It is published by Art in America, Inc., 850 Third Avenue, New York, New York 10022. The subscription rate is $50 a year, but a number of art libraries get this publication, and it can be reviewed at the library when it comes out. The publication is a sampling of auction prices for a wide range of art and antiques, and European as well as American auctions are covered. Key items that went at auction are selected, and their auction prices indicated. In the July–August 1980 issue, the following areas of collecti-

bles were covered: Old Master pictures, Benin (African) bronzes, Master drawings, American paintings, American and European art, and Victorian paintings. Silver sales are given considerable coverage.

There are many illustrations in black and white, so one sees a sample of what is being sold and can get a feel of the market, even if he cannot get a fix on what the item he has for sale is worth. Other issues of the *International Art Market* cover antique furniture rather thoroughly.

Richard Hislop, at Pond House, Weybridge, Surrey, England, puts out an *Annual Art Price Index*. The last issue was a comprehensive report in two volumes that covered oil paintings, watercolors, and drawings. This firm publishes periodic reports on the auction market that concentrate (in each issue) on a certain number of artists. This report costs $368 for paintings, $179 for watercolors and drawings.

Mr. Hislop has prepared price curves for a number of artists, showing their price movements over the years. He has a very large computer inventory of art prices by artists, so that if you want all prices on Thomas Heeremans, the Dutch artist, over a period of years, he can supply those prices for a fee, which depends on what you want in the way of prices—average prices, all prices, for one year, for five years, or what.

Art-Price Annual has been put out for many years, so that a person interested in tracing prices for a particular artist can secure a good deal of assistance by using it year by year. The annual covers many auction sales of furniture, antiques, paintings, drawings, and prints, with an index for locating the particular sale on a particular date at which a particular item brought a particular price. This publication is issued by Art & Technology Press, 18 Lipowskistrasse, Munich, Germany. Major libraries, as well as many art libraries, have these volumes.

A similar publication is *World Collectors Annuary*, an alphabetical classification of the prices of paintings, watercolors, pastels, and drawings, edited by AME van Eijk van Voorthuijsen at Voorburg, Holland. This publication, too, is available in a number of major libraries.

Art Prices Current is published by William Dawson & Sons Ltd., Cannon House, Folkestone, Kent, England. It has been published annually since 1907–08, so that prices at auction can be traced over a period of many years. This is a record of sale (auction) prices at the principal London, Continental, and American auction rooms. Part A covers paintings, drawings, and miniatures, and part B covers engravings and prints. The classification is by artist. These books are found in major art libraries.

The same firm also publishes *Book Auction Records,* a priced, annotated annual record of international book auctions.

For Victorian paintings there is a specialized publication called *Prices of Victorian Paintings, Drawings and Watercolors*—from the records of Sotheby's Belgravia (the lesser auction gallery and the one specializing in

Victoriana). It is published by Carter Nash Cameron Ltd. in association with Barrie and Jenkins. The last issue we saw was 1976. It can be secured from 25 Lloyd Baker Street, London WC1X9AT, England. It is also in major art libraries.

The Reports of the Auction Houses

The major international auction houses put out extremely elaborate, lengthy, detailed reports on what took place in their establishments for the year just past—the 1978–79 season, the 1979–80 season, and so on. The quality of the black-and-white and color reproductions is the best and gives an excellent idea of the more important items sold.

Christie's calls its annual *Christie's Review of the Year*. It is a Studio Vista Book, published by Cassell Ltd., 35 Red Lion Square, London WC1R4SG, England, an affiliate of Macmillan Publishing Co., Inc., New York, and can be secured from Christie's, 502 Park Avenue, New York, New York 10022. Christie's Review of the Year 1980 was offered through Rizzoli International Publications, Inc., 712 Fifth Avenue, New York, 10019, and at fine bookstores throughout the United States. The price was $45.

Sotheby Parke Bernet's annual is called *Art at Auction*. It is put out for Sotheby Parke Bernet Publications by Philip Wilson Publishers, Ltd., Russell Chambers, Covent Garden, London WC2E8AA, England, and 81 Adams Drive, Totowa, New Jersey 07512. It can also be secured from Sotheby Parke Bernet, 980 Madison Avenue, New York, New York 10021 and at fine bookstores. The price on the jacket of the latest issue (1979–80) was $45.

The Auction Year is issued by Phillips Fine Art Auctioneers, 867 Madison Avenue, New York, New York 10021. The 1979–80 issue was priced at $10.

All these annuals are departmentalized so that one can review what has happened during the year and see what major items the auction house sold in jewelry, silver, Impressionist paintings, twentieth-century painting, contemporary art, furniture, sculpture, tapestries, clocks and watches, musical instruments, objects of art, icons, coins, ethnographica, antiquities, books, manuscripts and autograph letters, porcelain, glass, Art Nouveau, Chinese and Korean ceramics and works of art, Japanese, Persian, Islamic, Indian, and Tibetan works of art, including rugs and carpets, arms, armor, guns, cars and model cars, and wines.

The most systematic and analytical report in the auction business is issued by Michael Broadbent, director of Christie's wine auction, 8 King Street, St. James's, London SW1Y6QT, England. It is called *Christie's Wine Review*, and the last issue sold for 4 pounds 10—about $10.

Every major wine, and a number of other wines as well, is priced

year by year, so that one can easily determine, with accuracy and no guesswork, price trend and present price—for Bordeaux, Burgundy, champagne, German wines, vintage port, old Madeira, old sherry, sundry wine and spirits, and vintage brandy.

After almost every major sale, Mr. Broadbent analyzes the market at the time and indicates its strengths and weaknesses. No other department head in any auction house anywhere turns out the analytical reports that he does.

Two very useful, very summary reports on auction prices have come out recently:

Art & Auction is published ten times a year by Auction Guild, 250 West 57th Street, New York, New York 10019. The annual subscription is $25. It contains news of the auctions, what sold for what (the most important things), and some analysis of what is happening. There is also a detailed auction calendar for three months ahead, indicating what auction houses located where are offering what for sale.

Art and Antique Auction Review is published monthly by University Arts, Inc., IFM Building, Old Saybrook, Connecticut 06475. The annual subscription rate is $36. The last issue was twenty-four pages long and had sample sales and prices for twelve different auction houses. There is a simple description of each item sold, indicating whether it is antique or not, sometimes with the date it was produced, the measurements of antiques, and the price. It supplies a quick rundown on auction prices for particular items.

4

The Auction Houses: What They Want and What They Can Sell

The auction houses are a major means of disposing of a number of kinds of collectibles. They are so publicized by the press that more and more collectibles are being sold by their owners through auction. High prices that the houses secure for a number of collectibles are so broadcast throughout the country that the auctions seem to be attracting sellers who otherwise might not think about selling. In recent years, sales increases for almost every auction house have been dramatic—every year. Nevertheless, not everything can be sold advantageously at auction. We might start with the things that might *not* sell best at auction:

Antique and classic automobiles. The American auction houses, at least the *major* ones, have handled very few automobiles. There are specialized automobile auctions, and we will take them up later. The two big auction houses, Sotheby Parke Bernet and Christie's, have done little with automobiles, but of the two Christie's has done the better job. Phillips of New York has also had some successful automobile sales.

Household goods. The major auction houses are set up to handle mainly collector or investment items, and they handle very little of the ordinary household items that are sold by families moving out of town or to smaller quarters or the sales of such household items by estates.

Stamps. The major auctions, mainly Sotheby Parke Bernet, are getting into postage stamp auctions, but here again there are specialized stamp auctions, and they dominate the stamp business. It might be pointed out that these specialized stamp auctions, which we will take up later, sell perhaps a combined total of $25 million worth of stamps a year.

Coins. The major auction houses do not dominate the rare coin business by any means. The coin dealers do. Sotheby Parke Bernet went

The collection of Edgar and Bernice Chrysler Garbisch was auctioned by Sotheby's in 1980 in a series of sales in New York and on premises in Maryland for a record one-owner total in this country of just over $20 million. Shown here in the Garbisch Manhattan drawing room is a Monet which brought $280,000. (It had sold in 1917 for $7,600.)

into the coin auction business for a time, then seemed to pull out of it, only to come back in early 1980.

Vintage wines. For legal reasons *no auction house* handles vintage wines in the United States. In London vintage wine auctions are a major activity, and Christie's wine sales are rapidly approaching the large total of $10 million a year. For wines to be sold at auction, they must be shipped to London. There are only two main wine sales in the entire United States per year *by auction.**

These are the categories of collectibles that the major auction houses *do* handle—most of them:

Art
European Old Master paintings
European nineteenth- to early-twentieth-century Paintings
American paintings—mainly nineteenth- to early-twentieth-century—and American folk art
Contemporary art—realistic and nonrealistic
Drawings of all schools of art
Prints of all schools of art and photographs
Watercolors, mainly English
Sculpture—From classic B.C. to contemporary, including African art

Furniture
American antique
European antique
Victoriana
Art Nouveau and Art Deco

Ornaments and Ornamental Items
Gemstones and jewelry
Georgian silver
American silver
Artistic glassware, including paperweights, Tiffany, and the glass of Nancy, France
Oriental rugs and carpets and tapestries
European porcelain and pottery
Chinese ceramics

Personal Collectibles
Rare books
Autographs—some
Stamps and coins—some
Antique and classic cars—a very few, but more in England and Switzerland than in this country
Antique toys and clothing

* In 1981, Christie's conducted its first wine auction in the United States, in Chicago. The sale was big and prices were high. This sale may very well be followed up by other Christie's wine sales throughout the country.

What Items Interest the Auction House to Sell

As a general rule, the auction houses are most interested in the more expensive items. They are set up to do a dollar volume business, and the lowest-priced items cannot supply this dollar volume. On the other hand, there are often *some* items that sell for a few hundred dollars, even in the major salesrooms, like Christie's Park Avenue and Sotheby Parke Bernet's Madison Avenue salesrooms. The day before this was written this writer purchased two very fine American pewter teapots, highly ornamental and of the nineteenth century, from Sotheby Parke Bernet's major Madison Avenue gallery for $100.

Unique kinds of items are generally not handled by the major auction houses. In California there is a collector of old locomotives, who has bought and sold several. This is not a strictly auction item. Neither is an enormous antique bar from an old hotel in Pennsylvania that a collector in Oil City, Pennsylvania, was interested in selling.

The major auction houses are interested in handling a fairly large volume of items that have appeal to a fairly sizable group of buyers. A representative of Sotheby Parke Bernet in London once stated that Sotheby's would sell anything for anybody, but if this auction house in effect does handle everything offered to it, it may well not be the best equipped to get the best price for anything and everything offered to it.

The Functions of the Auction House

The auction houses (or auctions) are commission houses—at least for the most part. As a general rule, they do not own the merchandise they sell. They take merchandise from the owners on consignment and offer it for sale, on a bid basis—the highest bidder getting the particular thing offered. For this service they charge a commission. The largest American (and international) auction houses sell to the highest bidder— say, $1,000 for a Victorian Belter chair. Before remitting the sales price to the owner-consigner of the chair, they deduct a commission of 10 percent, so that the net received by the owner is $1,000 less $100, or $900. But to the $1,000 they add 10 percent to the bill the buyer has to pay. He thus gets the chair on a top bid of $1,000 but has to pay $1000 plus 10 percent, or $1,100. The auction house keeps this $100 as a sort of additional commission—getting $200 in all. This is the general method of charging by the major auction houses.

It is somewhat hard for the owner of collectibles to reach the buyer, and it is harder for him to reach a *group* of buyers so that he can see what the buyer who wants the collectible the most will pay him. This the auction is equipped to do. If you have a Dutch primitive painting

by Dieric Bouts, how do you as an individual reach prospective buyers? And if you can reach prospective buyers, how much can you get for your Dutch primitive? It is not exactly a painting with a definite market price. Not even the gallery that recently sold this Dutch primitive had much of an idea what its value was.

The Dieric Bouts brought at auction in April 1980 the very large sum of $3,740,000 when sold by Sotheby Parke Bernet in London. The painting was a "discovery" the value of which was not even remotely suspected by its owner. It was bought by Norton Simon of California and his wife, the former screen actress Jennifer Jones. The owner of the painting, located in Europe, reached the high bidder, located in California, through the auction process and secured a price more than five times what even the auction house originally thought it could get, which was only 200,000 pounds sterling—under $500,000!

Auction houses may like to make one sale for $3,740,000 and get a fine commission on the one sale, but the bulk of their business lies in selling inexpensive lots—of under $1,000 and many of under $500. The houses are best at selling investment collectibles that have an investor-collector market. If you have an American painting for sale, it is included in a sale of American paintings. Because a large number of such American paintings are offered for sale at the same time, a large group of buyers is attracted to the sale. One or more are likely to bid on and buy your American painting.

Of tremendous value to a sale of anything is a catalogue of what is being offered—particularly a descriptive catalogue with illustrations of some of the offerings.

Along with the catalogue goes a certain amount of advertising and publicity to bring in the potential buyers. The auction house may even write and phone prospective buyers whom they know from past purchases. A gallery official may very well make a phone call to a prospective buyer and say, "You were interested in buying a Patek-Philippe repeater watch. We have three coming up in our sale of June eighteenth." Or he may say, "You wanted an American Gilbert Stuart. We have one coming up for sale April eighth. Why don't you come in and examine it prior to the sale?"

An integral part of the auction is the exhibition of the things offered for sale, which is held a few days before the sale takes place so that prospective buyers can examine the items for quality and for defects. No one should buy anything without having inspected it in advance. It is too easy to buy something that is not at all what the buyer thought it was prior to his acquiring it. At the exhibition gallery attendants and the heads of departments are present to answer questions about particular items, including wear and damages.

The financial function of an auction house is all-important to a

seller of anything. When one sells to an individual or even negotiates to sell, he always wonders: If we arrive at a price, will I be able to collect for the sale? Of course, in real estate in times of high interest rates and tight money, the house seller is almost never sure that the sale will go through. Many, many sales cannot be completed because the bank doing the financing will not supply the needed funds, either because it is short of mortgage funds or because it does not feel the buyer of the house is able financially to carry his monthly payments—and few house buyers have all the cash necessary to buy houses at present high prices.

A major auction house performs the very necessary function of seeing to it that a deal is completed and that the seller of the collectible gets his money—and within a reasonable period of time.

During the last few years "buyers" of automobiles and many other things, who bought things privately from people who advertised their things for sale, have resorted to many tricks to cheat the seller out of his money. Even cashier's checks of a major New York bank have been forged—not one check, but many checks. The seller accepts the offer of a buyer of his secondhand Rolls-Royce, let's say. The price is $15,000. The buyer brings to the final closing on the sale a First National Bank check for $15,000. Only the check is a fake and never saw the inside of the First National Bank! The buyer has the Rolls-Royce, and the seller a worthless piece of paper.

But this is not all. The buyer of the Rolls-Royce has many other such checks where that one came from, and he proceeds to buy other cars with other forged First National Bank cashier's checks. The way this particular operation was detected was the *number* on the check. The number on each forged check was the same. The First National Bank simply notified other banks in the area to look out for forged checks bearing the number.

The auction houses perform a great service in seeing to it that the seller of the collectible gets paid. Each house makes sure it gets paid before it remits payment to the seller of the collectible. Very often the auction house wants cash payment, particularly if the buyer is unknown to it. Or if a check is given, the buyer must wait until the check clears before the house will release to the buyer the purchased item.

In a few cases, particularly when dealers are the buyers, the auction house may extend credit for a limited period of time—and pay the seller of the goods on the theory that the auction house is not running much of a credit risk with an important dealer.

Once in a while a buyer will say that he hasn't the funds to pay, but that he will come in next week and pay. Then maybe he doesn't, and maybe he is never heard from again. In that case, the collectible

the auction house thought it had sold was, in effect, not sold, and it is returned to the seller or held for another sale.

The Auctioning Process

The objective of the auction house, the main reason for the existence of auctions, is to gather together prospective buyers of a particular collectible, like American nineteenth-century paintings or Russian icons, to bid on what is offered. Because an auction offers many such items, many prospective buyers are gathered together for the sale. One buyer may be interested in one or two offerings, and another may be interested in three other things or just one thing. Both individual buyers and dealers are present and bidding at the auctions of nearly every kind of collectible. The individual buys to collect or to invest or to decorate his home, and the dealer buys for resale at a profit. In many auctions of particular items, dealer buying predominates.

The ultimate aim of the auction house is to get people bidding against each other. The sale is made to the buyer who is willing to pay the most for a particular item or lot offered—the one who makes the last and highest bid. The auction process is a kind of competition among prospective buyers to determine who will pay the top price for an offered item. Without an auction it is often very hard for a seller to locate prospective buyers. They may be all over the country or even the world. It is impossible for the seller to get each to make an offer of a specific dollar amount with the hope that the buyer who wants the item the most will be the one who makes the highest offer while the seller is considering those who have answered his ad in the paper or while he is going from dealer to dealer, trying to get the best bid!

The seller of a collectible usually has some idea of how much he wants to get, or expects to get, for his collectible at auction. When he brings his collectible to the auction house for sale, he talks over the probable price with an auction official, usually someone in the department which handles his collectible—European painting or American slant-top desk, or whatever it is. The auction official will usually say, "I think your slant-top desk should bring fifteen hundred dollars, maybe as much as eighteen hundred dollars."

The seller may reply, "Oh, no. I wouldn't take less than two thousand for it," to which the auction official may well say, "If you want that much, I don't think we can auction the desk for you. We can't get that much."

After some back-and-forth discussion a range of price of, say, $1,600 to $1,800 may be decided upon by auction house and seller, with the seller stating that he will not take less than $1,600 for the desk. This

is his *reserve,* or reserve price, the minimum price he will accept from any buyer of the desk.

The actual auction goes something like this:

The auctioneer says, "Now we come to Lot Fifty-six—American late-eighteenth-century slant-top desk. Will anybody start the bidding at, say, one thousand dollars? No, then how about eight hundred dollars?

"I have a bid of eight hundred dollars on this slant-top desk. Will anybody raise it?

"Now I have a bid for nine hundred dollars, one thousand dollars, eleven hundred dollars, twelve hundred dollars, thirteen hundred dollars, fourteen hundred dollars, fifteen hundred dollars, sixteen hundred dollars, seventeen hundred dollars.

"Do I hear any more bids? Sold to the gentleman on the aisle for seventeen hundred dollars."

The auction house has passed the seller's reserve of $1,600, and the desk has been sold. Had $1,600 not been reached, the desk would have been *bought in*—which means "Not sold"—and returned to the seller.

Since $1,700 was achieved, the auction house takes 10 percent as its commission and remits $1,530 to the seller of the desk. It also takes 10 percent of the selling price of $1,700–$170—and tacks this onto what the buyer must pay. So the auction house's commission amounts to $340 in all—$170 plus $170.

Of course the seller might have wanted to get a minimum *net* to himself of $1,600, in which event the reserve would have had to be higher. Maybe the auction house would agree to this higher reserve, and maybe not.

To guide buyers, the auction house estimates probable selling price for almost every item sold. In the case of the slant-top desk, the estimate would have been $1,600 to $1,800. The auction house bases these minimum and maximum estimates on what such desks have brought at auction in the immediate past. Had they been bringing $2,500 to $3,500, then that would have been the estimated price range for the particular desk in this sale. The seller would have been very pleased, and his reserve price might well have been $2,500 or even a little higher. The reserve price is almost always somewhere between the low and the high estimates printed in the catalogue by the gallery.

Now if the desk had reached only $1,000, the seller would have had to pay the auction house something simply for going to the trouble to take the item in, catalogue it, advertise it, and offer it at the auction. This fee might be 5 percent of the highest price reached at the auction—$1,000—or $50. The seller also has to pay for trucking the desk to the auction, insuring it, illustrating it (if it is illustrated in the catalogue), and any special advertising. One can sometimes "trade" with

the auction gallery on whether the 10 percent commission deducted from what the buyer receives can be reduced a bit, to, say, 9 or 8 percent. The buyer's commission (buyer's premium) of 10 percent is always added to the purchase price by the auction gallery. Sometimes the insurance, trucking, and cost of illustrations can be traded on. Sometimes the auction gallery will absorb a part, or even all, of these costs. Christie's auction had in effect in the past a plan whereby it would pick up at the seller's home or warehouse the pictures, antiques, or whatever was for sale and ship the items to London for sale—all at no expense to the seller. If the goods did not sell, they were returned to the seller in America—all at no cost. Of course, this plan applied to more expensive collectibles, mainly paintings that the auction house felt sure it could sell at a reasonably high price—several thousand dollars each.

Getting Your Collectibles Accepted by the Auction House

In Sotheby Parke Bernet in London, Christie's in London, and the smaller auction houses of Phillips and Bonham's, there is a counter—usually only one—to which prospective sellers bring their collectibles for the auction officials to examine in order to see whether they think the house can sell them profitably. In the major auction houses, hundreds of items are brought in each day, examined by experts in each area of collectible, and either accepted for auction or returned to the prospective seller. At least one major London auction house states that its policy is to take whatever is offered to it for sale, but this kind of acceptance can mean little to prospective sellers. The seller may think he has a genuine Ming vase worth $5,000, but the auction house may feel it is a nineteenth-century copy worth $500 or even less. Or instead of a $250,000 portrait by Rembrandt (in the opinion of the seller) the auction house may feel it is a copy worth perhaps $250.

In America the reception is more departmentalized, but it operates in essentially the same way. If you have an Old Master painting, you go to the head of the Old Master Department. If you have a piece of silver, you take it to the Silver Department.

The best thing for the prospective seller to do is to take his collectible *in person* to the auction house and meet the officials who will be handling its sale face to face.

If a visit is not convenient, the next best thing is to have a professional 8- by 10-inch black-and-white glossy photograph print made. On the back should be the dimensions of the piece, what it is made of, and its colors. Homemade photos are often worse than useless, and snapshots are still worse, particularly of paintings, where detail is important.

The photo or photos should be sent to the auction house for exami-

nation and *tentative* opinion. The house can make no final judgment on the auction value of your collectible without having seen it.

The Major Galleries and the Lesser-Volume Galleries

The leading galleries from the point of view of volume and expertise in a number of areas of selling are certainly Sotheby Parke Bernet and Christie's, followed by Phillips. These galleries are located in New York— as well as in London and elsewhere. (London has been, and probably still is, the auction center of the world. It attracts more international buyers than any other city in the world.)

Sotheby Parke Bernet is located at 980 Madison Avenue, New York, New York 10021; telephone: 212-472-3400. Its Los Angeles gallery is located at 7660 Beverly Boulevard, Los Angeles, California 90036; telephone: 213-937-5130. Its other offices are listed in the back of this book.

Christie's main American office is at 502 Park Avenue, New York, New York 10022; telephone: 212-826-2888. Its California office is at 9350 Wilshire Boulevard, Beverly Hills, California 90212; telephone: 213-275-5534. Its other offices are also listed in the back of the book.

Phillips is located at 867 Madison Avenue, New York, New York 10021; telephone: 212-570-4830.

One characteristic of the largest auction firms is that they have specialized sales with catalogues prepared to cover just one specialty or a group of closely related specialties—American paintings, posters, American furniture, etc. The lesser galleries have far fewer specialized sales and in one sale may include American, English, and French furniture, miscellaneous paintings, some Georgian and Victorian silver, various kinds of glassware, and so on.

These are some of the other auction galleries located in New York City, New York being clearly the art and antique capital of America:

Astor Galleries, 1 West 39th Street, New York, New York 10018; telephone: 212-921-8861.
William Doyle Galleries, 175 East 87th Street, New York, New York 10028; telephone: 212-427-2730.
William J. Fischer, 54 East 13th Street, New York, New York 10003; telephone: 212-674-4343.
Lubin Galleries, 72 East 13th Street, New York, New York 10003; telephone: 212-254-1080.
The Manhattan Galleries, Inc., 1415 Third Avenue, New York, New York 10028; telephone: 212-744-2844.
Tepper Galleries, 110 East 25th Street, New York, New York 10010; telephone: 212-677-5300.

We have visited these galleries over a period of many years and have bought collectibles from most of them. We have also sold collectibles through them.

Besides size and the handling of special collectible sales, there are other differences between the major and the smaller galleries.

Very often the smaller galleries buy the things they offer for sale instead of taking them on consignment to sell on behalf of the seller. They buy one or several pieces or perhaps an entire estate outright, then auction off the items in the same way they would the consigned things. Christie's states that it never buys for resale at the auction. Thus, it auctions only those things owned by others and consigned to Christie's.

Sometimes a service is performed for the seller if he is able to sell to an auction house. He, of course, knows exactly what he is going to receive and does not have to wait to see how he makes out when the auction takes place. He also does not have to wait until the auction takes place to receive his money. He gets it right away, whereas sometimes there is a lag of a month or even more until he is paid for the goods consigned by him to the auction house and then sold at auction.

Once in a while a seller will need a cash advance from the auction house to tide him over while waiting for the auction to take place. A New York City college found itself in just this predicament a few years ago. It approached the Tepper Galleries with the request for an advance of cash prior to the sale. The gallery obliged and then was paid off by the college after the sale took place and its goods were sold.

Some of the smaller galleries have a commission arrangement like that of the larger galleries—10 percent from the seller and another 10 percent added to the bill the buyer pays after the auction takes place. The Astor Galleries has a fifteen percent commission to be paid by the seller if the lot sold brings less than $500, but only 10 percent if the lot brings $500 or more. The buyer pays 10 percent, as in the case of the larger galleries.

The Tepper Galleries has the same commission arrangement.

It is well to understand exactly how the commission works when one is selling anything through auction, as well as who pays for haulage, insurance, illustrations in the catalogue (if there is a catalogue), and special advertising of any kind.

The large auction houses almost always have printed catalogues for sales, most of them containing illustrations. In London the less important sales sometimes have unillustrated catalogues. The smaller auction houses may simply have a list of what is being offered for sale, sometimes with sketchy descriptions, such as "Oil painting of cows—on canvas" or "Antique rocking chair." Very often the smaller galleries do not have the personnel to identify and describe what they are offering for sale.

Auction houses perform a very valuable service to sellers when they research, reattribute, appraise, and sell at good prices various items brought to them which owners thought were relatively worthless. Here are four good examples, all sold by Christie's. *(Above)* A rare brazier, made by John Potwine, circa 1724, and sold for $10,000 in January 1980. *(Left)* This silver wine cup, the "Bradford Cup," actually belonged to the Governor's inventory of 1657 (Governor William Bradford of Plymouth Colony), and brought $56,000 in a 1981 auction.

(Above) An early eighteenth-century (1707) Dutch beaker made in Groningen. It brought $16,500 at a 1978 auction.
(Left) Considerable research by the auction house established that this 18-inch gilt bronze figure was a very important eleventh–twelfth century piece from the Li-Tan Kingdom, "The Luck of Yunnan." With proper identification, it brought $75,000 in November 1980.

In cities other than New York, it is often possible to find good local auctioneers. These are some of the leading auction houses outside New York.

CHICAGO, ILLINOIS—Chicago Art Galleries, Inc., 1633 Chicago Avenue, Evanston, Illinois 60201; telephone: 312-475-6960.

GARRISON, NEW YORK (for the region around New York City)—Richards C. Gilbert, Route 9, Garrison, New York 10524; telephone: 914-424-3635.

MILWAUKEE, WISCONSIN—Milwaukee Auction Galleries, 4747 West Bradley Road, Milwaukee, Wisconsin 53223; telephone: 414-355-5054.

NEW ORLEANS, LOUISIANA—Morton's Auction Exchange, P.O. Box 30380, 643 Magazine Street, New Orleans, Louisiana 70190; telephone: 504-561-1196 and 800-535-7801.

PHILADELPHIA, PENNSYLVANIA—Samuel T. Freeman & Co., 1808 Chestnut Street, Philadelphia, Pennsylvania 19103; telephone: 215-563-9275.

PONTIAC, MICHIGAN—C. B. Charles (holds auctions in various parts of the country), 825 Woodward Avenue, Pontiac, Michigan 48053; telephone: 313-338-9203.

SAN FRANCISCO, CALIFORNIA—Butterfield & Butterfield, 1244 Sutter Street, San Francisco, California 94109; telephone: 415-673-1362. This firm operates in Seattle, Portland, Sacramento, Santa Barbara, Los Angeles, and the Monterey Peninsula.

WASHINGTON, D.C.—C. G. Sloan & Company, Inc., 715 13th Street, NW, Washington, D.C. 20005; telephone: 202-628-1468.

—Adam A. Weschler and Son, 905-9 E Street, NW, Washington, D.C. 20004; telephone: 202-628-1281.

Some Guidelines for Dealing with the General Auctions

So far we have been talking about the general auctions, not about the specialized auctions for postage stamps or automobiles or coins. The general auctions include the largest auctions which handle all kinds of things for sale but which hold specialized sales of Art Nouveau or Chinese export porcelain or Continental furniture, etc.

As a general rule, the most important collectibles for sale and the most important estates are handled by the largest auction houses because they can catalogue *expertly,* they handle the things for sale professionally, they usually prepare *explicit* catalogues, they have good display rooms, and they draw large bodies of potential buyers, some of them from far-off countries. If your collectible is very important or your estate or entire collection is large and of quality, a major auction house may very well be the answer.

If the major auction will not handle what you have for sale or if you are far from an office of a major auction, you may have to go to a

* Addresses and telephone numbers of local auctioneers are found in the yellow pages of telephone directories.

smaller auction. On the other hand, some of the smaller auction houses from time to time offer for sale excellent items, collections, and estates for which they seem to get very good prices. Some auction records have been achieved in these.

If a major auction house agrees to handle your collectible for sale, that is the first step. There are many details to work out: Who picks up the item and pays for the cartage—you or the auction house? Who pays the insurance while the item is at the auction house? Who pays for catalogue illustrations or any special advertising? What exactly is the commission charge you will be required to pay? Is it 10 percent from you plus the buyer's premium of another 10 percent? Or can you get down the 10 percent charged to you to, say, 9 percent or 8 percent?

If at the auction your item fails to sell, do you pay a smaller percentage on the highest price reached at the auction—like 5 or 3 percent? Or will the auction house agree to make *no charge* for these buy-backs? Will you be charged storage if you do not retrieve your collectible right after the sale—provided it does not meet its reserve and does not find a buyer?

Be careful to point out any damages to your collectible for which the auction house is responsible, and make your claim on them promptly.

If the auction house feels it is desirable to sell your collectible in London, who bears the cost of the shipment there? Who bears the return cost if your item does not sell there? These things should be spelled out in a contract. Otherwise, you may get into a serious disagreement with the auction house.

What sale your collectible is placed in is all-important. The major auction houses have grades of sales from, say, "Old Master Paintings" to "Fine Old Master Paintings" to "Important Old Master Pictures." You try to get your painting in the last type of sale. Important sales bring in the most and the best-heeled buyers. The first category often does not. The better the sale you are in, the more likely you are to get a better price. On Saturday, May 3, 1980, Sotheby Parke Bernet in New York had an Americana sale. The furniture was excellent and brought in a group of buyers interested in fine furniture. The day before, the same gallery had a sale in which the furniture was decidedly of lower quality. There were relatively few buyers, and they failed to bid up the prices of most of the furniture very high! Obviously you should try to get your furniture into the Saturday sale.

The Specialized Auctions

Postage Stamps

The postage stamp auction business is prodigious. Almost every working day in New York three stamp auctions are held. These are held throughout the year with the exception of July and August.

This long-lost masterpiece by Frederick E. Church, "Icebergs," hung unrecognized for decades in a boys' home in Manchester, England. Sotheby's uncovered the history of the painting when it was offered to them to sell, and they auctioned it amid much publicity for a record auction high for any American painting—$2.5 million.

A very rare plate block of ten of the 1898 Trans-Mississippi $1 black from the C. T. Church Collection realized $1,050 at auction on October 12, 1953. Offered again on June 28, 1980, as part of the Arnold D. Frese Collection, it brought $126,500. In both instances it was sold by Harmers of New York.

The Auction Houses

The major stamp auctions are Harmers of New York, 6 West 48th Street, New York, New York 10036; Robert A. Siegel Auction Galleries, 120 East 56th Street, New York, New York 10022; Harmer Rooke-Scott, 3 East 57th Street, New York, New York 10022; and J. and H. Stolow, 915 Broadway, New York, New York 10010.

Harmers is probably the largest volume stamp auction house in the world. It charges the seller a 10 percent commission, the buyer another 10 percent, like the major general auction houses.

Coins

There are two main coin auction houses. Stacks is located at 123 West 57th Street, New York, New York 10019. It holds about ten large coin auctions per year. Its commission rate is charged only to the coin seller, not to the buyer, and varies between 10 and 20 percent, depending on the size of the collection offered, whether photographs must be taken of the coins, whether plates must be made, and other factors.

The other major coin house is Bowers and Ruddy, 6922 Hollywood Boulevard, Los Angeles, California 90028.

Autographs

Probably the most important outlet for autographs, certainly the oldest, is Charles Hamilton, 25 East 77th Street, New York, New York 10021. For many years this firm was virtually the only autograph auction house. Mr. Hamilton is possibly the leading autograph expert in the country and is particularly adept at spotting fakes. He has written several books in the field.

The seller is charged a commission of 25 percent. If, however, a large collection of autographs or a very important autograph is offered for sale, this rate might be "shaded" a bit.

Both major auction houses, Christie's and Sotheby Parke Bernet, have come into the autograph auction business recently and have succeeded in securing some record prices.

Carpets

Both Sotheby's and Christie's sell a large volume of carpets. In fact, all general auction houses sell carpets.

Recently there has been a new and very professional carpet auctioning firm in operation: John C. Edelmann Galleries, 123 East 77th Street, New York, New York 10021. Mr. Edelmann was formerly in charge of carpet sales for Sotheby Parke Bernet. His firm charges the seller as

well as the buyer a 10 percent commission—like the major general auction houses.

Vintage Wines

In the United States, wine auctions are virtually nonexistent. In a year there may be two major sales, and few more, because government regulations make wine auctioning in this country very difficult. The Heublein auction is held once a year somewhere around the country, but rarely in the same city. It is operated by Christie's winemaster, Michael Broadbent, who comes over once a year to America to conduct the sale.

The Chicago Wine Company, P.O. Box 27, Chicago, Illinois 60648, apparently conducts a few auctions of fine vintage wines, but only by sealed bid. The last wine auction held by this firm contained more than 900 lots of wines.

The largest vintage wine auction house in the world is Christie's, 8 King Street, St. James's, London SW1Y 6QT, Michael Broadbent, director. The trouble is that one must ship his wines to London for sale. When they are once in London, however, prices in that city at auction are usually very high. Christie's charges a 15 percent commission to sellers and no commission to buyers. The cost of shipping to England from the United States amounts to about $1 a bottle plus 1 percent of the value for insurance. There is sometimes pilferage in transit; it can be avoided by shipping via air, but here the cost amounts to about $7 a bottle or $80 for a case of twelve bottles.

Sotheby Parke Bernet, 34–35 New Bond Street, London W1A 2AA, England, also has a good wine department and operates in about the same way that Christie's does.

The charge by Heublein, Inc., to sell your wine is 25 percent of the auction price achieved, and arrangements can be made by writing to Alexander C. McNally, Heublein, Inc., Farmington, Connecticut 06032.

This auction house is most interested in fine old vintage wines by the case, although rarities like 1806 Lafite are, of course, the exception. Heublein's is very selective in what it takes. This writer was turned down on a case of 1961 Lafite-Rothschild, when he offered it for sale. As the auction goes along each year, however, it will probably become less selective. In order not to waste your time, or Heublein's either, you might telephone Mr. McNally at 203-677-4061 and indicate what you would like to sell, in that way determining whether or not he would be interested.

Christie's, at the time of this writing, is planning to hold vintage wine sales in this country.

A letter written by Ronald Reagan before he assumed the Presidency brought an auction high for an A.L.S. (autograph letter signed) by a living person. It sold at the Charles Hamilton Auction of Autographs in January 1981 for $12,500, which was double the previous high for any A.L.S. by a living person. (The last page of the letter is shown here.)

Antique and Classic Car Auctions

Car auctions are getting to be very big business. Not only are there specialized car auctions, but there are many, possibly hundreds, of local car auctions held around the country each year. At these auctions all kinds of cars are sold. In a 1979 auction in California, Christie's sold two Mercedes cars—one for $400,000 and one for $320,000. Car auctions in America are the exception for either of the major general auction houses—Sotheby Parke Bernet or Christie's. Phillips has had some good experience in selling cars at relatively high prices in an on-premises sale.

The main car auctions are specialized auctions of cars and related items only. The leading specialized car auction is probably Kruse International, Kruse Building, Auburn, Indiana 46706. This firm conducts (as a subsidiary of Thorp Sales Corporation) about two dozen auctions each year all over the United States. It handles all kinds of cars, from the finest Duesenberg double-cowl Model J phaetons to Chevies of the 1950's and 1960's.

Many cars are sold without any minimum price requirement. In other words, the seller takes what he gets at the auction. If he wants to establish a reserve, or minimum price, acceptable to him, he must pay an entry fee of $100 to $200 and, in addition, pay the auction house a higher commission than if he places his car for sale without any reserve price.

Commissions vary from 12 percent for a car selling for less than $500 (with a reserve) down to 5 percent for a car offered for sale without any reserve but achieving at auction a price of more than $20,000. The maximum commissions that a seller must pay are $8,000 if he has established a reserve and $5,000 if he has not established a reserve.

The Kruse firm will take a car for sale in almost any condition. It does not even have to be running.

One other major car auction is Hudson and Marshall, Inc., 1 Beaconsfield Park, Macon, Georgia 31298. Hudson and Marshall averages about ten sales per year.

One big caution in offering a car for sale through an auction is: *Do business only with a financially reliable firm!* There have been auctions that brought very satisfactory prices for one's car, but the seller didn't get his money!

Another caution is: *Make sure the auction house treats the consigned car well.* An unreliable house can scratch paint, have parts stolen, and damage the car mechanically. The exact condition of the car when it is delivered to the auction house for sale must be agreed on by both house and seller. Photos might even be made of the exterior to show there are no dents, pieces missing, or paint damaged.

Finally, if a car is offered for sale at auction but fails to find a buyer at a price satisfactory to the seller, it may be some time before it can be offered for sale again—by an auction house, a dealer, or the seller individually. When an auction offers something for sale that reaches, say, $8,000, and does not sell because the $8,000 is under what the seller wants, that car is pegged for a long time as a nonseller and as an $8,000 car—at most.

Rare Books

The most important rare book auction house in America is almost certainly the Swann Galleries, 104 East 25th Street, New York, New York 10010. Rare book auctions are its specialty, and it conducts in the neighborhood of forty book auctions a year, many more than either Christie's or Sotheby Parke Bernet. The catalogues of this auction house are like the catalogues of Harmers stamp auction or Charles Hamilton's autograph auction. You can generally depend on them to be correct and to describe what is being sold exactly and in detail. Prices also indicate the exact *market* price for a particular rare book. Half the sales of this auction house are to buyers who never even come to the auction and may never have seen the books being offered for sale, but who rely entirely on the catalogue descriptions. It might also be pointed out that when Charles Hamilton conducts an autograph auction, the autograph is not even brought to the platform for the buyers to see. They have either inspected in advance or are bidding on the basis of the catalogue descriptions.

Stephen C. Massey is director of books and manuscripts for Christie's in New York. He is the son of the late Douglas Massey, the father being for many years in charge of books and manuscripts for Christie's London. Douglas Massey may well have been the leading expert on books in Britain. Both Christie's and Sotheby Parke Bernet handle rare books.

At the dealer level Lucien Goldschmidt of New York and Bernard Quaritsch of London are unquestionably among the most important in the world and offer an important market for the purchase and sale of rare books. H. P. Krause of 16 East 46th Street, New York, New York 10017 is also a leading dealer in old and rare books and manuscripts.

Lucien Goldschmidt is located at 1117 Madison Avenue, New York, New York 10028. Quaritsch is at 5–8 Lower John Street, Golden Square, London W14 4AU, England.

For books before 1800, we should also add the name of C. Harper Lathrop, 300 Madison Avenue, New York, New York 10017.

5

Marketing Collectibles to and Through Dealers

Some collectibles are naturals to market through auction houses. One of the easiest and almost certainly most profitable ways to market a large estate containing many diverse items is to auction it. An enormous estate, like the Garbisch estate, sold in 1980 by Sotheby's containing everything from the finest Postimpressionist paintings in the seven-figure range to an American blockfront kneehole desk worth six figures to a Victorian stained pine sewing rack of the mid-nineteenth century worth somewhere around $100, can best be marketed through auction. The job of cataloguing was monumental and would have to have cost at least in the high five figures. The advertising was extensive and costly.

But the auction house brought in the prospective buyers from all over—in droves.

An estate containing *very few* high-priced collectibles might also best be sold via the auction. There is hardly a dealer who would have purchased the extensive Consuelo U. Ford estate in 1970 with its valuable things, plus its glassware, china, plain pieces of furniture—many items going for $25, $50, or $75. Just the job of "moving" all these items individually was a natural for the auction house. So are on-site or house sales held on the premises, where one can purchase everything from a Chippendale chair to an old power mower originally sold by Sears Roebuck.

At the other extreme of a natural for the auction house was a great landscape by J. M. W. Turner, one of the rarest and most valuable Turners ever to come up for sale. This painting was owned by Mrs. Flora Whitney Miller, honorary chairman of the Whitney Museum of American Art, New York.

For this one painting Sotheby Parke Bernet prepared an entire catalogue. Nothing else was offered for sale by this catalogue but the one

Marketing Collectibles to and Through Dealers

painting by Turner, and it was sent all over to prospective buyers and to the news media—an elaborate, color-illustrated catalogue to act as a drawing card for buyers equipped to pay seven figures for a great work of art. The auction gallery felt the painting had wide enough appeal to merit a catalogue and, *in effect,* an auction just for one item. It brought $7 million ($6.4 million plus 10 percent buyer's premium).

"Natural Collectibles" to Be Sold to Dealers

Coins

Coins can be sold through an auction house, and may even do very well when sold at auction, but they are a natural to be sold to dealers because to a considerable extent they are a standard commodity with a standard price. Coins are graded according to condition, which usually is subject not to personal judgment, but to a great degree to objective determination. For many collector coins, one has only to see what the coin is—an 1874 three-dollar American gold piece, for instance—then determine its condition, and the price is fairly easy to ascertain.

These are standard grades of coins:

Proof. The coin is struck or made from scientifically polished dies and blocks. There are no imperfections and no wear since the coin has never been circulated. They are strictly collectors' items and bring by far the greatest prices of all grades of coin. A proof set consists of a penny, nickel, dime, quarter, and half dollar, all of the same year—for American coins, of course.

Uncirculated. These are coins that can be purchased new at banks as they are received from the government. They have not been circulated and thus show no wear or damage.

Extra or Extremely Fine. These coins have been circulated only briefly and thus show no wear or loss of original luster.

Very Fine. On this coin there are few signs of wear. All details of design and lettering are sharp.

Fine. It is obvious from their appearance that these coins have been circulated. The design and letters are still sharp. The high points show signs of wear.

Very Good and *Good.* These coins, despite their designations, are obviously worn. Some of the details may have disappeared.

Fair and *Poor.* The design and lettering on these coins are somewhat difficult to discern.

Since all these grades are recognized by the coin business, one fits his coin into the classification and comes out with a value.

You start out on your coin-selling activity by looking up coin dealers in the telephone book and visiting a dealer located nearby, asking him

what he would pay for your coin. Then another dealer can be visited, and another, just to be sure you are being offered "market buying price."

All dealers use one guide to *buying* prices and *selling* prices—R. S. Yeoman's—for United States coins. This guide, entitled *A Guide Book of United States Coins,* is issued by the Western Publishing Company, Racine, Wisconsin 53404. It comes in two editions. The red-cover edition contains dealer *selling* prices; the blue-cover edition contains dealer *buying* prices—what the dealer is likely to offer you for your coin. Obviously the dealer sells the coin for more than he has to pay you for it. Hence, the two editions.

Coins change price rapidly. There is a weekly newspaper for coin dealers and collectors called *Coin World* (Amos Press, Sidney, Ohio 45367) that costs $15 a year to subscribe to. Current prices for a tremendous group of coins are listed in this weekly publication.

There is even a teletype service which dealers can use to get literally up-to-the-minute prices.

Certain kinds of coins, certainly most American coins, are probably the most easily sold to dealers. Most American coins are standard commodities with determinable market values—for buying and for selling. Other coins are less standard. These are the general classifications of coins:

1. American gold coins
2. American silver coins
3. Foreign gold coins
4. Foreign silver and bronze coins
5. Ancient coins—divided into the ancient Greek and ancient Roman
6. Hammered coins—coins with hammered edges made in Europe from the eighth to the fifteenth centuries
7. Treasures—excavated in various parts of the world as well as brought up from sunken ships. In recent years more and more of these sunken ship coins have been brought up because of better salvage methods. The *Chameau* went down off the coast of Nova Scotia in 1725. A coin treasure was retrieved by Dutch archaeologist Alex Storm in 1966. In 1971, 493 gold coins of this treasure were sold. Each coin averaged about $400.

The later items in the above list are, for the most part, not standard coins that have an easily determinable market value, and they are better handled by auction. Those coins which are the most standard items and the most easily sold to dealers at fairly standard prices are American coins of all kinds and the more standard foreign coins.

Many major dealers conduct an auction business as well, and vice versa, many major coin auctions also do a dealer business. Such a combi-

Marketing Collectibles to and Through Dealers

nation dealer-auction house may advise the coin seller on how best to sell his coin or coins. These are some of the leading dealers who also do an auction business:

Stacks, 123 West 57th Street, New York, New York 10019. This firm calls itself "America's Oldest and Largest Rare Coin Dealer," and it very likely is both. Its auction business is also large.

Bowers and Ruddy, 6922 Hollywood Boulevard, Los Angeles, California 90028. The volume of this firm, as both dealer and auction house, places it in a class with Stacks on the East Coast.

Superior Stamp and Coin Company (of Los Angeles), 9301 Wilshire Boulevard, Beverly Hills, California 90210.

Rare Coin Company of America (of Chicago), 31 North Clark Street, Chicago, Illinois 60602.

Paramount International (of Dayton, Ohio), 1 Paramount Plaza, Englewood, Ohio 45322.

New England Rare Coin Galleries (of Boston), 89 Devonshire Street, Boston, Massachusetts 02109.

Kagin's (of Des Moines, Iowa), 1000 Insurance Exchange Building, Des Moines, Iowa 50309.

Postage Stamps

Without a doubt stamps are auctioned in greater numbers than any other collectible, but they are also sold to and by dealers all over the country (and all over the world).

Postage stamps, like coins, are a standard item, to a considerable extent, and a graded item, with fairly definite grades determined by their quality.

As in coins, there is a more or less standard and authoritative publication which values stamps of many kinds by quality—mainly condition. *Scott's* is issued each year in five editions by the Scott Publishing Co., 3 East 57th Street, New York, New York 10022. Volume I covers United States and United Nations stamps. The other four volumes cover the rest of the world. Each volume costs between $14 and $16.

There are less comprehensive stamp value catalogues. One of the better ones for North American stamps is the *Harris Reference Catalog,* which covers the United States, the United Nations, and Canada. It is available from H. E. Harris & Co., Ltd., 645 Summer Street, Boston, Massachusetts 02210 for $2.25.

In New York City there are about 100 major stamp dealers who buy from sellers and sell to buyers. In the United States there are at least 1,000 major dealers in all.

For many stamps of the United States and elsewhere, *Scott's* is an invaluable guide to values when the seller offers his stamp or stamps

to a dealer. A price range is established, and a dealer will likely pay somewhere in the general vicinity of the *Scott's* price for a particular stamp.

At the Other Extreme from Coins and Stamps

Automobiles—of Almost All Kinds

These are very difficult to sell to a dealer. Here is one example of trying to sell an exotic (or oddball) automobile to a dealer. The Washington, D.C., real estate developer Robert N. Wolpe in 1978 decided that he no longer wanted his Rolls-Royce Silver Cloud II sedan. He had just had it completely gone over mechanically, including wiring, by McNey Rolls-Royce in Washington. Still, it overheated somewhat, and he had Gladding Rolls-Royce of Glen Burnie, Maryland, overhaul the heating system, so that problem was rectified. We looked the car over, and it was in good mechanical condition. The leather seats were fairly good, not really in need of replacing. National Auto Top Company of Washington, automobile upholsterers, suggested simply refurbishing the leather. The paint and body were only fair, and a complete paint job and some body work were recommended.

Mr. Wolpe did not want to take time off from his very active business to bother to have the necessary body and paint work done, so he offered the car for sale to a Rolls-Royce dealer. The offer was, to him, a very surprising $1,500 to $2,000—for a car that had just had more than $4,200 spent on mechanical and cooling system work!

Such an offer is not at all unusual for a dealer to make to a car owner, whether the car is an exotic of some sort, a Rolls-Royce in good mechanical condition, or simply a standard American used car that the owner would like to sell outright to a dealer instead of trading in on a new car.

For standard American cars, the NADA book (National Automobile Dealers book) contains values for many American used cars—average retail value and the value of the car for loan purposes.

If you offer your car to a dealer, you certainly are not likely to get anywhere near average retail value. You may be made an offer under both retail and loan value—well under these values. Many dealers do not even want to bother tying up their capital in purchased used cars. They will often tell sellers to go elsewhere.

There are several value books for used foreign cars, particularly fairly late used foreign cars. *Buyer's Guide Reports* is published twenty-eight times a year by DMR Publications, 1410 East Capitol Drive, Milwaukee, Wisconsin and covers new and used foreign car prices. Values of foreign cars go back about eight years—list price new, average wholesale

price, and average retail price. One issue has the 1971 Jaguar XKE V-12 convertible quoted at $6,950 list price, $3,700 average wholesale price, and $4,650 average retail price. Maybe so! Still, few people are going to sell a 1971 Jaguar V-12 convertible to a dealer or to anyone else for $3,700 or even $4,650.

Many sellers of exotic foreign cars place "No dealers" in the advertisements, meaning "We don't want any insulting offers by dealers."

On the other hand, it is just possible that a dealer may have a customer for your car but can find no such car. In that event he has a good idea of what his customer will pay if he can come up with a car. He consequently knows what he can afford to pay you and turn a quick profit on resale. In this case, you *might* get a good price from the dealer.

As a general rule, consignment sales to a dealer are far better than direct sales. You simply tell him you do not want to sell to him outright, but you will consign your car to him for sale, and you expect to get a good price, which you state. You and the dealer may well compromise on an asking price suitable to you and at the same time not so high that the dealer can't sell your car.

At this time the commission to the dealer must be established—very often 15 percent of the price. Remember that the higher the rate of commission, the more likely is the dealer to move your car.

On the other hand, you should think carefully before you consign a car to a dealer for sale. He would far rather sell a car *he owns* outright and get all cash so that he can go out and buy another car. If he sells your car, he gets far less cash—only the commission. With this sum he cannot go out and buy again.

The dealer, of course, might very well like consigned cars, particularly those of quality. He does not have to tie up his cash in their purchase, and the more cars he has for sale, the more attractive is his showroom to prospective buyers.

Still, if you ask about a certain car that the dealer has on his showroom floor for sale, he may start out with "That's not our car. That's a customer's car." He may even add, "He certainly wants a lot of money for that car," and the buyer is immediately turned off that car and onto another car that the dealer owns—"a great bargain!"

If you have a prime automobile in pristine condition, like a Rolls-Royce Corniche convertible or a Lamborghini Miura or a Ferrari 275 GTB-4, you might well give serious consideration to consigning it to a very reliable, very important dealer for sale. Customers generally buy from dealers, not from individuals. The dealer is somehow considered more reliable, more expert, more likely to tell the customer the true condition of the car—and more likely to rectify any defects in the car after it has been purchased—than a private seller. The dealer can, and usually does, get a higher price for the car than the individual who

sells directly (usually through advertisements in newspapers and elsewhere) can get.

The exact condition of the car must be agreed upon by the dealer and the consignor. There should be photographs of the car taken when it is delivered to the dealer. Too often a car is seriously run-down or damaged when the dealer has it on consignment.

Some years ago a Bentley coupe, 1951, was consigned by this writer to a major New York dealer for sale. The body was by the Swiss firm of Graber, and the paint was in top shape. The car was in good condition to be offered for sale. Several months after consigning the car to the Rolls-Royce and Bentley dealer for sale, still no action. I finally went around to the firm to see what was the matter. I found the car stuck off in the corner, not in the main salesroom, and with the seat out. The battery was nowhere to be found. The car was placed under a leaking pipe—which was leaking on the car when I arrived to inspect it. The paint had been damaged by the leak, and the car looked altogether dingy. Needless to say, no one ever came in even to try out the car, much less to buy it. The car was removed from the dealership and sold privately—after it had been extensively refurbished.

Upon consigning your automobile (of any kind) to any dealer, be certain to keep your title to the vehicle until you have to turn it over to a buyer—provided the dealer secures a buyer for you. If the dealer has your title, it is possible that he will sell the car, make out the title to the buyer—and pocket the money that belongs to you. "Selling out of trust" is not unknown as far as automobile dealers go. If you have any doubts on that score, call the installment sales vice-president of any bank handling automobile financing and ask him whether his firm has ever found a dealer who sold out of trust.

To end this section on a more positive note, if a major dealer of the finest cars will take your car on consignment, there is little question but that he will have access to customers who will pay good prices—better than an individual seller can get. In addition, the showroom of the major dealer and the fine cars he handles will tend to rub off on your car so that it may very well sell and at a relatively high price.

A tremendous plus for consigning your car to a first-class dealer is that he may handle the trade-in himself. If you, the seller, offer your car for sale and find a willing buyer, but one who must trade in the car he owns, the deal will probably fall through unless you can take his car in part payment. Very likely you, the seller, will not want his car, but a dealer may take in his car in trade—and still give you all cash for your consigned car that he sold for you. If you ask, I feel confident that you would find dealers who would perform this service for you.

There may well be a technical reason, in the case of certain cars,

Marketing Collectibles to and Through Dealers

for sale or for consignment to a dealer. The more expensive a car, the harder it is to find a buyer to pay cash. If the car is sold to a dealer, the seller need never worry about the state of the buyer's finances. The seller has his money and is out of the car. If he consigns to the dealer, the dealer may perform the very valuable function of seeing to it that the car can be financed if the buyer does not have all the cash with which to buy it. Banks and sales finance companies are set up to do business with dealers, not with individual sellers of cars.

Suppose your Rolls-Royce Silver Cloud III convertible is consigned to a dealer for sale. Such a car was consigned by its owner to Motor Classic of White Plains, New York, in early 1980. The asking price was $55,000—not high for the car, but a great deal of cash for any buyer to come up with.

Now suppose Motor Classic, which, incidentally, spent a good deal of money advertising this car, finally comes up with a customer, say, a business executive with a salary of $75,000 a year. The would-be buyer has $25,000 in spare cash, but no more. He would have to finance the remaining $30,000 over, say, three years. The amount the buyer would have to pay *per year* would be about $10,000 of the principal plus interest—say, $1,500. The total payment would be about $11,500 per year for three years, the early payments including a larger percentage of the interest charges.

The finance company or bank feels the credit of the buyer is strong enough for him to buy the car. The dealer gets the buyer's down payment of $25,000 on the car sold for $55,000 and mails it to the seller of the car. The finance company or bank sends the dealer the balance of $30,000, and the bank mails the time payment book to the buyer. The buyer pays the $30,000 off over three years, or thirty-six months, plus interest on the balance—a little over $1,000 a month in all. From the $30,000 check the dealer receives from the bank, the dealer deducts his 15 percent commission (15 percent of the $55,000 sales price—$8,250) and mails the balance to the seller of the Rolls-Royce.

The dealer can arrange such financing. The individual seller will find it very hard and very time-consuming to arrange such a time payment plan, if it is possible for him to arrange it at all.

Stamp, coin, watch, and other specialist dealers can be located anywhere, and shipment *to* and *from* them is not hard because the collectible to be shipped is neither large nor heavy. An automobile is, obviously, both large and heavy, and it is hard to consign a car from Connecticut to Los Angeles or to buy a car in Los Angeles for shipment to a customer in Connecticut. Local car dealers in antiques and classics are thus more important than in the case of easily shipped collectibles. These are some, but by no means all, of the leading specialty car dealers:

Carriage House Motor Cars, Ltd., 520 East 73rd Street, New York, New York 10021—particular emphasis on Rolls-Royce.

George Haug Co., Inc., 517 East 73rd Street, New York, New York 10021—emphasis on Rolls-Royce.

Steven Kessler Motor Cars, Inc., 317 East 34th Street, New York, New York 10016, specialists in top-quality Italian cars, but with cars of other countries of origin.

Motor Classic Corporation, 868 North Broadway, White Plains, New York 10603—all makes of later-model classic cars, especially Ferrari.

Thorobred Motorcars, Inc., 3200 North Washington Boulevard, Arlington, Virginia 22201—large stock of Italian cars, later models.

Charles Schmitt & Company, 3500 South Kings Highway, St. Louis, Missouri 63139—large stock of later-model cars.

Rallye Motors, Inc., 20 Cedar Swamp Road, Glen Cove, New York 11542—specialists in Mercedes-Benz.

Leo Gephart, Inc., 340 North Main Street, Englewood, Ohio 45322—all types of cars from 1910 Thomas Flyer to Eldorado Biarritz 1978.

A & G Classic Cars, 621 North Central Avenue, Phoenix, Arizona 85004—many prewar classic cars.

Motor Cars Limited, 2120 Cedar Springs Road, Dallas, Texas 75201—specialists in finer prewar classics.

Rare Art Objects, 1741-12th Street, Atlanta, Georgia 31905—unusual postwar classics of the more expensive kind: Ferrari racing cars, Lamborghini, Porsche, Rolle-Royce, older Jaguars.

The Toy Store, 11031 Santa Monica Boulevard, Los Angeles, California 90025—very large stock of old cars and classics.

Ferrari West, 851 Del Monte Avenue, Monterey, California 93940.

Foreign Cars Italia, 4100 West Wendover Avenue, Greensboro, North Carolina 27407.

Grand Touring Cars, 15115 North Airport Drive, Scottsdale, Arizona 85260.

Art and Antiques—Their Sale to and Through Dealers

Coins and stamps are naturals for collectors to sell to dealers. Many have reasonably determinable market prices, and they are graded according to quality, each grade having a different market price.

While automobiles tend to have something of a market price, car dealers pay far less attention to it than do coin and stamp dealers. You can usually sell a standard American coin or stamp quickly, over the counter, at a fairly readily determinable price. You can rarely sell an automobile of any kind that easily and with little price haggling.

Art and antiques come somewhere in between, but they are, in general, more like automobiles—in respect to the marketing of them to dealers.

One of the major European Continental art dealers sells mainly consigned Old Master paintings. His collection of paintings for sale is

more than excellent. If he had to buy his paintings outright, his cash outlay would be far more than he could manage. Consignment enhances his capital and enables him to attract prospective customers by means of a large and top-grade inventory, most paintings hanging in his extensive showrooms, a town house in The Hague. Although many of the consigned pictures sell fairly quickly, others remain on the dealer's walls for years. Some have been hanging there for possibly ten years, perhaps even longer.

An automobile dealer will frequently volunteer the information "That is not our car. It belongs to a customer," with the implication that "It is not as good as one of our own cars."

The painting dealer will not point out the same thing. It is customary for dealers in paintings to handle consignments.

Usually very fine paintings cost a great deal, and it is expected that even the best-heeled dealers cannot always buy the paintings for their inventory that they have for sale. Fairly recently a major large Rembrandt portrait was offered for sale by a university in New York City. A major dealer undertook to sell the painting. The university wanted $1 million for the Rembrandt. The dealer asked $1.1 million, the extra $100,000 to constitute his commission. Although he tried to sell the painting, he could not. Then another dealer took up the job of selling the Rembrandt. He succeeded. He secured $1.8 million. Presumably he got a higher commission. In any event, he did sell this very valuable painting on consignment and at a more than satisfactory price.

Consigning fine art to dealers is safer and more logical than consigning cars to dealers for sale. This writer has consigned paintings for sale to several different dealers over the years. In all cases the consignment was handled satisfactorily, even though the paintings were not always sold. The sale was seldom quick, but in those consignments in which the paintings were sold, they brought a very gratifying profit. Some of the consignments were handled by New York dealers; several, by European dealers.

In each consignment the receipt of the painting or paintings by the dealer for the account of the owner-seller must be explicit and *signed* by the dealer. The insurance coverage for damage, fire, and theft must also be worked out both as to the amount of coverage and as to who pays the insurance premiums. It is, of course, best if the owner-consignor pays the premiums. He knows that he has the insurance, that it is paid up currently, and he can make claim upon loss and follow it up.

In a way, it is much more advantageous to the seller to consign a painting or an antique to a dealer to sell than an automobile. The painting and the antique (as well as many other kinds of collectibles) speak for themselves. An automobile does not speak for itself. The dealer

This painting of Grand Central Station by John Sloan was sold less than five years ago for $65,000 by Kennedy Galleries. It was bought back two years later for more money and then resold recently for over $100,000. (Major galleries will often buy back paintings from their clients; they also handle sales for many people on a consignment basis.)

can say, "Yes, that is a consigned car, but we would rather have you look at this car over here." After the dealer throws out a remark or two, the prospective buyer may well get the idea that the car has far too much wrong with it, things that do not meet the eye, and that he may be lucky to get it home without having the engine fall out on the street. In a work of art or an antique, you can see quality and condition. In an automobile, quality and condition are far more obscure, and the buyer cannot easily make up his mind about the overall condition of the car.

Outright Sale of Art and Antiques to Dealers

At many auctions of art, antiques, and other artistic collectibles, dealers make the highest bids and get the items—in competition with private collectors and investors. In fact, it was almost the rule that at auctions of art, antiques, and collectibles, the dealers generally ended up buying the finest and highest-priced items, and they are still buying many of the top pieces even with increased private buying.

Dealers are not always acting on behalf of clients in their buying activities. They are very often willing to pay top dollar for things for their own inventory, particularly as the important pieces become scarce.

This situation is somewhat anomalous since a dealer must mark up to resell at a profit or else go out of business. The fact of the matter is that the better dealers have a following of customers who want the dealer to be on the lookout for certain very fine collectibles (which usually bring high prices). These customers in effect pay the dealer to use his judgment in locating the kinds of things they want to collect. His customers do not object if the dealer makes a markup for his locating activities, for his expertise in selecting the best, and for actually handling the entire transaction.

It follows that the best dealers are always looking for the best items, no matter where they are to be found—at auction or from individuals. *The very best items can be sold very often directly to dealers at an advantageous price.*

A number of years ago a leading federal judge in New York bought an unusual large clock at an auction held for charitable purposes by a church. It is believed he paid in the neighborhood of $500 for the clock. After some research among antique furniture dealers, he found that he had a unique item: an Art Nouveau clock made by the great artisan of that type of antique—Hector Guimard. He showed the clock to the Art Nouveau dealer Lillian Nassau, of New York. After a brief conversation, Mrs. Nassau bought the clock for $40,000. We asked to look at this clock in Mrs. Nassau's shop. It was a striking piece of "furniture"

of the late nineteenth century, possibly one of two clocks of this model made by Guimard. When we asked the price, we were told by a salesperson, "We are not quoting a price on that clock as we are not anxious to sell it. If we did sell it, the price might be in the neighborhood of seventy-five thousand dollars."

This was a top-grade collectible, rare and in fine condition. Probably no other such clock is available anywhere.

This represents the sale of an extremely fine collectible, rare, in good condition, that a dealer in Art Nouveau would want, just to have, and certainly it could be sold fairly quickly by the dealer, and at a profit; but because of its rarity, she preferred to keep it.

Such rare, fine, good-condition collectibles are naturals for their owners to sell to leading dealers. A fine and rare collectible can be sold to almost any first-class dealer handling top-quality items.

Robert Sack, of the firm of Israel Sack, leading American antique dealers today, has this to say about buying directly from sellers: "We like to buy direct. The purchase is very low-key. The seller does not have to place his antique at auction, go through a fairly elaborate process of selling it, perhaps see his antique fail to sell at the auction."

Robert Sack points out another advantage of selling directly to dealers: "Everything is very quiet. No one knows that you, the sellers, have fine antiques, and would-be housebreakers will not spot you."

There is a great deal to what Robert Sack says. There is no publicity involved when you sell to a dealer. America's dance king, Arthur Murray, once did a TV show. After one of the shows his apartment was robbed. The robber was caught. When the police asked the robber why he had chosen Arthur Murray to rob, he said, "I saw him on TV, and I figured this guy is loaded."

There is something of a problem of determining how much to ask when you offer your art or antique to a dealer. My wife and I had a painting by Jacopo del Sellaio that we offered for sale through auction in London. When it came to determining the reserve (minimum) price, $6,000, which at the time was about 3,000 pounds sterling, came to mind. The Old Master director of the auction house felt this was high and suggested 2,500 pounds. Since this was double what we had paid for the painting, it was an acceptable figure to me, and the auction house placed this reserve on the painting. It sold for no less than 8,000 pounds—$16,000!

How would we have known to ask a dealer $16,000 for the painting that we were ready to take $6,000 for? Would the dealer have made an offer to me of $16,000? Suppose he had offered $8,000. I would have been delighted and would not have shopped it around to several

dealers. One has the feeling that the auction "wrings" the last cent out of art and antiques. Maybe so.

Dealers are the main customers of the auction house in many areas of art and antiques. Theoretically it does not pay to sell at auction if a dealer will buy your collectible. The auction house comes between you, the seller, and the dealer who buys from you via the auction. The house steps in and is compensated. As an illustration, if your painting or antique achieves a hammer price at the auction of $1,000, the dealer-buyer (if a dealer buys it) pays $1,100—the price plus the 10 percent buyer's premium. The auction house keeps the added 10 percent. It also keeps 10 percent of the selling price of $1,000 and remits $900 to the seller. Out of the sale you get $900, and the auction house gets $200. The dealer pays $1,100. Now, theoretically, the dealer buying directly from you could afford to pay *you* the $1,100 instead of the auction house—and you would be $200 better off.

Theoretically so. Practically, I don't know. The auction house has performed the service to you, the seller, of locating the buyer who has bought your collectible, and it should be paid for that service.

We have sold both at auction and through dealers. It is likely that we will sell in both ways in the future. Our profit on sale has been excellent selling through dealers and at auction, and while the auction commission seemed to be high, that did not make any difference since our profit was also very high—in the rapidly rising market.

Certain collectibles probably should never be sold at auction. In this category are certain unique paintings. In 1970 Finch College in New York offered at auction a religious painting of the fourteenth century—a large group of saints on an extremely large panel. The artist was Simone da Cusighe, a very early Italian artist. One of the unique features of the painting was that it was signed in full. Such early paintings rarely bear signatures, and it is often hard to determine who the artist is.

The auction house Old Master director estimated that the price would be between $50,000 and $75,000. Before the sale the Louvre apparently indicated to him that it might send a representative to examine and possibly to bid on the painting.

At the sale in October 1970, there was not a single bid on the painting by anyone. The college took it back. This writer purchased it for $12,500 and later shipped it to London to be sold at auction. It brought just enough to allow him to break even on the painting—about $14,500. It went to the Belluno Museum in Italy. But even here there was trouble. The painting failed to sell at the auction. Only *after* the auction did the Belluno Museum purchase it.

Between the time the painting failed to sell at auction in London

and the time the Belluno Museum purchased it, the London Old Master dealer Julius Weitzner offered to take it on consignment for sale. He felt he could get a very good price for it. I believe he could have secured a very good price. It was not the kind of art object that the auction house could market effectively. It had very limited appeal, but it was unique. There are few such paintings for sale anywhere in the world, and it rounded out a museum's Italian painting collection.

Top-quality unique collectibles are sought out by dealers specializing in them, and they will pay top dollar for such items. They will, of course, pay within their financial capabilities, supplemented by assistance from banks, and for years British and Continental banks have assisted art dealers in their buying activities. Of course, if we get to top-quality unique items that many buyers want, the financial ability of dealers may well be exceeded. Perhaps the best-known painting in the world is Leonardo da Vinci's "Mona Lisa," which hangs in the Louvre. In the unlikely event that the Louvre should ever decide to sell this painting, it might best go through auction. The auction house would offer it to every major collector, investor, and art museum in the entire world, and a well-publicized auction should secure the highest price.

But the sale of the "Mona Lisa" or any great masterpiece is a far cry from the usual sales of paintings, antiques, and other collectibles. The very fine collectibles can well be sold to dealers. So can those a step down from the finest—the very good collectibles, like a set of eight American Sheraton chairs, a Venetian scene by Francesco Guardi, or a set of twelve silver serving dishes made by Paul Storr, fine Georgian pieces. These things are naturals for dealers to buy, and their owners should have no hesitation in offering them directly to first-class art, antique, and silver dealers, particularly if the owners have secured appraisals and are aware of values.

Perhaps two decades ago dealers might make "steals" in deals which allowed them to pay owners far under the market. Not so much today, however, for two reasons: The owner is usually fairly knowledgeable about what he has for sale, and unless the dealer offers the best price he can, some other dealer very likely will. Thus, the owner should by no means take the offer of the first dealer but should shop around for the best price, and the dealer should expect this shopping.

A collection of anything appeals to a dealer as much as it does to an auction house, provided the total outlay for the collection is within his financial means. A collection of American Chippendale furniture should certainly bring forth a good price to the owner from the New York firms of Israel Sack, 15 East 57th Street, New York, New York 10022; Bernard & S. Dean Levy, Inc., 981 Madison Avenue, New York, New York 10021; or Benjamin Ginsburg, at 815 Madison Avenue, New York, New York 10021, as well as from other leading dealers in American

furniture. A large set of Georgian silver flatware should secure a good offer from S. Wyler, Inc., 713 Madison Avenue, New York, New York 10021; S. J. Shrubsole, 104 East 57th Street, New York, New York 10022; James Robinson, Inc., 15 East 57th Street, New York, New York 10022; or any other major dealers specializing in fine silver.

In deciding on offering your collectibles to dealers or at auction, you might well start by showing them to dealers to see the reaction. You will have to know something about market price, and you can get an idea of market price from auction catalogues dealing with your collectible, whatever it is—American paintings, Americana, Georgian silver, English antiques, etc.

After you have secured offers from several dealers, visit the auction houses to see what their estimate on sales price and net return to you might be, remembering that unless one offers you cash, estimates are very "easy to make." No matter how well intentioned the auction house officials may be, it is very difficult to predict with accuracy what a buyer will pay for your collectible when it is offered for sale at some time in the future.

The Art and Antique Dealers' Associations

The British Antique Dealers' Association recently ran a full-page advertisement in one of the leading American art publications. It read:

THE BRITISH ANTIQUE DEALERS' ASSOCIATION

There are 500 members
throughout the country
elected for their integrity
and knowledge

Consult a member

When selling—the full price without delay
No deductions

When buying—a full guarantee
No premium

For a list of members
Apply: The British Antique Dealers' Association
20 Rutland Gate, London SW7 1BD
01–589 4128, 2102

This advertisement represents an almost brand-new function of the important British Antique Dealers' Association. The main objective of this ad is to get people to sell to the members of this association—the

dealers. It implies: *Before you sell your collectibles at auction, consult one of our members. We will give you the full price without any waiting period while the auction is getting ready to market your collectibles. We don't deduct any auction house commission of 10 percent—plus 10 percent from the buyer. For our buyers, we guarantee what we sell, unlike the treatment you might get from the auction houses, and the buyer pays no 10 percent buyer's premium.*

This full-page advertisement indicates that the association is going out full force to get people with collectibles to sell directly to dealers.

A membership of 500 is a big membership, and it includes small dealers as well as the "great dealers."

This ad is simply an illustration of the new art and antique dealers' associations. They seem to be of a frame of mind today to do everything possible to get collectors to sell directly to them, and they should not resent any communications from people who have collectibles they would like to sell. Dealers in art and antiques are in the position of facing a major fight with the auction houses to maintain their sales against a mounting volume of auction business.

A full-page advertisement recently appeared in an American antique magazine. It reads:

The Smart . . . Sell Direct
to these top experts who will pay you top prices.

The
National
Antique & Art
Dealers
Association
of America,
Inc.

The Association members must earn and maintain
a reputation for integrity and fair dealing.

Association Secretary
59 East 57th Street
New York, N.Y. 10022

The message of this advertisement is the same: *If you are smart, sell directly, not through auction. We have integrity, and we are fair dealers.*

On a separate page, an entire page, a list of members is included, with their specialties—American paintings, Old Master paintings, English eighteenth-century furniture, etc.

The above address is that of the Stair Gallery, top dealers in English antiques. The secretary of the association, James Berry-Hill, picks up association mail at that address.

The president of the association is Edward Munves, vice-president of James Robinson, specialists in antique English silver, Sheffield silver, porcelain, jewelry, and glass. This is his advice on how a seller of collectibles may make use of the association:

"The important thing for the seller is to get an idea of the value of an article that he has by going to an appraiser or to an auction house. I don't think the buyers (our dealers) should do the appraising. It is hard for them to 'wear two hats' and value the things they are making offers on. If I am going to be interested in buying I shouldn't appraise the item. This is a situation which is too tempting for many dealers.

"After getting an appraisal, then come in, and we will arrive at a price which is mutually satisfactory. As a protection, get an independent appraisal and then go to a reputable dealer and say, 'This is what I would like to get for this,' and then it may be a matter of negotiation.

"Send for the booklet published by the Association. Write to The National Antique and Art Dealers Association of America, Inc., at 59 East 57th Street, New York, and they will send you the booklet in which each dealer is listed along with his specialties. There are 31 pages in the booklet and some general information such as the sovereigns and rulers, general styles of art and antiques and periods. There is also a map of the city with the location of each dealer in the city, and a list of the New York museums.

"Use a member of one of the two appraisers' associations for the independent appraisal. Most of the specialists, however, are in private business, and these specialist dealers are able to pay the largest amount for the best items.

"The ordinary (second rate) item perhaps would do better at auction. The dealers listed in this Association are dealing in the best things—a thin line of 'cream at the top.' It is a rarified atmosphere.

"As for the great prices for silver, porcelain, etc., how many great things were turned out? Many more things are not great. The great are only a handful. These are the things that the great dealers handle. The mystique of a name is important at the top level."

Thus, the best dealers (and the dealers belonging to this association are, in general, the best) want the best and are willing to pay high prices for the best—immediately. The rest of the things they do not want and will not buy. If you have the best, then contact the association and its members.

The association is a member of CINOA (Confédération Internationale des Négociants en Oeuvres d'Art, or International Confederation of Dealers in Works of Art). CINOA is comprised of the most representa-

tive art associations of various countries, themselves composed of professional art dealers. The member countries are Austria, Belgium, Denmark, France, West Germany, Great Britain, Holland, Italy, New Zealand, South Africa, Sweden, Switzerland, the United States, and the Republic of Ireland.

There is another organization of importance to sellers of art and antiques: the Art and Antique Dealers League of America, Inc., 800B Fifth Avenue, New York, New York 10021. The league too is a member of CINOA.

Here again the members of the league do not tend to deal in less important art and antiques, for the most part. On the other hand, I bought a fine Castiglione drawing from member Herman Galka, 14 East 77th Street, New York, New York 10021, some years ago, paying $60 for it. I later sold it for $2,250. From the same dealer I bought a Dutch seventeenth-century portrait by Miereveld for $700 and sold it for $8,000. Thus, some of the dealers do deal in lower-priced items. Mr. Galka has also sold some things at very good prices, and I would not hesitate to sell or to consign to him.

The league headquarters are at the dealership of Vojtech Blau, one of the leading Oriental carpet dealers in New York.

There is one important organization of dealers in the area of paintings, but it includes dealers who sell things other than art. This is the Art Dealers Association of America, Inc., 575 Madison Avenue, New York, New York 10022. This is a relatively small group of dealers in top-quality paintings from Old Masters to contemporary art.

One highly important function of this association is to make appraisals of artworks given to educational institutions, charitable institutions, and museums. Its appraisals are taken very seriously by the Internal Revenue Service for contributions taken as an income deduction on Income Tax Form 1040. It appraises paintings, drawings, graphics, sculpture, and photographs.

As far as the individual seller goes, this organization is also working on a comprehensive plan to make it attractive for sellers to approach the Art Dealers Association directly to secure buyers.

Members of the association include many leading and prestigious dealers who handle, as a general rule, the *best* works of art, not the medium-grade or lesser works of art. This association, which is smaller than the others, is very highly thought of. Membership is only by invitation.

There are approximately 105 members of the Art Dealers Association. Members are added from time to time, so the 105-member figure is an approximation. When the association put out a list of new members as of July 15, 1980, 13 new members were listed. This is the distribution of the members:

Marketing Collectibles to and Through Dealers 83

New York City	81
Birmingham, Michigan	1
Boston	1
Chicago	4
Cincinnati	1
Dallas	1
Houston	2
La Jolla, California	1
Los Angeles	5
Milwaukee	1
New Haven	1
Palm Beach, Florida	1
Philadelphia	1
San Francisco	1
San Rafael, California	1
Santa Barbara, California	1
Washington, D.C.	1

It is worthwhile to secure the Activities and Membership Roster of the Art Dealers Association of America, which includes the updated list of dealers in your general area, by writing to its office. If one of these nearby dealers is not interested in what you are offering for sale, he might suggest another who would be.

The Activities and Membership Roster says, "The Association's members deal primarily in paintings, drawings, sculpture and graphics. Some members of the Association deal also in one or more of Oriental prints, African art, Pre-Columbian art, American Indian art, Middle Eastern Antiquities and French furniture."

Alongside the name of each dealer in the roster is what he deals in. For example, Associated American Artists, 663 Fifth Avenue, New York, New York 10022, deals in "Oriental Etchings, Lithographs, Woodcuts and Serigraphs, 15th through 20th Centuries," while the Graham Gallery, 1014 Madison Avenue, New York, New York 10021, deals in "16th–20th Century European and American Painting and Sculpture; Antique Silver and Porcelain; Naive Painting; Comic Art and Works by Famous Illustrators." (This gives you an idea of what the dealers handle, and their telephone numbers are also listed so that you may call them about what you are offering for sale.)

A list of the members of the three associations is to be found in the back of this book (pages 215–233).

The Antique Exhibitions and Sales

In the course of any year about 2,500 antique exhibitions and sales are held around the United States. These are sometimes called armory shows because many of them are held in armories, the most important

such show being the Winter Antiques Show put on by the East Side House Settlement at the Seventh Regiment Armory in New York. The dates are usually the last week in January and first days in February. In this show many of the most important art and antique dealers display their wares—very likely their best wares—for sale.

In connection with this show, there is a preview party at a usual cost of $60 a person and a special patrons' and collectors' reception at $90 apiece. The New York Annual Antique Conference sponsored by *Antiques Monthly* has tied their date in with this exhibition and sale, and with the Americana auctions held in New York at that time.

There are just a few other art and antique exhibitions and sales of the quality of the Winter Antiques Show—the Philadelphia, Pennsylvania and the Wilmington, Delaware, shows probably being the most important ones. The Washington, D.C., Antiques Show is an elaborate event, with luncheons and expert speakers on various phases of art and antiques. There are annual exhibitions throughout the United States which are gaining importance.

These major shows are not exactly a major market for the sellers of collectibles. The vast majority of the rest of the 2,500 (more or less) exhibitions and sales are a potential market for the seller of collectibles.

Most sellers of collectibles do not have a Rembrandt for sale or a Tiffany lamp or a Louis XV bureau plat by Bernard van Riesen Burgh II. Many of the owners of collectibles they would like to sell have an old painting by a minor Hudson River school artist or a few pieces of American coin silver or an early plain Victorian table or a Weller vase or some Hawkes glass goblets.

The major art and antique shows do not offer any market for pieces that are not important. Important dealers buy only important things.

In the Seventh Regiment Armory other art and antique exhibitions and sales of a far different nature are held. Actually art and antique exhibitions might be graded by the types of collectibles the dealers offer. Some exhibitions and sales present fine and very expensive things, and others show far lesser and far less expensive things. One might even grade the exhibitions and sales by the average price of offerings. The Winter Antiques Show in New York might have an average offering price of, say, $2,000. If one confined his average computation to antique furniture, the average price might well be close to $10,000.

At the lesser exhibitions and sales at the Seventh Regiment Armory the average price of the things offered might be $200 to $300 or something in that general price range. The "least" exhibitions and sales offer everything from kitchen tables made in the early part of the present century to old pincushions to tintypes to electric-line blue or green glass insulators. All manner of old jewelry is offered from genuine stones

and gold to imitation stones with gold-plated settings—the gold worn off some of the pieces!

These art and antique exhibitions and sales are *buying* as well as *selling* sessions. On the day before the grand opening of an exhibition and sale, the dealers set up their stalls. On that day there is always a good deal of buying by some dealers from others. A southern dealer may well appear at the exhibition and sale with a Connecticut-made eighteenth-century slant-top desk. Such a desk was actually in the possession of a dealer exhibiting and selling a few years ago in Lexington, Kentucky.

The market for such a desk is much stronger in the North than in the South. Had this southern dealer been exhibiting in New York or Hartford, Connecticut, or Boston, a New York or New England dealer might well have bought the desk before the show even opened to the public.

In some sales there is more buying and selling among dealers than there is selling to the public. One dealer can use what another dealer has because the former has customers more interested in the item than the latter has. The former thus buys the item from the latter—at a profit, of course, but low enough still to allow him to mark the item up and sell it at a profit for himself.

At these exhibitions and sales almost all dealers will be receptive to offerings by private sellers. In the future, with more and more competition from the auction houses, it is expected that at these exhibitions and sales dealers will actively seek sellers of art, antiques, and other collectibles.

The atmosphere of an exhibition and sale is particularly conducive to advantageous selling by collectors. The seller of an eighteenth-century English wineglass doesn't have much to offer a major antique dealer or even a major antique glass dealer. Nor does he have much to interest an auction house. On the other hand, if he comes with his glass to a dealer in glassware and bric-a-brac at a small antique exhibition and sale, he might very well be able to sell it advantageously. He shows it to a dealer and asks if the dealer is interested. If the dealer is, an attempt is made to reach a satisfactory price. If the price offered by the dealer is not satisfactory to the seller, the dealer knows that the seller will simply go to the dealer in the next booth to get the latter's highest offer.

At these exhibitions and sales two things happen: The dealer disposes of what he brought to the exhibition and sale (or at least some of it), and he takes in cash. A few art and antique dealers, like Jack Partridge from Maine, will sell almost everything they have brought with them and return to their home bases "cash heavy."

Under such conditions, they are inclined to buy at least something

at the exhibition if they can. At one of these exhibitions and sales at the Seventh Regiment Armory in New York (not the important Winter Antiques Show), I inquired whether a silver dealer had any Georgian wine labels for sale. She answered that she did not, but that a young man who had visited her booth had said he would bring in a number of such labels if she were interested in buying them. He did bring them in and sold them to the dealer, who sold some to me.

It is a hard job for a seller of collectibles to trudge around the streets trying to find a dealer interested in buying his teapot or whatever it is. At the antique exhibitions he can offer his teapot to a dozen dealers in the space of, say, an hour. In that time he may well find a buyer at a satisfactory price.

The Antique Show Calendars

The antique business has a number of publications that include extensive advertising of dealers, auctions, and exhibitions-sales. One excellent publication is *Antique Monthly*. Each issue costs $1.50, but the annual subscription is $14 and can be secured by writing to Boone, Inc., P.O. Drawer 2, Tuscaloosa, Alabama 35402.

Antique Monthly has a regular listing of "Upcoming Shows" by date. In one issue of this newspaper the month of August starts out with:

August 1–5—Boone/Blowing Rock, North Carolina, Holiday Inn Conference Center, Managed by Jeff Stewart

August 3–5—Detroit/Birmingham, Michigan Antiques Show—Birmingham Ice Sports Arena, Ted Kromer Shows

Not every exhibition and sale is listed, but many are, since the managers of a show can secure a listing in *Antique Monthly* for $1.

American Collector is an antique newspaper which can be secured for $1 by writing to P.O. Drawer C, Kermit, Texas 79745. *American Collector* contains a page entitled "Show Calendar" which is fairly comprehensive and classified as to kind of show-sale. The shows each week are listed somewhat like those in *Antique Monthly*, but there is a classification. For the April 21–27 week the first classification is "Antiques," and under this heading the first show is "Doylestown, Pennsylvania, April 22–24. Antiques show, Warrington Country Club, Route 613 and Almshouse Road, three miles south of town. Sponsored by Bucks County Antique Dealers Association." The next item is "Sausalito, California, April 24–26—Marin County 28th Annual Antiques Show and Sale, DESST Hall, Chairman: Mrs. Charles Radfield." Several other shows in diverse parts of the country are listed under the heading "Antiques."

The next heading is "Art," and here are listed several art shows and sales.

The next heading is "Auctions," and here are listed local auctions.

For the rest of the month the headings are:

Bottles	Paper
Glass	Stamps

For a person interested in disposing of certain types of glass there is the "Maybrook, New York (25–26) Hudson Valley Depression Glass Club, Inc., Show and Sale, indoor Pavilion Drive in Theatre, Route 208, Exit 55 Off Interstate 84; Hours: Friday, 4:00–8:00 P.M., Saturday, 10:00 A.M.–4:00 P.M. Donation $1.25.

On other dates there are other specialized exhibitions and sales, including:

Insulators	Dolls
Miniatures	Marbles
Collectibles	Books
Match covers	Paper
Stamps and coins	Cartridges

This classified listing is particularly valuable for sellers of specialized items—cartridges, for instance. On the twentieth to the twenty-second of the month the Anaheim, California, Cartridge Collectors' Association held its Third Annual All-Cartridge Show at the Anaheim Sheraton. Information on the show could be secured from Jim Estes, 1943 West Houston, Fullerton, California 92633; telephone: 714-871-1766.

In different issues different collectible shows are advertised, so that sellers of very specialized items can be aware of upcoming shows in the field of their collectible.

The magazine *Antiques* also does coverage of upcoming shows by date. This prestigious magazine, which costs $4 a single copy, $33 per year, is available in many libraries. The main office is 551 Fifth Avenue, New York, New York 10017.

Almost all antiques magazines and newspapers contain detailed advertisements of upcoming exhibitions and shows, together with names of the dealers exhibiting at the show.

Many sales are accompanied by elaborate catalogues with advertisements of the exhibiting dealers, plus advertisements of shops in the town or city in which the show is held. The Darien, Connecticut, Community Association put on an antique exhibition and sale one fall and listed each exhibiting dealer along with his specialties, an important addition for anyone thinking of *selling* to the dealers. One dealer handled "English soft paste and Chinese export porcelain." A second handled "Formal and country furniture and paintings." A third handled "Banks, paper-

weights, glass, silver and furniture." Another was described as handling "Fine jewelry."

The Antique Centers

The antique center is a permanent exhibition and sale. In an antique center a number of dealers have booths and sell all the time. The center is open every working day and perhaps Sunday. The dealers may alternate. A dealer in antique glass may have a booth and sell for two weeks, after which another dealer in something else will display for two weeks; or dealers will alternate on weekends, the glass dealer occupying the booth one weekend and the other dealer occupying the same space the following weekend.

Antique centers are important places for collectors to buy and owners of collectibles to sell. In general, their merchandise is not top-quality, although sometimes a number of fine things are handled by some of the dealers, like antique Venetian glass, and we have seen some fine Venetian glass in New York at such a center in the past.

Many large cities have such antique centers, which can be found in the classified phone book. New York has several good centers. One is listed in the phone book:

> Manhattan Art & Antique Center
> 1050 Second Ave.
> (55th to 56th Sts.)
> 355-4400

A complete selection of rare quality fine Art and Antiques under one roof—Period. Furniture, Silver, Clocks, Bronzes, Jewelry, Carpets, Collectibles, and much more . . . 85 distinguished shops and galleries in a tri-level enclosed mall. There's nothing else like it in New York. Monday to Saturday 10:30–6:30 and Sunday, 12–6. Convenient Parking on Premises. FREE ADMISSION

In the antique centers you are not pressed for time to find a dealer who is interested in what you have to make a sale before the show closes. You can even develop a continuing relationship with the dealers and try to find things in which they are interested.

A variation of this antique center selling technique was developed by a professor of business administration at the American University in Washington, D.C. He and another person rented space in Georgetown and had a Sunday antique center—not a big one, but a center of sorts. He bought knickknacks and less expensive antiques and paintings in the area, sometimes at flea markets. These he brought to the Georgetown antique center (such as it was) and resold—at a handsome profit. The professor in the course of his buying picked up a typical good signed

landscape by a California artist. A similar painting by the California artist hangs in the White House and was valued by the Internal Revenue Service as a donation at several thousand dollars. The professor paid $115 for his comparable picture. He did not know what it was when he purchased it, but I was able to identify the painting for him and advise him that he had made a "discovery." In his buying and selling efforts, he was able to supplement his university salary.

The Flea Markets

The flea market is something like the antique center except it is periodic, mainly in the warm months of the year, and is usually held on weekends, maybe only a few weekends in the summer. It is like the antique exhibitions and sales, but is held more frequently and usually in the open air.

The flea market is often a far more humble exhibition and sale than the antique center or the exhibition and sale. The offerings must appeal to people who drive by and are willing to part with relatively small sums of money as a result of "impulse buying."

Some of the flea markets are used as sales outlets for dealers handling high-quality things. The summer weekend Bethesda, Maryland, flea market has many dealers handling paintings at $7.50 apiece, but it also has a dealer in very good jewelry, some pieces priced in the thousands. Dealers at these markets both sell *and* buy.

The *American Collector*'s "Show Calendar," which is referred to above, has a section entitled "Recurring Flea Markets." The issue that was quoted from above has listed recurring flea markets at Pasadena, and Pomona, California, Centralia, Illinois, New Orleans, Columbia, Maryland, Baltimore, Norton, Massachusetts, and Franklin, Tennessee. The last is held "Every Wednesday, April–September, Friendly Fleas, Harpeth Square, Box 332, Franklin, Tennessee 37064, phone (615) 373-1742."

"Let Your Fingers Do the Walking"

Telephone directories in major cities are now starting to feature the "Antique Dealers Guide," and this section is *advertised* in the classified New York City telephone directory. The box ad simply states: "These dealers have arranged to be listed under captions describing their specialties." There are almost four full pages containing this dealer classification, and the sections are:

Archeological Objects
Architectural
Arms & Armor
Art Nouveau & Art Deco
Autographs
Automobiles
Bottles
Brass Objects
Bric-a-Brac
Bronze Objects
Cameras
Clocks
Clothing
Coin Operated Machines
Coins
Copper Objects
Dolls—Collectors
Enamels
Furniture—American
Furniture—English
Furniture—French
Furniture—Italian
Furniture—Spanish
Glass & Glassware
Guns & Rifles
Interior Decoration
Ivory Objects
Jade Objects

Jewelry & Precious Stones
Kitchen Accessories
Lamps, Chandeliers & Sconces
Memorabilia
Microscopes
Movies
Music Boxes
Nautical Objects
Paintings & Prints
Paperweights
Pewter Objects
Pianos
Pool Tables
Porcelain
Posters
Pottery
Quilts
Railroad Objects
Religious Objects
Rugs
Sculpture
Silverware & Silver Objects
Statues
Surveying Instruments
Tapestries
Toys
Watches

The listing includes some important dealers like Vojtech Blau in carpets and rugs, Wyler in antique silver, Hartman in rare art, Lillian Nassau in Art Nouveau, and William Scolnik, the watch dealer. However, many of the important dealers are not in these lists, whereas many of the smaller dealers are—notably in art and antiques.

6

Selling Locally and on Premises

The Commission Marts

A very large number of people have something to sell, something that they think might have value and that they would like to turn into cash. Some of them think what they have may be a treasure and worth a great deal, but others simply have something that they would like to get rid of and get a reasonable price for. The thing they have for sale is very often no great collectible and probably not worth a great deal of money, but it may be worth something. Included in such items their owners would like to sell may be simple pieces of Victorian furniture and furniture of the early part of the present century; simpler items of jewelry, including some gold, pieces containing some diamonds, and a few pieces of Victorian jewelry; flat silver and some holloware; glass of various kinds, including Venetian glass, Hawkes glass, Heisey glass, Depression glass; sets of china, including Limoges, Minton, Old Paris, and Spode; brass candlesticks and brass fire fenders and andirons.

All these things—plus many other items—constitute the stock of the commission marts, and they are selling at a tremendous rate of speed.

Ten years ago a commission mart was something of a rarity. Today marts are literally all over the place, and there are thousands of them throughout the United States.

The commission marts are shops which secure their stock of items to sell from owners who place them on consignment.

For the seller, the selling of things through the commission mart is no "big deal." Generally a housewife (or her husband) will bring a number of things to the mart to discuss selling them. The reason may be that a little cash is wanted. Or things in the home have simply become superfluous. Or the children have grown up and the family is moving

to smaller quarters and thus must get rid of some furniture and other possessions. Or the wage-earner is being transferred, and the move offers the opportunity to get rid of some things.

The would-be seller brings in the things and discusses their salability with the operator of the commission mart. The operator may say, "We have four sets of china for sale now, but yours is a particularly attractive and large set of Haviland Limoges. It is simple and with a gold border, and people seem to like that pattern. There are also very few chipped pieces, and few people will bother with chipped pieces. Yes, we can sell it for you if we can agree on an asking price."

The set is very nearly complete, with 12 pieces of each type of dish, plus platters, tureens, etc. There are about 100 pieces in all.

A price of $500 is established for the set through discussions between commission mart operator and seller. The mart may take 30 percent of the selling price as commission.

The mart usually has an automatic price reduction policy. If in thirty days the consigned item does not sell, 10 percent may be taken off the price. If in sixty days it does not sell, another 10 percent is taken off the price, etc.

Very often would-be sellers have little idea of what they have. Many commission mart operators have acquired considerable knowledge about many of the things they handle and can date china and glassware fairly accurately.

Still, many operators are part-time. They may be open five days a week from, say, 10:00 A.M. to 4:00 P.M. The rest of the time they are home with their families. Many operators are housewives (or a group of housewives) who want to pick up a little extra money by developing a small business while their husbands are at work—and if all the children land in college at the same time! Very often the operators are prominent in their communities, which may consist of wealthy people. One such operator in Darien, Connecticut, comes to work in a Cadillac Eldorado convertible. Another, in Bronxville, New York, owns a Rolls-Royce.

Not all things handled by commission marts are in the class of "little nondescript items" by any means. A few years ago a mart in Darien, Connecticut, had a magnificent pair of polished wood putti (angels), Italian of the eighteenth century—about five feet high, on wooden plinths. The asking price for the pair was $3,000. The buyer—this buyer!—finally got them for $2,500. At other times in some of the Fairfield County, Connecticut, commission marts there have appeared such items as American Sheraton chairs (a set of four of the simpler variety), an English Queen Anne inlaid commode of the early eighteenth century, a set of eighty-five pieces of Venetian glass flecked with gold of the late nineteenth century, a set of a dozen pieces of Heisey glass, a set

of twelve long-stem Hawkes glasses, an eighteenth-century large glass Venetian bowl with the original sticker of Ovington and Company, New York, on it.

Some Guidelines for Selling Through Commission Marts

The commission marts are not set up to handle the more important, more valuable collectibles—art, antiques, or other collectibles.

The high-priced market is not there. Buyers are mainly housewives, smaller collectors, and smaller dealers. Dealers regularly visit commission marts and usually make a good profit on resale.

Smaller auction houses often visit commission marts and sometimes make a good profit on things they buy there and resell at their auctions.

Commission marts are set up to handle an extremely wide variety of lower-value collectibles as well as household items of all sorts.

The commission mart may well be a one-stop place to market almost everything one has in his home and would like to sell for one reason or another.

The commission mart will usually take anything and everything, from 1 to 1,000 items—and they can be extremely diverse.

The sale is not necessarily quick—or sure either. The goods may remain for sale for a long time.

The price can be set by the seller according to what he feels the value is, but the mart must agree with his price. If the mart takes many things at prices it feels are unrealistically high, there will be few, or even no, sales.

There is generally no immediate cash for the seller. He usually must wait an indefinite period of time to get paid—and may never be paid if his consigned items do not sell.

In the past, prices asked have been very low in comparison with those of the auction houses and dealers. In the past few years prices have been rising rapidly until they are now about at the level of the smaller dealers and sometimes above the prices realized by the secondary auction houses, particularly in the latter's less important sales.

In some cases the seller may well have a choice of two about equal means of selling—the commission mart versus the smaller "antique" dealer down the street. These numerous smaller dealers in many ways are like the marts in the items offered and in their prices. The dealer owns more of the items offered for sale and takes fewer items on consignment, whereas the mart usually owns less merchandise offered but has most of it on consignment.

Breakage often runs high in commission marts. There are many "lookers" every day, and some housewives regularly visit as a kind of pastime. The responsibility for breakage, together with amounts, must

be established by contract. The mart should definitely be held responsible.

Thefts at commission marts (and dealers) are running high, and the mart must be responsible by contract for them.

Very often the commission mart is the only logical outlet—particularly for controversial and inexpensive items that dealers may not want and that auction houses can get little for.

Marketing through a commission mart often implies for the seller a price that he feels is low and under the market. At least he can argue with the mart about the fair selling price. If he is offered too little by a dealer, that is that; he can take his collectible home with him. An auction house may allow no reserve at all to be established if it feels the item is too unimportant to allow a reserve (minimum price) to be established by the seller.

Any owner of an item he feels *may* have a very substantial value or perhaps an item that may turn out to be a "discovery" should first visit dealers in the item and auction houses. If neither has an interesting price or reserve price to offer, the commission mart may be the answer.

The commission marts are sometimes operated by highly knowledgeable people. Sometimes they themselves will suggest sending to an auction an item the mart has not been able to sell, particularly to an auction house with which they have a continuing relationship. Sometimes this move will result in a higher price than the asking price for the same thing while it was sitting in the commission mart. This is not an unusual outcome from such a move.

Locating Suitable Commission Marts

A commission mart located in a town of, say, 2,000 people will probably be of little use to you in marketing any collectible of much value. In all probability knowledgeable buyers, particularly those who will pay somewhere near market price, may be few.

Probably the best commission marts are those in the business sections of the larger cities, like New York, Chicago, and Los Angeles.

Suburban commission marts are growing extremely rapidly, however, and collectors often make the rounds of such marts. If the mart is located in a suburb containing old families and with large houses, it is a natural to draw both collectors and dealers. From time to time from the old estates owned by the old families come treasures or, at least, if not treasures, then "near treasures." This more or less continuous supply of collectibles to the marts for sale assures a fairly constant stream of buyers.

The firm of Bargain Hunter's Notebooks, P.O. Box 157, Old Greenwich, Connecticut 06870, issues the *Fairfield County Bargain Hunter's Note*

Book, which sells for $4.25. Fairfield County, one of the wealthiest counties in the country, is covered in this directory—Bridgeport, Danbury, Darien, Fairfield, Greenwich, New Canaan, Norwalk, Ridgefield, Stamford, Westport, and Wilton.

Along with low-priced bakery products and discount factory outlets, there is a list of commission marts handling antiques, paintings, and other collectibles.

Under "Darien" is listed Rose d'Or, 980 Post Road, Darien; telephone: 655-4668—a firm from which we bought on the day this page was being written. "They will buy outright also, but if articles are consigned, the percentage taken by the shop is one third of the selling price."

Under "Greenwich" is the Commission Mart, 245 East Putnam Avenue, Cos Cob; telephone: 869-5512. "You'll find everything from furniture to crystal in this three room shop and they will sell articles for you, taking one third of the selling price as their commission. Call for an appointment to consign. They also manage estate and tag sales." (We have bought items there also.)

The same publishing firm puts out the *Westchester County Bargain Hunter's Notebook* for $3.25 and the *Central Connecticut Bargain Hunter's Notebook* for $3.95, covering the same types of shop covered in the *Fairfield County Bargain Hunter's Note Book*.

House and Tag Sales

One of the biggest innovations in the late 1970's was the tag sale. A house owner decides that for one reason or another he doesn't want all the things he owns and would prefer to turn them into cash. He places the things in his home or in his garage or in his yard with a price tag on each—and usually sells nearly everything offered.

If he wishes to sell most, or all, of his belongings, and if he is selling some moderately valuable collectibles, particularly antiques, he calls an auction house to see how much it will charge to conduct a full-fledged auction on his premises. There are advantages to this kind of selling if there are good collectibles included: Nothing has to be trucked to the auction house. There is little risk of breakage if there is no moving. Insurance does not have to be taken out for the move or for storage at the auction house. The auction house does not have to go to the trouble and expense of storing and moving the items to and from the auction room and platform. Under these conditions the commission rate charged by the auction house for selling will probably not be more than the regular rate charged when the property owner ships things to a salesroom.

There is another big advantage to selling in the home. Prices are

rarely low. They often seem higher than the auction house achieves in its auction rooms, particularly if the home is located in a well-to-do area. This is a *house* sale rather than a *tag* sale.

The tag sale is on a level below the house auction and is for lesser items in estates as well as fewer things for sale—as a general rule.

There are firms specializing in tag sales, and this is a description of how they operate—from the *Fairfield County Bargain Hunter's Note Book:*

If you are breaking up your home, be it palace or cottage, to move or retire, chances are you will require professional help in disposing of the partial contents of your home. Auctioneers generally buy outright (but will sometimes take items on consignment) and resell at a higher price, whereas those who run tag or garage sales professionally will come into your home prior to the sale and price everything, arrange for publicity and then actually run the sale. Their commission will usually run from 20 to 30% of the total sales, and all items are offered to the public, not resold by the tag/estate sale conductors. It is wise to check the credentials of persons in either category. . . .

In Fairfield County these are some of the tag sale managers, many of them doing a big business in disposing of fairly important estates:

	Telephone (Area Code 203)
Early Bird, Greenwich	637-0745
Edward G. Pinto, Bridgeport	368-4836
Encore, Greenwich (Since 1969)	661-2276
Fran Landon and Estelle Watson, Darien	655-4759
Junk to Gems, Ridgefield	438-0889
Lock, Stock and Barrel, Westport	227-2923
New Leaf Associates, Greenwich	637-3410
Professional Tag Sale Co., Greenwich, Rye, New York	531-8428
The Resale Company, Westport and Rye, New York	226-0155

One great advantage in selling via the tag sale manager route is that a homeowner doesn't have to meet all his neighbors and have to explain that he is not really short of cash, nor does he have to indicate to a prospective buyer that his Tiffany plate is really worth the $300 being asked for it rather than the $100 that the neighbor is offering for it. Tag sale managers get owners completely out of the sometimes very unpleasant, plus time-consuming, task of "selling."

Tag Sale Versus House Auction

Tag sales are generally conducted for lesser collections, sometimes "tag ends" of estates or possessions. Someone or some organization removes the finer items in the house or estate and leaves the rest because the

rest is of far less value. The important items, those removed, may be taken by members of the family who want only the finer things, or the best may be sold to dealers, or turned over to an important auction. The lesser and the least tag sales are those conducted by the homeowner himself in his garage or on his front lawn.

The house sale conducted by the auction house is at the other end of the on-premises sales. These are important sales, held in a very professional manner, and *usually* they do as well financially for the owner as does shipping his things to the auction house in the city. These are some of the characteristics of the house auction conducted by a major auction house:

Generally, important buyers are attracted to the sale from towns other than the town in which the premises are located.

For important sales, dealers come from nearby large cities, and they are prepared to spend what they would spend at the city auction.

In important sales, dealers may come from Europe or even farther away. At the George R. Hann Collection sale, held by Christie's on May 19, 1980, at Treetops, Sewickley Heights, Pennsylvania, dealers came in force from Italy to buy Italian art and antiques offered in this sale—and they bought! Dealers who rarely visited America on business or pleasure came to America for this sale.

Dealers tend to bid art and antiques way up. In the Hann sale they bid items far above gallery estimates and probably above New York auction prices, too.

House sales *tend* to achieve higher prices than city auctions.

The local buyers are very, very important in house sales. They buy sometimes for nostalgic reasons, and they remember seeing the picture in the deceased owner's home, or they sat on a particular chair, etc.

It is easy to attract local buyers. They don't have far to come to the auction, and they may well visit local auctions, though they have never visited a city auction.

When local buyers buy, the job of moving purchases from estate to their homes is easy and generally inexpensive.

Trouble and expense for the estate or homeowner, and for the auction house, are at a minimum.

The auction house at a house sale can sell everything, not just the important items. Nothing has to be trucked to New York or Chicago to be sold. Nothing has to be stored or catalogued or taken item after item to the main salesroom. So long as the things are in a particular room they can be sold one thing after another, until each room is cleared.

To repeat, house sales *tend* to bring higher prices than city auction sales, to a considerable extent because people who travel far to the auction do not want to come away empty-handed and local buyers have

a tendency to bid items up over what they would have paid for similar items sold at the city auction because they knew the owner of the home or its reputation and because it is easy to visualize something being sold as it will appear in the buyer's home—just down the street.

Top-quality pieces will attract buyers if the sale is well publicized. Sotheby Parke Bernet sold the estate of the late Bernice Chrysler Garbisch in a series of sales at the Madison Avenue gallery and at an on-premises sale at Pokety Farms on Maryland's Eastern Shore. The entire collection brought a record for a collection sold in this country (a little over $20 million), and the on-premises sale brought a record for an on-premises sale in this country—nearly $4 million. There were numerous high prices, including $250,000 for an American Chippendale knee-hole desk, which was the highest price ever paid at auction for a piece of American furniture. An American bombé chest of drawers brought $160,000—well above the $50,000 to $75,000 estimate. Prices were strong right across the board, and top-quality pieces brought extraordinary prices. From 20,000 to 30,000 people saw the exhibition, and about 10,000 attended during the sale days. Buyers included a telephone bidder from London for a $19,000 Chinese export lot. There were fifteen telephones in use (three in the tent) and some pay phones, and more than 8,000 order bids were received.

The Firms That Do House Auctions

The major auction firms do house auctions and are very happy to take on a major estate to be auctioned on premises. As just noted, Sotheby Parke Bernet conducted the major auction of the Garbisch estate, an absolutely top-quality large estate. Illustrated catalogues were prepared for this sale, and previews were conducted well in advance of the sale, including one special tour for the press which gave the sale tremendous publicity. The same procedure was followed for Christie's auction of the George Hann Pennsylvania estate.

The major auction houses tend to restrict themselves to major estates. Still, they aren't as exclusive as might appear, and they do not turn up their noses at smaller estates. Christie's Stephen S. Lash, director of estates and appraisals, states that the main auction staff at 502 Park Avenue will auction estates on premises with a minimum auction value of $300,000 to $500,000.

If the estate is smaller than this size, Christie's East (the lesser auction house operated by the same company) will handle it if it is not too far from New York City.

Mr. Lash feels that if the house is known to a number of potential buyers, particularly if the contents are known, prices tend to be higher than the auction house could sell them for in its main auction rooms

Selling Locally and on Premises

in New York. Some of the very finest art and antiques may be shipped to New York or London, of course, for viewing and sale.

The major auction houses do not conduct many on-premises sales per year but the trend seems to be up.

On the other hand, Richards Gilbert, State Road, Garrison, New York, who specializes in house sales, some of a very major nature, conducted twenty-one such sales in the 1979–80 season. The firm has been conducting house sales for generations. It has no gallery of its own, and if it has to truck estates to a central location for sale, it hires a local hall.

At most house sales Mr. Gilbert reports an attendance of more than 1,000 people, and at an important sale held at Cooperstown, New York, 6,000 people attended. The firm tends to specialize in the New York State area.

The smaller auction houses should not be overlooked for house auctions. It is just possible that the O'Reilly brothers of the Plaza Art Galleries, 406 East 79th Street, New York, New York 10021, conducted as many as 1,000 house auctions over a long career as an auctioning firm. They are now out of the business.

The Freeman Gallery, 1808 Chestnut Street, Philadelphia, Pennsylvania 19103, a firm doing a regular and important auction business in the city, also conducts house auction sales within about a sixty-mile radius of Philadelphia. Mr. Freeman stated to us that his firm will consider estates as small as $150,000.

The Freeman Gallery will auction every item in an estate, and it sometimes brings entire estates to its main Philadelphia gallery for sale, one of the rooms containing a certain range or assortment of items, another room containing another. Mr. Freeman states that his firm will auction everything in the estate, whereas the major New York auction houses specialize in art, antiques, and other strict collectibles, not broken-down lawn mowers and well-worn coffeepots.

The commission structure of the auction houses for their on-premises sales is about the same as that for their main auction gallery sales, generally 10 percent from the seller and 10 percent added onto the buyer's price. There may be, however, a special charge for the tent used to auction the things in and possibly an extra charge for a catalogue. The Freeman Gallery estimates that these charges may possibly raise the commission from the seller of the estate to as much as 15 percent, instead of the normal 10 percent when goods are sold in the gallery of the auction house.

7

Collectors' Clubs as a Sales Medium

Collectors' clubs are a natural for disposing of many collectibles, for these reasons:

Collectors' clubs are a direct way to reach the market. The market for a Maserati Ghibli SS Spyder (convertible) is relatively small and specialized. There are very few customers and relatively few potential customers for such a car. Collectors' clubs marshal a good percentage of potential buyers of the subject of interest to the club, whether watches or Maserati automobiles.

Advertising in the journals of the collectors' clubs is usually one of the least expensive ways of reaching exactly the potential customers for your collectible that you want. There may be 1,000 potential customers in the entire country for a Ghibli SS Spyder. If one-fourth of the potential customers belong to the Maserati club, it is both easy and inexpensive to reach them by advertising in a journal that is sent out to, say, 750 members.

For a Patek-Philippe *tourbillon* movement watch there are in the United States probably fewer than 1,000 potential customers, possibly no more than 100 potential customers. The last offer I heard of on such a watch was $50,000. If a club journal can reach even a relatively few watch collectors interested in purchasing such a watch, that advertising can be both effective and inexpensive.

There is something of a feeling of trust on the part of a club member who reads about a car for sale by another club member. In used cars the reputation of the seller is unknown, and because he is selling a used car, his reputation may well be questioned. If he can dump a "junker" on the buyer, that seems to be "standard procedure."

The fact that the offeror of the collectible belongs to a club of collectors inspires some confidence on the part of would-be customers who belong to that club. It may even be felt that the buyer who got

something "less" than what he bargained for can complain to the directors of the club to put pressure on the seller.

The geographical area covered by a club publication can be very wide, national and possibly international. It is difficult for a newspaper or magazine to equal such coverage.

The potential buyer speaks the language of the seller. Potential buyers are very often unfamiliar with the thing they are inquiring about, whether it is a complicated Swiss watch or a gemstone or an Italian sports car. When the potential buyer belongs to a club, he must know something about the subject of interest to the club, and he may know a great deal about it. It is easy to communicate with such a potential buyer and explain just what you have for sale and its exact condition.

There is not so much chance of a "slip 'twixt cup and lip." An owner who advertises a Rolls-Royce for sale in a newspaper runs some risk. There are those who watch for advertisements of Rolls-Royce cars for sale, then work out a "method of operation" whereby they will come into possession of a Rolls-Royce without having to pay any money. Usually such a "customer" asks to try out the car around the block. He drives it around the corner—and is then never seen again. This practice has become so prevalent in large cities like New York that sellers of Rolls-Royces will often not keep their car for sale where they live but will first look over the potential customer and then take him to the location of the car, which may be far from the seller's home. If the would-be car thief knows where the car is, he may even visit it in the middle of the night without even bothering to come to see it after telephoning to the seller. He jimmies the locks and makes off with the Rolls-Royce.

If your potential buyer is a member of a club specializing in cars or watches or stamps, the chances that he is not a potential thief are much greater than if he is a person who reads your ad in the local newspaper, particularly a metropolitan newspaper.

Inquiry on the potential buyer can be made of the club management. It is often possible that he is known to one or more of the members or to the club executives and other employees. A deal almost fell through for my purchase of an automobile because I did not trust the seller and he did not trust me. Neither of us knew the other or knew *of* the other. The seller demanded cash in advance of delivering the car, which was at a location other than his home. He would take neither personal nor bank check, only cash—$20,000 cash.

Advertising in a club journal can be a very sub rosa operation. An advertisement in the journal is not as public as one in a newspaper. When placing an advertisement for "offers above $100,000," one may wish some anonymity. This kind of advertisement for a Lamborghini Countach actually appeared in a leading newspaper in the summer of

1980. The seller was a manufacturer of electronic equipment who owned, in all, four Lamborghini Countach cars, three valued at about $100,000 each and one for about $200,000. From my answering of the ad I learned his name, his home address, the name of his corporation, and the location of his corporation. It was obvious that he was well-to-do (to say the least), and had I been a potential thief, I would have located a prime target who no doubt had many things in his home worth stealing—not simply expensive cars.

The advertisement in the club journals avoids a good deal of this exposure to possible thieves. If you are selling a used automobile battery, the risk of being located as a "hit" is not so great, but the more valuable the thing you are selling, the greater the risk—and it is big!

There are many corollary benefits to a seller to belong to a club in his particular specialty. Let's take one example. The club is one that I have joined and is a good illustration of several benefits that attend such membership. The club could have been the Ferrari Club of America, Inc., the BMW Car Club of America, or any of the car clubs. This one is called the Maserati Information Exchange, and its address is Box 772, Mercer Island, Washington 98040; telephone: 206-455-4449.

The reason I learned about this club was that I needed an exhaust system for my Maserati Ghibli. The local Maserati dealer quoted me a price for the system alone (without installation costs) of $1,400 to $1,500.

I then called the Maserati Information Exchange in Mercer. Its quote on such a system, manufactured to Maserati specifications, was $341, plus $26.80 for shipping to my garage on the East Coast.

If I had been a member of this club, I would have got a discount on this order (and all other orders) of 10 percent, making the order cost $306.90 plus shipping, instead of $341 plus shipping. The annual cost of membership was $35, so it certainly paid to join, even though this was my only order to the exchange.

Four days after the order was placed, the exhaust system arrived in my repair shop in North White Plains, New York. In addition, the first issue of the bimonthly magazine of the club entitled *Maserati Information Exchange* arrived. It contained forty-eight pages with many illustrations. There is a classified section with a number of Maserati cars for sale—only Maseratis. The person who belongs to the club and reads the classified ad section of the bimonthly magazine may well be interested in Maseratis for sale.

The membership of the club as of early summer, 1980, was 850 and growing at the rate of about 1.5 members every working day. Almost every member is a Maserati owner, but membership is not restricted to Maserati owners.

Advertisements are placed in the bimonthly magazine at no cost to the advertiser.

The Maserati Information Exchange maintains a detailed record of every Maserati owned by members, from the serial number to the year of manufacture to the body style and to other characteristics of the car. When a part is sold to a member, there is a notation in the file covering the particular car. Presumably over a period of years a member's car will have such notations as:

Valves ground, February 1979
Fitted Borrani wheels, April 1980
New engine from factory—5 liter, September 1981

A tremendously important service is the assurance that the car has a "legitimate origin." Cars have been stolen in Italy (and elsewhere), and they find their way onto the American classic car market, often through newspaper advertisements. The Maserati Information Exchange, on inquiry, may come up with a history of the car a person is thinking of purchasing, not simply the history of work performed on the car and parts purchased for it, but the fact that it is a legitimately owned car—owned by one or another of the club members for, say, the past five years. There is hardly much worse in the field of collecting than to be stuck with a stolen collectible—car or anything else.

The *Maserati Information Exchange* contains a section of parts for sale, which includes everything from windshields for almost all models of Maserati to wire wheels to bumpers and rear trunk lids. Some parts are new, and some used, and the list includes some very hard-to-find parts. Prices are stated in the advertisements.

Various repair services are listed, including the repair of fuel injection systems—at a stated price.

There are car clubs for many makes of cars plus general clubs for owners of old cars and owners of sports cars or simply for those who have an interest in cars of one kind or another but who own no specialized car.

Car Collectors' Clubs Zero in on a Specialized Market

If you had an important, unquestioned, Botticelli Madonna for sale, you would hardly try to market it through a club of Old Master collectors. The appeal of such a picture is extremely wide, and you would either approach a top Old Master dealer to buy it from you or sell it for your account or offer it through a top auction house, probably in London, possibly in New York. You might even get the auction house to prepare a special sales catalogue just for your painting, at its expense or partly at its expense and partly at your expense. Regardless of who paid for the catalogue, it would be a wise merchandising device, even if it cost, say, $10,000.

On the other hand, if you owned a very special Lamborghini Countach, "souped up" for more than 200 miles an hour you might well market it through The Lamborghini Club, 2509 Fulton Avenue, Sacramento, California 95821. The Lamborghini is not widely known in the United States, although it is unquestionably one of the great sports cars in the world. At classic and antique car shows there are many enthusiasts, and even owners, who know little or nothing about the Lamborghini and have never even seen the last model of Countach, but there are many Lamborghini owners who would like nothing better than to know that a "special" like the car in the May 1980 issue of *Motor Trend* might be for sale.

The June 1980 *Road and Track* contained this advertisement:

Lamborghini Countach S (Special). Factory installed extra-high performance engine, 206 mph top speed. 184 m.p.h. through 30 degree unbanked curves, 65-in. adjustable rear air foil, 12-in. wide P7 rear tires. Red with champagne interior, tinted glass stereo and air. Meets Federal Specifications required by D.O.T. and E.P.A. We reserve the right to accept or refuse any offer. Over $100,000. (212) 895-0194.

This unique car might well land a customer from this advertisement willing to pay more than $100,000. Still, the Countach is a very specialized and temperamental machine with a very specialized potential buyer, and the Lamborghini Club might be the best place to market this Lamborghini-to-end-all-Lamborghinis.

On the other hand, a very specialized, extremely rare Mercedes-Benz—an SSKL—was advertised in *The New York Times* about three years ago. The SSK is rare enough and expensive enough, but the SSKL is practically nonexistent outside museums. It may be the most-wanted collector car in the world, with the possible exception of a few greats like the Bugatti Royale. The result of this one short advertisement in the *Times* was literally hundreds of telephone calls, and this writer asked the assent of his wife to offer $50,000 over the telephone without even looking at the car. Today such a car, if it were offered, should bring over $500,000 immediately, and a *Times* ad is probably the best way to reach a potential buyer. A major auction house should be able to do a similar good selling job. For this much-wanted treasure the Mercedes-Benz Club of America, Inc., Box 9985, Colorado Springs, Colorado 80932, might *not* be the very best way to market the SSKL.

The Lamborghini plant in Italy may close down as of the writing of this chapter—summer, 1981.

Now suppose one were fortunate enough to buy up the stock of spare parts owned by the plant at the time of the closing—all or a portion of the spare parts. At such a time a bargain purchase could no doubt be made.

Suppose a large stock of Lamborghini clutches was bought up at a favorable price. These clutches could best be advertised in the journal of the Lamborghini Club, for, say, $125 each. No other advertising and sales method would be better for these specialized items.

Very often clubs are the very best way to sell collector cars and parts, and these are some of the clubs in this automotive area.

The Automobile Owners' Clubs

Alfa Romeo Owners Club, 2304 San Pasqual Valley Road, Escondido, California 92027.
Austin-Healey Club of America, 705 Dimmeydale, Deerfield, Illinois 60015.
Austin-Healey Club, Pacific Center, Inc., Box 6267, San Jose, California 95150.
BMW Car Club of America, 345 Harvard Street, Cambridge, Massachusetts 02138.
The Ferrari Club of America, 2000 Weber Hills Road, Wayzata, Minnesota 55391.
Ferrari Owners Club, 3460 Wilshire Boulevard, Suite 1010, Los Angeles, California 90012.
Fiat Club of America, Inc., Box 192, Somerville, Massachusetts 02143.
EJAG North America (Jaguar owners' club), Box 220R, Carlisle, Massachusetts 01741.
Lotus Ltd, Box L, College Park, Maryland 20740.
Maserati Club. The Paddock, Abbots Ann, Andover SP11 7NT, England.
Mazda RX-7 Club, 1774 South Elvira, Los Angeles, California 90035.
Porsche Owners Club, 6229 Outlook Avenue, Los Angeles, California 90042.
RX-7 Club of America, 138 (R) Ardmore Avenue, Hermosa Beach, California 90254.
Mercedes-Benz Club of America, Inc., Box 9985, Colorado Springs, Colorado 80932.
Volkswagen Club of America, Inc., Box 4091-RT, St. Louis, Missouri 63136.

The car clubs often have regular news bulletins or periodical magazines in which advertisements can be placed. The Ferrari Club of America advertises: "Our monthly news bulletin contains the world's largest listing of Ferraris for sale or trade. . . ."

There are also general automobile clubs, not simply clubs for Maserati owners or Rolls-Royce owners:

Sports Car Club of America, Box 22476, Denver, Colorado 80222—perhaps the oldest and certainly the largest automobile club for specialized vehicles in America and probably in the world.
Sports Car Collectors Society of America, Inc., Box 1855, Quantico, Virginia 22134.
Midwestern Council of Sports Car Clubs, 1812-R North Kennicott Avenue, Arlington Heights, Illinois 60004.

Contemporary Historical Vehicle Association, Inc., Box 552, Cerritos, California 90701.
Milestone Car Society, Box 50850, Indianapolis, Indiana 46250.
Sport Custom Registry, 1306 Brick Street, Burlington, Iowa 52601.
Vintage Sports Car Club, 4350 North Knox Avenue, Chicago, Illinois 60641.
Vintage Sports Car Club of America, 170 Wetherill Road, Garden City, New York 11530.

Road and Track, issued monthly and available at newsstands, carries a section listing specialized sports and old car clubs with their addresses.

The American Sports Car (1979) is published by Beekman House, a division of Crown Publishers, Inc., 1 Park Avenue, New York, New York 10016. At the back of this book there are lists of a large number of specialized automobile clubs.

Modern Classics is an excellent book by Rich Taylor, published in 1978 by Charles Scribner's Sons, New York. The order department is at Vreeland Avenue, Totowa, New Jersey 07512. The back of this book contains a comprehensive list of clubs in the area of classic cars.

The Collectors' Club As A Means of Selling Coins

The dominant club in the field of coins is the Amertican Numismatic Association, P.O. Box 2366, Colorado Springs, Colorado 80901. The monthly publication of this club, *The Numismatist,* is one of the most comprehensive in the entire area of collectors' clubs. The May 1980 issue contains 271 pages, and there are many pages of advertisements inserted by dealers as well as individual coin sellers. One advertisement states: "1880 Gold Dollar, fully prooflike MS67 gem, from 1974 Stack's Globus Auction, $4,800. M. Mansfield, 5601 S. Broadway, #347, Littleton, CO 80121. (ANA member)."

The description is exact, and the seller points out that he is a member of the American Numismatic Association.

Another advertisement in *The Numismatist* reads: "For Sale: 1934 pennies, superb B.U. toning, $4.20 each, postpaid. Strauss, Box 526, Peekskill, N.Y. 10566."

The official publication of the American Numismatic Association (ANA), *The Numismatist,* has been published since 1888. It is a monthly journal. The association states: "Advertising is accepted from members only, who must agree to abide by the very strict Code of Ethics."

The ANA has approximately 33,000 members, so the potential buyers of coins are many. They reside in the fifty states, the District of Columbia, Canada, and other foreign countries. The descriptive publication of the association states:* "It offers an entrée for contacting and

* "A Summary of Advantages of ANA Membership" by President of the ANA, George D. Hatie.

meeting collectors, dealers, authors, scholars, sculptors, government officials and people in all walks of life who are involved in numismatics."

Membership in the association does provide some assurance that sales and collections will be handled honestly and expeditiously: "Although ANA in no way guarantees the credit of its members, an ANA dealer or member will usually extend credit or send coins on approval to one who supplies his ANA membership number."

There is also a complaints procedure:

Any member who has evidence of any improper conduct on the part of another member (such as dishonesty, counterfeiting, overgrading, slander, misrepresentation or other improper or illegal activities) may make a complaint to ANA and any matters not resolved by the executive vice president will be presented to the board which will expel or suspend the guilty member or take other disciplinary action against him if warranted by the evidence. Although the ANA does not act as a collection agency, the filing of a justified complaint usually results in obtaining prompt satisfaction from the accused member.

This is an important advantage of joining the association if one wants to sell through *The Numismatist*. If a person has had any experience with collecting for collectibles sold, he knows the benefits of such assistance in collecting moneys due for things sold.

The ANA also grades and certifies coins:

ANA maintains the American Numismatic Association Certification Service in its headquarters to which coins may be submitted for an expert determination as to their authenticity. Certificates of authentication are issued. In order to combat counterfeiting, this service is available to the general public, but ANA members are entitled to a fee discount of ten percent.

ANA is in the process of studying the establishment of a grading service to which members may submit coins and other numismatic items for an opinion as to their condition on the basis of official ANA grading standards.

There is a very rigid code of ethics that assures sellers (as well as buyers) of coins of fair and honest dealing. These are some of the significant parts of the code with respect to coin sellers:

I agree to base all my dealings on the highest plane of justice, fairness and morality;

I agree to neither buy nor sell numismatic items of which the ownership is questionable;

I agree to take immediate steps to correct any error I may make in any transaction;

I agree not to sell, exhibit, produce, nor advertise counterfeits, copies, restrikes, and reproductions of any numismatic items if their nature is not clearly indicated by the word "counterfeit," "copy," "restrike," or "reproduction" incised in the metal or printed on the paper thereof, with the exception of items generally accepted by numismatists and not in any way misrepresented as genuine;

I agree to represent a numismatic item to be genuine only when, to the best of my knowledge and belief, it is authentic;

I agree to fulfill all contracts made by me, either orally or written, to make prompt payments upon delivery, and to return immediately any item that is not satisfactory.

If you had advertised a coin for sale in *The New York Times* and received an inquiry from a buyer in Seattle, Washington, indicating that he was interested and asking you to send the coin to him on approval since the asking price was satisfactory, you as a prudent seller would hardly ship the coin under those conditions. You might well never see the money—or the coin again. The situation might be different in the case of a response by one of the ANA's members to an ad in *The Numismatist*.

Membership dues for the American Numismatic Association are $15 a year.

Many local coin clubs as well as state and regional organizations belong to the American Numismatic Association, so that the readers of the ads in *The Numismatist* are considerably more than the estimated membership.

Small advertisements cost 10 cents per word, and numbers and prices count as one word. The minimum charge for small ads is $2.50. Display advertising is from one-eighth of a page to a full page. One-eighth of a page for one issue of *The Numismatist* costs $26. A full page costs $149.

The range of the subject matter of this association is immense. It includes trade coins (issued by local merchants in the past), all foreign moneys, paper money as well as coins, bus tokens, medals, Indian wampum, very rare moneys like old stone pieces, and even ration coupons and ration books.

Trade coins (or merchant-issued coins) started to be used in England in the seventeenth century. They proliferated in America in the Civil War period but were outlawed in 1864. They continued even into the twentieth century, nevertheless. Many of these coins are on the collectible market.

For 3 percent of the value of a coin or other money, you can secure from the association a certificate of authentication. For an additional $6, you can get a determination of the grade of the coin or other money— whether "uncirculated" or "fine" or what. The association *does not value* what you send in. It accepts your value in the application of the 3 percent fee, *but* if you value low, you insure your coin in the mail low; and the association insures it for a like amount when the coin is returned to you. If the coin is lost or stolen in the mail, you collect from the U.S. Postal Service *only the insured amount.*

There are many specialized coin (and other allied collectible) associ-

ations, including such diverse groups as: the Tokens and Medals Society; Early American Coppers; and the American Numismatic *Society* of New York City, a strictly research group doing work of historical significance.

There are also numerous state associations and regional associations.

If one has a collectible even remotely in the area of coins and other money, he can locate an association that might be operating in his field by writing or calling the American Numismatic Association. Many specialized, as well as regional, groups belong to the ANA, and even if the specialized or regional group is not a member, the ANA may very well refer the collector to an association concerned with his type of collectible.

Stamp Collectors' Clubs and Associations

Stamp collecting is an immense activity and involves millions of collectors. Sales of stamps are immense. The dealer organization is immense, and so are the stamp auctions.

There are hundreds of local and regional stamp clubs, and the general national clubs and associations are very large. Here are the main national stamp collector organizations, all of which put out monthly publications:

American Philatelic Society, Box 800, State College, Pennsylvania 16801.
Society of Philatelic Americans, P.O. Box 9041, Wilmington, Delaware 19809.
Bureau Issues Association, 59 West Germantown Pike, Norristown, Pennsylvania 19401.
American Topical Association, 3308 North 50th, Milwaukee, Wisconsin 53216.

The association most buyer-seller-oriented, as well as investment-oriented, is the American Philatelic Society of State College, Pennsylvania. It is also the largest association and has about 50,000 members. Its journal, called the *American Philatelist,* is sent to the 50,000 members, each of whom pays annual dues of $10. The *American Philatelist* is a magazine of almost 100 pages and has a number of pages of "Stamps for Sale." As of late 1980 the cost of placing a one-time advertisement in the journal was $1.58 per line. A full page cost $528. The organization is very large and has a staff of about forty people. It claims to be the largest stamp collector organization in the Western Hemisphere.

Watches and Clocks

The National Association of Watch and Clock Collectors can be reached at Box 33, Columbia, Pennsylvania 17512. It consists of about 30,000 members and is growing. Membership dues are $20 a year. Six times a year *The Bulletin,* an educational periodical, is sent to members.

On alternate months *The Mart* is sent to members, so there are six such issues per year. This is the commercial publication of the national association. It is an 8½ by 11 publication and contains roughly 44 pages, many "For Sale" and "Want to Buy" advertisements included.

The publication office of *The Mart* is Rose P. Brandt, Star Route, Ridge Road, Glens Falls, New York 12801. Mrs. Brandt has put out *The Mart* for thirty years.

The rates on watches for sale is $6.50 per line, but one must purchase at least three lines, a minimum of $19.50 per ad. If more than six lines are desired for the advertisement, the rate goes up to $7.50 per line. Want ads cost only $4 per line.

The catch to using *The Mart* for advertising your watch or clock for sale is that you must be a member of the National Association of Watch and Clock Collectors for six months before you can advertise.

There Are Clubs for Collectors in Every Field

The Antique Outboard Motor Club, 2316 West 110th Street, Minneapolis, Minnesota 55431, issues a newsletter that takes advertising. The newsletter is so specialized that it has been included in the following chapter on selling via magazines and newspapers. I once owned an Evinrude Four, an old-time outboard motor, a natural to sell via the newsletter of the Antique Outboard Motor Club. So popular was this motor that I sold it at a profit before I ever took possession of it—or even saw it!

This collectors' club and many other specialist clubs are listed in *Ulrich's International Periodicals Directory*. The 1980–81 edition is priced at $69.50, published by R. R. Bowker Company, 1180 Avenue of the Americas, New York, New York 10036. Each listing indicates whether or not the club has a periodical and whether it takes advertising of the collectible for sale. This directory can be found in major libraries.

The American Collector, a monthly newspaper, is available from P.O. Drawer C, Kermit, Texas 79745. Its "Show Calendar" is important in locating specialist collector clubs. In each issue shows, including specialized club shows, are listed. For instance, in August 1980, there was a show put on the by Connecticut Antique Bottle Collectors Association, and the time and location of the show were listed.

Another issue mentioned that a show was put on by the Hudson Valley Depression Glass Club, and specifications and addresses are given. Comics were represented at the Capital District Comic Club.

In the same month, the National Insulators Association held its regional show and sale sponsored by the Northwest Collectors. The Associated Matchcover Clubs of California held their twenty-fifth Annual Convention at Fresno, California. The California Cartridge Collectors'

Association held its third Annual All-Cartridge Show in Anaheim, California.

We spoke to the head of the American Musical Instrument Society, which is composed of 400 to 500 members and can be reached at Box 194, Vermillion, South Dakota 57069. It publishes a yearly journal and holds an annual meeting; membership costs $18 a year. This is not a strict buying-selling organization, by any means, although Frederick Selch, the president, is well aware of what is happening to the values of musical instruments, which are going up rapidly and, in some cases, to tremendous heights.

The Encyclopedia of Associations is published by Gale Research Company, Bock Tower, Detroit, Michigan 48226. Section 13 of Volume I (fourteenth edition) is a compilation of "Hobby and Avocational Organizations." Under "Cultural Organizations" museums are listed. All kinds of specialist collectors' clubs are included in this directory, which is available in many libraries.

There are collectors of everything—and everything is collected. In a recent TV broadcast of the *MacNeil/Lehrer Report*, Robert MacNeil asked repeatedly, "Is there anything that somebody doesn't collect?"

The question indicates the breadth of collecting and the tremendously wide distribution of collectors of one thing or another. More and more specialist collectors are forming clubs, and many clubs put out newsletters, journals, or magazines. If the club does not allow advertising in its publications, at least membership in a specialist club can put potential sellers in touch with potential buyers.

8

Advertising in Newspapers and Magazines

Some collectibles, but not all collectibles by any means, can advantageously be advertised in metropolitan newspapers. Fewer collectibles can be advertised in the newspapers of the smaller cities and towns. In some of the smallest town newspapers, almost no collectible can be advantageously advertised. The collectible or collectibles may be of too specialized interest to appeal to the readers of many newspapers. General-interest magazines are not a natural medium for the sale of collectibles. Specialized newspapers and magazines, on the other hand, are naturals for advertising many collectibles for the following reasons:

Specialized publications reach people with specialized interests, and many of these are collectors or investors or both. The publication *Stamps* obviously is going to reach a large number of people interested in collecting stamps.

A general broadside like the use of a large metropolitan newspaper with a circulation of 1 million to sell some antique Spanish spurs is costly. The metropolitan newspaper would far better serve the seller of a 1965 Ford Mustang for $3,500.

The major objective of the seller of a collectible is to reach potential buyers, and his subsidiary objective is to reach them inexpensively. A small-circulation specialized newspaper or magazine may well "hit" a group of potential buyers at an advertising cost of very little *per potential buyer.*

General newspapers and magazines are often read very casually as far as collectibles for sale go. The important things to readers are what the government in Washington is doing (or failing to do or doing wrong), what business is doing, what stocks and bonds are doing, and the sports.

On the other hand, when *Road and Track* arrives (at $1.75 a copy), I can hardly wait to sit down in quiet to read every single ad for classic

and antique cars for sale and to look at the pictures of many of the cars.

Details and pictures of the collectibles can often be included, whereas they cannot be so easily included in general magazines and newspapers, except at very great cost—if at all. Pictures and details tend to intrigue potential buyers and produce calls expressing interest.

The seller may have some assurance that the reader of his ad is not only familiar with the collectible being sold but perhaps more reliable than the person who scans the metropolitan newspapers, perhaps looking for a way to acquire a car (or whatever) without having to pay for it! Very often the ads in metropolitan newspapers pick up readers who haven't even a vague idea of what the thing offered for sale is—whether it is a Model 600 Mercedes-Benz or a portrait by George Romney.

In many ways the easiest kind of sale is that from one's home to the buyer, and such a sale can sometimes be accomplished via specialized magazines and newspapers. A sale via an auction house takes time and involves perhaps a 20 percent commission plus possible damage and other loss. A sale through a dealer may involve much time, a high commission to the dealer, and damage to the thing consigned to the dealer. If you can advertise a 2.9 Alfa Romeo roadster for sale and sell it out of the garage at your home, you have made a sale quickly, and you have been paid quickly, with no risk and no loss or damage. Things do not always go well in direct sales via advertisements, but they often do.

In direct sales via advertisements in specialized publications the buyer may well feel that he is not buying a "pig in a poke," particularly if the seller turns out to be substantial. I have answered ads for cars for sale. One seller was a well-known TV commentator. Another was the son of the director of engineering of the Chrysler Corporation. Another owned, at the time, Pepperidge Farm, the top-quality bakers.

Very often such advertisements are reprinted by other publications. Such a reprint of Ferrari cars resulted in the sale of my own Ferrari. This "reprint publication" would not have picked up my car for sale had it been consigned to a dealer for sale. There is no additional cost, of course, for this "pickup" advertising.

Art and Antiques

A simple piece of antique furniture like a Hitchcock chair can hardly be sold to a major American antique dealer like Israel Sack. A painting by a "follower of Thomas Gainsborough" cannot easily be sold to Wildenstein in New York. Nor are these collectibles readily salable through the major auction houses at any substantial price—if a house will take them at all.

These are two examples of items which might well be advertised for sale in newspapers and magazines. Such collectibles aren't expensive. They do not have to appeal to important collectors who are not likely to scan "Antiques and Art for Sale" in the *Daily Clarion*.

At the other extreme, a block-front, slant-top Massachusetts desk may well be sold to Israel Sack, and a full-length portrait of a lady by Thomas Gainsborough may well be sold to Wildenstein. The important art and antique firms buy important works—not the lesser things.

Still, these great collectibles are not naturals for advertisements in any newspaper or magazine, not even the specialist magazines in the areas of art and antiques.

If a person has a small Italian credenza of the seventeenth century for sale for, say, $175, he might well offer it by advertising in the local paper. Through such an ad in a Washington, D.C., newspaper I bought such a credenza for $175. It had been offered for sale by a homeowner in nearby Virginia, and the purchase was concluded quickly.

In the same Washington, D.C., newspaper very good semiantique china was located.

The New York Times has a small section devoted to private sales of art and antiques. It might be tried advantageously, particularly to reach buyers in the greater metropolitan New York area. It bears repeating that lesser art and antiques, rather than important items, might be advertised in this newspaper. The same rule would apply to other newspapers around the country—large city and smaller community newspapers. The Sunday *New York Times* has a large page full of advertising under the heading "Merchandise Offerings." Under "Antiques" are such items as "Boehm Birds," "Antique Maps," and "Antique Brass Beds." If the ad is for a large house sale in which antiques and art are included, the offering might draw in dealers prepared to buy a great deal. In general, this "Antiques for Sale" section is not very large and does not contain many items for sale.

For the simpler type of antique and painting, *Antique Monthly* has a fairly comprehensive section, "Classified Advertising." Under "Items for Sale" are small sections on:

Glass and China	Firearms, etc.
Furniture	Dolls and Toys
Books	Pewter, Brass, and Silver
Paintings and Prints	Miscellaneous

Under the last heading was an item (which I use for illustration) "Posters for Sale. 300 different pre-1946. My first list. Vaudeville, Advertising, War. $2.00. Box 12670, Seattle 98111."

Advertising copy is due by the first of the month and should be sent to Antique Monthly, P.O. Drawer 2, Tuscaloosa, Alabama 35402.

The advertising rates are 50 cents per word, with a $10 minimum charge for twenty words or less.

The American Collector has a large "For Sale Classified Ads" section. The address is P.O. Drawer C, Kermit, Texas 79745. Many categories of items for sale are included—collector plates, porcelain, pottery, Hummels, china, glass, lamps, furniture, silver, antique jewelry, miniatures, clocks, watches, brass, copper, pewter, prints, bottles, fruit jars, insulators, beer cans, western relics, barbed wire, Indian relics, gems and minerals, guns, pocketknives, military items, decorations, rare books, magazines, comics, catalogues, maps, autographs, documents, paper money, coins, tokens and medals, badges, advertising items, dolls, stamps, postcards, toys, musical instruments and music, and all kinds of items classified simply as "Miscellaneous."

Some of the items are of some importance and value, like Icart prints and forty-five different kinds of barbed wire for $15. Even General Göring's yacht is listed for sale for $870,000—not an inexpensive collectible!

The magazine *Antiques* has a small "Clearing House" of collectibles for sale. The rate is $1.20 per word with a $30 minimum charge per ad. The address to send advertising is 551 Fifth Avenue, New York, New York 10017.

Spinning Wheel Antiques and Crafts also has a "Selling" section in which ads are taken for 20 cents per word with no apparent minimum charge per advertisement. *Spinning Wheel* is published in Hanover, Pennsylvania 17331, by Everybody's Press.

The relatively new and very good magazine *Art and Antiques* has a very small section on items for sale—like antique jewelry, English china, century-old grand piano, etc. Rates are $1.20 per word, $30 minimum charge per ad. One should write to Trading Post, Art and Antiques, 1515 Broadway, New York, New York 10036. The firm advertises that it reaches 150,000 readers and will take a display advertisement for as little as $50.

Americana magazine is published every two months at 475 Park Avenue South, New York, New York 10016. It contains two pages of "The Americana Exchange Buy • Swap • Sell." The cost is $1.70 per word, and the magazine claims a readership of 1 million.

Practically no newspapers or magazines, either general or specialized, advertise privately owned paintings or other pictorial art for sale. Plenty of dealer-owned art is advertised, but rarely is privately owned art. What art is advertised is usually lower-priced and includes no important masters.

Art/World, a monthly newspaper published by Arts Review Inc., 1295 Madison Avenue, New York, New York 10028, does advertise some important art, but not a great deal of it. In the April–May 1980 issue,

under "Art/World Classifieds" there was advertised a Marino Marini painting, a drawing, and a sculpture. There was a significant early Italian painting advertised by the Master of San Miniato, circa 1450–60, a Madonna and Child. There was another ad for lithographs, etchings, and sculpture by Renoir, Toulouse-Lautrec, Picasso, Chagall, Dali, and Norman Rockwell. There were photographs by Stieglitz, Man Ray, Shahn, and Eakins. A classified line of thirty-six letter spaces costs $3 with a minimum price ad of $9.00.

Overall, the publications are probably not a natural for advertising art and antiques for sale and not for important and high-priced art and antiques. Other means of selling finer things are probably more effective.

For certain collectibles, advertising may well be the best and possibly the only practical means of selling. In fact, the old standby *The New York Times* may still be the best answer—not for all collectibles, but for some.

Collector Cars

In order to evaluate various methods of marketing collectibles, one first of all goes back to his own experience in selling. In selling Old Master paintings, our own answer was the major auctions—in London and in New York, beginning in 1973 and every year thereafter to 1979. In antiques, the answer was marketing through antique dealers. In automobiles the answer was *The New York Times*. The last three collector cars we sold were sold via this newspaper. The *Times* has a long tradition of offering exotic cars for sale, dating back at least to the 1920's, when it was customary to see advertised an Alfa Romeo collapsible coupe, which at the time meant, of course, a convertible. It was through such an advertisement in the late 1930's that this collector's first foreign classic car was bought: a 1928 Mercedes-Benz Model S convertible with body by Erdmann and Rossi. It was for sale by *the* Mercedes-Benz dealer in New York, Zumbach, and the negotiations for purchase were conducted by general manager Jacques Schaerly, an elegant gentleman with a fine twisted mustache.

The demonstration was conducted by the great Mercedes mechanic Werner Maeder, than whom there was no finer Mercedes mechanic in America. Mr. Maeder indicated, during the trial run, that he had driven the car in Central Park at 90 miles an hour, high though such a speed may seem, even today. The purchase was quickly concluded, thanks to the advertisement in *The New York Times,* and this writer fairly happily parted with his $350 to purchase this car.

When, in 1977, we sold our large house, which had ample garage space for classic cars, it was necessary to reduce our collection of classics.

All three cars were advertised in the "Imported and Sports Cars for Sale" part of the sports section of the Sunday *New York Times*. No other edition of the paper has seemed to produce results for us, and we have placed many such advertisements in the *Times* over a period of twenty-five years.

The ads were short, to the point, and inexpensive. A few ads resulted in the satisfactory sale of a 1967 Maserati Ghibli coupe, a 1960 Ferrari 250 GT convertible, and a 1960 Rolls-Royce Silver Cloud I with right drive and body by James Young. The last, being a limousine and large, sold the most slowly.

Certain oddball cars did not sell so well via *The New York Times*. One was a "Special," an Italian sports coupe, one of a kind, made in 1950 by a small Italian firm, Italmeccanica, and powered by a Cadillac engine. The car was a terrific performer for the era and had won a dozen auto show prizes for uniqueness of design, beauty, and excellence of condition and appearance. At the time it had a very limited appeal. It was advertised first by a leading dealer in New York over a period of months—in 1953—with no result—then by this writer directly. It was finally sold after having been offered over a period of about six months. No dealer who had taken it on consignment had been able to move it.

Another car, which was extensively advertised but was hard to sell, finally was sold after having been offered over a two-year period: a 1952 Bentley with right-hand drive coupe body by Graber of Switzerland. The trouble with offering this car in the early 1960's was that it was "old" and at the time neither antique nor new nor nearly new. It had right-hand drive, less desirable than a left-hand drive here in America. Finally, buyers did not understand the Graber body. It made the car look unlike a Bentley so that the owner didn't have the prestige of owning a Bentley. Anyway, what was more wanted was a Rolls-Royce, and there were many people at the time, strange as it may seem, who didn't know exactly what a Bentley was or who made it—including my excellent mechanic in Union Bridge, Maryland, who announced to me, after having put the car in excellent condition: "That's a pretty well-made car. Where did you say it came from—England?"

For a car owner selling, say, a Lamborghini Miura, a very fine and much sought-after classic car, one might simply advertise "Miura coupe, 1967, $26,000, call Stan Z, 532-2348," and nothing more. This is just about the length and description contained in the advertisement in *The New York Times* that I answered this year, and I bought the Miura from Stan Z, who turned out to be one of the leading magazine illustrators of the country—Stanislaw Zagorski.

For certain other collector cars explicit and detailed advertisements should be used. There are relatively many advertisements for Mercedes 450 SL's, which have been produced in sizable numbers from 1973

on. If one has a mint 1973 car, he should play up the fact that an eight-year-old car in mint condition is for sale, something like this:

Mercedes-Benz 450 SL convertible, 1973, with detachable hard top. Top metallic gray, body ruby red. Superb paint job just completed. Red leather interior in beautiful condition. Brand-new steel radials. Fiberglas soft top. New brakes, exhaust system. Chrome perfect and unmarked. 42,000 miles. Valves just ground and engine completely checked out with new points, plugs, etc. This car is one of several sports cars owned by a collector for five years—the second owner. Will deliver anywhere in the U.S. for expenses. Price $13,000. Call 401-555-4623 at any time.

This advertisement says several things:

1. The car is in top condition.
2. It is a relatively low-mileage car carefully taken care of by a longtime owner.
3. Everything that is not replaced has been carefully taken care of.
4. It sounds as though nothing mechanical remains to be done. The valves have been ground; that means the interior of the engine has been checked over.
5. The price is well within market, especially for a prime example.
6. There is no "Call 2:00 to 4:00 P.M. except Tues. and Thurs." or other limitations that turn off buyers.
7. "I will deliver anywhere just for my expenses." This means the owner has confidence that his car will make it without breaking down, that you, the buyer, don't have to risk breaking down on the road, and that you will get the car in perfect condition at no expense *to yourself* to go out to bring it back from wherever it is.
8. Since the owner has other cars, he obviously could afford to keep this car in good condition and had pride in his collection. He also didn't spend all his time driving the car to work and to the supermarket.

This car ad, of course, competes with such ads as: "Mercedes 450 SL, 1973, two tops, $13,000—Call after 5:00 P.M. weekdays—203-555-8938." The first ad gives the car a definite competitive advantage over the second car.

There are two sections of interest to the exotic car seller in *The New York Times*—"Antique and Classic Cars" and "Imported and Sports Cars." What is included in each section is somewhat flexible, and some advertisers place the same ad for the same car in both—to be sure it is seen. Both include many American cars of recent vintage like Corvettes.

The newspaper is read by potential car buyers all over the country. The Rolls-Royce we advertised in the *Times* was sold to a man from Pennsylvania. The Maserati was sold to one from New Jersey, and the Ferrari to a local buyer, although a dealer sent a man by plane armed with all cash from Chicago to see the car.

Over a period of almost forty years this writer has sold nearly 100 classic cars, almost every one by ads in *The New York Times.*

Local newspapers should by no means be ignored in advertising collector cars, particularly the less expensive cars. The *Washington Star,* the *Washington Post* and other major city newspapers that reach sophisticated car buyers should be tried. We have used such newspapers. They brought in lookers but did not result in any sales. A good rule might be: *Advertise in local newspapers the less expensive, less exotic cars and in the* Times *the more expensive exotics.* Of course, savvy buyers are always looking in the local papers to see whether someone in the city is offering an exotic locally. They also hope the local man in, say, Keokuk, does not know what the New York or Los Angeles market is—and these two cities are among the relatively few cities containing sophisticated buyers willing to pay a good price for a rare and fine exotic.

The New York Times' advertising rate for exotic cars changes from time to time. As of early 1981, these were some of the rates:

For advertising in a 50- to 75-mile radius of New York City the rate is $5.60 per line with a three-line minimum for the Sunday *Times*—$16.80 being the minimum cost of the ad. This is called the City Suburban rate. The same area for three days—Sunday, Wednesday, and Friday—is $35.52 for the three lines.

If one wants to advertise his car nationwide for just Sunday, he pays an additional $1.00 per line—$6.60 instead of $5.60 per line, with a three-line minimum of $19.80. For seven days nationally the rate for three lines is $83.46.

There are three local zones: (1) Long Island, New York, (2) Westchester and Connecticut, and (3) New Jersey. For just one of these zones the ad costs $2.05 per line for Sunday, and with a minimum of three lines Sunday, $6.15.

The New York number to call for placing various *Times* ads is 212-354-3900.

An effective, but not inexpensive, medium for advertising cars is the *Wall Street Journal,* published by Dow Jones & Co., Inc., 22 Cortlandt Street, New York, New York 10007. This newspaper, published every weekday, might very well produce good results for high-priced luxury cars that would appeal to its readers. The advertising rate in 1981 per line is $10.96 for one ad, and an ad of five lines may be taken for $54.80. Ads can be called in to the newspaper in New York at 212-285-5352. The best day to advertise seems to be Friday, the last day the paper is published before the weekend begins. Rates are for the eastern edition.

A unique medium for advertising automobiles is *Hemmings Motor News.* This magazine recently advertised on its cover "World's Largest

Antique, Vintage and Special-Interest Auto Marketplace—Paid Subscribers Over 199,000."

The publication appears each month and has apparently been published for twenty-seven years. It is no fly-by-night. The May 1980 issue, which sold for $2, had 527 pages, almost every page containing advertising. One page, chosen at random, contained forty-six explicit advertisements.

Advertising copy is sent to HMN Advertising, Box 380, Bennington, Vermont 05201. The space rate for nonsubscribers to the magazine is 25 cents per word with a minimum of ten words per advertisement. For subscribers the rate is 17 cents per word. Bold type costs $1 extra per ad.

For a display advertisement of one-sixteenth of a page with one illustration the cost is $32. The cost for a full page with eight photos is $490.

This magazine is used by advertisers of everything automotive from Mercedes-Benz 770 K tourers at $500,000 to Mustangs at $1,500, including all sorts of parts from almost everything to build a Mustang from the ground up to "Radiator Ladies" for Rolls-Royces.

It was apparently the main medium for advertising Rolls-Royce cars used by the Viceroy Carriage Company of London, which at one time sold as many as a dozen Rolls-Royce cars per week—many of them to the United States.

Here again, the more explicit the ad, the better, and still better, include a photo of the car. This writer bought a Maserati Ghibli from an ad in *Hemmings Motor News*. The car will be delivered by the dealer, Motor Classics of White Plains, New York, shortly.

If one is interested in neither buying nor selling, he might consider subscribing to the magazine for a year for $11.75. If he is simply interested in automobiles, he can keep the magazine on his bedside table and read it every night. In about a week of reading he might be able to review most of the material contained in one issue!

For postwar classics, particularly sports cars, *Road and Track* magazine is an old standby, and for years it has had an excellent "Market Place" with a number of cars for sale well illustrated. The advertising rate is $30 for a twenty-five word ad. Additional words cost 60 cents each word. If there is a picture in addition to the twenty-five words, the cost per ad is $60.

One of the issues of this magazine contained everything from a standard Bentley 1951 Mark VI sedan at $15,000 to a Cobra Daytona racing coupe, the 1965 world champion, for $140,000. There was advertised a 1933 Mercedes-Benz 380K convertible, an extremely rare car, and a 1979 Mazda RX-7, a very plentiful car. There were all sorts of custom cars. The address is Market Place, Road and Track, 1499 Monrovia Avenue, Newport Beach, California 92663.

Advertising in Newspapers and Magazines

The classic and antique car business does not lack magazines and newspapers for advertising cars of various kinds for sale. I will mention some of those that I feel are most effective in selling classic and antique cars.

Old Cars Weekly is a weekly newspaper. The address is 700 East State Street, Iola, Wisconsin 54945. The paper has a large classified section, with a circulation of 89,000, and rates are $1.99 for an ad of eleven to fifteen words. Photos are an additional $6.

Auto Week is a small newspaper which is very useful for advertising exotic cars. It is published at 740 Rush Street, Chicago, Illinois 60611. The rates are $20 for twenty-five words or less, one time.

Cars and Parts is a monthly magazine which can be reached at P.O. Box 482, Sidney, Ohio 45367. There are just under 200 pages, and the magazine is almost all "classified." The circulation is 120,000. The advertising rate is 14 cents per word, with $1 minimum ad.

Car Exchange magazine is a new monthly started in the last two years by Krause Publications, which publishes *Old Cars Weekly*, listed above. The circulation is 27,000 and is increasing. Advertising rates are 9 cents a word with a ten-word minimum per issue. Photos cost $8 additional.

Car and Driver, a monthly, seems to get results for the important exotic cars with a fairly high price tag, although it has only a small classified ad section. Most ads are contained on a one-page "Car and Driver Market Place." The rate is $1.60 per word, and a picture may be included for an additional $20. *Car and Driver* is at 1 Park Avenue, New York, New York 10016.

Motor Classic Corporation of White Plains, New York, runs a large advertising program for its sports and competition cars and sells everything from $14,000 Model A Ford roadsters to Cobra Daytonas at $175,000 and even some lesser-priced cars like mid-1970's Jaguar sedans at under $5,000. It reports its best results come from advertising in *The New York Times, Hemmings Motor News, Car and Driver, Auto Week,* and *Road and Track*. It likes the *Wall Street Journal* but points out that ads in that newspaper are expensive.

For strictly antique cars of all kinds and all prices, probably the best advertising medium is the *Bulb Horn,* the quarterly magazine which goes to members of the Veterans Motor Club of America. The circulation is about 5,000, but they include a large percentage of antique car enthusiasts and collectors. We are mentioning the *Bulb Horn* here in this section on advertising media, although it also belongs in the section on advertising in club bulletins and periodicals. It is the "mouthpiece" of the Veteran Motor Club of America. Classified ads of fifty words or less are free to members and $2 for nonmembers. There is a charge of $1 for each additional fifty words or part thereof. Photographs are $5 and copy is accepted for one issue only. Write to the *Bulb Horn* at 9 North

Rocky River Drive, Berea, Ohio 44017. Membership is now (as of 1981) $20 per year ($23 outside the United States). For membership application, write to 105 Elm Street, Andover, Massachusetts 01810.

Postage Stamps

A usual way to sell stamps is to a stamp dealer or through auction, through the specialized stamp auctions. Nevertheless, many stamps are advertised—and sold—via magazines.

Stamps is a weekly magazine put out by H. L. Lindquist Publications, Inc., 153 Waverly Place, New York, New York 10014. Each issue costs 50 cents. It has a circulation of 30,000. There is a fair-sized "Trading Post," and advertising rates are 75 cents per line, or fifty lines for $30.

Another good choice for an advertising medium for stamps is *Linn's Stamp News*, P.O. Box 29, Sidney, Ohio 45367. It is issued weekly and has a large circulation—82,000. There are about 95 pages in all, with about 19 pages of word ads—and small advertisements. The rate is $3.50 for a twenty-five-word ad in one issue.

Stamp Show News and Philatelic Review is put out by West Rock Show Associates, Inc., 1839 Palmer Avenue, Larchmont, New York 10538. The circulation of the magazine is 14,000. There are only three pages of word advertising per issue. The rate is $2 for twenty words and 10 cents for each additional word. A check or money order can be sent with the advertisement.

The Stamp Collector is issued every Saturday by van Dahl Publications, Inc., 520 East First Street (P.O. Box 10), Albany, Oregon 97321. There is a large "stamps for sale" section. The minimum size ad the publication will take costs $2.30, and for this sum up to twenty-five words can be submitted.

Stamp Trade International is issued twice a month. The circulation is about 8,000, and it contains approximately 55 pages. It is issued for *dealers*. There are only two or three pages of word advertisements. They cost 15 cents per word, and the minimum number of words must be forty. Three consecutive issues must be advertised in. Checks or money orders must be sent with the proposed ad. The address is the same as that for *Stamp Show News*.

Canadian Stamp News is a biweekly put out by McLaren Publications, Ltd., 1567 Sedlescomb Drive, Mississauga, Ontario L4X 1M5, Canada. The circulation is 13,000 for Canada and 3,000 for the United States. There are twelve pages of advertising, half of which are word advertising. One- to twenty-five-word ads cost $2.95 for one time. Checks or money orders must be sent with the ad.

The Sunday *New York Times* has about a page devoted to coins and stamps. The big dealers often advertise, and auctions are advertised.

A few individuals offer stamps for sale. In one ad 212 British Empire stamps were offered for sale for 50 cents. Many of the small ads are placed by dealers.

Coins

Coin World is a weekly available from Box 150, Sidney, Ohio 45367. The circulation is 110,000. The paper averages about 150 pages. The special August issue for the annual convention contains more than 200 pages. There are 22 pages of word ads and small classifieds such as those an individual seller would use. A twenty-five-word ad for one issue costs $2.92. As in many specialist newspapers and magazines, cash must be sent with the ad. A postal money order would no doubt be safer and as acceptable. Amos Press is the publisher.

The Canadian Coin News is put out by the same publishers as *Canadian Stamp News,* 1567 Sedlescomb Drive, Mississauga, Ontario L4X 1M5, Canada. There is a twelve-page classified section which can be removed from the newspaper, a biweekly. The Canadian circulation is 11,000, and in the United States the circulation is 2,000. An ad of twenty-five words costs $2.95 per issue. Payment by check or money order must be sent with the ad.

Coins, which is issued by Krause Publications, 700 East State Street, Iola, Wisconsin 54945, has a circulation of 120,000. Of the average 122-page format, there are usually between 6 and 8 pages of classified and display advertisements in this monthly magazine. Rates are one to ten words, $1.95 per issue, or $3.90 for twenty words.

Numismatic News is a weekly newspaper put out by the publisher of *Coins* magazine, Krause Publications, address above. Circulation for the newspaper is approximately 57,000, and the classified takes up about one-fourth of the fifty-page paper. The minimum advertisement is a one- to fifteen-word classified ad at $1.76.

World Coin News is a smaller weekly paper, with a circulation of about 12,000, also published by Krause Publications, address above. The minimum classified advertisement is $2.82 for one to twenty-five words.

Other Specialist Collectible Magazines and Newspapers

In many areas of collectibles there are magazines and newspapers for the collector, some surprisingly specialized. Many of these specialist collectible publications are listed in the comprehensive directory called *Ulrich's International Periodicals Directory,* eighteenth edition, 1979–1980, published by R. R. Bowker Company, 1180 Avenue of the Americas, New York, New York, 10036. This large directory is available in many libraries.

The directory lists periodicals and newsletters in the fields of art and hobbies, including coins and stamps, where there are many listings. A number of the subscription prices are now slightly higher than those listed in the directory, and a few of the firms are no longer in business we discovered when we called, but the list is very complete and helpful. There are listings from Americana to barbed wire and outboard motors (antique outboard motors). Among the many listings is an interesting bi-monthly publication on silver, called *Silver,* which includes advertising. The subscription to the magazine is $12 per year and the cost of placing an ad is 10 cents per word in light type and 15 cents per word in bold face type with a minimum of $2.50. The magazine has been in business since 1971 and their address is now P.O. Box 22217, Milwaukee, Oregon 97222. The circulation is about 3,500 and they have recently moved from Portland, Oregon offices.

One of the listings that intrigued us was that of the *International Barbed Wire Gazette,* a monthly magazine now costing $10 a year. It is published by Jack Glover of Sunset, Texas 76270. We tracked him down on the telephone and he told us that he has a circulation of about 1,500 now and subscribers all over the world (even a few on Fifth Avenue, New York). He told us that he wrote *The Barbed Wire Bible,* classifying the various types of barbed wire, illustrating them and numbering them, and that he had sold some 85,000 copies to date. The book, in its eighth edition, is $7.95. His magazine has been published since 1971 and he carries a "trends update" on the various types of barbed wire in every issue of his magazine. He does this by number (so you would need the book to follow trends). He lists the numbers and the current values. It is a small magazine, sixteen pages at the time of this writing, but the full page ad costs $90 and a half page costs $50. A quarter of a page is $30 and a one-inch line in the classified is $4.50. He takes advertising for some related things—not just wire—and mentioned that he had sold a number of boots through his magazine. He lists shows; and dealers sell and trade through his columns.

If you want to advertise in this unusual little magazine or buy *The Barbed Wire Bible,* just write to him at his publishing firm, called the Cow Puddle Press, in Sunset, Texas. He said that Sunset was a very small town of only a few hundred people and the postman sometimes spends half the day at his place. Barbed wire is getting to be a popular collectible. There are thousands of types. Rare types are becoming more expensive to collect, and, according to Jack Glover, there are a great number of collectors. As for the price trends, he said they were "up . . . way up." (If you have barbed wire to sell, this is a good place to advertise it for sale.)

9

The Donation of Appreciated Collectibles

Donating works of art to museums, educational institutions, and charitable institutions may be as advantageous financially as selling the work of art. This is illustrated by the story of the donation of a painting by the Renaissance artist Marco Palmezzano to a large eastern university. The painting was "Madonna and Child with Two Saints"—67 by 62¾ inches, on wood panel, and signed by the artist, who lived in Italy from 1459 to some time after the year 1543.

An elevator operator took the painting to the New York City restorer Francis Moro in 1966, with the instruction to sell it, if possible, for $1,000. There is no information on where the elevator operator got the painting. Moro sold the painting to this writer for $1,000.

In late 1972 the painting was donated to an eastern college museum. Two experts in New York, Herbert Roman and Herman Galka, valued the painting at somewhere between $45,000 and $50,000.

This writer on his Form 1040 income tax return valued the painting at the lower of these two figures—$45,000.

Donations reduce the adjusted gross income at the bottom of the first page of Form 1040 (the federal income tax form that everyone files every April 15). The limit allowed is 30 percent of adjusted gross income—with certain exceptions. In this donation to a college museum, a $150,000 adjusted gross income can be reduced by a maximum of 30 percent and 30 percent of $150,000 is $45,000. To find out how much income $45,000 will protect from taxation, you divide $45,000 by 30 percent and get $150,000.

To simplify, let us suppose that your adjusted gross income is the same as your taxable income. If you paid a federal income tax on $150,000 taxable income, your tax (for the latest year, 1980) would be $73,528 (for married taxpayers filing joint returns) and your tax rate then would amount to 64 percent on the top bracket,* assuming

*Beginning in January 1982, the maximum tax rate is reduced from 70 percent to 50 percent.

that the income was investment income, rather than salary or fee income.

If the $150,000 income was reduced by $45,000, the taxable income would be $105,000. The tax would be $44,948, which is $28,580 less than the tax on $150,000 taxable income—$73,528.

The painting might have been sold instead of donated. If the price achieved at, say, auction was $45,000, the auction house would have collected 10 percent from the seller and 10 percent from the buyer, amounting to 20 percent of the selling price, buyer's premium included. The seller would have netted $36,000, less the $1,000 the painting cost, which equals $35,000.

This $35,000 would have been a capital gain, and 40 percent of this gain would have been added to ordinary income on Form 1040—$14,000.

For the tax year we have been hypothesizing, the individual's income was $150,000, to which the $14,000 would be added. The tax rate on the $14,000 would be about 64 percent—$8,960.

So the $36,000 net from the auction house on the picture would have to be reduced by this tax of $8,960, leaving $27,040.

This $27,040 must be compared with the tax saving through donation—$28,580. It would have been better to donate than to sell—*in this case.*

This actual statement of how this donation worked has to make many assumptions. One must assume that the picture would bring the appraised value if it were sold at auction, or to a dealer, or through a dealer by being consigned to him. Gregory Martin, Old Master director of Christie's in London, estimated that the painting would have brought much more than $45,000 if sold at auction. François Heim, major Old Master dealer of Paris, valued the painting at a figure far above $45,000. But would the picture have brought more? And if so, how much more?

The Valuation Branch of the Internal Revenue Service reviewed the value of $45,000 and saw fit to reduce it to $10,000. The appellate staff of the IRS reviewed that valuation, raised the value back up to $45,000—and closed the case. Actually, fighting the Valuation Branch might have taken a good deal of time and cost a good deal of money in legal fees and in securing expert witnesses to appear at higher levels in the IRS and perhaps in court.

Of course, not everyone has an income of $150,000 to protect to the extent of $45,000. If one's income were $50,000, he could protect 30 percent of that income through the donation of the painting—$15,000, reducing taxable income to $50,000 less $15,000, or $35,000.

The painting was valued at $45,000, not $15,000, and the remaining $30,000 of valuation could be carried forward to subsequent years—five—until it was used up.

Charitable donations or contributions of appreciated property apply

no matter what one's adjusted gross income is. It can be $10,000, in which case a contribution of 30 percent, or $3,000, can be made to reduce income on Form 1040 to $7,000. The tax on a taxable income of $10,000 is $707 and on a taxable income of $7,000 is $228. Several years ago this writer discovered two Indian pictures, small ones, but authentically signed, by the western artist Edward Deming. He bought the pair at a sidewalk sale in Mamaroneck, New York, for $15. They would certainly value at $3,000 or some figure not far less and thus supply some tax saving for a $10,000-a-year wage earner.

To Whom to Donate

There are, in general, three categories of organizations to which donations of appreciated property may be made: museums; schools, colleges, and universities; charitable institutions.

The object or objects donated must be related to the function of the organization. If you donate a painting to a university that has no museum, and the university places the painting in a storeroom or in the office of a dean, that contribution might not be allowed as a donation of appreciated property at fair market value by the IRS. The painting should be used as a material part of class instruction in a school or placed in a museum for viewing. (If unrelated, the appreciation must be reduced.)

The institution to which the object has been given cannot say, "We need the money more than we do the painting, and we are going to sell it and use the cash as fast as we can." Such a contribution will likely not be treated as an income-deductible contribution at fair market value.

Obviously, in order to make a contribution for income tax benefits, the educational institution, museum, or charitable institution must want what you have to give and have use for it. You may, for instance, find it very hard to donate your American table to the American Wing of the Metropolitan Museum of Art. It has plenty of tables, some of them the finest examples of American antique tables. It will take only the very best.

A few years ago we donated to the St. Louis City Art Musem a small Egyptian mummy case. It had come from Cairo many years ago, was in excellent condition, with most of the original paint, and was authenticated by the Cairo Museum. The St. Louis Museum apparently had no such small Egyptian mummy case and was happy to receive it. As a matter of policy in giving, there is a good deal of merit in giving to smaller institutions, many of them outside major cities. For years we have donated Old Master paintings to the Carpenter Art Galleries of Dartmouth College, Hanover, New Hampshire. When we made our

first contribution, the museum was certainly not overburdened with donations of fine paintings. The more paintings the museum received and displayed, the more it got. Other donors got the idea and made their own contributions. Now the paintings have outrun the display space in the museum, and the college has received $3 million with which to build a large new art museum. This large museum will very likely secure more paintings and even painting collections.

You could approach your alma mater or secondary school and find out whether it would be interested in receiving something that you have and might part with. On the other hand, major museums have been known to make acquisitions from individuals. Even a major museum might be contacted by a potential donor to see if it might be interested in a fine Icart print or a fine Clichy glass paperweight or a mint-condition painted American table of the seventeenth century.

How to Value Your Contribution

Your valuations for things contributed to museums, educational institutions, and charitable organizations must be accurate as well as conservative, since the Valuation Branch of the Internal Revenue Service is "just waiting to cut your valuation."

The IRS puts out each year Publication 561, *Valuation of Donated Property,* which should be secured from your local IRS office and read carefully before anything is donated anywhere. These are the rules on giving.

What you must have determined for you is fair market value. IRS Publication 561 (revised November 1979) defines fair market value:

Fair market value does not ordinarily lend itself to fixed rules or formulas. It is determined by considering all the factors that reasonably bear on determining the price that would be agreed upon between a willing buyer and a willing seller, neither being under any compulsion to act and both having reasonable knowledge of the facts.

If a seller had a painting the artist of which he did not know, he might ask $1,000 for the painting. A potential buyer, a dealer, might instantly recognize that the painting was by Rembrandt and worth $500,000. If the dealer paid $1,000, the asking price, for the painting, that would certainly not be fair market value. The seller did not have reasonable knowledge of the facts.

Auction price of similar items, from silver to paintings to antique furniture, may be a guide to value, but perhaps not the best guide.

My *Antiques as an Investment* states on page 4:

For a piece of antique furniture, or a painting, or any item within the general overall category of art and antiques, market value or fair value is the price

that the usual kind of dealer who handles the particular item is likely to receive for it in the process of normal selling."

A bureau plat made by Bernard van Riesen Burgh II and sold by French and Company in New York in the normal course of business would be sold at what should be considered the fair market price. If, however, French and Company were anxious to cut its inventory, as when it moved to its new Madison Avenue quarters, the prices received could be expected to be very much under market—as they were in actuality.

On the other hand, if a Second Avenue, New York, shop should happen to run into a BVRB bureau plat, that shop could not be expected to secure the high price that French and Company could secure. If, in addition, the bureau plat cost the Second Avenue shop a good deal of money in relation to its capital (and it most certainly would), that shop might sell the piece for a quick but small profit.

The retail price is frequently higher than auction prices for the same quality painting [or other collectible].

Valuations of the object or objects you donate must be secured and must be by recognized experts familiar specifically with what is being given. If you are donating an autographed letter signed (A.L.S.) by George Washington, one of the best valuers you can get in this country, possibly in the world, is Charles Hamilton of New York City, author of many books on autographs and operator of the leading autograph auction firm in the country. Still, he may be limited in his qualifications for valuing rare postage stamps!

IRS Publication 561 (1979) states:

To identify and locate scholarly experts on unique, specialized items or collections, you may wish to use the current Official Museum Directory of the American Association of Museums. It has both a subject category and a geographic index.

The Encyclopedia of Associations, Gale Research Company, is another useful starting point, particularly section 5 which describes educational organizations. Section 6 describes cultural organizations, and section 13 describes over 450 national hobby and avocational organizations, including various highly specialized private collector groups. It also has an alphabetical and key word index. These books may be available in a state, city, college or museum library.

To help you locate a qualified appraiser for your donation, you may wish to ask an art historian at a nearby college or the director or curator of a local museum. The telephone company's consumer yellow pages for metropolitan areas often list specialized art and antique dealers, auctioneers and art appraisers. Associations of dealers may be contacted for guidance.

To find out some of these "associations of dealers," one must go back to an earlier IRS Publication 561, parts of which have been deleted in the later edition. The earlier listings, however, still hold true, and we are using the 1975 Publication 561. These are recommended associations of dealers:

The Art Dealers Association of America, Inc., 575 Madison Avenue, New York, New York 10022.

The National Antique and Art Dealers Association of America, Inc., 32 East 57th Street, New York, New York 10022.

The Antiquarian Book Sellers Association of America, Inc., Shop 2, Concourse 630 5th Avenue, New York, New York 10020.

National groups of appraisers are also cited:

The American Society of Appraisers, Dulles International Airport, P.O. Box 17265, Washington, D.C. 20041.

The Appraisers Association of America, 541 Lexington Avenue, New York, New York 10022 [now at 60 East 42nd Street, New York 10017].

The Internal Revenue Service cannot accord recognition to any appraiser or group of appraisers from the standpoint of unquestioned acceptance of their appraisals.

For art, the foremost appraisal group is the Art Dealers Association of America. In a recent, highly significant valuation case brought before the United States Court of Claims, the attorney for the U.S. Department of Justice, representing the Internal Revenue Service, stated on page 11 of his brief for the United States to the trial judge:

> Fortifying the worth of their opinions is the fact that both the persons have been selected by their colleagues to serve as president of the prestigious Art Dealers Association of America. The appraisal work done regularly by that organization on an anonymous basis provided them with vast additional relevant experience.

On page 38 of the same brief he stated:

> Certainly their participation in the Art Dealers Association of America, and the high offices held by them in that organization, cannot be regarded as reducing their independence or integrity. That organization . . . is intended to upgrade public confidence in the profession and to take customary pressures and influences off of individual dealers when making appraisals, e.g., for tax purposes.

This is the opinion of the U.S. government of the Art Dealers Association of America and its appraisals. It would seem clear that anyone contemplating donating a painting should secure the valuation of the association regardless of what other appraisals he might use.

The Art Dealers Association of America confines itself to giving appraisals for works of art "already actually donated or committed for donation," and it will not appraise works of art purchased less than two years before its appraisal is requested. Before you actually give any item, you should obtain someone's authoritative appraisal. If you have paid $300,000 for a picture and an expert says your picture is worth, for donation purposes, $25,000 or less, you might want to think

The Donation of Appreciated Collectibles

twice about donating it. This was the exact valuation of a painting purchased for $300,000 and donated to a museum of fine arts in Texas—quite a difference between cost and appraised value!

For Old Master paintings this writer has secured appraisals for many years on his donations to museums and educational institutions from two members of the Appraisers Association of America: Herbert Roman, vice-chairman for European art prior to 1900 on the Channel 13 Auction and former member of the Board of Directors of the Appraisers Association of America, 25 East 77th Street, New York, New York 10021; and Herman Galka, also a former board member of the Appraisers Association of America and a board member of the Art and Antique Dealers League of America as well as a member of the American Association of Museums. His address is 14 East 77th Street, New York, New York 10021. These two appraisers specialize in paintings all the way from Old Masters to contemporary. Mr. Galka appraises in other areas of collectibles as well.

The Art Dealers Association has members with appraisal knowledge in the fields of twentieth-century and contemporary American and European works of art, nineteenth-century works of art, Old Masters, drawings of all eras, etchings, lithographs, serigraphs, primitive art, sculpture, prints, photographs, pre-Columbian art, ancient art, illustrated books, print reference books, antique silver and porcelain, comic art and works by famous illustrators—among other things.

If the association feels qualified to make an appraisal, it will. Otherwise, it can refuse to do so.

The Activities and Membership Roster of the Art Dealers Association of America states:

> The Association has established what it believes to be the most competent, effective and independent service for the appraisal of paintings, drawings, sculpture, graphics and photographs which are being donated to non-profit institutions where an appraisal is necessary for income tax purposes. During the sixteen years of its existence, the Association has appraised over $350,000,000 of art objects. Inquiries concerning this appraisal service should be directed to the Association.

The association definitely does not do appraisals for anyone who submits his work of art for appraisal. It appraises only for specific purposes:

> The Art Dealers Association of America has an appraisal service which is generally limited to providing donors with evaluations on works of fine art being donated to museums or other non-profit institutions where such an evaluation is needed for income tax purposes. We *do not* otherwise appraise, authenticate or provide information with respect to market values either for insurance purposes or for the owner's general information.

The Activities Roster does state, however: "In exceptional situations, we also appraise fine art works in estates for estate tax purposes."

There are other limitations on the appraisal activities of the association: "Please note that our expertise as an Association is limited to the fine arts—paintings, drawings, graphics and sculpture in the Western tradition, and photographs. We *cannot,* for example, appraise such items as furniture, objets d'art, antiques, Oriental or primitive art."

I might add that individual members on occasion do appraise in these fields, even though the association does not. One of the most competent appraisals I have seen was that of a Boston collection of American antique silver made by the Graham Gallery of New York. In fact, it was the basis of a proposed purchase by a large Pittsburgh museum.

Cost of Appraisals

The Art Dealers Association of America is only one organization that will make appraisals, but an important one. Its appraisal fees, as of 1980, were as follows:

Appraised Value	Fee
Up to $2,000	$ 50
$2,001 to $4,999	100
$5,000 to $9,999	200
$10,000 to $24,999	350
$25,000 to $49,999	450
$50,000 to $74,999	600
$75,000 to $99,999	750

Other appraisers may charge anything, from so much per $1,000 of valuation to a flat fee.

The American Society of Appraisers has also been mentioned by the Internal Revenue Service as a source of appraisals. It has a mail address, as previously indicated, at Dulles International Airport, P.O. Box 17265, Washington, D.C. 20041. Its areas of expertise are:

Antiques
Fine Arts
Gems and jewelry
African sculpture
Rare books and manuscripts
Coins
Pre-Columbian art
Orientalia
Residential contents (overall, the contents of houses).

While there are about 5,000 members of the American Society of Appraisers, there are 300 appraisers of personal property (including the above categories of personal property). The organization does a big business in real property appraisals.

The 300 personal property appraisers are tested and certified. A member must have had at least two years of full-time appraisal experience before he is permitted to take the test and five years of full-time appraisal experience before he is permitted to take the senior examination, which is conducted by the International Board of Examination plus a member or members of the full-time staff of the society.

Most of the appraisers are not dealers, and no duality of interest is permitted. A selling or a buying dealer cannot appraise the thing sold or bought by him.

A list of the personal property appraisers will be sent without charge if you write to the above address in Washington, requesting it.

The member appraisers are not generalists. They specialize in particular areas, and examinations are prepared for each area. The correction of examinations is done by experts who do not know whose paper they are checking.

The appraisal fee is a fixed fee, not based on the value of the thing appraised. It may be so much "for the whole job" or so much per hour of appraisal time—like $50 per hour, more in the big cities, less in rural areas.

The Appraisers Association of America is located at 60 East 42nd Street, New York, New York, 10165. For $3 one can secure the membership roster, which contains more than 120 pages of geographical listings of members—by city and state—and a revised list is prepared every other year.

To qualify for membership in the association, one must have five years of working in the field as an appraiser and must submit copies of several appraisals. The Membership Committee, formed of members of the association, passes on each applicant.

Members have prepared valuations on art objects for this writer for almost twenty-five years. The association is essentially a fine arts appraisal organization. The fees are made by the individual members, not by the association. In the past, at least, the fees have been reasonable and not related to the value of the object appraised. Of course, each member establishes his own fees.

These are some of the members of the Appraisers Association of America:

Vojtech Blau, 800B Fifth Avenue, New York, New York 10021—rare Oriental and European rugs, tapestries, textiles.
David L. Dalva II, Dalva Brothers, Inc., 44 East 57th Street, New York, New York 10022—French eighteenth-century furniture, porcelain, and bronzes.

John C. Edelmann, 123 East 77th Street, New York, New York 10021—carpets, tapestries, textiles.

Wally Findlay, Wally Findlay Galleries, 814 North Michigan Avenue, Chicago, Illinois 60611—paintings, works of art.

Herman Galka, 14 East 77th Street, New York, New York 10021—fine arts, paintings, sculpture, silver, furniture.

Victor J. Hammer, Hammer Galleries, 51 East 57th Street, New York, New York 10022—Impressionist paintings, drawings and sculpture, Americana, and living contemporaries.

Alan Hartman, Rare Art, Inc., 978 Madison Avenue, New York, New York 10021—jades, porcelain and other Oriental arts, antique silver, European porcelain, enamels and furniture.

Kirk Alan Igler, Landrigan and Stair, 818 Madison Avenue, New York, New York 10021—European furniture, Oriental rugs and carpets.

Ralph M. Kovel, 22000 Shaker Boulevard, Shaker Heights, Ohio 44122—Americana, American and English furniture, glass, porcelain, silver and silverplate, bottles.

Edward J. Landrigan, 818 Madison Avenue, New York, New York 10021—precious stones, jewelry, objets d'art, antique cars.

John L. Marion, president, Sotheby Parke Bernet, 980 Madison Avenue, New York, New York 10021—paintings, works of art, furniture.

Louis J. Marion, 363 Central Park Avenue, Yonkers, New York 10704—fine arts, modern jewelry, modern paintings, personal property, rugs.

Edward P. O'Reilly and William H. O'Reilly, 402 East 79th Street, New York, New York 10021—former owners of Plaza Art Galleries—modern and contemporary works of art, furniture, oil paintings, jewelry, real estate, antiques.

Herbert Roman, 25 East 77th Street, New York, New York 10021—nineteenth-century American and European paintings.

Harold Sack, Israel Sack, Inc., 15 East 57th Street, New York, New York 10022—Americana, American furniture.

Patrick Silleck, Silleck and French, 373 Greenwich Avenue, Greenwich, Connecticut 06830—porcelains, Oriental objects, silver, English and American furniture and accessories.

Ira Spanierman, 50 East 78th Street, New York, New York 10021—American and European paintings.

David H. Stockwell, 3701 Kennett Pike, P.O. Box 3840, Wilmington, Delaware 19807. Americana, eighteenth- and early-nineteenth century American and Irish furniture, glass, Chinese export porcelains.

Benjamin Stack, Stack's, 123 West 57th Street, New York, New York 10019—rare coins, paper currency and medals.

Alistair John Stair, Landrigan and Stair, 818 Madison Avenue, New York, New York 10021—eighteenth- and early-nineteenth-century English furniture, English porcelain and glass.

John S. Walton, Box 307, Jewett City, Connecticut 06351—American antique furniture.

Spencer A. Samuels, 13 East 76th Street, New York, New York 10021—paintings, drawings, sculpture, fourteenth- to nineteenth-century antique furniture and tapestries.

The auction houses, both major and minor, also do appraisals. Sotheby Parke Bernet describes its appraisal service in this way:

> Appraisals may be done for insurance, estate, family division or other purposes (*excluding* gift tax).
>
> Appraisal fees vary according to circumstances. Flat rates will be quoted based upon time involved, total appraisal value, and costs of processing. Travel expenses are additional. Appraisals can be delivered within three weeks from the date of the appraisal visit.
>
> A partial rebate of our fee will be made on any property subsequently consigned to us for sale within a year of our appraisal. Further information may be obtained from Miss Marjorie Crodelle or Mr. Warren P. Weitman, Jr. (212-472-3452).

Simple letter appraisals can be secured for $150 plus expenses of travel if there are only a few items to appraise. If there are more items, there may be a minimum fee of $500, and the day rate may be $1,000.

Informal appraisals may be secured by your taking the item to the gallery to ask if it is interested in auctioning it. The Heirloom Discovery programs of both Sotheby Parke Bernet and Christie's result in informal verbal appraisals that cost nothing. They are conducted not at the gallery, but around the country. One might write to the gallery to find out when (and if) such a program is planned for Hanover, New Hampshire, or Wheeling, West Virginia, or wherever.

Christie's program and charges are comparable to SPB's. Each auction house has representatives in major cities throughout the country, which you might visit to find out the best way to secure appraisals.

In my own case I mail a black-and-white glossy print of the art I have for sale to London and ask the painting director what he thinks my painting might bring at auction, describing it in some detail. The answer comes back: "Perhaps $5,000–$7,000."

C. G. Sloan in Washington, D.C., charges $100 an hour for appraisal work plus $50 an hour for travel time, and we have given a good deal of business to Sloan in the way of appraisals in the past.

Other auction houses around the country also do appraisal work.

Christie's and Sotheby Parke Bernet personnel might appear on the witness stand in court if your valuations differed enough from those arrived at by the IRS for you to go to court to support your value. The cost of such expert testimony is not low, but the quality of the testimony is high, and the cost may be justified in the case of a very important donation of a painting or other work of art. We have worked with Messrs. Christopher Burge, head of paintings of Christie's, New York, and with Perry Rathbone, vice-president of Christie's, and their testimony has been tremendously effective!

What the IRS Emphasizes in Valuing Contributions

The first things the IRS states, under the heading "Paintings, Antiques, Other Objects of Art," are:

Your deduction should be supported by one or more written appraisals from qualified and reputable sources.

Not all appraisers are experts on all art. More weight may be afforded an appraisal prepared by an individual specializing in the type of art being appraised. A specialist in Impressionist paintings is not likely to be considered much of an expert appraiser on American antique silver.

The appraiser must be able to establish the authenticity of the donated art. [The first point raised by a representative of the IRS Appellate Staff in a recent dispute between a donor of a painting and the Valuation Branch was whether the artist could be determined with a high degree of certainty since the painting was about 450 years old. Fortunately, the painting was signed and published. (At that time the representative had before her the finding of a court in connection with another case where there was an unidentified Old Master painting.]

An important item in the valuation of antiques is physical condition. The appraisal report should contain at least the following:

1. A summary of the appraiser's qualifications to appraise the particular property.
2. A statement of the value and the appraiser's definition of the value he has obtained.
3. A full and complete description of the article to be valued.
4. The bases upon which the appraisal was made, including any restrictions, understandings, or covenants limiting the use or disposition of the property.
5. The date the property was valued.
6. The signature of the appraiser and the date the appraisal was made.

That is what a typical appraisal of an art object should include, outlined by the IRS:

1. A complete description of the object, indicating the size, the subject matter, the medium, the name of the artist, approximate date created, the interest . . . transferred. [How much is given to the museum, charitable institution, or educational organization—half this year and half next year, or what.]
2. The cost, date and manner of acquistion [if purchased within the past five years. Otherwise, the cost does not have to be included, and it might be wise *not* to state: "This painting was purchased by me at the Salvation Army secondhand shop ten years ago for $15. I think it is worth $5,000 today!" But if you paid a high price, mention it.]
3. A history of the item including proof of authenticity—such as a certificate of authenticity, and a table showing succession of ownership.
4. A photograph of a size and quality fully identifying the art object, preferably a 8″ by 10″ or larger print. [The print should be a black-and-white glossy. No snapshot will do, and a black-and-white is probably better than a color print,

The Donation of Appreciated Collectibles

although one might include both black-and-white and color if the colors were very impressive.]

5. A statement of the factors upon which the appraisal was based, such as:

a). Sales of other works by the same artist, particularly on or around the valuation date.

b). Quoted prices in dealers' catalogues of the artist's works or works of other artists of comparable stature.

c). The economic state of the art market at or around the time of valuation, particularly with respect to the specific property.

d). A record of any exhibitions at which the particular art object has been displayed. [It might be added that inclusion of the work of art in any authoritative books on the artist or sculptor or cabinetmaker is a big plus for the value of the object.]

e). A statement as to the standing of the artist in his profession and in the particular school or time period.

Watch That the Valuation Branch Does Not "Get You"

The Valuation Branch of the IRS is particularly concerned with "rigged valuations." It states:

> Sometimes, an appraisal will be given less weight if the appraiser is associated with either the donor or the charitable organization. While not the situation in most cases, appraisers who are associated—other than for making the instant appraisal—with either of the parties to the contribution have rendered appraisals that were essentially nothing more than shams devised to give color of legitimacy to grossly inflated valuation figures.

Still, after all these requirements and warnings have been set forth, it must be remembered that Congress has decided that it is in the interest of the country to encourage donations of appreciated property to educational and charitable institutions and to museums. In fact, the rules have been liberalized by Congress as well as by the IRS itself over the years. There is one provision that should be illustrated, and that is a special deduction of 50 percent of adjusted gross income, but only if the amount the object appreciated is reduced by 40 percent—that is, the amount of the appreciation must be reduced by 40 percent.

Let us go back to the painting that was valued at $45,000 and cost $1,000. The appreciation, which was $44,000, might have been reduced by 40 percent—by $17,600. To this reduced appreciation ($44,000 less $17,600, which equals $26,400) the donor can add the actual cost of $1,000, making $27,400 in all.

If, to simplify how this deduction works, we assume the donor's adjusted gross income is $54,800, it can be reduced by this figure—$27,400—making the adjusted gross income on Form 1040 $27,400. It has been reduced by 50 percent. It can also be used to reduce one's

adjusted gross income of $10,000 to $5,000, and the rest ($27,400 less $5,000, which equals $22,400) can be carried forward until it is used up and for a maximum of five subsequent years.

The donation must be related "to the purpose or function constituting the basis of the charitable organization's exemption."

Example. If a painting contributed to an educational institution is used by that organization for educational purposes by being placed in its library for display and study by art students, the use is not an unrelated use. But if the painting is sold and the proceeds used by the organization for educational purposes, the use is an unrelated use.*

If the use is an unrelated use, then, though the 30 percent limitation on the deduction from adjusted gross income is used, the appreciation must still be reduced by 40 percent, and in this case 30 percent is the maximum allowed.

In all the above calculations and examples we are talking about appreciated property that falls into the long-term, not short-term, capital gain category.

As this section was being written, a call came in from a restorer of an antique desk that had been bought for a few hundred dollars and seemed to be getting a reputation in Connecticut as "the million-dollar desk." Whether it is worth $1 million is problematic, but it seems clear that it is worth much more than the few hundred dollars that it cost. If it should be worth $100,000, the owner might well choose to reduce the capital gain of approximately $100,000 by 40 percent, making $60,000 deductible from his adjusted gross income. This $60,000 deduction would reduce an adjusted gross income of $120,000 to $60,000.

The income tax on a joint return of $120,000 is $53,900 *roughly.* The income tax on a joint return of $60,000 is $19,700—again roughly. The tax saving on this 50 percent of adjusted gross income deduction is $53,900 less $19,700, or $34,200. The higher the income from *investments,* which higher income is taxed at rates up to 70 percent, the more it pays to look into this alternative of the 50 percent deduction on which the appreciation is reduced by 40 percent.

You may deduct a contribution if it is made to, or for the use of, any of the following qualified organizations:

A state, a U.S. possession, a political subdivision of a state or possession, the United States, or the District of Columbia, if the contribution is made exclusively for public purposes;
A community chest, corporation, trust fund, or foundation. . . .
Examples of these types of organizations include:
Charitable nonprofit hospitals and medical research organizations;

* Publication 526, *Charitable Contributions* (under: *Gifts of Appreciated Property,* page 4).

Churches, synagogues, or other religious organizations;
Most educational organizations.*

Included also are war veterans' organizations, nonprofit fire companies, a civil defense organization, a domestic fraternal society, a nonprofit cemetery company. But "contributions to certain private nonoperating foundations, veterans' organizations, fraternal societies, and nonprofit cemetery companies, are limited to 20 percent of adjusted gross income. . . ." These organizations also do not qualify for the 50 percent deduction on which the capital gain is reduced by 40 percent. Finally, "You may not carry over gifts to which the 20 percent limitation applies." Thus, in this case, the five-year carry-over is out.

The Tax Advantage of a Donation is the Right of Any Taxpayer

The Valuation Branch *must* recognize your right to a tax reduction if you make a contribution to a college, school, charitable organization, or museum. IRS Publication 561 states in the very first paragraph of the introduction:

Our Federal Government recognizes that donations to religious, educational, charitable, scientific, and literary organizations have contributed significantly to the welfare of our nation; and the tax laws are designed to encourage such giving. You are entitled to take a charitable contribution deduction, subject to certain conditions and limitations, on your income tax return for genuine gifts, not loans or exchanges, of cash or property to qualified organizations. For property other than cash the amount of the deduction is the fair market value of the property, reduced in some cases by all or part of any increase in value over your acquisition cost or other basis. In all cases, the fair market value is the starting point for determining your allowable contribution deduction.

* Publication 526, *Charitable Contributions* (under: *Qualified Organizations,* page 1).

10

Contacting the Museum Market

The Paris art dealer M. Heim, with associates, discovered a painting by the eighteenth-century French master Fragonard. The purchase price was $5,000. Shortly after the purchase, it was sold to a museum for $1,250,000. At about the same time this painting was sold, the Italian industrialist Giorgio Geddes, on behalf of an associate, offered a painting by the Italian master Piero della Francesca for $1.5 million. He offered it to a number of American museums, but with no success. Finally, it was sold to a European museum—for over $2 million. The buying museum was the same in the case of both these paintings—the Louvre in Paris.

Selling to a museum sounds easy. Only it is not! When a sale is consummated, it can result in a very satisfactory profit. The trouble is that few sales to museums are actually made. Selling to museums is a very specialized kind of activity for any owner of a collectible, and the peculiarities of the museum market must be understood.

Very few museums have any acquistion budget at all, let alone a large acquistion budget. In America the museums with the ability to purchase works of art can almost be counted on one's fingers. They include:

The Metropolitan Museum of Art, New York
The Cleveland Museum of Art
The Chicago Art Institute
The Toledo Museum of Art
The J. Paul Getty Museum, Malibu, California
The Kimbell Art Museum, Fort Worth, Texas
The National Gallery of Art, Washington, D.C.

Museums tend to buy only the best. They are not in the market for even medium-grade Old Masters or Impressionists or American silver

or American furniture of the eighteenth century. Museums are up against the opinion of the board of trustees, the community, particularly its artistic intelligentsia, the newspapers and periodicals of the community, and the viewers. There are always those who will not hesitate to criticize museum acquisitions.

Museums also tend to pay the "best." One rarely looks at a museum acquistion and its price and concludes: "What a bargain that is!" The reaction is more often: "A good painting, but a very high price!"

Contacting the actual buyers is often hard. It is always best to go to the top—the director or the curator or, in a larger museum, the curator of paintings, of European paintings, or of sculpture. To contact the "lower downs" is useless in most cases. They will usually do little more than give you a courteous hearing—possibly—and then "file" the information on what you have for sale.

Selling to museums is often a long, drawn-out procedure that frequently amounts to no sale in the end, after months or years of negotiations.

For the average offer of works of art to museums the price may very well not be the "best price" for which museums are noted, but something very much less than the best. A museum offered to buy the great F. E. Church "Icebergs" that sold earlier this year, but the price offered was far under the $2.5 million the painting brought at auction. All sorts of appraisals are generally necessary, and it is often difficult and expensive to secure these.

The item offered must be *indisputably* in the "best" category. Its history must generally be known, and there must be no doubts cast on the fact that it is a genuine Fragonard or a piece of furniture made by Gostelowe, or whatever. A fine piece with a doubtful provenance will almost always *not* suit museums.

The condition must be the best. Museums do not want poor-condition items unless they are great pieces like a painting by Giotto or a sketch by Leonardo da Vinci.

Very often the museum may have no funds to buy but can raise the funds from those affiliated with it—trustees, members of the advisory council, etc. This collection procedure, of course, takes time, and each donor must be convinced that the item the museum wants to buy is deserving of his contribution.

The Positive Side of Selling to Museums

You can reach the museums through dealers. Major dealers, like the Newhouse Galleries in New York in the area of Old Masters or Israel Sack in the area of antique American furniture, can definitely reach the museum market. They can reach not only the museum market but

the key buying individuals. They can put in a call to the director of the Metropolitan Museum of Art and get him on the phone. For the ordinary individual having something to sell, such a high contact is extremely difficult to make.

If Clyde Newhouse calls the director and says, "I have a wonderful Rembrandt portrait that I think you might like to see, I would advise your taking a look at it as soon as possible, as there is a lot of interest in this painting," I would expect the director would ask to see the painting later the same day. I would also expect him to have with him for the viewing the curator of European paintings, the chief restorer, and some other functionaries.

As a matter of fact, this situation probably did take place a relatively short time ago, when a gallery did offer a Rembrandt portrait to the Metropolitan for $1.1 million. The Met turned the painting down. Shortly thereafter it was sold elsewhere—for $1.8 million.

The job of the seller of a prime collectible is to get a leading dealer to agree that the collectible is of museum quality and would appeal to a museum as a prospective buyer. The dealer is the "qualifier" and, in a sense, the sponsor of the work of art.

The dealer can open the door to the museum. If he, an important dealer, thinks the work of art is good, the museum officials are likely to think it is good, too—or at least *might* be good. In any event, the approval of the painting by the dealer will influence the museum officials in a positive way.

The dealer may simply say to the museum officials, "I have a Rembrandt that I think you should see. There is a lot of interest in it." On the other hand, he might say, "I have a Rembrandt that has just arrived. I have shown it to no one yet. I wanted you to see it first." This is a real play to the museum. All museums, and almost all buyers, want to be the first. They want fresh paintings and other fresh works of art. There is nothing more depressing to the price of any work of art than for it to have been offered around over a period of months or years.

In the course of the conference between the dealer and the museum officials, it may come out that the work of art is on consignment to the dealer. Many dealers, even the very best dealers, handle consigned works of art. If it is consigned, the seller may change his (or her) mind and it may be withdrawn from consignment to the dealer; this may present a certain urgency, so the museum might be induced to act on it fairly quickly.

Marshal your supports. In an important work of art one of the first questions the prospective buyer may ask is: "Who says it is a Titian?"

Mr. Newhouse might then say, "Morassi and Pallucchini both say

it is a Titian, and one of the best. In fact, Pallucchini has published it in his work on Titian and illustrated it on two full pages."

The dealer may even be able to help with the attribution of the work. We were once shown an unique medallion that appeared to be Egyptian. It was the property of a dealer who discovered it in a house in the country and identified it as a very early and unique Egyptian work, probably worth at least in the high five figures. This attribution job can often be done by the dealers themselves, and sometimes they recognize and attribute works of art almost instantly.

If the dealer will do the job, that's the way to do it. There is little question that working through a dealer is decidedly the best way to approach a museum. A woman living in Weston, Connecticut, brought a portrait of a female saint, presumably French, to the Bridgeport Museum to offer it for sale. The museum had no purchase funds and so referred the lady to me. She said she wanted $200 for the painting. I bought it. I would estimate that in the fifteen years that we have owned this painting its value has grown more than 100 times. It is a Simon Vouet and was shown in the University of Maryland's Vouet Exhibition several years ago.

When I bought this painting, I did not know it was by Vouet. After a little major study a dealer might well have identified it as a Vouet. He then might have offered it to a museum with which he had contact at a price considerably more than $200.

The dealer must be given a good percentage of the sales price to induce him to take on the job of selling it. In the case of the Rembrandt portrait referred to earlier the dealer wanted 10 percent of the selling price; it was not a high percentage, but it represented $100,000. The Getty Museum paid the art dealer, Julius Weitzner, nearly 10 percent of the purchase price of the great Titian that brought $4,065,000 several years ago—"The Death of Actaeon." This was good compensation to Mr. Weitzner for buying the painting and owning it for a few days. On a $200 painting the dealer would very likely want 50 percent of the selling price if he could get $2,000 for it instead of $200—a very reasonable percentage commission in this case.

Combination Sale and Contribution

A prominent Long Island art collector, himself a leading authority on Italian art, "sold and donated" a rare set of Italian prints to the Metropolitan Museum of Art. Before making this combination sale and donation, he secured competent appraisals of $100,000 on the prints. This value the museum agreed to.

He then transferred the prints to the Metropolitan for $80,000 cash plus a contribution of $20,000, the difference between the appraised

value of $100,000 and the $80,000 cash payment by the Met to him.

The advantage to the Met was that it bought the prints for $20,000 under the appraised value and was thus more inclined to buy them than had the price been $100,000.

The advantage to the collector was that he took a long-term capital gain on his sale for $80,000 cash, but he deducted $20,000 from his reported income on his tax return. Since he is almost without doubt in the 70 percent tax bracket, his final net financial gain for making the $20,000 donation was 70 percent of $20,000, or $14,000. Of course, the $80,000 cash income helped put him in the 70 percent tax bracket, but the cash addition to his income could not have been much over 28 percent of $80,000, if that, considering that the whole capital gain was $80,000; and of course, the prints had cost him something, even if he had purchased them thirty years or so earlier.

When the seller-donor's income tax was audited, the Internal Revenue Service's Valuation Branch promptly eliminated the $20,000 donation completely, saying that the prints were worth no more than they were sold for—$80,000.

The seller-donor pointed out that he had been offered $100,000 cash for the prints by the Chicago Art Institute, but he preferred to give $20,000 of the $100,000 value to the museum in his own city—the Met. The Appellate Staff of the IRS reversed the Valuation Branch and allowed the full $20,000 deduction.

In the case of the possible sale to the Metropolitan Museum of Art or the Chicago Art Institute, both these major museums could have afforded to buy the prints for $100,000 cash. Many other museums don't have $100,000 to spend for prints—or for anything else. There are, no doubt, museums that have $25,000 they might pay to acquire prints. Suppose that the prints many years ago cost the seller $10,000. If he sold them to the smaller and poorer museum for $25,000, he could still make a profit.

Now if his valuations from competent appraisers are $100,000, and his contribution is $100,000 less the $25,000 cash payment, the deduction on his income tax return is $75,000. If the IRS reduces his $75,000 contribution to $55,000, their valuation will be what it was in the case of the Long Island donor—$80,000. In many ways this is still a good deal for the donor—not as good as the Met deal, but good, nevertheless.

Any museum would like to buy *something,* and many museums have at least some purchase funds, so it might pay to bargain with the museum on cash-payment-plus-contribution based on a total value of $100,000. The museum might pay in cash $25,000 or $30,000 or $40,000, the difference between this cash price and the $100,000 being the contribution which is deductible from income on Form 1040.

We have been using as an example the prints actually sold to the Metropolitan Museum of Art for $80,000, the remainder, $20,000, being a contribution. The same principle applies whether one is talking about a set of Italian prints valued at $100,000 or a set of Icart prints valued at $2,000. A museum might very well be interested in acquiring some Icart prints if they were of fine quality—or some Art Deco furniture valued at, say, $3,000, or a Barye bronze valued at $4,000.

Among recent major acquisitions by a museum via part purchase and part donation were the five Gilbert Stuart portraits of five U.S. Presidents acquired by the National Gallery of Art in Washington, D.C. The price was, reportedly, in seven figures.

Major Works Often End Up in Museums

The Smithsonian and the Boston Museum of Art were the purchasers of the famous "Athenaeum portraits" of Martha and George Washington by Gilbert Stuart. From 1981 to 1983 they are to be exhibited in Washington, and from 1983 to 1986 in Boston. Orginially they were to have been purchased by the Smithsonian for the National Portrait Gallery in Washington. The final price, after much publicity, was reported to be just under $5 million.

Museums have been major purchasers—privately and at auction—of major works coming onto the market from Leonardo da Vinci's portrait of Ginevra di Benci for well over $5 million (National Gallery of Art) and Velasquez's portrait of Juan de Pareja for another over $5 million price (Metropolitan Museum of Art) to other major pictures such as the Titian "Death of Actaeon" (London's National Gallery) for more than $4 million and the Rubens "Samson and Delilah" for $5.4 million—one of the big 1980 auction prices.

See What the Museums Are Actively Seeking

Theodore Rousseau, curator of paintings of the Metropolitan Museum of Art in New York, used to visit art galleries in Europe regularly (no doubt in the United States as well). He would make a mental note of paintings these galleries had for sale that he thought would make suitable works for his museum. He would indicate to the gallery owners that he would like someone to buy this or that painting and donate it to the Metropolitan Museum of Art.

We once visited the Bond Street firm of Partridge in London, where we saw a fine half-length portrait by Thomas Gainsborough. The gallery manager told us that Mr. Rousseau would very much like someone to buy the painting and give it to the Met.

No doubt Mr. Rousseau's plan worked, at least at times, and he

did get good works of art donated to the Met. This would, of course, be a contribution to a museum, not a sale.

Arthur Blumenthal, curator of art of Dartmouth College Museum, earlier this year showed us a photo of a Renaissance painting in the stock of a London dealer and asked us to look at the painting if we were in London because the college was thinking of purchasing it. The price was about $25,000. We asked him if Dartmouth had enough in its acquisition budget to buy the painting, and Mr. Blumenthal replied that it had.

Now if we had looked at the painting and recommended that Dartmouth go ahead with the purchase, obviously no one would have made a sale to the Dartmouth Museum but the London dealer. Of course, we might have approved the purchase by Dartmouth and then asked the London gallery for a commission of up to 20 percent of the purchase price; many dealers will give such a commission if a deal is promoted in this way. We think that taking such a commission would be entirely unethical.

Although the painting in London was good, we did not feel it was an excellent purchase for the museum. We had in our collection at one time a Jacopo del Sellaio painting of much the same period—also an Italian painting. It was a far better painting than the London painting. From Mr. Blumenthal we could have found out what paintings Dartmouth wanted to buy and then tried to sell it one of ours. As a matter of fact, Dartmouth has about twenty paintings from our collection, but all of these were donated by us, and no money changed hands. Mr. Blumenthal did, however, express an interest in one of our eighteenth-century British portraits, and no doubt, we could have done a combination sale and contribution with this painting. (Actually we gave it to the college museum shortly thereafter.)

We were in the Leger Galleries on New Bond Street, London, looking over the paintings for sale in the mid-1970's. A very large and beautiful flower picture was hanging. Upon closely looking at this painting, our companion on the trip, George Delacorte, who has made many donations to the Metropolitan Museum of Art in New York (as well as to the City of New York), immediately sent a telegram to Curator Rousseau of the Metropolitan asking Mr. Rousseau whether he would like Mr. Delacorte to buy the flower painting and donate it to the Met. Mr. Rousseau was out of New York at the time and did not reply, so the Met did not get this fine painting.

The Cheekwood Fine Arts Center in Nashville, Tennessee, several years ago got the novel idea of having the major painting dealers from New York bring down to Nashville some of their American paintings and display them. A big banquet was given, and prospective donors to the museum were invited to the dinner and the display of paint-

ings. These donors bought a large number of the paintings on display.

The objective of the museum was not to have these paintings bought and donated right away, but to have the donors hold them for several years until they appreciated in value. I gave two talks at the banquet and meeting with charts, showing how the American paintings had risen, in price in the past several years and indicating what their future price appreciation might be. My estimates of future price increases were actually under what actually took place.

Had a number of these paintings been held by purchasers, they could have been donated five years later at as much as five times their purchase price. Or they might have been sold to the Cheekwood Museum at their actual cost, and the appreciation taken by the donors as a contribution.

A Paris dealer in Old Masters, Pardo, a few years ago, had for sale for $25,000 a splendid painting, a Renaissance portrait, not by one of the greatest artists of the period, but a very good (and known) artist of the period. He also had for sale for $12,000 a very fine drawing of villas on the Brenta River by the great eighteenth-century Italian canal painter Francesco Guardi.

When we visited the Pardo Galleries the next year, we found the portrait had been sold and the price of the Guardi drawing was $16,000, not $12,000. When we pointed out to Mr. Pardo that he had offered the drawing to us for $12,000, he reluctantly agreed to lower his price to that amount—but only to us because we knew what the price had been the year before.

A short time later the Italian portrait came up at auction in London, where it brought far more than $25,000. The drawing is now worth a very minimum of $25,000 and probably more. It is a fine, attractive, and unquestioned Guardi drawing.

Had these two works of art been purchased and held for just two years, they might easily have been sold to museums for their exact purchase prices—$25,000 and $12,000 respectively. The difference between the purchase price and the fair value, as attested by competent appraisers, could have been taken by the donor as an income deduction on his Form 1040. The sale would have been at a bargain price, one that a museum might afford and at the same time feel was a good deal for it. The bargain sale would have got all the money outlay back to the donor, and he would still have the tax advantage of his contribution.

Museums Want Quality Art and Antiques to Round Out Their Collections

All museums want to add to their collections. Sometimes they simply want to increase their present collections of Old Masters or American

antique furniture or antique silver. Sometimes they want to expand into areas in which they are weak or not represented in their collections at all—like Victorian, Art Nouveau or Art Deco furniture, or Gallé and other glass made in Nancy, France.

Sometimes they want to upgrade their collections. The Minneapolis Museum more than a decade ago got rid of many Old Master paintings, plus a number of unique items like a Renaissance bed, in order to have funds to buy other things like Postimpressionist paintings. While it got rid of some things in order to secure funds to buy other things, it strengthened itself where it was weak. Other museums add the best examples of an artist when the examples they have may not be of the finest quality. About a decade ago the Metropolitan Museum of Art bought one of the finest Renoirs ever on the market, for a price just over $1.5 million. The museum was very much criticized for this "expensive purchase." In retrospect, it was not an expensive purchase, as Renoir prices have exceeded $1.5 million. At the time, however, the price was not low. If you have an item that is of quality and one that the museum "is short on," a direct advantageous sale may be possible.

On the other hand, 99.99 percent of the collectibles that owners would like to sell are not salable to museums. They are not unique, and they are not of museum quality, not even of small-museum quality. We have sold just one item to a museum, a unique large signed panel painting by Simone da Cusighe, to the Belluno Museum in Italy. The painting is where it belongs—in an Italian museum. Such a painting will probably never again come onto the market, not that it is a Giotto or a Raphael, but it is still unique.

Even in the case of this Italian painting, which almost any Italian museum might like to own, there had to be a very qualified seller. The seller in this case was Christie's Old Master director in London, Gregory Martin, who sold it directly to the Belluno Museum.

Museums—Where They Are, What They Contain, and What They Want

There is probably no museum anywhere that would not like to have something to add to its collection. While some things can be purchased by some museums, some must be given to other museums because they do not have acquisition funds. Although museums want the best, they sometimes have to settle for less than the best, particularly the smaller, less well-endowed museums. However, even the large and important museums have "study collections," which generally contain items that they do not choose to put on display to the public. In this group might be some worn early American silver, a painting by a member of the school of Leonardo da Vinci, a once fine antique tea set with some

chips and cracks, an American Chippendale highboy with replaced legs. Such items are useful for instruction purposes because they can be examined close up and handled if necessary.

There are many museums in the United States (and in the world) and there are two useful directories of museums to help one locate museums and at the same time determine the nature of their collections and interests.

The Directory of World Museums, edited by Kenneth Hudson and Ann Nicholls (New York: Columbia University Press, 1975), has a classified listing of museums as well as an index of outstanding specialized collections of various kinds.

Museums of the World (New York: R. R. Bowker Company, and Munich: Verlag Dokumentation, 1975) is a directory of 17,500 museums located in 150 countries. It includes a subject index.

11

Preparing the Collectible for Market

There is an old saying in the real estate business: "You won't make a profit on your property simply because your name is Robinson." That means, in order to resell your property at a profit, you usually have to do something to it—that is, unless you want to hold it for a long time.

The same goes for collectibles of all kinds. Something has to be done, in some manner, to resell at a profit—perhaps not very much, but *something*.

Getting Ready for the Market

In late 1977 a former helicopter pilot, Umberto Melina of New York City, visited a small auction in New York. Included in the particular sale was a medium-size painting. The painting had no frame, but it did have a hole. It was not the most prepossessing-looking painting, and the auctioneer couldn't get even one bid on it. He sold it to Mr. Melina for $50. The painting was signed by Heinrich Bürkel, a Munich painter of the nineteenth century, but this name didn't seem to affect the willingness of buyers to bid on it. Mr. Melina, who occasionally buys and sells paintings and some other works of art, had the hole in the painting repaired, had the picture cleaned, and ordered a nice frame made for it. The job of restoration and framing wasn't very difficult or costly since the painting measured only 20 by 24 inches.

The cleaning and restoration brought out the picture well. There was a barn and a mountainous landscape with some livestock and a few little figures. The colors were pleasant, although muted, and the signature proved to be genuine. The picture was in excellent condition, other than the small hole, which was repaired well, and the work was typical of the artist, who has enjoyed a revival of popularity in Germany.

Mr. Melina was now ready to resell his painting. He took it to

Preparing the Collectible for Market 151

The Umberto Melinas purchased this painting for $50 at a Manhattan auction in 1977 and after cleaning, restoration and proper identification, the Heinrich Bürkel landscape brought $35,200 at Christie's. They owned it about two months.

Christie's in New York. It turned out that the painting was a known Bürkel, and while Bürkel was not one of the great masters of all time, he was a competent and pleasing artist. The Christie's sale in New York City on October 25, 1977, included Mr. Melina's painting. It brought $35,200. It is reproduced in color on page 89 of Christie's annual volume *Review of the Season 1978* and carries the title "Forge in the Bavarian Alps."

What Mr. Melina did was recognize a painting for sale in a small auction that had some value on the international art market, and he had learned that Bürkel had this value by visiting art auction sales all the time. When he placed the repaired cleaned painting in a major auction of nineteenth-century European paintings, it drew buyers from the Continent who knew the artist and his general world market value.

True, Mr. Melina has the knowledge of and an eye for paintings. He knows the important name artists, and he has an eye for what is quality. These abilities are developed, and it did not take Mr. Melina very long after terminating his career as a helicopter pilot to move into a new kind of business.

This buy-sell operation of Mr. Melina's is nothing new for him. He does it all the time. We know. We have been acquainted with him for many years, and he has been kind enough to tell us some of the things he does to make good investments—and realize on them—in the art and collectible field.

Mr. Melina owned this painting for fewer than sixty days—from the time he bought it until the time he sold it. He rarely owns any work of art for longer than sixty days. In fact, many of his "investments" he owns for forty-five days or even less before reselling them.

Mr. Melina told us this story on the evening of the big Christie's Henry Ford sale of May 13, 1980. When he finished, he started on another story for us. He said, "But I haven't told you about the Max Liebermann I sold for $42,000." We asked what he had paid for it. He replied, "Essentially nothing." Then the auction began, and we never got the whole story. But the Liebermann story is simply "more of the same," and we have the feeling that Mr. Melina's annual income from these little buying and selling activities runs about the same as the salary of the president of IBM—perhaps a little more!

Identifying Your Art

The first step in getting your work of art ready for market is to learn what it is you have—if possible. We have received hundreds of letters from would-be sellers of art which start out in about the same way: "I have an old painting of cattle in a field that I inherited from my grand-

mother who was born and raised in Des Moines. Could you tell me what it is worth and how I should go about selling it?"

If there is no further identification of the painting than this, its value is problematic—and is probably very little. The question is where to sell it, because there is little market for a painting of cattle by an unknown artist.

Most art collectors are familiar with a few schools of art, perhaps only one school of art and perhaps a limited number of artists in that particular school of art. My wife and I know certain of the artists of Renaissance Italy. A number of years ago a painting restorer in New York, had a painting for sale that one of his clients had brought to him in the hope that the restorer could sell it for him for $1,000. It was a painting of St. Jerome in the Wilderness on a panel about 10 by 12 inches. It was, to us, Italian Renaissance, but we did not know the artist.

We then went to the Frick Art Reference Library in New York and got out all the books on Italian Renaissance art by the great authority and writer in the field Bernard Berenson. After going through page after page of illustrations of various Renaissance paintings, we felt that the painting *might be* by Lorenzo Costa.

Our next step was to get out the photograph file from the Frick Art Reference Library on Costa. The hand of the artist Lorenzo Costa seemed to be the same hand that had done our painting.

Next, we had a *professional* 8-by-10-inch glossy photograph print made of the painting by a specialist art photographer. We sent the print to the Old Master director of Christie's, London, Gregory Martin. He wrote back to us, "Yes, I think your painting is by Lorenzo Costa, and we will be glad to sell it for you at auction."

To make a long story short, Christie's sold the painting for us for $12,000!

This was a fairly difficult painting to identify as to artist. Many paintings that owners would like to identify and perhaps sell are easier to identify, the Heinrich Bürkel that Mr. Melina bought at a small auction in New York for $50, for instance. That painting was signed, as are many paintings that people have in their homes or have purchased with an eye to investment.

Many libraries have directories of artists, and these directories should be consulted as part of the task of identifying artists' signatures. One leading director is: Thieme and Becker, *Künstler Lexikon.** The first edition was published in 1907 and it continued in print until 1950. It was reprinted in 1964. This is a most comprehensive listing of virtually

* Thieme, Ulrich, and Becker, Felix. *Allgemeines Lexikon der bildenden Künstler von der Antike bis zur Gengenwart.* Germany: Leipzig, Seemann, 1907–1950, (37 volumes).

all of the known nineteenth century and earlier artists, and there are some additions of later artists. Backgrounds to the artists are given. Many museums have this directory in their libraries, and no art library should be without all thirty-seven volumes.

The other major source is: William Bryan, *Dictionary of Painters and Engravers* (New York: Macmillan and Company, 1903–1904). This is the same type of alphabetical listing as Thieme-Becker. It is in five volumes. The fourth edition (1903–1904) mentioned above, was an enlarged edition, in five volumes. It was reprinted and published by Kennikat Press, Inc., Port Washington, New York, in 1964. The fourth edition was copied exactly by offset printing process. A few sets are still available at $149.50, and the books are usually found in art libraries. The dictionary was first published in 1816 and other editions date: 1849, 1876, 1884 and 1948–1955. Two other directories are Hans Vollmer, *Kuenstler Lexikon des Zwanzigsten Jahrhunderts* ("Artists' Directory of the Twentieth Century," Leipzig: E. A. Seemann Verlag, six volumes), and *Cyclopedia of Painters and Paintings,* edited by John Denison Champlin, Jr. (New York: Empire Book Company, Charles Scribner's Sons, 1913), four volumes. It was first published in 1885, then in 1886, and 1887.

A comprehensive and up-to-date directory of artists that many libraries now have is: E. Benezit. *Dictionnaire des Peintres, Sculpteures, Dessinateurs et Graveurs.* (Dictionary of Painters, Sculptors, Designers [Drawings] and Engravers.) Paris: Librarie Gründ, 1976. This is the new edition, in ten volumes, which includes American artists. Previous editions were dated: 1911–1923 and 1948–1955. This dictionary includes facsimile signatures, biographies, dates, museums which have the works, and also some prices over the years, including auction prices.

Another up-to-date directory, not always available in libraries, of seventeenth-century through nineteenth-century artists (including some from the early 1900's) is the revised edition of Mantle Fielding's *Dictionary of American Painters, Sculptors and Engravers.* It was published by Modern Books and Crafts, Inc., Greens Farms, Connecticut, in 1974, and adds names to the original 1926 publication.

There is a directory of recent American artists and others in the field of art (dealers, etc.), in the publication: *Who's Who in American Art.* There have been updated editions, the latest being the 1980 edition published in New York by R. R. Bowker Company.

Getting the Painting in Shape to Show

Unless he is an expert painting restorer, nobody should be permitted to touch any painting for the purpose of improving it in any way. A nonexpert should hardly even remove a painting from its frame or remove the glass if any covers it. Accidents are too easy.

Theoretically an old painting can be cleaned with a mild cleaner like Weber's cleaning fluid, except that even mild cleaners have been known to remove the dark paint in seventeenth-century Dutch paintings. The older the painting, the harder the paint becomes and the more impervious to cleaners—but not in the case of the black backgrounds in two paintings owned by this writer that were severely damaged by inexpert painting restorers. A signature was even inadvertently removed from a column in a seventeenth-century Dutch painting of a church interior by Dirck van Deelen and Jacob de Wet. The de Wet signature, a genuine signature, came off completely, as did much of the black background.

It is also inadvisable to have art students try to clean or restore paintings no matter how long they have studied art.

In an antique sale at the 34th Street Armory Exhibition and Sale in New York City in 1967 a rather dull painting of a platter of fish painted on a wood panel was offered for sale as an "old painting—eighteenth century" by an antique dealer. The asking price was $150.

After some bargaining this writer bought the painting for $125. It was in good condition, but he had it cleaned by a painting restorer in McLean, Virginia, for about $25. The colors brightened considerably.

There was a peculiar monogram on the picture, but not even one letter could be deciphered.

It seemed that the painting might have been seventeenth-century—not eighteenth-century: Walter Bernt's *Die Niederländischen Maler des 17. Jahrhunderts* ("Dutch Painters of the Seventeenth Century") was consulted. This is a directory of many of the artists of that country of origin and period in history, with illustrations of their work. After much page turning, there at last appeared an artist whose work seemed to be the same as that in the painting just purchased. Better still, there was a monogram of his signature—exactly like the one in the picture. The painting was undoubtedly by the seventeenth-century Dutch artist Pieter de Putter.

The picture was auctioned six years later in December 1973 at Sotheby Parke Bernet in New York. It brought $2,400.

There is a directory for almost every school of art, and there is some dealer or art expert who can help you identify the painting you have.

Of course, one might well start out by bringing the work to an art dealer located in the same city and asking him, "What do you think this picture is?" and go on from there to secure an authentic identification if it is possible. Some artists were never prominent enough for them to have lived on and acquired much of a market value, but many did become prominent and have acquired value. The trick is to find such

paintings or other works of art, if one can, identify them, and then determine their value.

In 1966 a very fine painting of Hagar and the Angel by Jacopo Vignali was purchased by this writer from the prestigious painting and antique dealer French and Company, located in New York. The price was $3,200. The painting was signed and typical of the artist. It was dull and badly in need of cleaning. Still, the figures in the painting were sharp, and it was obvious that cleaning would bring out the richness of the colors.

It was determined that this Old Master was certainly of high enough quality to sell at auction in London in 1974. The best Old Masters at the time sold best in London—and probably still do. Christie's was the auction firm decided upon.

The important thing about getting this painting ready for market was that it was decided *not* to clean it. London Old Master dealers seem to prefer uncleaned Old Masters—if they can see the general quality and condition of the painting.

In 1974 Christie's sold this painting for $21,000. It went to the important London dealer Colnaghi and Company, and recently it was placed on display at the Royal Academy. Such was its quality!

Getting Antiques Ready for Market

The president of the Women's Club of a city in West Virginia bought a simple Victorian drop-leaf table. The only trouble with the table was that one of the leaves was missing. The president had a cabinetmaker make a leaf for it. This work could not have been inexpensive.

As an investment the making of the leaf could hardly have been justified. In original condition, at that time, the table was worth at most $250. With one replaced leaf its value was problematic.

Some antiques (using the broad definition of an antique as anything over 100 years old) are not worth restoring if one buys and restores in order to make money on his antique.

To start out, you must be sure of what you have. To have real value, the antique must be of the period in which it is supposed to have been made. A Louis XV piece must have been made somewhere in the period from 1725 to 1775. English Regency furniture was made from about 1795 to 1830. Duncan Phyfe American furniture was made between 1790 and 1847.

Take the piece of furniture to an antique dealer, as a starting point, if you do not know exactly what it is that you have. If it turns out to be French, then take it to a dealer in French antiques. If it is American, then take it to a dealer in American antiques.

In many cases you may be stopped right there. The piece may not

Preparing the Collectible for Market

be an antique at all, but simply a reproduction, in which event it has no value *as an antique*. All auction houses, large and small, will help you identify your antique and determine its authenticity.

All antiques need extremely competent restoration in order to be marketed effectively. If a leg is off, it is hard to sell the antique anywhere. A few years ago the Plaza Art Galleries in New York offered an eighteenth-century Italian settee for sale. Two legs were broken off but were tied to the settee. When the settee was brought onto the sales platform, it was placed on a dolly. One side of the settee was higher than the other, and the two legs were obviously broken off. The auctioneer announced that they had the legs. Still, so forlorn-looking was the settee that people in the audience of buyers laughed. It sold for $100—and the lot included another very good Venetian eighteenth-century settee, an Aubusson carpet in fair condition, and two stools, one French Directoire, the other Victorian. Had this settee and the other things in the lot been restored properly, the entire lot should have sold for $1,000 or more.

Another Italian settee was sold at auction at about the same time. It was certainly of no better design than either of the settees in the $100 lot sold at Plaza. It had a broken leg; only this leg had been skillfully put back. Sotheby Parke Bernet sold this one for $950.

We are sure of all our facts here—prices and exact condition. We bought all these things ourselves!

The Garbisch Collection of furniture and paintings was an absolutely top-notch collection. There was one French piece with a large section of veneer gone. Had the piece been carefully restored, the price it brought at auction might well have been higher.

There is a wide variety of charges among restorers. One restorer will charge $50 for a job another will charge $300 for. Shopping around must be done, and it is often wise to ask antique dealers where they have their restoration done. They must have this work done expertly, but at a reasonable figure, so that they can resell their antiques at a profit. The markup of the dealer cannot be absorbed by the restorer.

As far as the finish goes, it should simply not be dingy-looking. A light polish is all that is required, not even that if the surface is reasonably good in appearance.

If one has a top-quality Queen Anne armchair or a pair of superb Chippendale chairs, it makes no difference what the upholstery looks like. Some of the finest American antiques are placed for sale without any upholstery whatever. This kind of display is for the benefit of expert collectors and dealers so they can see the construction and the condition and that it is antique. They couldn't care less about upholstery.

For anything less than top-quality antique pieces, the upholstery should not only be there but be acceptable—and not necessarily more

than acceptable. It is easier to sell a piece to a dealer if it is upholstered. It is easier for him to sell it to most buyers if it is respectably upholstered. The same is true for the auction. Women buyers like upholstery that is attractive, not torn, and clean. They seem to shy away from torn and dingily upholstered furniture of any kind, and women buy a good deal of antique furniture from dealers and at auction.

Very often antiques are sold, particularly at auction, with the finest satin upholstery, some by such fine makers as Scalamandré. This writer bought a magnificent settee covered with green and gray Scalamandré silk of antique design that at the time cost about $75 a yard. Still, the richness of the upholstery did not seem to help the price much.

One can buy fine synthetic fabrics from cut-rate houses and take these to middle-grade upholsterers, but not necessarily to the best upholsterers. In all probability the buyer, if a woman, will want to make her own selection of upholstery.

Upholstering is by no means inexpensive, and if one can get a chair upholstered, including synthetic fabric, for $125, and a settee for $400, he is doing well.

At many auctions of antiques, the upholstery is torn apart by dealers inspecting the piece. The theory is that if the fabric is torn away, revealing a genuine antique, the price will be higher than had the dealers not been permitted to tear away the fabric. If the dealers are not allowed to tear away the fabric and to examine the frame under the upholstery they are not going to take a chance at the auction that the piece is genuine. Before buying, a reputable antique dealer will want to remove the fabric for an inspection, but he will have his own upholsterer put it back in place after the examination. This is Israel Sack's standard procedure when examining antiques for possible purchase.

Take pictures of all sides of your antique before consigning it to dealer or auction house, and have a clear understanding that if the piece does not sell at the reserve price, the auction house or dealer will restore the fabric to its condition when consigned. This agreement should be in writing and signed.

Getting Silver Ready

When silver bullion hit $50 an ounce, there seemed little reason to restore any damaged pieces. Melting down was the name of the game, and even high-priced Greenwich, Connecticut, dealers took items off their shelves and sold them for scrap. Not so anymore with the drastic price cutback.

Whatever the piece of silver—American antique, Georgian, modern—it must be restored prior to sale because a dented teapot, a teapot

with a hole in it, or a tray with a broken foot is severely penalized in both the dealer and auction market.

It is important to realize that while damaged silver does not sell well, it costs relatively little to restore silver in a very competent manner. When one restores valuable paintings or antiques, the restorer must be the very best, and such a restorer is sometimes hard to locate.

This is not quite the case in silver. There are many competent restorers of silver, and many of them charge relatively little for their work, certainly little in comparison with the value of a fine piece of silver and with what restoration does for salability in the auction room or to a dealer.

In New York, silver restorers located in the area of the jewelry and silver center (Forth-seventh Street between Fifth and Sixth avenues) are generally competent. They have to be to suit the silver dealers in that area. These are some restorers-repairers in that area:

Restore-All Silversmiths, 47 West 47th Street, New York, New York.
Silver Repairs, 45 West 47th Street, New York, New York.
Jean's Silversmiths, 16 West 45th Street, New York, New York.
Keystone Silver Company, 1050 Second Avenue, New York, New York.
Thome Silversmiths, Inc., 328 East 59th Street, New York, New York.

As in the case of furniture restorers, one can ask silver dealers located in any city or town where they go to get the best repairs done on their silver. While it is possible to recommend silver repair shops, it is a dangerous thing to recommend painting and furniture restorers. These latter vary too much in quality of work done and in price, and the job of restoring and repairing silver is apparently less difficult, while the cost is rarely very great.

If one is interested in securing identification of exactly what his piece of silver is, together with its possible market value, he might visit one of these silver dealers located in New York City:

S. J. Shrubsole, 104 East 57th Street.
James Robinson, Inc., 15 East 57th Street.
S. Wyler, Inc., 713 Madison Avenue.

These dealers specialize in the finest antique silver and rarely handle ordinary "sterling." They can, of course, identify for you any antique silver that you have, as can the major auction houses.

A piece of Georgian or the more important American pieces of silver can often be positively identified according to when they were made, the city of origin, and often the maker. Hallmarks enable the collector in many cases to identify exactly what he has.

These are some guidebooks to identifying English (Georgian) silver:

Bradbury, Frederick. *Guide to Marks of Origin on British and Irish Silver Plate.* Sheffield England: J. W. Northend, Ltd., first published in 1927 and there is a 1978 edition available in convenient size for collectors at leading silver dealers in London and New York. In New York it is priced at $12.50. It covers silver and also Sheffield plate. Bradbury also wrote *History of Old Sheffield Plate*, published in 1912.

Jackson, Sir Charles James. *English Goldsmiths and Their Marks.* London: Macmillan and Co., Ltd., 1921. This is a 747-page book containing more than 13,000 identifying marks and covering silver as well as gold. It was reprinted in 1964 by Dover Publications, Inc., New York, and is usually available in major libraries.

Chaffers, William. *Hallmarks on Gold and Silver Plate.* London: Reeves and Turner, 1896. A 302-page book, available at some libraries.

Wyler, Seymour B. *The Book of Old Silver.* New York: Crown Publishers, 1937. The book, which contains 401 pages with the index, has been constantly in print. The 1981 edition sells for $11.95 and is available at S. Wyler, Inc., 713 Madison Avenue, New York 10021.

Banister, Judith. *Old English Silver.* New York: G. P. Putnam's Sons, 1965. Her books on silver are recommended.

To assist in the identification of American silver, these books would be helpful:

Currier, E. M. *Marks of Early American Silversmiths.* Portland, Maine: The Southworth-Anthoensen Press, 1938. There is a 1970 edition published by Robert Alan Green, Harrison, New York. This book is usually available in libraries.

Buhler, Kathryn C. and Graham Hood. *American Silver in the Yale University Art Gallery.* New Haven, Connecticut: Yale University Press, 1970.

Fales, Martha Gandy. *Early American Silver for the Cautious Collector.* New York: Funk & Wagnalls, 1970.

Graham, James, Jr. *Early American Silver Marks.* New York, 1936.

Ensko, Stephen. *American Silversmiths and Their Marks.* New York: Southworth Press, 1927.

French, Hollis. *A List of Early American Silversmiths and Their Marks.* Massachusetts: The Walpole Society, 1917.

Thorn, C. Jordan. *Handbook of American Silver and Pewter Marks.* New York: Tudor Publishers, 1949.

A piece of antique silver—American, Georgian, or Continental—is something very special and usually very valuable. Trays, salvers, and waiters often have cracks that must be soldered with silver solder. Teapots, coffeepots, creamers, slop bowls, sugars, sauceboats, and other pieces of holloware often are punctured, and sometimes pieces of the metal are even missing. To put in a new piece is extremely difficult and is not for a strictly commercial restoring and repairing firm in the jewelry and silver center of New York or any other major American city. Antique silver has a different color from modern silver, and it must be matched exactly in the repair job. Piecing in is also very difficult,

and if one breathes on such repairs, the breath moisture often clearly indicates the exact outlines of the patch or pieced-in piece. An expert silver restorer can produce a piece of repaired silver that passes even the breath test. Cousins, a silver and jewelry firm in Canterbury, England, and Pye and Company, also in Canterbury, can secure expert repairs on silver, the like of which I have never seen in this country.

Very often a silver restorer is asked to piece in a fine hallmark on a much more recent and less illustrious piece to give it more value, work he can often do with great expertise. If he is caught doing such work in England, there are criminal penalties.

Silver coins should never be touched—for polishing or for anything else. Fine silver, on the other hand, should be cleaned and polished with a mild (not scratchy) cleaner made only for that purpose. No piece of silver that is not clean and polished should be offered for sale anywhere.

Coins and Stamps

Art, antiques, and silver often require restoration and repair by experts, and if restoration is required, it must be done in the most competent manner and may cost a great deal. A great, but small, Flemish primitive painting was expertly restored some years ago by the leading restorer of this type of painting. The cost was a reported $35,000!

At the other end of the restoration spectrum are coins and stamps. The correct attitude toward restoring coins is simply stated by this author in "Investments You Can Live with and Enjoy," *U.S. News & World Report*, 1976: "In connection with condition, the would-be collector should be warned never to clean a coin. Cleaning not only lessens value; it can destroy value. Any dealer who sees that a coin has been cleaned with anything stronger than a little soap and water will generally refuse to purchase it."

So do nothing to a coin, no matter what it looks like!

The same holds true for stamps. It used to be a standard procedure for a collector to bring home his purchases, carefully affix gummed hinges to them, and stick them in a stamp album. Now it is not recommended procedure even to affix a hinge to the back of a stamp. In a way, this damages the original glue on the stamp, and the damage can be detected under the magnifier so that value is decreased in some cases.

Andrew Levitt, president of Sotheby Parke Bernet's Stamp Auction Company, told us in an interview what might be done to prepare stamps to sell:

"Put the stamps in order by country—U.S., Canadian, etc.

"Put the stamps as much as possible in chronological order by date.

They should be presented in a sequence so that one can look at them and not have to shuffle through masses of stamps.

"Often they are already in stamp albums—properly packaged. If they are not in albums, then use stock cards with pockets. These are cardboard cards about the size of a piece of typing paper. The pockets allow the top of the stamp to be seen.

"Placing hinges on the stamp lessens value. Cleaning may not lessen value and might actually increase the value slightly—if done professionally; but replacing the glue can be detected with proper instruments, as can cleaning.

"It is best to give the stamps untouched to the auction house or dealer.

"As for value, get at least two opinions from reputable stamp dealers or auctioneers—members of the Stamp Dealers Association."

Classic and Antique Automobiles

A "cream puff" has always been a great treasure to automobile dealers. A 1967 Cadillac Eldorado in average condition sells for $1,200 at most (mid-1981), and many such cars sell for as little as $750. A dealer might pay $400 to $500 for such a car in average condition, if he bought it at all. But offer him a 1967 Eldorado with 5,000 miles on it and in condition equal to the low mileage—and see what he will offer you! It is likely to be far more than any $1,200.

A Rolls-Royce firm in New York had three of the same model Rolls-Royce Silver Cloud II standard sedans of about the year 1960 for sale. Two were in *average* condition—not bad—for $12,500 and $15,500 respectively. The first had right-hand drive (used in England). The second had left-hand drive, the preferred drive in the United States. The third Cloud II was in mint condition in every respect, and even with right-hand drive its price was $45,000—maybe above market, but far in excess of the price of either of the other Cloud II's in average condition.

Some automobiles can be sold in average condition and at fairly good prices. But some average-condition cars are very difficult to sell, the most notable such car being Rolls-Royce.

A "fair"-condition Rolls-Royce Silver Cloud II was offered by its owner to a dealer in the Washington, D.C., vicinity. It had just had $4,200 spent on the mechanics and was in good mechanical condition. The dealer offered the owner $1,500 to $2,000 for the car!

The owner finally sold the car privately for $7,000. The average price at the time for a good-condition Rolls-Royce Silver Cloud II with right-hand drive in this country was $12,000 to $13,000. This was under the price of a mint-condition car which might have had a market price at the time of up to $18,000.

The $7,000 car was then (1978) restored very nearly as much as it is possible to restore a car (with the exception of taking off the body, taking out the engine, and starting to rebuild from the chassis up). The amount of money put into the restoration was $15,700, making a total investment of $22,700, a sum far over the 1978 market, but just a little more than the 1980 market, which had risen. Too much had been spent getting this car ready for market, and there was little or no room for any profit in the whole transaction.

In some ways this is an illustration of going overboard on restoration of a classic car. It is also demonstrates how fantastically the cost of restoration has risen in the past ten years—far in excess of any inflation that has taken place in the same decade.

Let's take another example of "getting your car ready to sell," this restoration in many ways at the opposite end of the cost curve. In late 1977 Rodney Bostian, who did the above Rolls-Royce restoration, was offered an automobile by an owner living not far from his small town in Maryland. The car, a 1966 Ford Mustang convertible, was not a junker, but it was not far above that level. The bumpers were corroded beyond restoration. The paint was in frightful condition. The body was dented and rusted in places. The tires were worn out, as were the brakes and many other things. The upholstery and carpets were in need of much repair and some actual replacement. The only two things good about the car were a fairly new (replaced) six-cylinder engine, with 16,000 miles on it, and a new top.

Mr. Bostian removed all the paint and went to work replacing all rusted body metal. He replaced the bumpers. He put in new brakes and a new exhaust system. He added wide oval tires for a superb ride and fine appearance. The upholstery was repaired, and new carpets were installed.

He then offered the car for sale—at a profit to himself, of course. It was sold—to this writer—for $1,600, in early 1978.

Immediately offers were received on this car wherever it was driven. It wasn't even offered for sale, but people came up and tried to buy it. The paint job was about a $200 job, but it was done so well that it looked as though it had cost twice that figure at least.

The car was run for two years, with almost no repairs of any kind. In early 1980 an offer was received from our building superintendent in Stamford, Connecticut, for $3,500 cash—more than twice its cost, even with all repairs over two years added to the cost.

Rules for Getting Your Classic or Antique Car Ready for Sale

Remember, today restoration can cost you a sum truly out of this world, like the labor cost for installing leather in a Rolls-Royce sedan—just

the labor cost—of $5,350. Labor can cost as much as $60 an hour on a Rolls-Royce or other exotic. A Rolls-Royce paint job can cost $6,000 or more, particularly if there is body work to be done. I know. I just paid it! Chrome work can be $125 for a center bumper and $65 for each small side bumper—if you can find a chrome plater to do the work at all in any reasonable period. It took more than one year to get some chrome work done on my Rolls-Royce.

The *appearance* of the car is critical. There must be no dents. The paint must be excellent. The chrome must be nearly perfect. Rust cannot be tolerated anywhere. The top must be perfect. Upholstery must be very good—not necessarily perfect, particularly if it is original leather. Carpeting must be excellent. The head liner must be good.

There must be nothing *seriously* wrong mechanically. The transmission must be in good condition. The differential must be quiet. The engine must have no costly noises, like a knock, and the engine should be absolutely clean and even painted if the painted parts are worn. Engine cleaning and painting cost little and add immeasurably to the impression the car makes.

You must know the market, and total costs cannot be over the market, or you are very likely to lose money on your car. Try to be in a position to offer your car under the market. Then it may well sell. Otherwise, you may be stuck with it for a long time—while you are advertising it *and advertising it* for sale.

The car should be as original as possible. The exhaust system on a Mercedes classic—a high-priced classic—should be genuine Mercedes. This is a *general* rule.

There are places to economize if the parts problem costs so much to rectify that you have to price your car way above the market. A few years ago a Maserati dealer stated that he had the rear muffler (resonator) and tailpipes for my Ghibli coupe, but the price was $475. This was too much, and I replaced the entire system with Midas at about $125. If the buyer didn't like the Midas system, he could put on a Maserati system with little trouble, but the Midas system did the job. In London the Viceroy Carriage Company, which buys and sells Rolls-Royces, told me that it always replaced exhaust systems, buying not from Midas but from a firm supplying Midas—to get the systems a little cheaper!

For almost every important foreign car there are suppliers that can give genuine parts at less money than many dealers sell them for. The Maserati parts man in upstate New York asked why I wanted an air-conditioning compressor from him when Ford used the identical compressor and sold it at about half the price! Lamborghini in certain places on the car (some lights on some models) used Fiat 850 parts, the Fiat 850 being one of the lowest-priced cars built in recent years in Italy. Why not get the same part at a fraction of the price Lamborghini charges?

For almost every exotic classic car make there is a club of enthusiasts.

There are dozens of such specialist car clubs (see Chapter 7), and the members are often aware of just where expensive and hard-to-find parts are available at reasonable prices.

There are repairers, and there are repairers. A minor tune-up on a Rolls-Royce Silver Cloud I can cost well over $200 in New York. A Greenwich, Connecticut, Rolls-Royce mechanic, Paul Longo, charged $14.50 for such a minor tune-up—and even had the car road-tested prior to delivering it.

A paint job, stripping to the metal, can easily cost $2,500 and more—very much more—for the classic Mercedes-Benz cabriolet or convertible. A superb job is done on every car brought to Sal Maranello, Maranello Collision, 297 Warren Street, Brooklyn, New York 11201. The same complete job was quoted by Mr. Maranello at $1,700 maximum. Since this firm paints for the finest Rolls-Royce dealer in New York, its work speaks for itself. Painting a Rolls sedan, however, would cost possibly $3,500.

For less costly work—both mechanical and body—one might visit Bay Lincoln Mercury, Inc., 6502 Fifth Avenue, Brooklyn, New York 11220. Its work is of excellent quality as demonstrated on an Eldorado Cadillac convertible in need of body and paint repairs. The work was extremely inexpensive and expertly done.

There may be used parts for a fraction of the cost new. The cost of a hubcap (wheel cover) about a year ago for a Rolls-Royce Silver Cloud was $275 from England. Bob's Auto Parts, Route 9W, Saugerties Road, Kingston, New York 12401, supplied the identical part (new) for $190. If this sum was too much, he supplied an excellent used wheel cover for $125, including a $30 trim ring thrown in at no extra cost. Bob's boasts the largest stock of used foreign car parts in the East. Since he has twenty-four acres of cars for parts on one side of the road and five acres across the road, we can believe it. We spent several hours going through this yard and even found an obscure make of car manufactured in Israel!

Hemmings Motor News, Box 256, Bennington, Vermont 05201 (twelve monthly issues for $11.75), lists suppliers of new and used parts for everything from antique Rolls-Royce cars to Mustangs, many prices being on the low side.

The appearance of certain cars must be *mint* to be able to secure a good price. A Rolls-Royce must *always* be mint in appearance—its buyers demand the very best. The restoration job must be for things that obviously make a vast difference, particularly in appearance. The wood in a Rolls-Royce must always be excellent, while the servo brake mechanism does not always have to work perfectly. Buyers of such cars know that they can get the servo mechanism overhauled easily and cheaply.

In certain cars perfection of condition is not paramount. An SSK

Mercedes-Benz in poor condition will sell immediately—and at a good price. Rare cars, like a four-cylinder Rolls-Royce, will bring a high price even in junkyard condition. So will a Mercer Raceabout junker. Their very high value, when put in good condition, allows for restoration costs. In perfect condition, however, these cars command premium prices.

Carpets and Rugs

If one happens to be fortunate enough to be the owner of, say, a Mughal prayer rug woven in northern India in the seventeenth century, and he proposes to offer this rug for sale, absolutely nothing should be done to it in advance of showing it to a major rug dealer or auction house. One such rare and beautiful rug, about 5 by 3 feet, is illustrated on page 106 of the Smithsonian Institution's publication *Oriental Rugs*, 1979.*

The color illustration occupies a full page in the book. It is obvious that some of the rug's colors have faded. The lights are very uneven. Something has happened to the deep red border on the left side of the rug; it has turned a very light red. The border has several colors—not all original. On the left there seems to be extensive reweaving that does not match the rest of the border. The rug also appears to have been folded the long way and shows the fold mark. There are a few spots on the lights.

What should be done to get this rug ready to market? Nothing! A seventeenth-century rug of this quality is a great rarity, and such imperfections as have been pointed out are to be expected. In fact, they are fewer than to be expected in a seventeenth-century rug, and any rug dating back 300 years is a museum piece.

The market for this rug is a museum, a major dealer, or an auction which will draw in the greatest rug collectors, because despite the surface appearance, such a rug has intrinsic quality and rarity.

From such a rarity we can generalize about how much to repair carpets and rugs of less antiquity and quality. As a general rule, rugs and carpets of collector quality that will bring, say, $5,000 and up should have nothing done to them. They and their condition must speak for themselves to knowledgeable buyers—and most purchasers of the fine Oriental carpets and rugs are highly knowledgeable.

The question is what to do about those Oriental rugs and carpets that sell for under $5,000 and the many that sell for a few thousand dollars or even less than $1,000.

* *The Smithsonian Illustrated Library of Antiques,* prepared by the Cooper-Hewitt Museum, 2 East 91st Street, New York, N.Y. 10028. (*"Oriental Rugs"* by Walter B. Denny is one volume in the series.) General Editor: Brenda Gilchrist.

Preparing the Collectible for Market 167

Generally, expert repairs pay for themselves and *do little more* than pay for themselves. The major New York City dealer Vojtech Blau feels that if a rug worth $1,000 has $500 spent on it in repairs, it may bring a maximum of $1,500, which is no more than $1,000 without the expenditure of $500 for repairs. He also points out that a first-class rug restorer may well charge you, the rug owner, $500 for the repair work, but the dealer, being a professional who gets many rugs restored over the period of a year, could get the same quality restoration job done for $150 to $200. "If you want the rug or carpet for your own use," Mr. Blau says, "then by all means have it repaired. Never let a tear go. It will only get bigger, and if a small tear is repaired, the pile easily covers the repair work."

Before selling the rug and before having any repairs undertaken, you should get two opinions on the value of the rug. Rug dealers who are members of the Art and Antique Dealers League of America or the National Antique and Art Dealers Association of America can be visited for this purpose. If the rug is worth little, it may not pay even to have it cleaned. If it is a great rarity, it should be in *original condition*, so that repairs and restorations may not be justified.

For the in-between carpets and rugs, these repairs and refurbishings may be justified:

Cleaning only by a specialist carpet and rug cleaning firm, and only where absolutely necessary.
New fringe on the outside.
Repair of holes and tears.
Recoloring where required—for aesthetic purposes.
Flat stitching on a worn spot.
New pile where there is a spot—to bring the pile to the level of the pile of the rest of the rug or carpet (this job must certainly be performed by an expert restorer).

If the carpet or rug is to be consigned to a dealer or auction house for sale and it is not a "treasure," it must be in presentable condition or a good deal of the potential market—the buyers for home furnishing and decoration—will be cut off. A small place in the middle of a large carpet where the pile is gone entirely can completely eliminate this large "home" market.

Strange as it may seem, Vojtech Blau does not favor selling to or through dealers, as a general rule, unless one has a very fine and very valuable carpet. If the dealer makes an offer, the seller is often sure it is too low. For that reason two appraisals of value and condition are recommended, as indicated.

If a rug or carpet is sold at auction, Mr. Blau feels, competition will likely result in a good price. For the past year there have not been

"dealer combinations" that buy together in order to eliminate competition and thus force down auction prices.

All auction galleries sell carpets, and one auction specializes in rugs and carpets, at least in the East: John C. Edelmann Galleries, Inc., 123 East 77th Street, New York, New York. 10021.

Repairing Porcelain and Offering It for Sale

For undamaged porcelain there is nothing to do in order to offer it for sale except perhaps wash it with soap and water so that it is not dirty. Most porcelain is not antique, but a number of pieces are, and it might be best to show these suspected antique pieces to one of the major auction houses for positive identification. Most antique pieces are marked, and a brief description of these marks is contained in this writer's "Investments You Can Live with and Enjoy," *U.S. News & World Report.*

Probably the best place to market porcelain is through auction. There is an advantage in marketing broken pieces of porcelain through auction. The auction houses prefer to see the exact condition of the porcelain even though the pieces are simply tied onto the main body when you bring it in.

Porcelain cannot, however, be marketed with broken pieces tied to the main part of the piece or missing, unless it is a fine Ming piece of a Kändler figure produced by the Meissen factory, for instance.

The pieces that have been broken off will at least have to be glued back on, but here one must be cautious. Permanent glue cannot be used since when the piece is put back on with this glue, the broken piece cannot be removed for expert repairing, and "homemade repairs" cannot be accomplished on porcelain that has any substantial value. The restoration must be done by experts. The owner of the piece can go so far as to glue the broken member temporarily with soluble glue that can later be dissolved.

There are two types of repair for fine porcelain—good repairs and excellent repairs—and there is one kind of repair suitable to each broken piece—provided the piece is worth repairing at all. Good repairs are essentially glue-backs. Nevertheless, some excellent porcelain is restored by this method. One of the most prominent porcelain restoration firms in the United States uses this method: Echo Evetts, 171 Madison Avenue, Room 910, New York, New York 10016; telephone 212-679-2711. We include the telephone number because one must make an appointment to have work done, and there is a waiting period. At the time of this writing the waiting period (before work could even be started) was about six weeks, and it takes about two weeks to complete the job once it is started. This firm works with the major auction houses and has a pickup

and delivery service from and to the auction houses. Its busiest months are March–April and August, September, and October—the time of the big auction sales. The firm glues the pieces together, makes some pieces, fills and eliminates cracks—so they cannot be seen with the unaided eye.

The dealers in porcelain often go over each piece of porcelain, poking it with a large needle to detect repairs, which are softer than the porcelain. This is a common sight in London at Christie's and Sotheby Parke Bernet.

The glue used is a soluble epoxy specially made and approved for porcelain repair by a number of leading museums. It can be removed by a special solution.

A hairline crack can be virtually removed from European porcelain, but not from Chinese porcelain, which is usually much harder than European porcelain.

Evetts has a definite policy of not refiring anything. In general, museums do not want their finest pieces refired because they feel the essential nature is thereby changed too much. The firm generally uses very little paint to "smother the piece."

Evetts is considered absolutely top in the field of porcelain restoration. In other cities and towns around the country you might ask the local dealers who handle porcelain whom they use for repair work.

The other firm much used on the finest porcelain in the New York area is Lloyd Pardo, Box 305, Franklin, New Jersey 07416; telephone: 201-827-5018. While we classify this firm as doing the "excellent" type of repairs, the process is really more different than excellent. What the firm comes up with is a piece the repairs on which cannot be detected even by use of the ultraviolet light, which will detect the glue type of repair. In eight out of ten pieces repaired by Pardo, so it claims, the repair cannot be detected even with ultraviolet light.

This process uses refiring and is used on major pieces. If one should bring to the Pardo firm a small Meissen figure, say, six inches high, from which a finger is completely missing, it can replace the finger for between $100 and $200, depending on the position of the wrist on the figure, the curl of the finger, etc.

For a small figure worth $5,000 a repair costing $200 is not great, considering what it accomplishes. A fine figure without one finger leaves as much to be desired from an aesthetic sense as from the point of view of value.

If a teapot is broken into, say, eight pieces, it can be repaired by the refiring process, but the cost might well be $2,500 for the repairs. Such a cost might be warranted for exceptional Meissen or Sèvres pieces but hardly for a teapot which, if perfect, was worth, say, $500. In such

Among major discoveries by Christie's Oriental specialists were two fourteenth-century wine jars. The one illustrated here was being used as an umbrella stand. A rare underglaze blue and red example, in spite of a repaired rim, it brought $573,000—an auction record in the early 1970s for any work of art other than a painting. (Christie's)

cases it would be better to buy a replacement. In a Medici porcelain bowl, broken in two, the repair would mean the difference between securing a good price, like $150,000, and being unable to sell the piece at any reasonable price at all. Tokyo Museum officials were reportedly flabbergasted when they could not detect such a fired repair on an Oriental piece valued at $140,000.

The auction houses do not themselves have pieces of porcelain repaired. They recommend firms to the owners, firms that are particularly competent to do restoration. Sotheby Parke Bernet, Christie's and A La Vieille Russie, a New York retailer of fine porcelain, all recommend Pardo—as well as Echo Evetts when the nonfiring type of repair seems suited to the piece.

Before anyone spends a great deal on restoring, he should be sure of what he has and of its value, or $1,000 may be spent to restore a porcelain teapot which is worth, in perfect condition, $500. Recently in Venice there was for sale a late eighteenth-century Doccia teapot with the spout broken off and glued back on. The price was $100. We passed up this teapot because it would have cost us at least $500 to repair, while its value in perfect condition was hardly $500.

Most available porcelain of an antique or semiantique nature is English. There is some American. The chances are that the antique tea set you find at a dealer's shop is English and of the nineteenth century. There is a little German porcelain for sale, some Italian and a little French. There is a very small quantity of Dutch and Austrian porcelain for sale. German, Italian, French, Dutch, and Austrian pieces are found more in Europe than in this country.

Usually, but not always, if you buy at auction, the porcelain will be correctly identified, but we did buy a teapot described in the sales catalogue as being eighteenth-century when it even had a date mark representing the year "1815." The auction house did not offer to take the teapot back or make a price adjustment, but the $125 paid for the teapot was a fair price even for an 1815 pot—which illustrates the advice *Examine everything before you buy at auction!*

Porcelain, most of it, is marked so that one can identify the maker and the general period in which it was made, sometimes right down to the year it was made, and this identification holds particularly true in the case of European porcelain. There are three good books on marks:

Chaffers, William. *Marks and Monograms on European and Oriental Pottery and Porcelain,* 15th revised edition. New York: Dover Publications, 1966.
Cushion, J. P., and W. B. Honey, *Handbook of Pottery and Porcelain Marks,* 3rd edition, revised. London: Faber and Faber: 1965.
Godden, Geoffrey A. *The Handbook of British Pottery and Porcelain Marks.* New York: Frederick A. Praeger, 1968.

The Cooper-Hewitt Museum, the Smithsonian Institution's National Museum of Design, has put out (1979) an excellent book—*Porcelain* by Jerry E. Patterson—in which pieces from all countries and marks are illustrated; there is also a comprehensive bibliography of specialized works of various kinds of pottery and porcelain—Chinese, Chinese export, Japanese, and other porcelains.

George Savage's *Dictionary of Antiques*, 2nd edition (New York: Mayflower Books, Inc., 1979) is an excellent dictionary which includes porcelain marks—English, German, Italian, French, and Belgian, as well as Ming and Ch'ing dynasty marks. Also in the book are silver marks for English silver and an excellent bibliography and reading list.

12

What Type of Collectible Are You Selling?

It serves little purpose to make a list of channels and methods through which to sell a particular collectible. For certain collectibles it is best to market through a particular channel, and it is almost useless to market through another. Let us indicate the natural marketing methods for a *sampling* of collectibles, bearing in mind that these are simply examples of how particular collectibles fit into particular marketing organizations by particular methods.

An Important Botticelli Painting of the Holy Family

A church or museum needs a large sum of money to build a new structure or to add to the present structure and decides to sell an important painting. It should be given to a major auction house to sell, and the question is whether to sell it in New York or London. London would probably be the best place because the finest Old Masters are sold there—still—and seem to bring the best prices. The sum the painting will bring is so large that it is hard for any dealer to handle: it might well be in *eight*, not simply seven, figures.

A Good-Quality Dutch or Flemish Painting or an Italian Painting—Artist Unknown

The first thing is to have an 8- by 10-inch glossy black-and-white photograph taken of the painting by a *professional* photographer of paintings. The Dutch or Flemish painting photo could be sent to the Netherlands Art Archives in The Hague, and the Italian to the Art Historical Institute in Florence, for identification of its artist, if possible.

Another photo or, better still, the painting itself might be shown to the Old Master director of Christie's and/or the old Master director of Sotheby Parke Bernet—both these officials located in New York.

If identification is possible, auction catalogues of the major auction houses can be searched to find out whether paintings by the artist have been auctioned and what prices were realized.

The painting, depending on the artist and the quality of the painting, may be sold through a major auction house or to a painting dealer.

A Very Good Painting by an Important Artist Whose Works Are Sold Regularly

The painting we are talking about here is positively identified, but it is not necessarily one of the masterpieces like the Botticelli. Let us say that it is a very fine Canaletto or Guardi or a Remington or Russell western or an Eakins portrait or a landscape by Jacob van Ruisdael.

The first place to offer such a painting might well be to one of the top dealers in such paintings in the United States—such as Wildenstein, Newhouse, Knoedler, Kennedy, Coe-Kerr, Graham, Hirschl & Adler. Keep in mind that some of these deal in Old Masters and others in American paintings. You might get a very high offer from one of these galleries that might have a customer for the picture right away.

If a suitable price cannot be secured from a gallery, the next step might be to sound out a major auction house on its sale. Get its best estimate of what it will bring, remembering that it is only an estimate, not an offer to buy.

A Very Fine Painting of a Lady by Gilbert Stuart

Unless the Gilbert Stuart is a portrait of George Washington, the auctions, even the major ones, do not seem to be the best place to sell it for the highest return. Try to sell such a picture, as well as many other Old Masters, directly to an important art dealer. The Newhouse Gallery in New York and the Vose Gallery in Boston and probably other major art dealers are natural markets for Gilbert Stuart.

A Medium-Grade Italian Baroque Drawing—Artist Unknown

This drawing might best be marketed through a major auction house. In its first Old Master drawings sale in the summer of 1980 Sotheby Parke Bernet in New York secured some very good prices. Both Sotheby's and Christie's are now selling drawings successfully.

A Medium-Grade Classic Car Like a Mercedes-Benz 190SL

This car might best be auctioned through one of the specialized auto auctions which bring in potential buyers for such cars. A major car, like a Bugatti Royale, might be sold through a major auction house, but the auto auctions probably do better for medium-grade cars.

A Fine Classic Car Like a Mercedes-Benz 300SL Gullwing

If the car is in mint condition, it might best be sold to a major classic car dealer or consigned to a highly reliable classic car dealer. If a mint-condition Gullwing is placed on a prominent dealer's showroom floor, it should "sell itself."

A Good Standard Classic Car, but Not an Important "Exotic" Sought by Dealers or Collectors

A Rolls-Royce Silver Shadow standard sedan, made from 1966 on, or a standard Silver Cloud sedan, made from 1955 to 1965, might first be advertised in *The New York Times* in the cars for sale section, which goes all over the country.

It might also be advertised in *Hemmings Motor News*. In this monthly magazine with a large country-wide circulation a picture can be included at a reasonable charge.

A Case of Very Fine Vintage Wine Like Lafite-Rothschild 1961

First I would offer the case to a major dealer in the finest wines like MacArthur Liquors in Washington, D.C., or a major retailer in New York or another major city. If I couldn't negotiate a sale at a good price, I would ship the case to London to the biggest wine auction for vintage wines—Christie's—or possibly Sotheby Parke Bernet in London.*

A Set of Six Good (but Not Great) American or Hepplewhite or Sheraton Chairs

From recent sales I am not convinced that the major auction houses get the best prices for the lesser items of American furniture. I would offer these chairs to a good (but not a very important) dealer to buy outright.

* One must be careful that the seller has the legal right to sell wine in the state, as wine sales by individuals are strictly regulated.

A Massachusetts Block-front Kneehole Desk in Mint Condition

This piece I would offer to a major American antique dealer, like Israel Sack or Benjamin Ginsburg or Levy, all in New York, and I would expect to get a very good offer of cash on the spot.

A Very Rare American Stamp with an Inverted Picture—in Mint Condition

This stamp I would offer at auction to one of the long-established stamp auctions like H. R. Harmer in New York which have clients who have been buying from them for years. I would not overlook the possibility of marketing through the relatively new Sotheby Parke Bernet stamp auction and Christie's stamp auction.

A Four-Dollar American Gold Piece Called a Stella

This coin I would bring to any large dealer who could write out a large check on the spot or pay in cash. The stella has a definite market price and should be snapped up immediately by a dealer. Condition is immediately determinable.

A Group of American Coins Containing a Number of Indian Head Pennies

This group of coins can be offered to almost any coin dealer, large or small, located anywhere. Reference must be made to the price of each coin in the catalogue.* The only question is condition, and values in the catalogue are stated according to the classification of the condition of the coin. The collection might be shown to a few dealers so that there is agreement on the condition of each coin.

A Fair-Sized Diamond Bought a Long Time Ago the Value of Which is Unknown

This stone might be taken to the Gemological Institute of America† in New York for certification of size, color, perfection and other characteristics. Then I would approach a leading diamond brokerage firm like the New York Diamond Exchange and ask it to get the best price for me for a 10 percent commission, getting my final approval before it

* Perhaps the best-known directory for American coins is R. S. Yeoman's *Bluebook of United States Coins/Handbook of United States Coins with Premium List.*

† The Gemological Institute of America, 580 Fifth Avenue, New York, New York 10036, telephone (212)-221-5888.

was sold. For this type of stone auctions might not produce the best possible price.

A House Containing a Number of Medium-Grade Antiques, Carpets, Glassware, Silver, etc., Located in a Suburb of a Major City

First try to secure the services of a major city auction house to conduct an on-premises sale with a suitable catalogue and publicity.

If that is impossible, you can turn to local auctioneers to do a comparable job. In every area, like Fairfield County, Connecticut, there are several much used and experienced on-premises auction houses.

If no auction house will handle the job, a tag sale might be held by tag sale specialists.

If things are left over after the sale (unsold), they might be sent to one of many consignment shops. More important pieces might be offered to local antique dealers.

If the estate contains certain antiques and other salable items and the owner needs cash right now, he might well sell the entire estate to one of the smaller auction houses, like the Manhattan Galleries or the Doyle Gallery in New York.

# 13

Contemporary Works of Art

From a marketing or sales point of view contemporary art can be divided into four categories:

1. Contemporary art with an international market—auction market included—which category would certainly include the Jasper Johns that in the fall of 1980 brought $1 million and Jackson Pollock down to lesser-priced artists like Frank Stella and Bernard Buffet.
2. Contemporary art with a national market and an auction market here in the United States. Such an artist with an American market, including an American auction market, is Jim Bama, the western artist.
3. Contemporary art with a national market, but no auction market, including artists unknown to the auction rooms and auction buyers. This was the position of Jim Bama as recently as 1979, when his works had never been offered at auction. He represents a transition from one market—domestic dealer market—to another—domestic dealer *and* auction market.
4. Contemporary art with little or no market—international or national—and no auction or dealer market. Every contemporary artist starts out like this, with no market anywhere. Mr. Herbert Rivers, assistant to the New York and London dealer Julius Weitzner, told us of the struggles of the highly important contemporary artist Jackson Pollock to find any market. He said, "When I was with Mr. Pollock in the 1940's, he would put on a show in a barn, and there he would have a lot of paintings hanging. Then he would sit and wait for the viewers to come in. They didn't come. Mr. Pollock became very angry. Still, nobody was interested in looking at his art." One of Pollock's paintings, and probably two, have sold for $2 million.

The Whitney Museum of American Art paid $1 million for "Three Flags" by Jasper Johns in September 1980. The Pace Gallery of New York negotiated the sale on behalf of Mr. and Mrs. Burton Tremaine of Meriden, Connecticut, who had bought the painting from the Leo

Contemporary Works of Art 179

"Three Flags" by Jasper Johns was purchased in 1959 for $900 by Connecticut collectors. In 1980 they sold the painting for $1 million in a private sale negotiated by the Pace Gallery of New York. This is the highest price on record for a painting by a living artist. The Whitney Museum made the purchase through fiftieth-anniversary gifts, donations and museum funds. (Collection of Whitney Museum of American Art, New York; photograph by Geoffrey Clements)

Castelli Gallery of New York City in 1959 for $900 plus $15 for delivery to the buyer. "Three Flags" could have been sold on the international art market in recent years, London as well as New York. In 1959 it is doubtful that anyone would have bought the painting at a good price had the Tremaines decided that for one reason or another, they didn't want it. The logical market was the dealer who sold them the painting—Mr. Castelli—but the gallery would no doubt have purchased the painting at something less than $900 in order to be able to sell it again for the presumable market price of $900.

In 1980 Jim Bama, the highly competent western artist, made the transition from private and dealer market to national auction market. We talked with Mr. and Mrs. Jim Bama in 1977, and at that time none of his paintings had ever been offered for sale at auction. His sole dealer was the Coe Kerr Gallery of New York.

In April 1980 Sotheby Parke Bernet offered one of Bama's paintings at auction, a painting of a high-school bull-riding champion, Joe Simms. The painting had sold in 1974 or 1975 (Bama didn't remember which) for $4,500 to the Alan Husburg Gallery in Sedona, Arizona. Bama added, "It may have sold again, but then it turned up in a catalogue [Fowler's], and then I guess someone decided to put it in auction. The auction house called Warren Adelson [of the Coe Kerr Gallery of New York] to put a value on it."

Sotheby Parke Bernet estimated that it would bring at auction $10,000 to $15,000, on the basis of the value given them by the Coe Kerr Gallery.

Before the painting came up at auction, we cautioned both Bama and Coe Kerr about the possible sales price. A Bama had never before been sold by any national auction house, and if nobody there was interested in buying the painting, it could bring anything—or nothing. Bama's paintings were on display at Coe Kerr. Within the year Bama had sold one painting for $24,000, one for $22,000, and four for $18,000 each—all through his dealer, the Coe Kerr Gallery.

We felt it highly desirable for the gallery to bid on the painting at the auction. Suppose it reached only $5,000, and the retail market on Bama's paintings was about $18,000. What would such a low auction price do to the retail market of Bama and Coe Kerr?

Whether the gallery took our advice I do not know. In any event it didn't need to. The painting sold for $18,000, at market and well over the gallery's high estimate. It was bought by the important collector Malcolm Forbes, who had been a buyer of Bama at the time of Bama's 1977 show at the Coe Kerr Gallery in New York. Presumably now Bama is an artist recognized by the major American auction market. His market has broadened.

Contemporary Art with Little or No Market—Auction or Dealer Market, International or National

Most contemporary works of art are in this category. While a Jasper Johns or a Robert Rauschenberg or a Jackson Pollock makes headlines, the supply of these important "money" artists on the market is relatively small. The contemporary art with no market numbers in the thousands and probably tens of thousands.

Start thinking about art in this category before it is bought. The ultimate determinant of whether or not to buy it is whether you like it to decorate your home or you think it represents a high degree of artistic achievement. Price and market value are not primary considerations—provided you have the money to buy what you would like as a home decoration or what you think is a competent piece of art.

Of course, you might gamble, and it is strictly a gamble. You might think that for one reason or another, the artist will one day become a "money artist." The Robert Scull Collection was put together with at least some thought to the value that the artists in it might achieve someday. The collection that cost Mr. Scull about $130,000 sold in October 1973 for about $2,250,000. The artists rose in value, but they did not rise in value all by themselves. Mr. Scull "developed" the artists. He pushed them as artists, and to a considerable extent, he made the market.

If you like a contemporary artist who has no real market, by all means buy his works, but not as an investment, unless you are gambling.

As an investment, one should at least buy the works of artists who are handled by galleries of some importance—not necessarily major galleries, but those with a degree of importance. Even in paintings handled by such galleries, the market is extremely difficult to determine. It is even more difficult to realize a profit on the paintings.

In determining the market consider the Bama situation:

The Coe Kerr Gallery of New York staged a Jim Bama show in 1977. The prices of Bama paintings then averaged around $9,000, and one painting sold for $14,000—the high. It was entitled "Butch Kelly, Bronc Rider," and it measured approximately 24 by 30 inches.

In 1980 the price range was $18,000 to $24,000. Bamas had sold for these prices. One was priced at $30,000.

If one had an "average Bama," it would have been worth perhaps $9,000 in 1977 and about $20,000 in 1980. Theoretically, at least, the investment in Bama had risen from $9,000 to $20,000—better than double in three years.

Suppose, however, that Mr. Forbes had not bought the Bama in 1980 for $18,000 at Sotheby Parke Bernet. Suppose there had not been

an underbidder to force Mr. Forbes to pay $18,000. What would the real market have been for Bama?

Suppose the owner of the Bama that sold at auction for $18,000 had decided against offering it at auction. Suppose he had gone to the dealer handling Bama, Coe Kerr, and offered it the painting. It is possible that Coe Kerr might have been stocked up on Bamas and not offered to buy the painting. Then what would the owner of the Bama who wanted to sell it have done? Where would he have gone to sell it? Would he have taken a chance selling it at auction when a Bama had never been sold by any major auction in the country? Would a dealer other than Coe Kerr have made an offer on the painting by an artist the gallery was not handling, an unknown on the auction market? What would the dealer have offered?

This is the problem with painters today without an active auction market and without a dealer market.

The natural market for an artist not traded on the auction market is the dealer who handles the artist and who sold the painting originally. If the artist is not illustrious and has little or no auction or dealer market, and his prices have not risen since the dealer handling him sold the painting to the person who now wants to sell it back to the dealer, the seller may be presented with some choices. The dealer may possibly offer him back in cash what the customer paid for the painting, but this offer is far from a certainty. The dealer is in business to make money—in order to cover at least his operating expenses. He is thus likely to offer less for the painting than he charged for it originally. Many dealers operate on the basis of 40 percent to the artist and 60 percent to the dealer himself. Sometimes the split is fifty-fifty, and sometimes 60 percent to the artist and 40 percent to the gallery. It would not be unusual for the gallery to offer the seller of the painting half of what he paid for it originally—if the seller demanded cash and the market had not risen.

The dealer might suggest an alternative. The painting might be traded in on another painting in his stock. In this case the seller would likely get as a trade-in allowance the full price he paid originally.

There is another alternative. The dealer may give the seller a credit that he can use at any time to buy another painting the gallery has for sale. This credit will be equal to the full purchase price of the painting paid by the seller.

Of course, a trade-in on another painting or a credit is not as good as cash. The seller has no bargaining ability, and the selling gallery can charge anything it wants for the new picture the seller buys in place of the traded-in painting.

For this type of painting with no auction market and no dealer

market the outlook for profitable investment and sale at a capital gain is not as bright as it might appear.

Consignment to the dealer for sale is a possibility, and it has worked for this collector, but the painting may remain unsold for years, and the dealer may want up to fifty percent of the sales price. The painting may also not be pushed by the dealer since it is not his, but the customer's, painting.

Contemporary Art with a National Market, But No Auction Market

The vast majority of works of art on the market are contemporary paintings with little or no market of any kind—dealer or auction. True, such art is sold by dealers, but once a work of art has been sold, it has been sold. There is no need for the dealer who sold the art to repurchase it if the buyer wants to resell it in the future. The market is what the dealer would pay for the work of art in the wholesale market or buying directly from the artist, and it is well below the retail price—the price the customer paid for the art when he bought it from the dealer. The dealer might pay 50 percent of the sales price if the purchaser wanted to resell it to the dealer, perhaps a little more, perhaps less—that is, if the seller wanted cash instead of a trade-in or a credit toward the purchase of some other work the dealer had for sale.

One step up in the "salability scale" from the contemporary work of art that neither auction house nor dealer wants is the work that does not have an auction market but that does have a dealer market—nationally or at least regionally.

Sabina Teichman can be used as an illustration of a highly competent, imaginative semiabstract contemporary artist who had sold many pictures, many of them hanging in museums, but with no auction market. Prices of her works ranged a few years ago from a few thousand dollars to $10,000.

Dance king and Impressionist collector Arthur Murray was determined that Sabina Teichman would have a national auction market, and he saw to it that her paintings appeared from time to time at Sotheby Parke Bernet in New York. When her paintings came up at auction, he was usually the main bidder. For a long time he was always the top bidder, although it was his objective not to acquire her paintings, but rather to get the market accustomed to her paintings.

After a sale in which her painting or paintings appeared he sometimes told us, "This sale really went well for Sabina. Someone almost outbid me on one of her paintings." Finally, one of her paintings did sell to someone other than Mr. Murray, and as I recall, a prominent writer bought it at auction for $3,500.

This is an illustration of an artist being moved from the category of an artist with some national market and no auction market to one with a national (dealer) market and an auction market as well.

Unless there is an auction market for works of art by a particular artist, it is very difficult to determine the value of the work of art and it is very difficult to dispose of it. For a largely unrecognized artist the ability of the collector to realize on his investment is rather dim.

Pietro Annigoni is certainly one of the finest portrait artists in the world. His "Queen Elizabeth II" is probably the best portrait ever done of her. It has received universal acclaim and has been exhibited everywhere. At times Annigoni's paintings have come up at auction, but the auction market does not seem very aware of him, and I have seen his works go in small auctions in London for sums in the neighborhood of $1,000. Some years ago he came to the United States, and he told us of some of his commissions to paint portraits. The clients all seemed to belong to "The Billionaires' Social Register," and I would doubt that he painted any portrait at under $10,000.

However, his auction market was, as indicated, something far different from his original portrait market, and the auction market was an important method of determining the value of his paintings on the secondary market.

In the same category was Dimitri Berea, an artist of great talent and with excellent commissions in the five-figure category. His style is very much like that of Renoir. From time to time his works have appeared at auction, some at the Plaza Art Galleries in New York as part of estates coming onto the market. I have seen his simpler works go for under $1,000.

While this category of contemporary art is above the previous category in that there is something of a dealer market, it is not much more liquid, and it is still hard to determine the value of a painting or other work of art by the artist in the absence of an auction market.

Contemporary Art with a National Market and an Auction Market in the United States

When an artist has a national and auction market in the United States, there is a definite liquidity that artists without an auction market do not have. In fact, a good case can be made out for not investing in the work of artists who do not have an auction market. Their works lack liquidity, and their value is not easily determinable.

An artist does not have to be extremely valuable to have an auction market. He simply has to have his works known and bought on the auction market.

The auction market is by no means the same in price level as the

dealer market. The auction market is usually well below the price the dealer charges for the works of art originally, and it remains at this low level until the market for the artist's work is well developed. This development is carried on both by the auction house and by the dealer or dealers who handle the particular artist.

If a contemporary artist becomes very well known in artistic circles, if he has had a number of shows, if his paintings hang in one or more museums of some importance, and if his works get to be known at auction, his auction prices will at least have a tendency to approach the prices dealers ask for his work. Only when the artist really arrives will his auction prices equal dealer prices, and at this point auction prices sometimes exceed dealer prices.

Two auction sales illustrate the relationship of auction price to dealer price and to indicate what the auction can do to develop the market for an artist. One is the June 10, 1980, auction in modern and contemporary art at Christie's East. The other is the July 17, 1980, auction at Sotheby Parke Bernet.

Right now Photo Realism is a very popular and well-accepted category of contemporary art. The art is just what the name says. It is as realistically done as a photo. In fact, some Photo Realism is done by projecting a photograph on a screen. The artist then paints from the photo as exactly as he can.

In Christie's June 10 sale, Lot 147 was entitled "Albuquerque." It is a large painting, as most Photo Realist paintings are, although it is certainly not one of the largest. It measures 50 by 60 inches and depicts a racehorse, with rider, standing beside three men. Two of the men are holding a sign which says, "1966 World Wide Appaloosa Futurity, N. Mex. State Fair." The artist is Richard McLean, a fairly important Photo Realist known in American auction circles. The painting brought $15,000, about the market figure for this painting. It is not low in relation to the dealer market, nor is it high. It represents a good strong buyer interest at auction.

Lot 168 was another Photo Realist, this one by Ron Kleeman. It measures 50 by 68 and is entitled "Scullduggery Series, Prototype for the Dragging Sculls." The painting is a picture of the back of one of Robert Scull's taxicabs and is true to life. The picture auctioned for $10,000, somewhat below the price the house estimated it would bring, but still good in relation to the dealer price of Ron Kleeman.

The two Photo Realist artists are fairly well known and well accepted in the auction room. In all probability, Sotheby's would have secured a comparable price for these paintings had it sold them. They might well have brought comparable prices had they been sold in California instead of New York. There is probably a good national auction market for these works if they are sold in cities with enough buyer interest to

warrant an auction of fairly well-known and fairly high-priced contemporary artists. The auction is a natural outlet for such accepted paintings, and the price they will achieve there is determinable to a great extent.

When this auction alternative exists, it is possible to offer such paintings to dealers with the expectation that they will offer a fair price. They are likely to make such a fair offer because they know that the alternative is a fairly well-known price if the works are offered at auction. In a sense, for these "auction-mature" artists, the auction guarantees that the dealer will not be in the driver's seat as regards the price he will pay for such works. When artists have a national auction market, the works of art they produce are liquid and price-determinable, and the sellers have a real choice of selling at auction or to dealers. Without such an established auction market, the seller cannot be sure what he will get from a dealer should he offer such a work to him, nor does he know what the work will bring at auction, provided the house will take the work of art at all.

A second category of contemporary art sold in these two auctions is the "unimportant work" category, lesser-priced works that may be accepted at auction and that *may* bring a satisfactory price at auction, but not necessarily. These lesser works made up the bulk of the art sold at both of these summer, 1980, auctions.

The distinctions as regards whether the work can or cannot be sold at auction are not crystal-clear. Important works by a particular artist may sell at auction, whereas unimportant works by him may not be sold at any reasonable price.

In respect to the national auction market in the United States versus the international auction market, an important work by an artist may do as well in price in London as it will in the United States, whereas an unimportant work by the same artist may sell in the United States at auction but may not even be taken by a major London auction.

In Sotheby's New York sale in July 1980 an Irene Rice-Pereira, "Movement in Space," 34 by 42 inches, brought $3,500. The next lot was also a Rice-Pereira entitled "The Polarity of Light," 50 by 40 inches; it brought $1,800. Rice-Pereira has long been a recognized artist here in American art markets but not traded much internationally. Any Rice-Pereira would no doubt be accepted by a major auction house anywhere in the country. These two works didn't bring particularly high prices, but the American auction might well be the best place to dispose of them.

In the June 1980 sale at Christie's East, a Larry Rivers was sold for $800. Entitled "Napoleon Banner," it was originally put out as one of a series of thirty.

The next offering was in the same category by the same artist, Larry Rivers. It was entitled "Double French Money"—silk screen on paper

and Plexiglas. It was one work of an edition of 125, and it brought $1,800.

Had these works been important originals by Larry Rivers, the market would have been in London as well as in New York and thus international, but they were not important works by the artist, and their market was limited.

In the same sale an Elaine de Kooning entitled "Toro III," a collage with paper and colored chalk on paper, brought just $300. Had the work been important, it might have been sold in a London auction. Had it been a *Willem* de Kooning, it could have been sold in any auction anywhere in the world with the expectation that it would probably bring a "de Kooning price."

Tom Blackwell is a Photo Realist, not a Richard Estes, but a recognized Photo Realist artist. Lot 145 in the Christie's East sale was his picture of a motorcycle entitled "Tequila Sunrise," oil on board, signed. It brought $2,500. I wouldn't take a chance trying to sell this work at auction in any city but a large American city. The international auction market would not, I think, produce much in the way of results for this painting by this artist.

Then, in these two auctions, there were works of artists "trying to make the grade," to move from the strict dealer market to the auction market. Thus, Lot 15 in the Christie's East sale was a Jan Matulka entitled "Landscape," a signed watercolor, black charcoal and pencil on paper, 14½ by 11¾.

Jan Matulka lived and worked in New York for many years until his death. During his lifetime his financial results were something like those of Vincent van Gogh—almost none! Many Matulkas were bought by Betty Bartholet, the New York art dealer. The Whitney Museum in New York had a special Matulka show from December 1979 to February 1980. The show went on to the Houston Museum of Fine Arts and then to the Birmingham Museum of Art. The Metropolitan Museum of Art in New York even bought one of his works, as have other museums. The National Collection of Fine Arts in Washington bought a Matulka for $10,500, "The Phonograph," before the traveling exhibition opened. Another Matulka sold in the $20,000 range, and still another in the $30,000 range, to a private collector.

The Christie's East sale included a Matulka, "Landscape." It sold for $600. True, it was a small watercolor, black charcoal and pencil on paper, but $600 was no princely price.

Sotheby Parke Bernet's sale included a more important Matulka entitled "Composition," oil on board, 17⅝ by 25. There was also a picture on the reverse side. It didn't sell and was probably withdrawn.

The time has apparently not yet come when Matulka becomes "an auction artist." The dealer might have supported his price by "buying

in" Matulkas, but without such bidding on the part of the dealer, Matulka does not seem to have an auction market anywhere equal to private sales, as yet.

Matulka is an abstract painter. Constantin Kluge is a realist, a highly competent realist. We feel we should know. A Kluge hung at the end of the living room of our home for months. It was so large it covered the wall from floor to ceiling. This artist paints mainly in Paris, typical Paris scenes. He is handled by the Wally Findlay Galleries, and we feel Kluge is one of the most able artists this gallery has under contract. Kluges will sell around the $10,000 level, some more and some smaller ones less.

In Sotheby's New York sale in July two Kluges were offered. Lot 42 was "Le Quai des Orfèvres," 31⅞ by 31⅞. It was a pleasant scene and a typical Kluge. It brought $550—below the low estimate. The next lot was also by Kluge, "Parisian Street Scene," 28¾ by 36¼; it brought $900. If the gallery handling Kluge was in there bidding on these paintings, it did not have to bid far to buy them!

The auction prices of these Matulkas and Kluges bear little relation to the competence of these artists or to their dealer price. The simple and hard fact is that the auction market does not know the artists and will not bid them up to levels approaching dealer levels. The artists are thus not in the category of *Contemporary art with a national market and an auction market in the United States.* An owner of a Kluge or a Matulka would be foolish indeed, at this stage of development of the artist's auction market, to offer such paintings for sale at auction—that is, if he expected to realize a profit on his investment, provided he had bought the painting from the dealer handling the artist. Of course, if he had received the paintings as a gift or had purchased them at low prices, such as the farsighted dealer Elizabeth Bartholet had in the case of Matulka, there would be a profit, but it would be below the retail level, by a good amount, at the time of this writing.

Contemporary Art with an International Market, Including an International Auction Market

Important contemporary art has, for the most part, both an international dealer and an international auction market. True, there are national biases, and Jackson Pollock will probably sell better in New York and London than in Rome, but as a rule, the important contemporary works of art sell to international dealers and at international auction.

The significant thing about top-drawer contemporary art is that there is an auction market and auction price. Auctions hold an umbrella over the value of the art. If there is a determinable or at least approximate auction price, the dealer price cannot be far below it. The dealer *buying*

price cannot be far below the auction price. If the dealer is offered a Jasper Johns (or any other major contemporary works of art), he will have to pay a price comparable to the auction price. Otherwise, the owner of the contemporary work of art will place it in auction. Since dealers are major buyers in almost all auctions, contemporary art auctions included, the auction price represents the dealer buying price. The dealer will thus tend to pay up to the auction price (of a comparable work) for a contemporary work of art offered to him directly by a collector who wants to sell it. If the dealer doesn't make an offer somewhere in line with the current auction prices for comparable works, the seller will likely move on to the next dealer, who may offer him a better price.

In summary, as far as market and market price go, the most salable contemporary art is that art which has an international auction market since this market in effect creates the international dealer market.

This generalization holds true for paintings, sculpture, drawings, prints, and other forms of contemporary art, including "mechanicals," like some of the works of Irene Rice-Pereira, and "assemblages" of various materials and objects which constitute certain schools of contemporary abstract art.

Sotheby's, New York, on May 15 and 16, 1980, held a sale of "Contemporary Paintings, Drawings and Sculpture"—not designated "Important" or "Very Important." On May 16, 1980, Christie's held a sale of "Contemporary Art," and there was no designation of the sale's being "Important." There was not a great deal of difference in the two sales as far as quality of offerings went or the prices received or who the buyers were—dealers versus private buyers.

The most expensive lot sold at Sotheby's was Number 550, a Roy Lichtenstein acrylic on canvas, 48 by 48, of a girl telephoning. It brought $210,000 from a New York dealer, and the price he paid established a record for Lichtenstein—a high price record.

The next highest-priced work of art sold was a Mark Rothko that went to a New York private buyer for $180,000. The next high-priced lot, a Francis Bacon, sold for the same amount—$180,000—to a New York dealer. It was a record price for Bacon and for any contemporary British artist.

Lot 544, a Lichtenstein of sea and clouds, sold for $140,000 to a New York dealer.

Lot 529 was an Ellsworth Kelly, a green and black pattern, 95 by 68 inches. It sold for $57,500 to a private Chicago buyer.

The final high-priced lot recorded in the "high-priced lot report" of Sotheby's was a Robert Motherwell "Untitled," 116¾ by 140 inches. It went to a Missouri dealer for $55,000 and established an auction record for Motherwell.

In this sale 195 lots were "contemporary," and the earlier lots were

in other schools of art. These contemporaries—and they were for the most part nonrealistic (abstract) contemporaries—grossed $3,082,250 in this Sotheby's sale. Dealers were major buyers, and this is the point we are making. The auction price is something of an umbrella over the price of these contemporary works of art. If dealers outbid private buyers at auction, they are willing to pay up to auction price if the works are offered to them directly by collectors of contemporary art. This is a great advantage in collecting contemporary works traded on the international market and on the international auction market.

These sales could just as well have been held in London. Buyer interest and prices would not have been far different, although America seems to dominate nonrealistic (abstract) art, with Jackson Pollock probably at the pinnacle. An auction record for an abstract contemporary painting was established at Christie's, New York, in May 1980 when Jackson Pollock's painting "Four Opposites" sold for $550,000 in a $2.6 million record contemporary art sale.

The following artists are among those with an international market, including an international auction market:

Major American Abstract Expressionists: Jackson Pollock, heading the list, followed by Willem de Kooning, Hans Hofmann, Robert Motherwell, Adolph Gottlieb, Franz Kline, William Baziotes and others such as Karel Appel of the Cobra school.

Realists, such as Andrew Wyeth and, in the same school, his son, Jamie.

Surrealists with international standing: Salvador Dali, Yves Tanguy, Rene Magritte, Jean Arp, Andre Masson, Max Ernst, and Paul Delvaux, also Man Ray, whose painting of bright red lips floating across the sky brought a record for any Surrealist painting sold at auction when it sold at Sotheby Parke Bernet for $750,000 in the $6.4 million sale of the William Copley Collection in late 1979 (a Max Ernst brought $620,000, a Joan Miro brought $363,000 with premium, a Rene Magritte brought $270,000–$292,000 with the 10 percent buyer's premium—in the Copley sale).

Pop Artists (the "Pop" stands for popular, and the subject matter is objects well known to everybody like the can of Campbell's soup by Andy Warhol and Rosenquist's gigantic pair of lips): Andy Warhol, Robert Rauschenberg, Jasper Johns, Roy Lichtenstein, Claes Oldenburg, James Rosenquist, Larry Rivers, Robert Indiana, Alan D'Arcangelo, Jim Dine, Christo, Tom Wesselman, Ernest Trova.

Photo Realists or Super Realists: Richard Estes (at the head of the list of painters), Duane Hanson (the leading Photo Realist sculptor whose figures of two tourists sold twice well into five figures), Robert Cottingham, Ralph Goings, Richard McClean, Malcolm Morley.

So-called Color Field artists (the essence of this art is large spaces

or fields of color alone, and often just one color for the entire picture, perhaps with a little shading which is barely distinguishable): Mark Rothko, Barnett Newman, Ad Reinhardt, Jules Olitski, Sam Francis, Clyfford Still, Morris Louis.

Pattern-Geometric artists (characterized by patterns, geometric compositions, and the Op branch of the school—Optical Art): Joseph Albers, Frank Stella, Kenneth Noland, Victor Vasarely, Richard Anuszkiewicz (the original Op Artist), Jacob Agam (the leading Israeli Pattern-Geometric artist).

These are by no means all of the contemporary artists traded internationally, but it is a good-size sampling and includes leading names of the American contemporary artists traded internationally.

Contemporary Works of Art and Their Market—In Summary

Contemporary works of art with an international market, including both a dealer and an auction market, can be disposed of fairly easily, either at auction or to dealers.

The market price is determinable because the art has been sold at auction and prices have been published.

The major auction houses in the United States and abroad will take this art and sell it because there are buyers throughout the world and certainly in London and New York.

The major auction houses will very likely get good prices for such art.

Since the market is known and prices at auction have been published, there is a ready dealer market, and dealers in this art will probably pay market price, in some cases possibly more, since they frequently pay absolutely top prices for contemporary works of art at auction, outbidding private buyers.

One step down in marketability is contemporary art with a national market, including a national auction market—that is, the big auctions here in the United States. Because this art is sold at the major auctions, market price is determinable since prices are published by the auction houses.

This art, with a national market, is certainly not as liquid as art with an international market, nor is its price so determinable or well established.

When we get to contemporary art with a national market but no auction market, liquidity decreases a good deal. This art is hard to sell because it cannot safely be offered at auction. The auction houses realize that there is no national market and no national market price, and they are often unwilling to handle it, partly because prices realized will not satisfy the seller. For that reason, such art is not the very best to collect.

For this art the dealer who sold the art originally is the main market, and unless he wants to buy your work of art, the market is very uncertain.

Finally, we get to the category of contemporary art with little or no market—national or international—auction market or dealer market. Very competent works of art appear regularly at the smaller auctions, works by little-known or unknown artists. My wife, who is an artist, used to attend many sessions at the Plaza Art and Auction Galleries in New York when such works were offered for sale. The auctioneer, one of the O'Reilly brothers, knew that she would buy these paintings—at a low enough price. Very often he would get no bids whatever on them. He would then say, "Sold to Julie Rush for two fifty." The paintings never sold for more than the value of the canvas, stretcher and frame, and they rarely brought this much. Julie took these paintings and painted her own pictures over them.

Still, there will be other Jasper Johns and other Jackson Pollocks, and these two "seven-figure artists" are not the only contemporaries who have risen in price tremendously in recent years. There will be more, many more in the future.

14

Arts and Crafts

If this book were distributed to a cross section of the public, the area of collectibles in which the majority of readers would be interested (because of what they owned) would be arts and crafts. Few people own paintings with much commercial value. Few people have Mercer Raceabout automobiles sitting in the barn where Grandfather put them years ago. Few have early American silver.

Many people, on the other hand, have at least something that falls into the category of arts and crafts, and many of these items quite likely have value, often very much above what they imagine. Here are some of the main categories of arts and crafts which often have commercial value and may have a definite market, either via dealers or by auction. In fact, almost all these things have a definite auction market, are sold regularly on that market, and have a fairly determinable market price:

Antique Toys and Banks
Brassware
Cigar Store Indians
Carousel Horses
Commemorative Plaques and Allied
 Items
Decoys
Fireplace Equipment—mainly and-
 irons

Glass
Pewter
Pottery
Quilts and Coverlets
Scrimshaw and Woodcarvings
Weathervanes

In addition to these we might mention hook rugs, ship models, decorated tinware, etc., which are all crafted items—many under the category of American Folk Art. American Folk Painting is also a major category, with recent record prices for Edward Hicks. Twice his paintings have brought $270,000 at Sotheby's in New York. Major names in American folk art have been on the rise in recent years—reaching six figures

in a number of auction sales. Ammi Phillips is the second-highest-priced American folk art painter, having reached $185,000 at auction in 1980. Few folk art paintings reach these high levels, however. It is only the major names and exceptional works which reach these headline-making levels. To get a more realistic view of this market, take a look at a recent Sotheby's sales catalogue of Americana.

When we think of the term arts and crafts, we think also of the movement in England started by William Morris in the middle of the nineteenth century and continuing on into the early part of this century which was a revolt against the machine-made furniture and decorative items which had become prevalent by mid-century. The Morris Group's emphasis on hand-crafted (as opposed to machine-made) spread throughout the world. In this country, we are celebrating the hundredth anniversary of one of our most well-known art pottery firms—Rookwood. Art pottery has become a popular collectible and values have increased in recent years. Rookwood broke the $30,000 barrier at auction recently. Other major names in Art Pottery in the United States are Grueby, Dedham, Weber and the incomparable Tiffany.

When we mention Tiffany, we think also of Art Glass and the record prices for this art glass which have been achieved by Tiffany—topped by the $360,000 for a Tiffany Favrile leaded glass spiderweb lamp. The Art Glass of Nancy, France, of the Art Nouveau period is highly collectible; and names such as that of Emile Gallé are well-known and have reached five and six figure levels at auction. French glass paperweights are also a major area of collecting in the field of Art Glass. These mid-nineteenth century works of art have seen escalating prices over the decade. American glass, including American glass paper weights, are also popular collectibles. American glass items are included in the regular sales of Americana at auction in New York. Price trends can thus be easily followed by consulting the priced catalogues.

Arts and crafts discussed in this book are for the most part confined to the United States. The market in arts and crafts, of course, varies from country to country. In Britain there is a big business in model trains and engines, some large, elaborate, and expensive. British art pottery sells well in England. In the United States there is a certain amount of buying and selling of cameras. In England entire auction sales catalogues have been devoted to penny fairings, simple little toys that were sold for a penny or two or given away in country fairs in the past. Some of these penny fairings bring hundreds of dollars each at auction. In the United States they, to all intents and purposes, are unknown. On the other hand, electric trains are sold in the United States in some volume, and they have risen in fifteen years from nearly nothing, when they were given to the Salvation Army and Goodwill Industries, to many hundreds of dollars, sometimes hundreds for only an engine.

Toy soldiers are included in our category of toys, but they are really

distinct. They are not sold in any tremendous volume, but they are now collectors' items, and they bring a good amount of money—provided they are fine and scarce soldiers made a number of decades ago.

Our criterion for an arts and crafts item being an investment collectible is: *Is the item sold fairly regularly at auction, and does it have at least something of a determinable market price?*

All the items on the list qualify as investment collectibles. They are sold regularly at auction, have a fairly readily determinable market price, and are sold in some volume. Some arts and crafts items have graduated to full-fledged collectibles. American primitive paintings used to be in the category of arts and crafts as recently as ten years ago. Now they have moved up to the category of Gilbert Stuart, Robert Feke, and Gustavus Hesselius—among other early American artists. For the most part, these folk artists are far more primitive than the big-name artists of the period, but they tend to bring more and more money and to be more and more recognized as artists instead of limners or itinerant painters.

Over the years many other kinds of arts and crafts will undoubtedly become definite categories of investment collectibles. Even such a basic art and craft item as a weather vane is now becoming a real investment collectible. Sotheby's fairly recently auctioned off a metal weather vane—not a very sophisticated piece of art. It brought no less than $25,000—a sum that would buy a very good American painting or even a blockfront chest of drawers!

On Collecting Arts and Crafts—and Selling Them

There are arts and crafts and there are arts and crafts. Some are investments, and some most certainly are not. Antique brass andirons are an investment, but old books—just old books—are not, and we are not talking about rare books or important first editions. Old phonograph records are very often investments. On the other hand, Dick McDonough, of Greenwich, Connecticut, recently purchased 200 albums of records dating back perhaps thirty years for $35. If, in this collection, he finds just one "phonograph classic," he will be fortunate, but at the $35 dollar price he could hardly go wrong.

The market for every one of the investment collectibles in our list is rising fairly rapidly as of late 1981. This is by no means an exclusive list of wanted arts and crafts. It is a sampling of the arts and crafts which are rising in value. Demand for American Folk arts and crafts is increasing rapidly, and more are being sold. The increase in dollar volume is due not simply to higher prices but to more sales as well.

The safest of all arts and crafts to buy as an investment are those items traded on the American auction market. These items are not generally traded on the international auction market. The main market is

the American dealer and collector market, but the market is definitely strong nationally.

Almost all American auctions—the major U.S. auctions, the minor auctions in New York, and the local auctions all over the country—trade in these investment arts and crafts. A tremendous number of dealers, smaller dealers certainly included, handle them as well, and offer them at all times. The major auctions do not, in general, handle *noninvestment* arts and crafts—at least in their major sales. Their lesser sales, however, often include such items.

The demand for arts and crafts can easily be determined by noting what has happened to the sales catalogues of the major auction houses over the past two or three years. They have become thicker and thicker. More and more lots are offered for sale in folk arts and crafts, and now more than one thick catalogue is sometimes prepared covering just one auction sale, which may include well over 1,000 lots.

Regional organizations, particularly California auctions, are now offering more arts and crafts for sale. The major auction houses are preparing for California sales tremendous catalogues, which lean very heavily toward arts and crafts items.

Items are perpetually in transition from noninvestment to investment collectibles. Five years ago brass andirons made in America from the late eighteenth to the early nineteenth century were hardly an investment collectible. They were offered infrequently, the market was not strong, and price was not easily determined. The market was certainly not rising rapidly; sometimes it didn't rise at all from one season to the next. Now more and more antique American brass andirons are coming onto the market, and almost every Americana sale of a major auction house has a section on brass andirons. Almost every dealer exhibition and show contains a number of them for sale. They used to cost $100 to, say, $250 a pair. Now they range up to well over $1,000, and in the near future they may well rise to $2,000 and above. High prices are drawing andirons out of homes and to dealers and to the auction.

While old books do not have value simply because they are old, they are in transition. Some books have become investment collectibles in a decade. The Tom Swift books had little value ten years ago, and their value was not easily determinable. Today they can sell for $15 each. When we moved out of our home in Bronxville, New York, twenty years ago, I left a complete collection of Tom Swift books where I had found them when I bought the house—on the shelf!

The J. M. W. Turner that sold in 1980 for $7 million (with premium) was a fine investment for its seller. It may turn out to be a fine investment for its purchaser, apparently a South American. Many collectors, however, do not have that kind of money to invest in such a painting or other collectible. In fact, they may not have $7,000 to invest, but for

$700 they have a wide range of investment arts and crafts. Prices are low enough so that the market is active, and one's investment in arts and crafts, at least many of them, is liquid.

Conservatively, several million items of arts and crafts are sold annually—at auction, at dealers' shops, at art and antique exhibitions and shows, of which there are probably 3,000 in the United States each year. Commission marts and charity shops sell such items all the time. One mart sometimes sells well over $5,000 worth of merchandise per day—many of the items in the class of arts and crafts. More and more people are attending commission marts every day, and Rose d'Or in Darien, Connecticut, for instance, may have fifty people in the store at one time, many of them buying. This shop alone can make hundreds of sales in one busy day.

The home decoration market for arts and crafts is important, and it will very likely always be there, even in a deep recession. Most arts and crafts items are not tremendously expensive, and they almost all add to the decor of the home. When anyone buys such an item, he is usually combining home decoration and investment, and very often the home decoration motive is dominant. Postage stamps and gold coins do not offer this advantage to the investor.

The Auction Market for Arts and Crafts

To a considerable extent the major auctions determine what are investment arts and crafts and what are simply arts and crafts. The former are, for the most part, American, at least the arts and crafts sold in the United States. They are usually sold by the major auction houses in Americana sales—a conglomeration of American items of varying importance. The catalogue's table of contents of such sales indicates what *investment* arts and crafts now are.

This is the table of contents of a typical sale of Americana by a major auction house:

American Paintings	Scrimshaw
American and Other Glass	Pottery
Decoys and Bird Carvings	Folk Art
Pewter	Carpets and Rugs
Decorations	Decorations
Hearth Equipment	Lighting Devices
Quilts and Coverlets	Shelf, Wall and Tall-Case Clocks
American and Other Native Oil Paintings and Watercolors	Furniture

Other Americana sales may include such items as Chinese export porcelain, American folk sculpture, American native paintings and water-

colors, tinware and greenware, but even one huge sale consisting of eight sales sessions and 1,540 lots did not include all these items of arts and crafts.

A review of the recent Americana sales of Christie's and Sotheby's indicates their general price ranges. Sotheby Parke Bernet's Americana sale resulted in the hitherto unheard-of price of $25,000 for the weather vane. But Lot 117 of the June 10 and 11, 1980, sale was:

> Group of Seven Blown Colorless Glass Case Bottles, 19th Century, comprising a pair with gilt decoration on the shoulders and neck, both with matching ball stoppers, another two with similar decoration (faded and lacks stopper), and a group of four smaller case bottles with etched decoration outlining the shoulders. (Overall condition good.) Height 5 to 8¾ inches (13 to 22.5 cm.) See illustration of four on preceding page.

This lot brought just $60. The seller had to pay a commission to the auction house of 15 percent for selling it—$9—and thus netted $51. The buyer had to pay 10 percent over the $60 selling price—$6. Had the lot sold for more than $500, the seller would have had to pay 10 percent of the price, and the buyer the same figure—10 percent of any amount the item brought at auction.

The lesser auction houses will take the items we are talking about for sale, but the lots offered for sale may be indiscriminately combined with other objects and offered in one "package" of "seventeen pieces of old glass, tinware, and pottery."

Almost all major auction house Americana sales offer a great amount of scrimshaw, mainly carved whalebone, turned out by sailors on whaling vessels. Other bone is sometimes used. Scrimshaw carving is, of course, not confined to seamen on whaling vessels, but much of it came from such artisans.

In the same Sotheby auction was a somewhat plain scrimshaw item—an engraved whale's tooth, dated June 27, 1832. It was 5¼ inches long and was inscribed "S. Timoleon arrived in Payta, May 29, 1832. Sailed hence June 8 for and arrived at the Galapagos Island, June 27, 1832. No. 2." It brought $200. A very fine engraved powder horn signed "John Tribble, Fort Edward, New York," and dated 1758, 13 inches long and decorated with vines, a lion, and the bust of a soldier, brought $3,200. This was eighteenth-century, and the carver was identified as a private in the French and Indian Wars. Ordinary scrimshaw pieces often go for under $1,000 and even under $500.

The Dealer Market

In certain investment collectibles the dealer market is a questionable medium for the collector-investor. Antique and classic cars are one such

doubtful area. The dealer might not offer you a good price in relation to the retail price of your make and model car. Unique items, like the very early, very large Flemish mantelpieces we already have referred to, are another doubtful category. They occupy too much space in the dealers' shops and appeal to too few people.

Arts and crafts are in an entirely different category, if they are truly arts and crafts, not simply secondhand items or old junk. The vast majority of antique dealers in the country handle at least some arts and crafts, and as true antiques (particularly finer items of antique furniture) become scarcer, dealers will be forced to buy more and more items falling into this category.

If you have an early-nineteenth-century glass decanter with original stopper, you have no unique item. Still, such an item is wanted by many, if not most, antique dealers, especially those handling a large variety of lesser-priced items. Such a decanter can be offered for sale on a *bid basis* or on a *fixed price basis*. You can ask the dealer what he will pay for the item, indicating that you are interested in getting the highest dealer bid. You can, on the other hand, ask, say, $100 and see if the dealer will take the decanter at $100 or offer something less, like $85.

Obviously you must acquaint yourself with the general value of the decanter before you offer it, and you can do this by referring to Americana auctions of the major auction houses or to reference books on the value of arts and crafts.

Bids from several dealers can be secured. It is sometimes advisable to visit antique exhibitions and sales in which dozens of dealers will be displaying and selling, and you can go from dealer to dealer offering your decanter. This may well be a good method as the dealers are likely to be selling fairly rapidly and may be willing to spend some of the cash they receive to replenish their stock.

It is difficult to generalize about what arts and crafts will bring at auction today. Late-eighteenth- to early-nineteenth-century andirons bring from $250 to $1,250. A few pairs bring less then $250, while a few very fine, signed pairs bring more than $1,250. So-called antique toys usually do not go back a great many years, and very often the more recent toys seem to bring the best prices. Toy fire engines are fairly common items in the area of arts and crafts. Those of the 1920's sometimes sell for $35 to $50. A 1910 fire engine may sell for as high as $300 to $400. Toys rarely bring more than $50.

Banks that do not have a mechanical device rarely sell for as much as $100, almost without regard to age. Mechanical banks are another matter and seem to be much more of a collector item and a sophisticated investment item. Banks are classified according to subject matter, like monkey and parrot or Viennese soldier. They can range into four figures,

the latter bank selling for more than $2,000. Most mechanical banks sell for under $500; many sell from $500 to $1,000.

Brass candlesticks of the late eighteenth to early nineteenth century used to sell for as little as $25 a pair ten years ago. At the time everybody wanted antique silver candlesticks, and brass candlesticks were what one would buy if he couldn't afford anything better. In fact, brass candlesticks seemed to be at the bottom of the quality candlestick list. Today the same pair of candlesticks can cost $250.

Cigar store Indians do not come up regularly at auction, but when they do, they receive higher and higher prices. In the May 3, 1980, sale of fine Americana at Sotheby's, New York, Lot 1223 was a "Fine Carved and Painted Wood Cigar Store Princess, Attributed to Samuel Robb, New York, circa 1880," 5 feet 2½ inches high. It brought $3,000. A number of Indians were offered in this sale.

Commemorative plaques and dishes are a standard item in the antique business, and prices are to a great degree standard market prices that do not vary a great deal from auction to auction or from dealer to dealer. The range of such plaques and dishes is very wide, as are prices: Royal Copenhagen Christmas plates (Copenhagen) bring from perhaps $1,500 for a 1908 plate down to $29 for a 1979 plate, the price depending on the age of the plate as well as on the number of the plates in existence.

Decoys used by hunters are on the market in considerable volume and sell in a range of $50 to about $200, some rare decoys bringing more money. They can be classified with some precision according to where they were made and often who the "sculptor" was.

I have listed prices for brass andirons. Along with andirons often go fire fenders and fire tools. Ten years ago an early-nineteenth-century fire fender could be bought for less than $50, sometimes for less than $25. In 1980 a fairly good brass fire fender would cost up to $250. A set of tools can cost up to $200.

An immense amount of American glass is offered regularly at auction. Decanters especially are in regular demand and at increasing prices. Less than ten years ago an English Georgian decanter or an American decanter of comparable age could be bought for under $10, with its original stopper. Within the past ten years I have bought decanters of this age for as little as $2.50. Today a good decanter can cost $250, and few are sold at under $100. The later the decanter, of course, the lower the price, and the eighteenth- and early-nineteenth-century decanters bring the most, as is to be expected.

There is a large amount of Heisey glass on the market. It is simple glass with an *H* generally in the center of the bottom. A set of twelve Heisey water glasses can cost from $50 to $100. This glass is plentiful. It was made from the 1890's to 1957 by the U. H. Heisey Company

of Newark, Ohio. From 1964 to 1967 the Imperial Glass Company of Bellview, Ohio, used the old molds to make more Heisey glass, but even the original does not cost much money, much of it selling for under $25 apiece and little selling for over $100.

Libbey glass is more refined and sells for more, much of it exceeding $100. A very few pieces reach $1,000. Carnival glass is in this same price range, and its supply seems endless.

Cut glass has been rising in value, and it is not unusual to find finely cut pieces selling for $250 to $350 apiece, although much of this glass still sells for under $100.

Depression glass is what the name implies: inexpensive glass, often sold in ten-cent stores in the years of the Depression—1929 to 1934 or thereabouts. This glass sells in the range of about $5 up to $25, some pieces to $50.

Most pressed and pattern glass, at least the kind that is collected, was made from the 1820's to the 1890's. The volume of this glass on the market is no doubt greater than any other kind. While a few pieces sell in the hundreds of dollars, most sell for under $25. All pressed and pattern glass falls into certain definite categories and can fairly easily be identified as to category—cabbage rose, cable, cane, Currier and Ives, hobnail-printed, etc.

Pewter is sold in great quantities in many American sales. In Sotheby Parke Bernet's May 3, 1980, Americana sale Lots 892 to 944 were all items of pewter. The first lot sold was *Continental,* not American—a pair of candlesticks 5¾ inches high. The pair brought $375. The very next lot was a typical Americana sale offering: an American pewter coffepot made by Rufus Dunham, Westbrook, Maine, 1837–60. It was estimated to bring $350; it brought $550. Two American pewter teapots brought $500. An American pewter plate made in Middletown, Connecticut, 1755–82, brought $375. It was made by "Thomas Danforth II, Middletown, Connecticut." Many pieces of American pewter are stamped with the maker's name. An unmarked pair of American pewter candlesticks from the nineteenth century brought $425. American pewter rarely brings as much as $500, although eighteenth-century pieces sometimes go as high as the low four figures.

America has produced an immense amount of pottery. The kind that is most handled by auctions is glazed pottery, particularly early redware and the very popular nineteenth-century stoneware. Some items of pottery are masterpieces and bring large sums of money, like Lot 1153 in Sotheby Parke Bernet's May 3, 1980, sale of Americana. This was an incised salt-glazed stoneware jug, signed by R. G. Remmey of Philadelphia, and dated 1872, 7⅛ inches high and in fine condition. It brought $5,250. The very next lot sold, however, was a nineteenth-century glazed stoneware storage jar stamped "New York Stone-Ware

Co., Fort Edward, N.Y." It was 9¼ inches high and had a matching lid. It brought $20. It was a storage jar and not artistic in design or exterior decoration.

Probably more Weller and Roseville pottery is sold in America than any other. The volume is immense (the pottery was made over a long period and up until recent times), and the major auctions generally will not handle it. Ten years ago we advocated collecting this pottery because good pieces could be purchased for $10, $15, or $25. Prices have about tripled in the ten-year period, which is no great market performance.

Quilts and coverlets are almost always offered at the major auction houses. Many coverlets were turned out on the Jacquard loom, which allowed the use of larger areas of material and more intricate designs. These coverlets in double-weave pattern (both sides could be placed up on the bed) were manufactured from the early to the middle nineteenth century. Sometimes the name of the weaver was woven into the coverlet, and the name of the owner. As I am writing this chapter, I am looking at two such coverlets, both dated 1823 and both belonging to my great-grandmothers (one to Margaret Vreeland and one to Lavina Brinkerhoff). Both coverlets have my grandmother's name woven into the pattern. The first came down in my family. The second I found fifteen years ago in the Pelham, New York, antique exhibition and sale. The price at the time was $60; today it would be about $300. Sotheby Parke Bernet's Americana sale had a fine appliques and piecework album calico quilt, 93 by 108 inches, signed "Frank Thomas of Springfield, Delaware County, Pennsylvania" and dated 1856. It was a fine red and rust color. It brought $2,900. It was rare, while the reversible coverlets are not.

The Commission Marts

The third good market for arts and crafts is the commission mart. It has the advantage of easy dealing. A decanter may be offered to a dealer for $100, but the dealer may well offer only $35. A commission mart, on the other hand, does not have to put out its money for the decanter. It does not have to bargain with the seller since no cash is involved at the time the decanter is offered. The operator of the mart may express the opinion that the asking price of $100 is too high, but if the price is reasonable, the mart may very well take the item and label it "$100." If it does not sell, the operator may call up the owner and ask him to reduce the price. If it has not sold for $100 in, say, thirty days, the owner may voluntarily want to lower the price. It must be remembered, however, that the commission mart may take 30 percent of the asking price—$30 out of the $100 sales price, netting the seller $70.

Value Guides to Arts and Crafts

The most important guides to values of arts and crafts are the priced Americana sales catalogues of Christie's and Sotheby's, New York. Americana sales are held regularly.

There is a so-called *Official Price Guide to Antiques and Other Collectibles*, by Grace McFarland, put out by the House of Collectibles, Orlando, Florida 32811. This is a price reference book of 450 pages and includes price ranges of everything from "Beer Cans–Pull Tab" to "Locks and Keys" and all the major investment arts and crafts discussed here. The 1980 edition is priced at $8.95.

The Catalogue of American Collectibles by William C. Ketchum Jr. (New York: Rutledge/Mayflower, 1979), $25, is a large book and profusely illustrated, with fairly up-to-date prices, maybe a little out of date because it came out in 1979, and many prices have risen since that time.

The Lyle Official Antiques Review is put out annually. Compiled by Margaret Rutherford and edited by Tony Curtis, it is sold by Apollo, 391 South Road (U.S. 9), Poughkeepsie, New York 12601. This publication covers arts and crafts from all over the world, not just American arts and crafts. It does, however, include such items as a late-nineteenth-century American brass recording telegraph, from J. H. Bunnell & Co. This item brought $85 at Sotheby's Belgravia, London. This book has line drawing illustrations of everything sold and is thus helpful in identifying exactly what brought what price. The 1981 edition is priced at $18.95.

A comprehensive price book is *Antiques Illustrated and Priced, 1854 pieces, dated, and appraised for the collector, dealer and decorator.* This compendium of illustrated, priced items includes many whale oil lamps in tin, pewter, and brass as well as a pair of signed andirons by B. Edmunds, Charlestown, circa 1760–80—$700, the estimated value. The book is priced at $29.95.

Apollo of Poughkeepsie, New York, also offers for sale fifteen books of antiques and collectibles for $49.50 with "over 15,000 illustrated prices." Everything from militaria to caddies and boxes is covered.

Ralph and Terry Kovel have been writing in the field of American antiques for twenty-seven years, and their publications of priced items seem endless. Publishers Central Bureau, 7 Champion Avenue, Avenel, New Jersey 07131, apparently offers all their books for sale at reasonable prices, including:

The Kovels' Complete Price List, twelfth edition
Dictionary of Marks—Pottery and Porcelain
The Kovels' Complete Bottle Price List, fifth edition
The Kovels' Price Guide for Collector Plates, Figurines, Paperweights and Other Limited Editions

The Kovels' Collector's Guide to American Art Pottery
American Country Furniture, 1780–1875
Know Your Antiques, new revised edition
The Kovels' Organizer for Collectors
A Director of American Silver, Pewter and Silver Plate

 There are many encyclopedias of collectibles of one kind or another, but perhaps the most comprehensive is a series of books put out by Time-Life Books, Alexandria, Virginia. Each book in the series deals with a limited number of groups of antiques. The book which I am looking at now covers C and D (cookbooks to detective fiction, with coverlets, decoys, and cut glass in between.) Very thoroughgoing descriptions of each category, its history and characteristics, are given, but no prices. It is what the name says it is—*The Encyclopedia of Collectibles,* and it aids in identifying exactly what one has in the area of arts and crafts of all kinds, covering many areas of collectibles which many people are completely unaware of. The price of each volume is $8.95 plus postage and handling. With volume one, at the time of this writing, they send a softbound copy of *The Collectors Handbook: A Guide to the Marketplace,* and a paperback copy of *The Official Price Guide to Antiques and Collectibles,* published by House of Collectibles. This price guide, which we have listed earlier as selling for $8.95 in the 1980 edition, lists over 20,000 prices of popular collectibles. Ask for these two books (free) with your order for your volume one of *The Encyclopedia of Collectibles.* Write to Time-Life Books, Time & Life Building, Chicago, Illinois, 60611. The books, beginning with Volume One (advertising giveaways, art glass, art pottery, autographs, barbed wire, automobilia, banks, baseball cards, and baskets) are sent individually about every eight weeks and the subscription can be stopped at any time. Volume one was published in 1978 and the series still was under production during 1981. It would be a good set to suggest for your local library, as the number of books in the set and cost of such a large set is perhaps too high for most collectors interested in only a few of the subjects covered.

Appendix A
Selected North American Auction Houses, Associations, and Dealers

Auction Houses

The auction houses listed below for the most part handle general auctions, estates, appraisals, individual consignments. The list also includes some specialized houses. You might write or telephone to ask about the current commissions on consignments (usually the large auction houses charge 10 percent seller's commission with an additional 10 percent collected from the buyer). There are some exceptions, usually a higher commission of 15 percent for lots selling for less than $500, but for large estates and important consignments, there might be some negotiation for lower rates. A few galleries purchase, but as a rule, the largest galleries sell only on consignment.

We give here a selected list of auction houses throughout the United States and some in Canada but have not included all. For example, there is the Theriault Auction, which specializes in antique dolls and is important for doll collectors. It charges 25 percent commission. The address is P.O. Box 174, Waverly, Pennsylvania, 18471; telephone: 717-945-3041. Bowers & Ruddy Galleries is mentioned in the list of important coin dealers, but it also *auctions* coins and is among the leaders in this field. The gallery auctioned the Garrett Collection of gold coins in March 1980 at the Johns Hopkins University and in November 1979, when more than $7 million was realized for 622 lots, a world's record, plus the world record of $725,000 for any coin at that time. In another sale of interest, the world's most expensive stamp was auctioned for $850,000 plus premium in 1980 at Robert A. Siegel, whose address and telephone are 120 East 56th Street, New York, New York 10022; telephone: 212-753-6421. The firm has been auctioning since 1930. The world's most expensive work of art sold at auction was the $6.4 million plus 10 percent premium paid for J. M. W. Turner's Venetian painting "Juliet and her Nurse" at Sotheby Parke Bernet, New York, in May 1980. Sotheby Parke Bernet's salesrooms in North America are listed, but the Sotheby Parke Bernet Group Ltd., Christie's International Ltd., and Phillips are *international* auction houses with sales galleries and representatives throughout the United States and in major auction centers throughout the world. If you wish these international addresses, write to the

New York (or London) offices for the information. You might also request a copy of their newsletters, which give upcoming sales, and ask what the current subscription rates are. At this writing, it is under $5 per year for the Christie's, Sotheby Parke Bernet and Phillips newsletters, which also give auction highlights—prices, trends, as well as addresses of representatives.

New York

Astor Galleries, 1 West 39th Street, New York, 10018; telephone: 212-921-8861. General auctioneer, a small New York gallery, but also may purchase.

Christie's USA, 502 Park Avenue, New York, 10022; telephone: 212-826-2888. Fine art auctioneers since 1766, Christie, Manson & Woods International, Inc., with headquarters in London and auction rooms and representatives throughout the world. Auctioneer of Americana, antiques, books, paintings, furniture, jewelry, oriental art, sculpture, silver, tapestries. Also appraisers.

Christie's East, a division of Christie's USA, with weekly auctions at 219 East 67th Street, New York, 10021; telephone: 212-570-4141. Auctioneers of collectibles, dolls and toys, furniture, jewelry, prints, photographs, Victoriana, and other nineteenth century works of art.

William Doyle Galleries, 175 East 87th Street, New York, 10028; telephone: 212-427-2730. General auctioneer of fine art, American, English, and Continental antiques, works of art, jewelry, and collectibles.

John C. Edelmann Galleries, Inc., 123 East 77th Street, New York, 10021; telephone: 212-628-1700. An auction house specializing in rare rugs, carpets, tapestries, and textiles.

Richards C. Gilbert, State Road, Garrison-on-Hudson, New York, 10524; telephone: 914-424-3635. General auctioneer specializing in on-premises auctions, including estate sales.

Charles Hamilton Galleries, Hyde Park Hotel, second floor, 25 East 77th Street, New York, 10021; telephone: 212-628-1666. Specialist in autographs and manuscripts. Auctions and appraisals. Will also purchase certain items outright.

Harmers of New York, Inc., 6 West 48th Street, New York 10036; telephone: 212-757-4460. International stamp auctioneers and appraisers.

Lubin Galleries, 72 East 13th Street, New York 10003; telephone: 212-253-1080. General auctioneers, a small gallery.

Manhattan Galleries, 1415 Third Avenue, New York at 80th Street; mailing address: 201 East 80th Street (Manhattan Storage Building), New York 10028; telephone: 212-744-2844. General auctioneers and appraisers, handling estates, antique furniture, as well as reproductions, rugs, porcelain, paintings, silver, bronzes, Victorian pieces of art, etc.

Phillips, 867 Madison Avenue, New York, 10021; telephone: 212-570-4830, and at 525 East 72nd Street, New York 10021, between York and the East River; telephone: 212-570-4842. Fine art auctioneers and appraisers, founded in London in 1796. General auctioneers of fine art and antiques such as rugs, silver, collectibles, glass and ceramics, jewelry, paintings, posters, furniture,

etc. Headquarters are in London, and the firm has representatives throughout the world (see locations at the end of this section).

Art Galleries

Harmer Rooke, 3 East 57th Street, New York, 10022; telephone: 212-751-1900. Specializes in buying and selling numismatic investments, auctions, and appraisals, all metals, countries, ages, paper money. Also autographs and stamps.

Sotheby Parke Bernet, 980 Madison Avenue, New York, 10021; telephone: 212-472-3400, and 1334 York Avenue, New York, 10021; telephone: 212-794-3000. Member of the Sotheby Parke Bernet Group, founded as Sotheby's in London in 1744, now with auction rooms and representatives throughout the world. Auctions in fine art, including paintings, ballet and theater arts, books, manuscripts, coins, jewelry, prints, photographs, drawings and stamps, are held at the Madison Avenue galleries. Decorative arts, including furniture, silver, collectibles, and numerous other categories of decorative arts, are auctioned at the new block-long building at 72nd Street and York Avenue.

Stacks. 123 West 57th Street, New York, 10019, telephone: 212-582-2580. America's oldest and largest coin dealers. Purchases, gives appraisals, and also sells at public aution.

Swann Galleries, 104 East 25th Street, New York, 10010; telephone: 212-254-4710.

Tepper Galleries, 110 East 25th Street, New York 10010; telephone: 212-677-5300.

New York's International Auction Houses

Christie's International, Ltd., with headquarters at 8 King Street, St. James, London, SW1Y 6QT (telephone: 01-839-9060), has salesrooms and/or representatives in America, Argentina, Australia, Austria, Belgium, Canada, France, Italy, Japan, Mexico, Norway, Spain, Sweden, Switzerland, Holland, and West Germany, as well as throughout England. The New York address is 502 Park Avenue, New York, New York 10022 (telephone: 212-826-2888).

Sotheby Parke Bernet Group, Ltd., with headquarters at 34-35 New Bond Street, London, W1A 2AA (telephone: 01-493-8080), has salesrooms and/or representatives throughout England and in Scotland, throughout the United States, in Canada, Belgium, France, Germany, Holland, Ireland, Italy, Monaco, Scandinavia, Switzerland, Australia, the Far East (Hong Kong), South Africa, Japan, South America (Argentina and Brazil). The New York address is 980 Madison Avenue, New York, New York 10021 (telephone: 212-472-3400).

Phillips, with headquarters at Blenstock House, 7 Blenheim Street, New Bond Street, London W1Y OAS (telephone: 01-629-6602), has salesrooms and/or representatives throughout England and in Ireland, the United States, Canada, Switzerland, and Holland. The New York address is Phillips Son

& Neale, Inc., 867 Madison Ave., New York 10022 (telephone: 212-570-4830).

Auction Houses in the East—Outside New York

Richard A. Bourne Co., Inc., Corporation Street, P.O. Box 141, on Route 28, Hyannis Port, Massachusetts 02647; telephone: 617-775-0797.
Barridoff Galleries, 242 Middle Street, Portland, Maine 04104; telephone: 207-772-5011.
Robert C. Eldred & Company, Route 6A, East Dennis, Massachusetts 02641; telephone: 617-385-3116.
Samuel T. Freeman, 1808 Chestnut Street, Philadelphia, Pennsylvania 19103; telephone: 215-563-9275. America's oldest auction house under continuous one-family management (over 175 years in business).
John H. Frisk, 1611 Walnut Street, Philadelphia, Pennsylvania 19103; telephone: 215-563-3363. The Fine Arts Company of Philadelphia, Inc.
Garth's Auctions, Inc., P.O. Box 315, 2690 Stratford Road, Delaware, Ohio 43105; telephone: 614-362-4771 or 369-5085.
Julia's Auction, James D. Julia, Route 201, Fairfield, Maine 04937; telephone: 207-453-9725. A small auction house in Maine, estates, etc.
Emory Sanders, New London, New Hampshire 03257; telephone: 603-526-6326.
Robert W. Skinner, Route 117, Bolton, Massachusetts 01740; telephone: 617-779-5528, and Copley Square Gallery, 585 Boylston Street, Boston, Massachusetts 02116; telephone: 617-236-1700.
C. G. Sloan & Company, 715 13th Street, NW, Washington, D.C. 20005; telephone: 202-628-1468. Auctioneers of fine art, estates, appraisers.
Adam A. Weschler & Sons, 905–9 E Street, NW, Washington, D.C. 20004; telephone: 202-628-1281. Auctioneers and appraisers since 1890.
Richard W. Withington, Hillsboro, New Hampshire 03244; telephone: 603-464-3232.

Auction Houses in California

Sotheby Parke Bernet, Los Angeles, 7660 Beverly Boulevard, Los Angeles, California 90036; telephone: 213-937-5130.
Butterfield & Butterfield, 1244 Sutter Street, San Francisco, California 94190; telephone: 415-673-1362.

Auction Houses in Texas and the Midwest

E. M. Alexander, 1285 North Post Road, Houston, Texas 77055; telephone: 713-688-5900. General auctioneers.
Clements Auction Gallery, Box 727, Forney, Texas 75126; telephone: 214-226-1520 and 3044. Fine art auctioneers since 1938.
Columbia Auction Gallery, 3500 Columbia Parkway, Cincinnati, Ohio 45226; telephone: 513-321-8210.

Milwaukee Auction Galleries, 4747 West Bradley Road, Milwaukee, Wisconsin 53223; telephone: 414-355-5054.
Selkirk Galleries, 4166 Olive Street, St. Louis, Missouri 63108; telephone: 314-533-1700.
Stalker & Boos, 280 North Woodward Avenue, Birmingham, Michigan 48011; telephone: 313-646-4560.

Auction Houses in Florida, Georgia, Louisiana, and Tennessee

Mortons Auction Exchange, 643 Magazine Street, New Orleans, Louisiana 70190; telephone: 504-561-1196; toll-free 1-800-535-7801. A large auction house in the South.
Northgate Gallery, 5520 Highway 153, Chattanooga, Tennessee 37343; telephone: 615-842-5992.
Schrader Galleries, 211 Third Street, South, St. Petersburg, Florida 33701; telephone: 813-823-5657.
Trosby Auction Galleries, Atlanta, Palm Beach, and Miami. Tower Place, Suite 200, 3340 Peachtree Road, NE, Atlanta, Georgia 30326; telephone: 404-237-1779; 2506 Ponce de Leon Boulevard, Coral Cables, Florida 33134; telephone: 305-446-3436; and 905 North Railroad Avenue, West Palm Beach, Florida 33401; telephone: 305-659-1755.

Auction Houses in Canada

Phillips Toronto, Phillips Ward-Price Ltd., 76 Davenport Road, Toronto, Ontario M5R 1H3; telephone: 416-923-9876.
Sotheby Parke Bernet (Canada) Inc., 156 Front Street, West, Toronto, Ontario M5J 2L6; telephone: 416-596-0300.
Gallery Sixty Eight Auctions, 3 Southvale Drive, Toronto MG4 1G1; telephone: 416-421-7614.

Christie's USA

Directors and Department Heads to Contact at Christie's USA

CHRISTIE MANSON & WOODS INTERNATIONAL, INC.
502 Park Avenue
New York, New York 10022
212-826-2888
President and chief executive officer: David Bathurst, 212-546-1044
Estates and appraisals: Stephen S. Lash, 212-546-1138
Director, fine arts department: Christopher Burge, 212-546-1171
Museum liaison: Perry Rathbone, 212-546-1190
Christie's East president: J. Bryan Cole, 212-570-4150

Expert Departments

American Furniture & Decorative Arts: Ralph Carpenter, consultant, and Dean Failey, 212-546-1181
American Paintings: Jay E. Cantor, 212-546-1179
Art Nouveau and Art Deco: Alastair Duncan, and Nancy McClelland, 212-546-1026
Books and Manuscripts: Stephen C. Massey, 212-546-1195
Clocks and Watches: Winthrop Edey, consultant, 212-546-1152
Contemporary Art: Martha Baer, 212-546-1169
Decorative Arts: J. A. Lloyd Hyde, consultant, 212-546-1151
European Furniture: E. Charles Beyer, 212-546-1150
European Porcelain and Glass: Victor Bernreuther, 212-570-4733
Impressionist and Modern Paintings: Christopher Burge, 212-546-1171
Impressionist, Modern Drawings, and Watercolors: Susan Seidel, 212-546-1170
Jewelry: François Curiel, 212-546-1134
Musical Instruments: Charles Rudig, 212-570-4184
Nineteenth-century Paintings: Henry M. Wyndham, 212-546-1173
Old Master Paintings: Ian G. Kennedy, 212-546-1178
Oriental Art: Anthony Derham, 212-546-1158
Period and Antique Jewelry: Alison Bradshaw, 212-546-1192
Photographs: Dale Stulz, 212-570-4730
Prints and Modern Illustrated Books: Nicholas Stogdon, 212-546-1022
Rugs and Carpets: George Bailey, consultant, 212-570-4182
Russian Art: Alice M. Ilich, 212-546-1146
Sculpture and Works of Art: Alice Duncan, 212-546-1148
Silver and Objects of Art: Anthony Phillips, 212-546-1153
Tribal Art and Antiquities: Sabina Adamson, 212-570-4170
Watches: Jonathan Snellenburg, 212-546-1154
Wine: Jacqueline Quillen, 212-570-4156

Regional Offices of Christie Manson & Woods International, Inc. in the United States

Anne Johnson, Russell Fogarty, Donelson Hoopes, Christine Eisenberg. 9350 Wilshire Boulevard, Suite 328, Beverly Hills, California 90212; telephone: 213-275-5534. (Ms. Eisenberg handles the car auctions.)
Paul Ingersoll, 628 Morris Avenue, Bryn Mawr, Pennsylvania 19010; telephone: 215-525-5493. Mid-Atlantic agent for Christie's.
Francis Blair, 46 East Elm Street, Chicago, Illinois 60611; telephone: 312-787-2765. Midwest agent for Christie's.
Helen Stedman Cluett, 225 Fern Street, West Palm Beach, Florida 33401; telephone: 305-833-6952. Florida agent for Christie's.
David Ober, 3400 Prospect St., N.W., Washington, D.C. 20007; telephone: 202-965-2066

Auction Houses, Associations, and Dealers

Sotheby Parke Bernet

Directors and Department Heads to Contact at Sotheby Parke Bernet, Inc., USA

SOTHEBY PARKE BERNET, INC., NEW YORK
980 Madison Avenue
New York, New York 10021
212-472-3400

Chairman and president: John L. Marion, 212-472-3426
Appraisals and estates: C. Hugh Hildesley, 212-472-3454
Regional auction centers: John D. Block, 212-472-3568

Expert Departments at Madison Avenue SPB Galleries

American Paintings: Peter B. Rathbone, Grete Meilman, 212-472-3551
Books and Manuscripts: Jerry E. Patterson, 212-472-3593
Chinese Paintings: Paula Gasparello, 212-472-3529
Coins: Jeremiah Brady, 212-472-4847
Contemporary Paintings, Drawings, Sculpture: Linda Silverman, 212-472-3543
Impressionist and Modern Paintings: John L. Tancock, 212-472-3547
Jewelry: Dennis J. Scioli, Paul A. Russo, 212-472-3421
Paintings Department: Mary-Anne Martin, director, 212-472-4766
Modern Paintings, Sculpture: Shary Grossman, Polly Rubin, 212-472-3545
Modern Drawings: Ballet and Theater Arts: Hermine Chivian-Cobb, 212-472-4764
Nineteenth-century European Paintings: Thilow von Watzdorf, 212-472-3537
Old Master Paintings: Brenda Auslander, 212-472-3541
Photographs: Anne Horton, 212-472-3595
Prints: Marc E. Rosen, 212-472-3437
Prints, Nineteenth and Twentieth Centuries: Ruth Ziegler, Susan Pinsky, 212-472-3437-8
Vintage Vehicles: Chrys Landrigan, 212-472-4629

SOTHEBY PARKE BERNET STAMP AUCTION CO., INC, Andrew Levitt, 158 Deer Hill Avenue, Danbury, Connecticut 06810; telephone: 203-743-4458.

Expert Departments at the York Avenue SPB Galleries

1334 York Avenue
New York, New York 10021
212-794-3000
Director of sales of decorative arts: Robert C. Woolley, 212-472-3503

American Decorative Arts and Furniture: William Stahl, 212-472-3511
American Folk Art: Nancy Druckman, 212-472-3512

American Indian Art: Ellen Napiura, 212-472-3522
Antiquities, African and Oceanic Art: Richard Keresey, 212-472-3521
Art Deco: Eric Silver, 212-472-3504
Art Nouveau: Barbara Deisroth, 212-472-3508
Chinese Art: James J. Lally, 212-472-3516
Coins: Jeremiah Brady, 212-472-4847
Collectibles (including dolls, toys, mechanical banks, jukeboxes, slot machines, trade stimulators, automata, dollhouse miniatures, clothing, furs of the nineteenth and early twentieth centuries, lead soldiers, comic character watches, vending machines, music boxes, etc.): Pamela Brown, 212-472-4783
English Furniture: Gerald Bland, 212-472-3513
European Furniture: Thierry Millerand, 212-472-3514
European and Chinese Porcelain: Letitia Roberts, 212-472-3517
European Works of Art, Ceramics, and Tapestries: David Willey, 212-472-3507
Islamic Works of Art, Miniatures, and Manuscripts: Michael Jones, 212-472-3524
Japanese Art: Martin Lorber, 212-472-3525
Musical Instruments: John Turner, 212-472-8443
Portrait Miniatures and Paperweights: Sarah D. Coffin, 212-472-3532
Pre-Columbian Art: Claudia Giangola, 212-472-3575
Rugs and Carpets: Michael Grogan, 212-472-3451
Russian Art: Gerald Hill, 212-472-3619
Silver, Virtu, and Watches: Kevin L. Tierney, 212-472-3531

Sotheby Parke Bernet Los Angeles

7660 Beverly Boulevard
Los Angeles, California 90036
213-937-5130

Expert Department Heads SPA/LA

Arms and Armor: Terry Parsons
Art Nouveau and Art Deco: Kathy Watkins
Furniture, Decorations, Rugs, and Tapestries: Kenneth W. Winslow
Jewelry: Joseph Gill
Oriental Art: Peter Malone
Paintings: Barbara Pallenberg
Photographs: Beth Gates-Warren
Prints: Paula Kendall
Silver: Pamela Maher

Sotheby Parke Bernet Representatives—Regional Offices, USA

Mrs. Patricia Ward, 232 Clarendon Street, Boston, Massachusetts 02116; telephone: 617-247-2851.
Mrs. Catharine C. Hamilton, 700 North Michigan Avenue, Chicago, Illinois 60611; telephone: 312-280-0185.

Miss Flo Crady, Galleria Post Oak, 5015 Westheimer Road, Houston, Texas 77056; telephone: 713-623-0010.

Elena Echarte, SPB fine arts representative, 155 Worth Avenue, Palm Beach, Florida 33480; telephone: 305-659-3555.

Mrs. Wendy T. Foulke, 1630 Locust Street, Philadelphia, Pennsylvania 19103; telephone: 215-735-7886.

Andrea Comel di Socebran, 210 Post Street, San Francisco, California 94108; telephone: 415-986-4982.

John Marr, Suite 102, Aina Haina Professional Building, 850 West Hind Drive, Honolulu, Hawaii 96821; telephone: 808-373-9166.

Joan Tobin, SPB fine arts representative, 2903 M St., NW, Washington, D.C. 20007; telephone: 202-298-8400.

Important Coin Dealers

Kelman & Associates, P.O. Box 232, La Jolla, California 92038; telephone: 714-455-6292; in New York, 212-724-5518; in Chicago, 312-454-1284. Auction and purchase.

New England Rare Coin Galleries, 89 Devonshire Street, Boston, Massachusetts 02109; telephone: 800-225-6794. Auction and purchase.

Harmer Rooke Numismatists Ltd., 3 East 57th Street, New York, New York 10022; telephone: 800-221-7276. Auction.

Kagin's, 1000 Insurance Exchange Building, Des Moines, Iowa 50309; telephone: 800-247-5335. Auction.

The Old Roman, Inc., 560 Broad Hollow Road, Melville, New York 11747; telephone: 800-645-9174.

Bowers and Ruddy Galleries, Inc., 6922 Hollywood Boulevard, Suite 600, Los Angeles, California 90028; telephone: 800-421-4224. Auction.

Steve Ivy Numismatic Auctions, Inc., 7515 Greenville Avenue, Suite 800, Dallas, Texas 75231; telephone: 800-527-6810. Auction.

Mike Follett Rare Coin Company, Plaza Level, 1 Main Place, Dallas, Texas 75250; telephone: 800-527-7804.

Robert L. Hughes Enterprises, 9601 Wilshire Boulevard, Beverly Hills, California 90210; telephone: 800-421-0588.

Jess Peters, Inc., P.O. Box 123, Decatur, Illinois 62525; telephone: 217-428-2074.

Rare Coin Company of America, Inc., 31 North Clark Street, Chicago, Illinois 60602; telephone: 312-346-3443.

First Coinvestors, Inc., 200 I. U. Willetts Road, Albertson, New York 11507; telephone: 516-294-0040.

John Dannreuther Rare Coins, 5100 Poplar Avenue, Suite 714, Memphis, Tennessee 38137; telephone: 901-683-2492.

Galerie des Monaies of Geneva, Ltd., 970 Madison Avenue, New York, New York 10021; telephone: 212-734-9700.

Mintmaster Coin Galleries, 3272 Peachtree Road, NE, Atlanta, Georgia 30305; telephone: 800-241-0264.

Camelback Coin Investment Center, 4780 North Central Ave., Phoenix, Arizona 85012; telephone: 602-274-2646.

Superior Stamp & Coin Co., Inc., 9301 Wilshire Boulevard, Beverly Hills, California 90210; telephone: 800-421-0754. Auction.

Nashua Coin & Stamp, 168 Main Street, Nashua, New Hampshire 03060; telephone: 603-889-6312.

Henry Christensen, Inc., P.O. Box 1732, Madison, New Jersey 07940; telephone: 201-822-07940. Auction.

International Coin, Inc., 1302 East 66 Street, Richfield, Minnesota 55423; telephone: 800-352-2835.

Important Stamp Dealers

Scott (in association with Harmer Rooke & Co., Inc.), 3 East 57th Street, New York, New York 10022; telephone: 212-371-5700 and 800-221-7276. Auction.

Raymond H. Weill Co., 407 Royal Street, New Orleans, Louisiana 70130; telephone: 504-581-7373.

Earl P. L. Apfelbaum, Inc., 2006 Walnut Street, Philadelphia, Pennsylvania 19103; telephone: 215-567-5200.

Edward D. Younger Co., 171 East Post Road, White Plains, New York 10601; telephone: 914-761-2202.

Andrew Levitt, Inc., P.O. Box 342/SE, Danbury, Connecticut 06810; telephone: 203-743-2016.

Simmy's Stamp Co., Inc., 148 State Street, Boston, Massachusetts 02109; telephone: 800-225-6276. Auction.

Matthew Bennett, 29–31 C. W. Chesapeake Avenue, Baltimore, Maryland 21204; telephone: 301-823-3714. Auction and dealer.

Jacques C. Schiff, Jr., Inc., 195 Main Street, Ridgefield Park, New Jersey 07660; telephone: 201-641-5566. Auction.

Kover King, Inc., 120 West 44th Street, New York, New York 10036; telephone: 212-581-6910

Rasdale Stamp Co., 36 South State Street, Chicago, Illinois 60603; telephone: 312-263-7334. Auction.

Stanley Gibbons Auctions Limited, Drury House, Russell Street, London, England WC2B 5HD; telephone: 01-836-8444. Auction.

J. and H. Stolow, Inc., 915 Broadway, New York, New York 10010; telephone: 212-533-0790. Auction.

Gibbons Philatelists, Ltd., Suite 2906, Rockefeller Center, 1270 Avenue of the Americas, New York, New York 10020; telephone: 212-582-0165.

George Alevisos, 2716 Ocean Park Boulevard, Suite 1020, Santa Monica, California 90405; telephone: 213-450-2543. Auction.

Danam Stamp Company, 800 Kings Highway North, Cherry Hill, New Jersey 08034; telephone: 609-779-0779. Auction.

Peter Kenedi, 17200 Ventura Boulevard, Encino, California 91316; telephone: 213-986-5990, and Concourse-Eastland Center, Harper Woods, Michigan 48225; telephone: 313-371-8864; also 800-423-3103. Auction.

Suburban Stamp Inc., P.O. Box 715, 115 Progress Avenue, Springfield, Massachusetts 01101; telephone: 413-785-5348. Auction.

Art and Antique Dealer Associations

Here follow the lists of dealer-members of three leading nationally known art and antique dealer associations. Some dealers belong to more than one of the associations, such as the Newhouse Galleries of New York, which belongs to all three. Members are listed with their addresses, telephone numbers, and areas of specialization. They are listed geographically, but most are located in New York. Membership is available through election (invitation) to those who qualify and subscribe to the associations' codes of ethics.

The addresses of the associations, in the event you wish to write for additional information or updated lists, are as follows:

The National Antique & Art Dealers Association of America, Inc., with an address for inquiries at 59 East 57th Street, New York, New York 10022.
The Art Dealers Association of America, Inc., with an office at 575 Madison Avenue, New York, New York 10022
The Art and Antique Dealers League of America, Inc. with a mailing address at 800B Fifth Avenue, New York, New York 10021

Many of these dealers are also members of nationally known appraisers' associations. Two leading associations are listed below, and you may write for their list of appraiser-members:

Send $3 for the list of the Appraisers Association of America, Inc., at 60 East 42nd Street, New York, New York 10017. Local members usually are listed in the Yellow Pages of your telephone book, but if you wish to call New York, the number is 212-867-9775.

The American Society of Appraisers will send at no charge its list of appraisers of personal property, including art and antiques. Write its headquarters, P.O. Box 17265, Dulles International Airport, Washington, D.C. 20041

The National Antique & Art Dealers Association of America, Inc. List of Members by State

CALIFORNIA

Richard Gould Antiques, Ltd., 216 26th Street, Santa Monica, California 90402; telephone: 213-395-0724. Eighteenth- and early nineteenth-century English furniture, porcelains, and accessories.
R. M. Light & Co., Inc., P.O. Box 5597, Santa Barbara, California 93108; telephone: 805-969-0257 (by appointment only). Fine prints and drawings.
Earle D. Vandekar of Knightsbridge, Inc., 8485 Melrose Place, Los Angeles, California 90069; telephone: 213-655-4353. Eighteenth-century ceramics, English Continental, Japanese and Chinese export, antique furniture and chandeliers.

CONNECTICUT

Tillou Gallery, Inc., Prospect Street, Litchfield, Connecticut 06759; telephone: 203-567-5706. Eighteenth- and nineteenth-century American furniture, paintings, folk art, ceramics, and weapons.

ILLINOIS

Malcolm Franklin, Inc., 126 East Delaware Place, Chicago, Illinois 60611; telephone: 312-337-0202. Seventeenth- and eighteenth-century English furniture, porcelains, and paintings.

The Strassel Company, 1000 Hamilton Avenue, Louisville, Kentucky 40204; telephone: 502-587-6611. Seventeenth- and eighteenth-century English furniture and porcelains.

MASSACHUSETTS

Firestone & Parson Ltd., Inc., Ritz Carlton Hotel, Boston, Massachusetts 02117; telephone: 617-266-1858. Antique English silver, early American silver, antique jewelry.

NEW YORK

Didier Aaron, Inc., 32 East 67th Street, New York, New York 10021; telephone: 212-988-5248. Furniture, art objects, paintings, decorations.

A La Vieille Russie, Inc., 781 Fifth Avenue, New York, New York 10022; telephone: 212-752-1727. Snuffboxes, Fabergé, antique jewels, Russian icons, and objets d'art, eighteenth-century French furniture and decorations.

The Antique Porcelain Company, The Antique Company of New York, Inc., 48 East 57th Street, New York, New York 10022; telephone: 212-758-2363. Fine antiques and works of art, including porcelain, jade, faience, objets de virtu, furniture, carpets, Renaissance jewelry, gold snuffboxes.

Berry-Hill Galleries, Inc., 743 Fifth Avenue, New York, New York 10022; telephone: 212-371-6777. American and European paintings and sculpture, China coast paintings; western Americana.

A. Beshar & Company, Inc., 49 East 53rd Street, Second Floor, New York, New York 10022; telephone: 212-758-1400. Antique Oriental and European rugs, carpets, and tapestries.

Doris Leslie Blau, Inc., 15 East 57th Street, New York, New York 10022; telephone: 212-759-3715. Antique Oriental and European rugs and carpets, tapestries.

Blumka Gallery, 949 Park Avenue, New York, New York 10028; telephone: 212-734-3222. Medieval and Renaissance art.

Frank Caro, Inc., 41 East 57th Street, New York, New York 10022; telephone: 212-753-2166. Ancient art of China, India, and Southeast Asia.

Ralph M. Chait Galleries, Inc., 12 East 56th Street, New York, New York 10022; telephone: 212-758-0983. Chinese art, works of art.

Philip Colleck of London, Ltd., 122 East 57th Street, New York, New York 10022; telephone: 212-753-1544; also at 84 Fulham Road, London SW3 6HR. Eighteenth-century English furniture and works of art.

Dildarian, Inc., 595 Madison Avenue, New York, New York 10022; telephone: 212-288-4948. Antique Oriental and period European rugs and tapestries.

Paul Drey Gallery, 11 East 57th Street, New York, New York 10022; telephone: 212-753-2551. Old Master paintings, drawings, sculptures, and works of art.

R. H. Ellsworth, Ltd., 960 Fifth Avenue, New York, New York 10021; telephone: 212-535-9249. Oriental fine arts.

Richard L. Feigen & Co., Inc., 900 Park Avenue, New York, New York 10021; telephone: 212-628-0700. Paintings by the Masters, fifteenth to twentieth century.

Price Glover, Inc., 57 East 57th Street, New York, New York 10022; telephone: 212-486-9767. Eighteenth-century English pottery and pewter, furniture, paintings, and decorative objects.

F. Gorevic & Son, Inc., 660 Lexington Avenue, New York, New York 10022; telephone: 212-753-9319. Antique silver, old Sheffield plate, jewelry, bronzes.

Kennedy Galleries, Inc., 40 West 57th Street, New York, New York 10019; telephone: 212-541-9600. Eighteenth-, nineteenth-, and twentieth-century American master paintings, Old Master and modern prints, art of the Old West, paintings, bronzes.

D. M. & P. Manheim Antiques Corp., 46 East 57th Street., New York, New York 10022; telephone: 212-758-2986. English porcelain, pottery, enamels, and Chinese export ware.

Fred B. Nadler Antiques, Inc., 31 East 64th Street, New York, New York 10021; telephone: 212-744-6165. Chinese export porcelain.

Newhouse Galleries, Inc., 19 East 66th Street, New York, New York 10021; telephone: 212-879-2700. Fine paintings, seventeenth- through nineteenth-century European and American masters.

James Robinson, Inc., 15 East 57th Street, New York, New York 10022; telephone: 212-752-6166. Antique English silver, Sheffield, jewelry, porcelain, and glass.

Rosenberg & Stiebel, Inc., 32 East 57th Street, New York, New York 10022; telephone: 212-753-4368. Old Master paintings and drawings, eighteenth-century porcelain, French furniture, Renaissance and medieval works of art.

Israel Sack, Inc., 15 East 57th Street, New York, New York 10022; telephone: 212-753-6562. Fine American antique furniture.

H. Shickman Gallery, 929 Park Avenue, New York, New York 10028; telephone: 212-249-3800. Fine Old Master paintings and drawings, nineteenth-century French paintings.

S. J. Shrubsole Corp., 104 East 57th Street, New York, New York 10022; telephone: 212-753-8920. Antique English silver, early American silver, and old Sheffield plate, antique jewelry.

Stair & Co., Inc., 59 East 57th Street, New York, New York 10022; telephone: 212-355-7620. Eighteenth-century English furniture, porcelains, and paintings.

Garrick C. Stephenson, 50 East 57th Street, New York, New York 10022; telephone: 212-753-2570. Antiques and works of art.

Vernay & Jussel, Inc., 825 Madison Avenue, New York, New York 10021; telephone: 212-879-3344. Fine seventeenth- and eighteenth-century English furniture and clocks.

John Wise, Ltd., 15 East 69th Street, New York, New York 10021, telephone: 212-734-2228. Pre-Columbian art and Spanish-Colonial tapestries.

William H. Wolff, Inc., 22 East 76th Street, New York, New York 10021; telephone: 212-988-7411. Far Eastern antiquities.

PENNSYLVANIA

Alfred Bullard, Inc., 1604 Pine Street, Philadelphia, Pennsylvania 19103; telephone: 215-735-1879. Eighteenth-century English furniture and works of art.

Elinor Gordon, Box 211, Villanova, Pennsylvania 19085; telephone: 215-525-0981 (by appointment only). Chinese export porcelain, Chinese treaty port paintings.

Helen McGehee, 1604 Pine Street, Philadelphia, Pennsylvania 19103; telephone: 215-735-1879. Chinese export porcelain, early English pottery and porcelain, eighteenth-century English furniture and accessories.

Matthew & Elisabeth Sharpe, The Spring Mill Antique Shop, Spring Mill, Conshohocken, Pennsylvania 19428; telephone: 215-828-0205. Chinese export porcelain, eighteenth-century American, English, and Irish furniture, English ceramics and accessories.

TEXAS

Mrs. John W. Christner, 8301 Sovereign Row, Dallas, Texas 75247; telephone: 214-634-2005. Antique porcelains.

VIRGINIA

Glenn C. Randall, 229 North Royal Street, Alexandria, Virginia 22314; telephone: 703-549-4432. Seventeenth- and eighteenth-century English furniture and works of art.

Ricks Wilson, Ltd., Merchants Square (P.O. Box 504), Williamsburg, Virginia 23185; telephone: 804-229-6860. English furniture of the eighteenth century and, increasingly, American furniture of the eighteenth and early nineteenth century. Silver and porcelain.

WASHINGTON, D.C.

M. Darling Limited, 3213 O St., NW, Washington, D.C. 20007; telephone: 202-337-0096. English furniture and works of art, seventeenth through early nineteenth century.

Art Dealers Association of America, Inc., List of Members by State

CALIFORNIA

John Berggruen Gallery, 228 Grant Avenue, San Francisco, California 94108; telephone: 415-781-4629. Impressionist, Postimpressionist, and contemporary paintings and sculpture.

James Corcoran Gallery, 8223 Santa Monica Boulevard, Los Angeles, California 90046; telephone: 213-656-0662. Contemporary and modern paintings, drawings, and sculpture.

Feingarten Galleries, 8380 Melrose Avenue, Los Angeles, California 90069; telephone: 213-655-4840. Master sculpture.

Dalzell Hatfield Galleries, Ambassador Hotel, Ambassador Station Box 130, Los Angeles, California 90070; telephone: 213-387-6702. French and German paintings of the nineteenth and twentieth centuries, American art, sculpture, and twentieth-century graphics, modern master and Aubusson tapestries.

Margo Leavin Gallery, 812 North Robertson Boulevard, Los Angeles, California 90069; telephone: 213-273-0603. Contemporary and twentieth-century paintings, drawings, sculpture, and graphics.

R. E. Lewis, Inc., P.O. Box 1108, San Rafael, California 94902; telephone: 415-461-4161. Old Master and modern prints, Japanese prints, Indian miniatures.

R. M. Light & Co., Inc., P.O. Box 5597, Santa Barbara, California 93108; telephone: 805-969-0257 (by appointment only). Fine prints and drawings.

David Stuart Galleries, 748 North La Cienega Boulevard (penthouse), Los Angeles, California 90069; telephone: 213-652-7422. Contemporary paintings and sculpture; pre-Columbian and African arts.

Thackrey & Robertson, 2266 Union Street, San Francisco, California 94123; telephone: 415-567-4842. Nineteenth- and twentieth-century prints, drawings, and photographs.

Jane Wade, Ltd., 6489 Caminito Blythefield, La Jolla, California 92037; telephone: 714-454-3445. Nineteenth- and twentieth-century paintings and sculpture.

FLORIDA

Hokin Gallery, Inc., 245 Worth Avenue, Palm Beach, Florida 33480; telephone: 305-655-5177, and also 1086 Kane Concourse, Bay Harbor Island, Florida 33154; telephone: 305-861-5700. Twentieth-century masters and primitive art.

Irving Galleries, Inc., 332 Worth Avenue, Palm Beach, Florida 33480; telephone: 305-659-6221. Contemporary American and European paintings, sculpture, and graphics.

ILLINOIS

Fairweather-Hardin Gallery, 101 East Ontario Street, Chicago, Illinois 60611; telephone: 312-642-0007. Twentieth-century paintings, sculpture, and graphics.

Joseph Faulkner-Main Street Gallery, 620 North Michigan Avenue, Chicago, Illinois 60611; telephone 312-787-3301. Nineteenth- and twentieth-century American and European drawings, graphics, paintings, and sculpture.

Richard Gray Gallery, 620 North Michigan Avenue, Chicago, Illinois 60611; telephone: 312-642-8877. Nineteenth- and twentieth-century paintings and featuring "New Generation" paintings, also featuring sculpture, drawings, and graphics, primitive and ancient art.

Hokin Gallery, Inc., 200 East Ontario Street, Chicago, Illinois 60611; telephone: 312-266-1211. Contemporary paintings, sculpture, graphics, pre-Columbian, African, and oceanic art, Aubusson and modern master tapestries.

B. C. Holland, Inc., 224 East Ontario Street, Chicago, Illinois 60611; telephone: 312-664-5000. Nineteenth- and twentieth-century paintings, drawings, and sculpture.

MASSACHUSETTS

Alpha Gallery, 121 Newbury Street, Boston, Massachusetts 02116; telephone: 617-536-4465. Twentieth-century American and European paintings, sculpture, works on paper, nineteenth- and twentieth-century prints.

Harcus Krakow Gallery, 7 Newbury Street, Boston, Massachusetts 02116; telephone: 617-262-4483. Contemporary painting, sculpture, photography, prints, and drawings.

MICHIGAN

Donald Morris Gallery, 105 Townsend, Birmingham, Michigan 48011; telephone: 313-642-8812. Twentieth-century American and European art, African art.

MISSOURI

The Greenberg Gallery, 44 Maryland Plaza, St. Louis, Missouri 63108; telephone: 314-361-7600. Post World War II contemporary American art.

NEW MEXICO

The Munson Gallery, 653 Canyon Road, Santa Fe, New Mexico 87501; telephone: 505-983-1657. Nineteenth- and twentieth-century American paintings, sculptures, graphics.

NEW YORK

A.C.A. Galleries, 21 East 67th Street, New York, New York 10021; telephone: 212-628-2440. Early twentieth-century and contemporary American and European works of art.

Acquavella Galleries, Inc., 18 East 79th Street, New York, New York 10021; telephone: 212-734-6300. Old Master, Impressionist, Postimpressionist, and contemporary paintings.

Brooke Alexander, Inc., 20 West 57th Street, New York, New York 10019; telephone: 212-757-3721. Contemporary American prints and editions, contemporary American paintings and drawings.

Associated American Artists, 663 Fifth Avenue, New York, New York 10022; telephone: 212-755-4211. Original etchings, lithographs, woodcuts, and serigraphs, fifteenth through twentieth century.

Lee Ault & Company, 200 East 82nd Street, New York, New York 10028; telephone: 212-861-2317. Twentieth-Century paintings and sculpture, primitive art.

Babcock Galleries, 20 East 67th Street, New York, New York 10021; telephone: 212-535-9355. American works of art of the nineteenth and twentieth centuries, contemporary paintings, drawings, and sculpture.

William Beadleston, Inc., 60 East 91st Street, New York, New York 10028; telephone: 212-348-7234. Impressionist, Postimpressionist, and contemporary paintings and sculpture.

Blum-Helman Gallery, 13 East 75th Street, New York, New York 10021; telephone: 212-249-5350. Recent American painting and sculpture.

Bodley Gallery, 1063 Madison Avenue, New York, New York 10028; telephone: 212-249-2155. Contemporary works of art, modern master drawings, surrealist works.

La Boetie, Inc., 9 East 82nd Street, New York, New York 10028; telephone: 212-535-4865. Paintings, watercolors, drawings by Surrealists, Austrian and German Expressionists, Bauhaus artists, and other twentieth-century masters, fine prints by Surrealists, Expressionists.

Galeria Bonino, Ltd., 48 Great Jones Street, New York, New York 10012; telephone: 212-752-9556 (by appointment only). Contemporary paintings and sculpture.

Borgenicht Gallery, 1018 Madison Avenue, New York, New York 10021; telephone: 212-535-8040. Contemporary paintings and sculpture.

Aldis Browne Fine Arts, Ltd., 20 East 53rd Street, New York, New York 10022; telephone: 212-593-3560. Original prints and related unique works, nineteenth and twentieth centuries.

Byron Gallery, 25 East 83rd Street, New York, New York 10028; telephone: 212-249-0348. Max Ernst, Magritte, Tanguy, Surrealists, and modern masters.

Susan Caldwell, Inc., 383 West Broadway, New York, New York 10012; telephone: 212-966-6500. Contemporary paintings, sculpture, and drawings, architectural installation works.

Carus Gallery, Inc., 872 Madison Avenue, New York, New York 10021; telephone: 212-879-4660. German Expressionists, constructivists, Russian avant garde watercolors, drawings, and prints.

Leo Castelli Gallery, 420 West Broadway, New York, New York 10012; telephone: 212-431-5160. Contemporary paintings, sculpture, drawing.

Castelli Graphics, 4 East 77th Street, New York, New York 10021; telephone: 212-288-3202. Contemporary multiples, graphics, photographs, and drawings.

Paula Cooper, 155 Wooster Street, New York, New York 10012; telephone: 212-677-4390. Contemporary and advanced American art.

Cordier & Ekstrom, 417 East 75th Street, New York, New York 10021; telephone: 212-988-8857. Paintings and sculpture.

Betty Cunningham Gallery, 94 Prince Street, New York, New York 10012; telephone: 212-966-0455. Contemporary paintings, sculpture, and drawings.

Maxwell Davidson Gallery, 43 East 78th Street, New York, New York 10021; telephone: 212-734-6702. Fine nineteenth- and twentieth-century paintings, drawings, and sculpture.

Davis & Long Company, 746 Madison Avenue, New York, New York 10021; telephone: 212-861-2811. Nineteenth- and twentieth-century American works of art, nineteenth-century English watercolors and drawings.

Tibor de Nagy Gallery, Inc., 29 West 57th Street, New York, New York 10019; telephone: 212-421-3780. Contemporary art, both abstract and representational.

Terry Dintenfass, Inc., 50 West 57th Street, New York, New York 10019; telephone: 212-581-2268. Contemporary paintings and sculpture.

Paul Drey Gallery, 11 East 57th Street, New York, New York 10022; telephone: 212-753-2551. Old Master paintings, drawings, sculpture, fine works of art.

Robert Elkon Gallery, 1063 Madison Avenue, New York, New York 10028; tele-

phone: 212-535-3940. Contemporary paintings and sculpture, twentieth-century masters.

André Emmerich Gallery, 41 East 57th Street, New York, New York 10022; telephone: 212-752-0124; and 420 West Broadway, New York, New York 10012; telephone: 212-431-4550. Contemporary American and European art, pre-Columbian and ancient art.

Rosa Esman Gallery, 29 West 57th Street, New York, New York 10019; telephone: 212-421-9490. Modern and contemporary paintings, sculpture, drawings and prints, Russian avant-garde works.

Richard L. Feigen & Co., Inc., 900 Park Avenue, New York, New York 10021; telephone: 212-628-0700. Fifteenth- to twentieth-century masters.

Ronald Feldman Fine Arts, Inc., 33 East 74th Street, New York, New York 10021; telephone: 212-249-4050. Contemporary paintings, sculpture, drawings, prints, nineteenth- and twentieth-century American and European masters.

David Findlay Galleries, Inc., 984 Madison Avenue, New York, New York 10021; telephone: 212-249-2909. European and American paintings and sculpture of the nineteenth and twentieth centuries.

Peter Findlay, 162 East 81st Street, New York, New York 10028; telephone: 212-535-4663. Nineteenth- and twentieth-century European and American paintings and sculpture.

Fischbach Gallery, 29 West 57th Street, New York, New York 10019; telephone: 212-759-2345. Twentieth-century American paintings, sculpture, drawings.

Forum Gallery, 1018 Madison Avenue, New York, New York 10021; telephone: 212-535-6080. American paintings and sculpture.

Gruenbaum Gallery, Ltd., 38 East 57th Street, New York, New York 10022; telephone: 212-838-8245. Contemporary American paintings, sculpture, and drawings.

Xavier Fourcade, Inc., 36 East 75th Street, New York, New York 10021; telephone: 212-535-3980. Twentieth-century European and American paintings and sculpture.

Galerie St. Etienne, Inc., 24 West 57th Street, New York, New York 10019; telephone: 212-245-6734. Nineteenth- and twentieth-century Austrian and German art, nineteenth- and twentieth-century naive art.

Gimpel & Weitzenhoffer, Ltd., 1040 Madison Avenue, New York, New York 10021; telephone: 212-628-1897. Twentieth-century American and European paintings and sculpture, contemporary graphics.

Lucien Goldschmidt, Inc., 1117 Madison Avenue, New York, New York 10028; telephone: 212-879-0070. Drawings, prints, illustrated books.

James Goodman Gallery, 1020 Madison Avenue, New York, New York 10021; telephone: 212-427-8383. Twentieth-century American and European drawings, watercolors, sculpture, and graphics.

Martin Gordon, Inc., 25 East 83rd Street, New York, New York 10028; telephone: 212-249-7350 (by appointment only). Prints by nineteenth- and twentieth-century masters and print reference books.

Graham Gallery, 1014 Madison Avenue, New York, New York 10021; telephone: 212-535-5767. Sixteenth- to twentieth-century European and American paintings and sculpture, antique silver and porcelain, naive painting, comic art and works by famous illustrators.

Auction Houses, Associations, and Dealers 223

Grand Central Art Galleries, Inc., Hotel Biltmore, 43rd Street and Madison Avenue, New York, New York 10017; telephone: 212-867-3344. Representational American art.

Nancy Hoffman Gallery, 429 West Broadway, New York, New York 10012; telephone: 212-966-6676. Contemporary paintings, sculpture, and prints.

Stephen Hahn, Inc., 817 Fifth Avenue, New York, New York 10021; telephone: 212-759-6645 (by appointment only). French paintings of the nineteenth and twentieth centuries.

Hirschl & Adler Galleries, Inc., 21 East 70th Street, New York, New York 10021; telephone: 212-535-8810. Eighteenth-, nineteenth-, twentieth-century American and European paintings, sculpture, and drawings.

Leonard Hutton Galleries, 33 East 74th Street, New York, New York 10021; telephone: 212-249-9700. Specializing in German Expressionists, Russian avant-garde, sculpture.

Isselbacher Gallery, 1223 Madison Avenue, New York, New York 10028; telephone: 212-831-4741. Late nineteenth- and twentieth-century fine prints and drawings.

David Anderson Gallery, Inc., 521 West 57th Street, New York, New York 10019; telephone: 212-586-4200. Contemporary international paintings, sculpture, and graphics.

Sidney Janis Gallery, 110 West 57th Street, New York, New York 10019; telephone: 212-586-0110. Three generations of modern art from Cubism to Pop to Minimal painting.

Kennedy Galleries, Inc., 40 West 57th Street, Fifth Floor, New York, New York 10019; telephone: 212-541-9600. American paintings, sculpture, and graphics of the eighteenth, nineteenth, and twentieth centuries.

Coe Kerr Gallery, 49 East 82nd Street, New York, New York 10028; telephone: 212-628-1340. Nineteenth- and twentieth-century American paintings.

M. Knoedler & Co., 19 East 70th Street, New York, New York 10021; telephone: 212-794-0550. Old Masters, nineteenth- and twentieth-century European and American paintings and sculpture.

Kraushaar Galleries, 1055 Madison Avenue, New York, New York 10028; telephone: 212-535-9888. Twentieth-century American paintings, drawings, and sculpture.

Lefebre Gallery, 47 East 77th Street, New York, New York 10021; telephone: 212-744-3384. Contemporary paintings and sculpture.

David McKee Gallery, 140 East 63rd Street, New York, New York 10021; telephone: 212-688-5951. Contemporary paintings, sculpture, and drawings.

Pierre Matisse Gallery Corp., 41 East 57th Street, New York, New York 10022; telephone: 212-355-6269. Contemporary paintings and sculpture.

Midtown Galleries, Inc., 11 East 57th Street, New York, New York 10022; telephone: 212-758-1900. Contemporary American art, paintings, sculpture, and graphics.

The Milch Gallery, 1014 Madison Avenue, New York, New York 10021; telephone: 212-288-2770. American paintings and watercolors of the nineteenth and twentieth centuries.

Frederick Mont, Inc., 465 Park Avenue, New York, New York 10022; telephone: 212-355-6930. Fine paintings by Old Masters.

Multiples/Goodman Gallery, 38 East 57th Street, New York, New York 10022; telephone: 212-755-3520. Contemporary prints and paintings.

Newhouse Galleries, Inc., 19 East 66th Street, New York, New York 10021; telephone: 212-879-2700. Fine paintings.

Odyssia, 730 Fifth Avenue, New York, New York 10019; telephone: 212-541-7520. Contemporary paintings and sculpture.

The Pace Gallery of New York, Inc., 32 East 57th Street, New York, New York 10022; telephone: 212-421-3292. Twentieth-century paintings, sculpture, and graphics.

Betty Parsons Gallery, 24 West 57th Street, New York, New York 10019; telephone: 212-247-7480. Twentieth-century paintings, sculpture, and graphics.

Perls Galleries, 1016 Madison Avenue, New York, New York 10021; telephone: 212-472-3200. Paintings and sculpture by twentieth-century masters.

Poindexter Gallery, 1160 Fifth Avenue, New York, New York 10029; telephone: 212-831-2520 (by appointment only). Contemporary paintings and sculpture, primarily American.

Frank Rehn Gallery, 14 East 60th Street, Room 911, New York, New York 10022; telephone: 212-753-4694. Contemporary American paintings, watercolors, and drawings.

Paul Rosenberg & Co., 20 East 79th Street, New York, New York 10021; telephone: 212-472-1134. French paintings of the nineteenth and twentieth centuries, contemporary American and European paintings and sculpture.

Rosenberg & Steibel, Inc., 32 East 57th Street, New York, New York 10022; telephone: 212-753-4368. Fine paintings, drawings, works of art, and French furniture.

Serge Sabarsky Gallery, Inc., 987 Madison Avenue, New York, New York 10021; telephone: 212-628-6281. German and Austrian Expressionists.

A. M. Sachs Gallery, 29 West 57th Street, New York, New York 10019; telephone: 212-421-8686. Contemporary paintings and sculpture.

Saidenberg Gallery, Inc., 1018 Madison Avenue, New York, New York 10021; telephone: 212-288-3387. Twentieth-century European and American paintings, sculpture, and graphic art.

Schaeffer Galleries, Inc., 983 Park Avenue, New York, New York 10021; telephone: 212-535-6410 (appointment suggested). Old Master paintings and drawings.

Robert Schoelkopf Gallery, Ltd., 825 Madison Avenue, New York, New York 10021; telephone: 212-879-4638. Nineteenth- and twentieth-century American paintings, sculpture, and photography.

H. Schickman Gallery, 1000 Park Avenue, New York, New York 10028; telephone: 212-249-3800. Fine Old Master paintings, drawings, nineteenth-century French paintings.

Sonnabend Gallery, 420 West Broadway, New York, New York 10012; telephone: 212-966-6160. Contemporary and avant-garde paintings and sculpture, vintage and contemporary photographs, videotapes and films by artists.

Sperone Westwater Fischer, 142 Greene Street, New York, New York 10012; telephone: 212-431-3685. Contemporary paintings, sculpture, and drawings, with a specialty in European art.

Staempfli Gallery, Inc., 47 East 77th Street, New York, New York 10021; telephone:

Auction Houses, Associations, and Dealers 225

212-535-1919. Contemporary American and European paintings and sculpture.

Allan Stone Gallery, 48 East 86th Street, New York, New York 10028; telephone: 212-988-6870. Twentieth-century masters and contemporary art.

E. V. Thaw & Co., Inc., 726 Park Avenue, New York, New York 10021; telephone: 212-535-6333. Master paintings and drawings of all periods.

David Tunick, Inc., 12 East 81st Street, New York, New York 10028; telephone: 212-570-0090 (appointment advisable). Fine Old Master drawings, fine Old Master and modern prints by major and minor artists.

John Weber Gallery, 420 West Broadway, New York, New York 10012; telephone: 212-966-6115. Minimal, conceptual, and systemic art.

Weyhe Gallery, 794 Lexington Avenue, New York, New York 10021; telephone: 212-838-5478. Fine prints, drawings, and sculpture.

Willard Gallery, Inc., 29 East 72nd Street, New York, New York 10021; telephone: 212-744-2925. Paintings and sculpture, chiefly contemporary American.

Zabriskie Gallery, 29 West 57th Street, New York, New York 10019; telephone: 212-832-9034. Contemporary paintings and sculpture, earlier American paintings, and sculpture.

OHIO

Carl Solway Gallery, 314 West Fourth Street, Cincinnati, Ohio 45202; telephone: 513-621-0069. Twentieth-century American and European paintings, sculpture, and graphics.

PENNSYLVANIA

Associated American Artists, 1614 Latimer Street, Philadelphia, Pennsylvania 19103; telephone: 215-545-7374. Original etchings, lithographs, woodcuts, serigraphs, fifteenth through twentieth century.

Makler Gallery, 1716 Locust Street, Philadelphia, Pennsylvania 19103; telephone: 215-735-2540. Contemporary paintings, sculpture, and graphics, art of India.

TEXAS

Janie C. Lee Gallery, 2304 Bissonnet, Houston, Texas 77005; telephone: 713-523-7306. Contemporary American paintings, sculpture, and drawings.

Meredith Long & Company, 2323 San Felipe Road, Houston, Texas 77019; telephone: 713-523-6671. Nineteenth- and twentieth-century American paintings.

Valley House Gallery, 6616 Spring Valley Road, Dallas, Texas 75240; telephone: 214-239-2441. Paintings and sculpture of the nineteenth and twentieth centuries.

Watson/de Nagy & Company, 1106 Berthea, Houston, Texas 77006; telephone: 713-526-9883. Contemporary American and Canadian paintings, sculpture.

WASHINGTON, D.C.

Lunn Gallery/Graphics International Ltd., 3243 P Street, NW, Washington, D.C. 20007; telephone: 202-338-5792. Nineteenth- and twentieth-century prints, drawings, and photographs.

Art and Antique Dealers League of America, Inc. List of Members by State

CALIFORNIA

Bowen & Bossier, Inc., Michael Bowen, president, P.O. Box 7549, Lincoln Lane between Fifth and Sixth, Carmel-by-the-Sea, California 93921; telephone: 408-624-1169. English and Continental furniture and accessories—eighteenth- and nineteenth-century European and Oriental porcelains.

Richard S. Gorham Antiques Ltd., P.O. Box 4378, Mission at Seventh, Carmel, California 93921; telephone: 408-625-1770. Eighteenth-century antiques.

Merryvale, Inc., Mr. and Mrs. D. W. Macdonough, 3640 Buchanan Street, San Francisco, California 94123; telephone: 415-567-0615. Direct importers English and Continental furniture, fine porcelain.

David Orgell, Inc., 320 North Rodeo Drive, Beverly Hills, California 90210; telephone: 213-272-3355. Old English silver, antique porcelain.

Nettie Wolf Antiques, P.O. Box 188, Rancho Mirage, California 92270; telephone: 714-328-7016. Antiques and reproductions.

Winfield Winsor Showroom, 458–460 Jackson Square, San Francisco, California 94111; telephone: 415-362-0613. Wholesale decorator showroom (antiques).

Herbert B. Palmer & Co., 9570 Wilshire Boulevard, Beverly Hills, California 90212; telephone: 213-550-7225. Art dealers.

COLORADO

Ayers of Franktown, David W. Ayers, proprietor, Highway 83, Franktown, Colorado 80116; telephone: 303-688-3827. Seventeenth- and eighteenth-century English and American furniture and accessories.

CONNECTICUT

Lillian Blankley Cogan, Hearts & Crowns, 22 High Street, Farmington, Connecticut 06032; telephone: 203-677-9259 (by appointment only). Early American furniture and furnishings of the seventeenth and eighteenth centuries.

Avis & Rockwell Gardiner, 60 Mill Road, Stamford, Connecticut 06903; telephone: 203-322-1129 (by appointment only). American antiques, prints and paintings.

Thomas D. & Constance R. Williams, Brush Hill Road, Litchfield, Connecticut 06759; telephone: 203-567-8794. Eighteenth- and nineteenth-century decorative arts.

DELAWARE

Jackson-Mitchell, Willis Moore, Inc., Third and Delaware streets, New Castle, Delaware 19720; telephone: 302-322-4365. Eighteenth-century antiques—English.

David Stockwell, Inc., David Stockwell, president, 3701 Kennett Pike, Wilmington, Delaware 19807; telephone: 302-655-4466. American and Irish furniture, silver, Chinese export porcelain.

FLORIDA

Circa Antiques, 1219 East Las Olas Boulevard, Fort Lauderdale, Florida 33301; telephone: 305-514-1704. Antique furniture and decorations.

Douglas Lorie, Inc., 334 Worth Avenue, Palm Beach, Florida 33480; telephone: 305-655-0700. Antique silver, crystal, porcelain.

Marshall Antique Gallery, 11 South Federal Highway, Dania, Florida 33004; telephone: 305-923-4958 and 949-7765. Art and antique gallery.

J. J. Thomson, P.O. Box 22698, Fort Lauderdale, Florida 33315; telephone: 305-524-6155. China and enamel antiques.

GEORGIA

W. E. Browne Decorating Co., 443 Peachtree Street, Atlanta, Georgia 30308; telephone: 404-974-4416. Interior designers, French, English and Italian eighteenth- and nineteenth-century antiques.

ILLINOIS

Charles Frank & Company, Charles R. Feldstein, 932 Edgemere Court, Evanston, Illinois 60202; telephone: 312-869-1550. Period furniture, antique porcelain, and master drawings.

KENTUCKY

The Strassel Company, Louise A. Mendel, AID, and C. Mendel, 1000 Hamilton Avenue, Louisville, Kentucky 40204; telephone: 502-587-6611. Interior design, antiques, cabinetmakers.

Wakefield-Scearce Antique Galleries, Mark J. Scearce, proprietor, Washington Street, Shelbyville, Kentucky 40065; telephone: 502-633-4382. Antiques and decorative accessories, English silver and furniture.

LOUISIANA

Rothschild's Inc., Nat Greenblatt, Ruth Greenblatt, 229 and 241 Royal Street, New Orleans, Louisiana 70130; telephone: 504-525-0121. Antiques, silver, porcelain, and furniture.

Henry Stern, 329 Royal Street, New Orleans, Louisiana 70130; telephone: 504-522-8687. Seventeenth- and eighteenth-century furniture and porcelain.

Waldhorn Company, Inc., Stephen A. Moses, president, 343 Royal Street, New Orleans, Louisiana 70130; telephone: 504-581-6379. Antique jewelry, furniture, porcelain, silver, and weapons.

MARYLAND

Fleur-de-lis-Antiques, Inc., 7921 Norfolk Avenue, Bethesda, Maryland 20014; telephone: 301-652-1500. Chinese and Continental porcelain, French and English furniture.

MASSACHUSETTS

Brodney, Inc., 811 Boylston Street, Boston, Massachusetts 02114; telephone: 617-536-0500. Paintings.

Cherry & Watson Antiques, Route 6-A, Barnstable, Massachusetts 02630; telephone: 617-362-6823. Seventeenth-, eighteenth- and early-nineteenth-century furniture and related accessories, early American glass.

Good & Hutchinson Associates, Sheffield, Massachusetts 01034; telephone: 413-258-4555. Eighteenth-century antiques.

MICHIGAN

W. Russell Button, Inc., Rudolf Leuser, president, 955 Center Street, Douglas, Michigan 49406; telephone: 616-857-2194. Antiques, paintings, and objects of art.

Stalker and Boos, Ltd., 280 North Woodward Avenue, Birmingham, Michigan 48011; telephone: 313-646-4650. English and American furniture, porcelain, and paintings.

MISSOURI

Carriage House Antiques, Gary E. Young, proprietor, 1408 Franklin Avenue, Lexington, Missouri 64067; telephone: 816-259-3633. Eighteenth- and nineteenth-century furniture, silver, porcelain, and fine paintings.

Edward Keith, Inc., Aaron L. Levitt, president, 47th and Belleview, Kansas City, Missouri 64112; telephone: 816-531-9200. English and French antique furniture, English and French imported reproductions, interior design.

NEW JERSEY

Ardis Leigh, Mr. and Mrs. W. C. Leigh, 49 State Road, Princeton, New Jersey 08540; telephone: 609-924-9310. Eighteenth- and nineteenth-century American and English furniture.

Eugene Sussel, Cooper River Plaza No. 304, North Parke Drive, Pennsauken, New Jersey 08109; telephone: 609-663-1198 or 215-928-1588. Eighteenth- and nineteenth-century furniture, paintings, silver, ceramics, glass, appraisals.

NEW YORK

A La Vieille Russie, Inc., 781 Fifth Avenue, New York, New York 10022; telephone: 212-752-1727. Objets d'art, antique jewelry, rare gold boxes, Fabergé, Russian icons, fine eighteenth-century French furniture and decorations.

A. M. Adler Fine Arts, Inc., 21 East 67th Street, New York, New York 10021; telephone: 212-249-2450. Fine French and American paintings, ancient art.

J. N. Bartfield Art Galleries, Inc., 45 West 57th Street, New York, New York 10019; telephone: 212-753-1830. Fine and rare books, nineteenth-century American and European paintings.

Karekin Beshir Ltd., 1125 Madison Avenue, New York, New York 10028; telephone: 212-838-3763. Collection of rare rugs and fine rug repairing and cleaning.

Vojtech Blau, Inc., 800B Fifth Avenue, New York, New York 10021; telephone: 212-838-7520. Antique Oriental and European rugs of fine quality, tapestries and decorative textiles.

Yale R. Burge Antiques, Inc., 315 East 62nd Street, New York, New York 10021; telephone: 212-838-4005. English, French, Oriental, and country furniture of the eighteenth and nineteenth centuries.

Auction Houses, Associations, and Dealers 229

Frank Caro Co., 41 East 57th Street, New York, New York 10022; telephone: 212-753-2166; Ancient arts of China, India, Southeast Asia, and Central America.

Philip Colleck of London, Ltd., 122 East 57th Street, New York, New York 10022; telephone: 212-753-1544-5. English and French furniture, decorations, works and objects of art.

Eden Galleries, Irving J. Zweig, proprietor, Halls Pond Road, Belcher R.D. 1, Salem, New York 12865; telephone: 518-854-7844. American furniture, American paintings, English pottery and porcelain.

Devenish Company Ltd., 929 Madison Avenue, New York, New York 10021; telephone: 212-535-2888-9. Fine English and French eighteenth-century furniture, paintings, and objets d'art.

Jacques Français Rare Violins, Inc., 140 West 57th Street, New York, New York 10019; telephone: 212-586-2607. Rare violin dealer, appraiser.

E. & J. Frankel Oriental Art, 25 East 77th Street, New York, New York 10021; telephone: 212-879-5733. Chinese and Japanese antique art.

I. Freeman & Son, Inc., 12 East 52nd Street, New York, New York 10022; telephone: 212-759-6900. Antique silver, old Sheffield, furniture, and porcelain.

H. Galka. Inc., 14 East 77th Street, New York, New York 10021; telephone: 212-861-9890. Art and antiques—appraisals.

Benjamin Ginsburg Antiquary, Inc., 815 Madison Avenue, New York, New York 10021; telephone: 212-744-1352. American and English antiques—furniture, porcelain, pottery, silver, and textiles.

F. Gorevic & Son, Inc., 660 Lexington Avenue, New York, New York 10022; telephone: 212-753-9319. Antique English and Continental silver, old Sheffield plate, antique jewelry, works of art.

Hammer Galleries, Inc., Victor J. Hammer. Dr. Armand Hammer, 51 East 57th Street, New York, New York 10022; telephone: 212-644-4400. Nineteenth- and twentieth-century paintings and sculptures.

Hirschl & Adler Galleries, Inc., Norman Hirschl, Stuart Feld, 21 East 70th Street, New York, New York 10021; telephone: 212-535-8810. Fine European and American paintings.

Edwin Jackson, Inc., John Gerald, Joseph Whitley, 306 East 61st Street, New York, New York 10021; telephone: 212-759-8210. Fireplace equipment, including stoves, antique mantels, etc.

Leo Kaplan Ltd., 910 Madison Avenue, New York, New York 10021; telephone: 212-249-6766. Eighteenth-century English pottery and porcelain, nineteenth-century French art glass and English cameo glass, French paperweights, Russian enamels and porcelains.

Joseph H. Kilian, 39 Glen Byron Avenue, South Nyack, New York 10960; telephone: 914-358-5713. Antique silver and old Sheffield plate.

Lenem-Arts, Inc., 321 East 45th Street, New York, New York 10017; telephone: 212-986-0894 (by appointment only). Antique Indian miniature paintings and prints.

Bernard & S. Dean Levy, Inc., 981 Madison Avenue, New York, New York 10021; telephone: 212-628-7088. American and English furniture and fine paintings.

Linlo House, Inc., Mrs. A. M. Wigington, Wally Gibbs, 1019 Lexington Avenue,

New York, New York 10021; telephone: 212-288-1848. Eighteenth- and nineteenth-century English antiques, furniture, porcelain, lamps, accessories.

Ellen Pales Lomasney, Mr. and Mrs. Anderson F. Hewitt, proprietors, 84 Forest Avenue, Locust Valley, New York 11560; telephone: 516-671-9772.

Julius Lowy Frame & Restoring Co., Inc., Hillard Shar, Lawrence Shar, 511 East 72nd Street, New York, New York 10021; telephone: 212-535-5250. Antique picture frames, restoration of oil paintings.

Mallett & Son (Antiques) American Ltd., P.O. Box 396, New York, New York 10028; telephone: 212-876-9033. Fine English furniture and objets d'Art of the eighteenth and early nineteenth centuries.

D. M. & P. Manheim Antiques Corp., 46 East 57th Street, New York, New York 10022; telephone: 212-758-2986. English porcelain, pottery, enamels, and Chinese export ware.

Nesle, Inc., 151 East 57th Street, New York, New York 10022; telephone: 212-755-0515. Lighting fixtures.

Newhouse Galleries, Inc., Bertram Newhouse, Clyde Newhouse, 19 East 66th Street, New York, New York 10021; telephone: 212-879-2700. Fine paintings of all schools, European Old Masters and American and British paintings dating from the seventeenth through the nineteenth century.

Florian Papp, Inc., William J. Papp, 962 Madison Avenue, New York, New York 10021; telephone: 212-288-6770. Fine eighteenth-century English furniture.

Rosenberg & Stiebel, Inc., Eric Stiebel, Gerald Stiebel, 32 East 57th Street, New York, New York 10022; telephone: 212-753-4368. Fine paintings, works of art, French furniture and eighteenth-century porcelain.

Max Safron, 300 East 57th Street, New York, New York 10022; telephone: 212-753-0531. American and foreign masters.

N. Sakiel and Son, 1024 Third Avenue, New York, New York 10021; telephone: 212-832-8576. Antique Continental furniture, tapestries, and accessories.

Spencer A. Samuels & Co., Ltd., 13 East 76th Street, New York, New York 10021; telephone: 212-988-4556. Old master paintings, drawings, objets d'art.

Schillay and Rehs, Inc., 305 East 63rd Street, New York, New York 10021; telephone: 212-355-5710. Eighteenth-, nineteenth-, and twentieth-century oil paintings.

Sevenoaks Antiques, P.O. Box 280, Kingsbridge Station, Bronx, New York 10463; telephone: 212-549-1543. Antique pottery and porcelain.

Maurice Segal, 841 Broadway, New York, New York 10022; telephone: 212-533-3555. French eighteenth-century furniture and objets d'art.

Ira Spanierman, Inc., 50 East 78th Street, New York, New York 10021; telephone: 212-879-7085. Art gallery specializing in fine American and European paintings of the nineteenth and early twentieth centuries.

Philip Suval, Inc., John Suval, 17 East 64th Street, New York, New York 10021; telephone: 212-794-9600. China trade porcelain, English furniture, pottery, porcelain and glass, paintings.

Sylvia Tearston, 1053 Third Avenue, New York, New York 10021; telephone: 212-838-0415. English antique furniture, paintings, prints, porcelain.

Frederick P. Victoria, 154 East 55th Street, New York, New York 10022; telephone: 212-755-2581. French antiques and objets d'art.

David Weiss Importers, Inc., 969 Third Avenue, New York, New York 10022; telephone: 212-754-1492. Antique furniture and decorative accessories, including porcelain.

Wildenstein & Co. Inc., Harry Brooks, president, 19 East 64th Street, New York, New York 10021; telephone: 212-879-0500. Fine paintings and objets d'art.

Wine Antiques, Inc., 667 Madison Avenue, Suite 1006, New York, New York 10021; telephone: 212-759-5685. Antique English and Irish silver, old Sheffield plate, Victorian silver and plate and antique jewelry.

Rembert Wurlitzer, Inc., 910 Park Avenue, New York, New York 10021; telephone: 212-861-8195. Stringed musical instruments.

S. Wyler, Inc., 713 Madison Avenue, New York, New York 10021; telephone: 212-838-1910. Fine antique English silver and English porcelain.

NORTH CAROLINA

Crowell-Roberson, Inc., 611 Providence Road, Charlotte, North Carolina 28207; telephone: 704-372-5457. Eighteenth- and early-nineteenth-century furniture and accessories.

The Plantation House, Alice Conner, Lower Armstrong Ford Road, Belmont, North Carolina 28012; telephone: 704-825-3642. Antique furniture, mirrors, paintings, porcelains, and silver.

The Queen's Quest, Inc., Barbara Clare, 112 Water Street, Edenton, North Carolina 27932; telephone: 919-482-4860. Seventeenth-, eighteenth-, and nineteenth-century furniture and accessories.

Treasures Unlimited, Inc., 120 Greenwich Road, Charlotte, North Carolina 28211; telephone: 704-366-7272. English porcelain, English and Continental furniture, silver.

PENNSYLVANIA

Robert Burkhardt, R. D. Box 304 (Monterey), Kutztown, Pennsylvania 19530; telephone: 215-683-8100. Early American and English furniture, china, primitives, etc.

Carlen Galleries, Inc., 323 South 16th Street, Philadelphia, Pennsylvania 19102; telephone: 215-545-1723; 735-7937. Americana, American primitive art, Pennsylvania Dutch pieces, rare American furniture, silver and paintings of the eighteenth and nineteenth centuries.

David David, Inc., 260 South 18th Street, Philadelphia, Pennsylvania 19103; telephone: 215-735-2922. Fine American and European paintings, drawings, and sculpture, fifteenth century through the early twentieth century.

James Galley, Box 64, Rahns, Pennsylvania 19426; telephone: 215-489-2828. China trade procelain.

Margery B. George Antiques, 1408 South Negley Avenue, Pittsburgh, Pennsylvania 15217; telephone: 412-422-7307. Eighteenth- and early-nineteenth-century antiques.

William Moennig & Son, 2039 Locust Street, Philadelphia, Pennsylvania 19103; telephone: 215-567-4198. Dealers in rare violins, violas, cellos, and bows. They are also makers of violins, violas and cellos and are well known for restoration work.

Frank S. Schwarz & Son, 1806 Chestnut Street, Philadelphia, Pennsylvania 19103;

telephone: 215-563-4887, and Suburban Square, Ardmore, Pennsylvania 19003; telephone: 215-642-1500. American antiques and nineteenth-century paintings.

The Spring Mill Antique Shop, Matthew and Elisabeth Sharpe, Spring Mill, Conshohocken, Pennsylvania 19428; telephone: 215-828-0205. Chinese export porcelain, eighteenth-century American, English, and Irish furniture, English ceramics and accessories.

SOUTH CAROLINA

Jack Patla Co., 181 King Street, Charleston, South Carolina 29401; telephone: 803-723-2314. Antiques, art items, porcelain, silver.

Margaret M. Taylor, Inc., 156 Oakland Avenue, Spartanburg, South Carolina 29302; telephone: 803-585-4856. Eighteenth-century furniture and accessories.

TENNESSEE

Michael Corzine & Co. Inc., Antique Silver Co. of Tennessee, 2127 Green Hills Village, Nashville, Tennessee 37215, telephone: 615-385-0140. Antique silver, old Sheffield and Victorian plate, china, crystal.

Evelyn Anderson, Inc., Westgate Center, 6043, Highway 100, Nashville, Tennessee 37205; telephone: 615-352-6770. Period furniture, porcelain, paintings, rugs.

TEXAS

Finder's Fayre, James Steinmeyer, 1485 Calder Avenue, Beaumont, Texas 77702; telephone: 713-833-7000. Eighteenth- and nineteenth-century furniture, seventeenth- and eighteenth-century carpets, and tapestries.

Norman Foster, Inc., 3815 South Alameda Street, Corpus Christi, Texas 78411; telephone: 512-854-2601. Antiques gallery and interior design.

Heirloom House, Inc., O. Martel Bowen, W. T. Rogers, 2521 Fairmount, Dallas, Texas 75201; telephone: 214-748-2087. Eighteenth-century English and American furniture and accessories.

Wicket Importers, Inc., 2431 Westheimer, Houston, Texas 77098; telephone: 713-522-0779. Eighteenth- and nineteenth-century English furniture, paintings, English and Oriental porcelains, accessories, etc.

VIRGINIA

Chas. Navis Antiques, Inc., 5605 Grove Avenue, Richmond, Virginia 23226; telephone: 804-282-1928. American and English furniture prior to 1810.

Reese Antiques, 207 East Main Street, Richmond, Virginia 23219; telephone: 804-644-0781. Antiques, bric-a-brac, and reproductions (as well as furniture made to order).

WASHINGTON

Wm. L. Davis Co., Dorsey W. Bailey, Wm. D. Bowden, 1300 Fifth Avenue, Seattle, Washington 98101; telephone: 206-622-0518. English eighteenth-century furniture and accessories, oil paintings, prints, Oriental screens, scrolls, porcelain.

The Globe Antique Shop, 1524 East Olive Way, Seattle, Washington 98122; telephone: 206-429-5666, and 529 Pine Street, Seattle, Washington 98101; telephone: 206-682-1420. Furniture, Georgian silver, eighteenth- and early-nineteenth-century European and Asian ceramics, original prints, watercolors, and oil paintings, Oriental rugs.

Rosen/Colgren Gallery, Inc., 1205–7 Pine Street, Seattle, Washington 98101; telephone: 206-623-3230. Antique furniture, rugs, porcelain, silver, glass, and art.

David Weatherford Antiques & Interiors, 133 14th Avenue, East. Seattle, Washington 98102; telephone: 206-329-6533. Fine period English and French furniture and accessories, Oriental porcelains and fine art pieces.

CANADA

The China Shop, Fred Cowans, 2148 Mackay Street, Montreal, Quebec H3G 2M2; telephone: 206-329-6533. Fine period English and French furniture and accessories, Oriental porcelains, and fine art pieces.

Green & Son, 1070 Yonge Street, Toronto, M4W 2L4; telephone: 416-922-6400. Eighteenth-century furniture and objets d'art.

Appendix B
Price Trends in Collectibles

ART PRICES

Art Prices—Overall

Year	Index
1925	100%
1929	165
1930	100
1933	50
1935	71
1940	81
1945	102
1950	150
1955	290
1960	981
1970	1,800
1973	3,600
1979	7,000
1980	8,000

Price Trend of American Old Masters (1950 = 100%)

Year	Index
1950	100%
1955	95%
1960	90%
1965	100%
1970	100%
1973	150%
1974	150%
1975	150%
1979	300%
1980	400%

American Old Master Paintings, 1950–1980
(1950 = 100%)

How American Paintings of the
Nineteenth Century Have Soared in Price, 1960–1980
(1960 = 100%; 1980 = 3,000%)

YEARS

Prices of Impressionist Paintings, 1940–1980
(1940 = 100%)

Appendix B

**Price Rise for Italian Baroque
and Eighteenth-Century Paintings, 1950–1980
($500 to $7,000; 1980 = 1,400%)**

YEARS

**Price Rise for Dutch and Flemish Paintings
of the Seventeenth Century, 1950–1980
($250 to $6,000)**

Appendix B

FURNITURE PRICES

The Boom in Prices of Antique Furniture

YEARS

Price Trends in Collectibles

The Increase in American Antique Furniture Prices, 1960–1980
(1960 = 100%)

American Antiques

Year	%
1925	100%
1926	190%
1929	330%
1932	148%
1939	90%
1942	58%
1945	137%
1950	147%
1955	226%
1960	323%
1965	565%
1979	1,200%
1980	1,800%

Price Trend of Italian Renaissance Furniture
(1925 = 100%)

Year	%
1925	100%
1926	200%
1929	300%
1932	30%
1939	5%
1942	30%
1945	40%
1950	50%
1960	60%
1964	75%
1965	85%
1970	150%
1975	850%
1976	950%
1977	1,050%
1978	1,100%
1980	1,100%

Painted Italian Furniture of the Eighteenth Century, 1905–1980

Louis XV and Louis XVI Furniture, 1925–1980
(1925 = 100%)

LOUIS XV FURNITURE ———
LOUIS XVI FURNITURE ---------

Louis XV and Louis XVI Furniture

Year	Louis XV	Louis XVI
1925	100%	100%
1926	100	100
1929	100	100
1932	67	87
1939	34	43
1942	83	43
1945	166	93
1950	166	93
1955	166	93
1960	500	186
1965	700	533
1970	1,000	650
1975	1,500	800
1979	2,000	2,500
1980	2,000	2,700

CLASSIC AND ANTIQUE CARS

The Rising Market for Postwar Classic Cars

Mercedes-Benz 1951–1955 300S, Convertible or Cabriolet Models

1970	$ 1,500
1972	4,000
1974	8,000
1977	19,000
1979	up to 30,000
1980	40,000

Ferrari 250GT Convertible, 1960 with Two Tops

1967	2,500
1970	2,500
1972	4,000
1974	5,000
1976	7,000
1977	12,000
1979	22,000
1980	28,000

Appendix B

The Rise in the Market for Classic Cars

- 1950: $500 — 100%
- 55: $1,000
- 60: $1,500
- 65: $2,000
- 70: $2,500
- 75: $7,500
- 80: $25,000

YEARS

Antique and Classic Cars Rising Fast in Value, 1950–1980

Appendix B

Georgian Silver, 1950–1980

MISCELLANEOUS

Bordeaux: The Investment Wines of France
(The Great Chateaux: Vintage Year 1961—Case of Twelve Bottles)

Wine	1976	Auction Price in: 1979	1980
Lafite-Rothschild	$ 720	$ 1,300	$ 1,980
Mouton Rothschild	620	1,300	1,980
Latour	600	1,100	1,450
Margaux	480	1,000	1,490
Haut-Brion	290	500	1,320
Cheval Blanc	330	950	1,320
Ausone	250	1,000	1,100
Petrus*	720	(4,000*) estimate	2,650
TOTALS:	$4,010	$11,150	$13,290

* Sold, three bottles $1,000 record

Index

Adelson, Warren, 180
advertisements, 112–124
 of art and antiques, 113–116
 by auction houses, 47
 of automobiles, 116–122
 of coins, 123
 in collectors' club journals, 103, 113, 114, 115, 119–124
 in newspapers, 104, 112, 114, 119
 of postage stamps, 122–123
 risks of, 101–102
 as source for market value, 34
 in telephone directories, 89–90
Affleck, Thomas, 18
"Albuquerque" (McLean), 185
Alma-Tadema, Sir Lawrence, 12
A.L.S. (autograph letter signed), 61, 129
Americana, 115
Americana, *see* folk art
American Collector, 86, 89, 110, 115
American Musical Instrument Society, 111
American Numismatic Association (ANA), 106–109
American Philatelic Society, 109
American Philatelist, 109
American Society of Appraisers, 38, 132–133
American Sports Car, 106
Annigoni, Pietro, 184
Annual Art Price Index (Hislop), 40
antique centers, 88–89
antique furniture, 28–29, 30, 33
 American, 17–18, 30, 78, 175–176
 English, 13–15

antique furniture *(cont'd)*
 French, 20, 28–29
 Italian, 28, 29
 preparation for sale of, 156–158
 restoration of, 156–158
Antique Monthly, 84, 86, 114–115
Antique Outboard Motor Club, 110
antiques:
 advertising of, 113–116
 dealers in, 72–83
 definition of, 156
 eighteenth-century, 1, 15, 17–18, 20, 54, 55
 exhibitions and sales of, 83–86
 as investments, 1–3, 26
 see also arts and crafts
Antiques, 87, 115
Antiques as an Investment (Rush), 3, 28, 128–129
antique show calendars, 86–88
Antiques Illustrated and Priced, 203
"Antonius Caesar on Caracalla" (Alma-Tadema), 12
"Apache Scout" (Remington), 13
appraisals, appraisers, 37–38, 82, 128–136
Appraisers Association of America, 38, 133–134
"Aristotle Observing the Bust of Homer" (Rembrandt), 27, 33
armory shows, 83–86, 155
art, 147
 advertising of, 113–116
 attribution of, 27–28, 143, 152–154, 155–156

art *(cont'd)*
 contemporary, 178–192
 dealers in, 72–83, 182–183
 as investment, 1–3, 10, 11, 12–13, 17, 183, 184, 190
 markets for, 173–174, 178–192
 see also paintings
Art and Antique Auction Review, 42
Art and Antique Dealers League of America, 82
Art and Antiques, 115
Art & Auction, 42
Art as an Investment (Rush), 3, 8, 12, 13
Art at Auction, 41
Art Dealers Association of America, 37, 82–83, 130–132
Art Glass, 194
artists, contemporary, 190–191
 see also specific artists
Art News, 1–2
Art Nouveau, 16, 75–76, 194
art pottery, 194
Art-Price Annual, 40
Art Prices Current, 40
arts and crafts, 193–204
 auction market for, 197–198
 criteria for, 195
 dealers in, 198–204
 folk art as, 193–194
 glass as, 194, 200–201
 guides to, 203–204
 pewter as, 201
 pottery as, 194, 201–202
 quilts as, 202
 scrimshaw as, 198
 toys as, 194–195, 199–200
Art World, 115–116
"Athenaeum portraits" (Stuart), 145
attribution of art, 27–28, 143, 152–154, 155–156
auction catalogs:
 as sales aids, 47, 53, 64–65
 as sources for market value, 35
auction houses, 43–63, 171, 191
 advertising and publicity of, 47
 for autographs, 59, 61
 for automobiles, 43, 62–63
 bidding at, 46, 49
 for coins, 59
 commissions of, 46, 53, 59, 60, 62, 99
 dealers at, 41, 75, 77
 dealing with, 51–57

auction houses *(cont'd)*
 exhibitions at, 47
 functions of, 46–49
 growth of, 3
 house auctions run by, 98–99, 177
 as judges of market value, 34, 35–36
 listed, 52, 56
 reports issued by, 41–42
 as safeguard against cheats, 48
 specialized, 57–63
 for stamps, 57–59, 176
 transactions at, 49–51
 for wines, 45, 60, 175
Auction Year, 41
autographs:
 appraisals of, 129
 auctions of, 59, 61
automobiles, classic and antique, 1, 2–3, 5–6, 10, 14, 15, 25, 26, 28, 68–72
 advertising of, 116–122
 auctions of, 43, 62–63
 collectors' clubs for, 102–106
 consignment sales of, 69–71
 dealers in, 69–72
 financing for, 71
 markets for, 175
 preparation for sale of, 162–166
 restoration of, 163–165
 see also specific automobiles
Auto Week, 121

Bacon, Francis, 189
Bama, Jim, 178, 180, 181
Barbed Wire Bible, The (Glover), 124
Bartholet, Betty, 187, 188
Bassin, Addy, 16
Batoni, Pompeo, 32
Becker, Felix, 153
Belluno Museum, 148
Benezit, E., 154
Bentley, 5, 117
Berea, Dimitri, 184
Berenson, Bernard, 30
Bernt, Walter, 155
bidding, 46, 49
Bierstadt, Albert, 13
Blackwell, Tom, 187
Blau Vojtech, 16–17, 82, 167
Blumenthal, Arthur, 146
Book Auction Records, 40
books, rare, 63, 195, 196
Boston Museum of Art, 145

Index

Bouguereau, William, 13
Bouts, Dieric, 47
Bradford, William, 54
"Bradford Cup," 54
British Antique Dealers' Association, 79–80
Broadbent, Michael, 41–42, 60
Bryan, William, 154
Bugatti Royale, 31
Bulb Horn, 121–122
Bulletin, 109
Bürkel, Heinrich, 150–152, 153
Buyer's Guide Reports, 68–69

Cadillac, 162
Canadian Coin News, 123
Canadian Stamp News, 122
Car and Driver, 121
Car Exchange, 121
carpets and rugs:
 antique, 14
 antique vs. modern, 16
 auctions of, 59–60, 167–168
 Middle Eastern, 16–17
 preparation for sale of, 166–168
 restoration of, 167
cars, *see* automobiles, classic and antique
Cars and Parts, 121
Castiglione, G. B., 10
catalogs, *see* auction catalogs
Catalogue of American Collectibles, The (Ketchum), 203
ceramics, 7, 32, 168–172
 see also pottery
Charles Hamilton Galleries, 59, 61, 63
Château d'Yquem, 16
Cheekwood Fine Arts Center, 146–147
Chicago Wine Company, 60
"Children of the Mountain" (Moran), 13
Christie, Manson & Woods (Christie's), 3, 59, 60, 62, 63, 152
Christie's Review of the Year, 41, 152
Christie's Wine Review, 41–42
Church, Frederick E., 27, 29, 30, 58, 141
CINOA (Confédération Internationale des Négociants en Oeuvres d'Art), 81–82
clocks, collectors' clubs for, 109–110
clubs, collectors', *see* collectors' clubs
Coe Kerr Gallery, 180, 181
coins, 43–45, 65–67, 161, 176
 advertising of, 123
 auctions of, 59
 collectors' clubs for, 106–109

coins *(cont'd)*
 dealers in, listed, 67
 grading system for, 32, 65
 guide to, 66, 176
 market value of, 34
 silver, 161
Coins, 123
Coin World, 66, 123
collectibles:
 budget advice for purchase of, 25–26
 "decade of growth" in, 11–21
 defined, 4
 donations of, 125–139
 as investments, 1–8, 22–27, 195
 locomotives as, 4–5
 marketing methods for, 173–177
 memorabilia as, 4, 24
 photographs of, 36, 51–52, 153
 preparation for sale of, 150–172
 selection of, 22–26
 "standard," 17, 65, 67
 see also specific collectibles
collection, formation of, 24
Collectors' Club (New York), 1–2
collectors' clubs, 100–111
 for automobiles, 102–106
 for coins, 106–109
 journals of, 100–103
 for stamps, 109
 for watches and clocks, 109–110
Collectors Handbook, The, 204
Color Field art, 190–191
commission marts, 91–95, 202
commissions:
 of auction houses, 46, 53, 59, 60, 62, 99
 of dealers, 69
"Composition" (Matulka), 187
Conference on Diamonds, 10
consignment sales:
 of automobiles, 69–71
 in commission marts, 92
 outright sales vs., 75–79
 of paintings, 73, 183
contributions, *see* donations of collectibles
Costa, Lorenzo, 153
Cusighe, Simone da, 77, 148
Customart Press, 35

dealers, 25, 64–90
 in antiques, 72–83
 in art, 72–83, 182–183
 in arts and crafts, 198–204
 associations of, 79–83

dealers *(cont'd)*
 at auctions, 41, 75, 77
 in automobiles, 68–72
 in coins, listed, 67
 commissions of, 69
 as judges of market value, 34
 as museum contacts, 141–143
"Death of Actaeon, The" (Titian), 32–33, 143, 145
Deelen, Dirck van, 155
de Kooning, Elaine, 187
de Kooning, Willem, 187
Delacorte, George, 146
Denny, Walter B., 166n
de Wet, Jacob, 155
diamonds, 9–10, 11, 176–177
Dictionary of Antiques (Savage), 172
Dictionary of Painters and Engravers (Bryan), 154
Dictionnaire des Peintres, Sculpteures, Dessinateurs et Graveurs (Benezit), 154
Directory of World Museums, The (Hudson and Nicholls), 149
donations of collectibles, 125–139
 appraisals for, 132–136
 cost of appraisals for, 132–135
 income tax computations for, 125–126, 137–139, 144
 to museums, 143–145
 recipients of, 127–128
 sales combined with, 143–145
 valuation of, 128–132
"Double French Money" (Rivers), 186–187
drawings, 17, 147, 174
Duesenberg, 33
Dürer, Albrecht, 17

Edelmann, John C, 59
Encyclopedia of Associations, 111
Encyclopedia of Collectibles, 204
Encyclopedia of Painting, 13
Esterow, Milton, 1n
Evetts, Echo, 168–169, 171

Fairfield County Bargain Hunter's Note Book, 94–95, 96
Ferrari Club of America, 105
"Figures in a New England Landscape" (Church), 27
Fine Points of Furniture—Early American (Sack), 30
flea markets, 89

folk art, 19, 193–194, 195, 196, 197–198, 200, 201, 202
Forbes, Malcolm, 180
Ford Mustang, 10, 163
"Forge in the Bavarian Alps" (Bürkel), 150–152, 153
"Four Opposites" (Pollock), 190
Fragonard, Jean Honoré, 140
Francesca, Piero della, 140
Freeman, Samuel T., 99
Freeman Gallery, 99

Gainsborough, Thomas, 145
Galka, Herman, 10, 82, 125, 131
Gallé, Emile, 194
galleries, *see* auction houses; dealers
Geddes, Giorgio, 140
gemstones, 18
Getty, J. Paul, 32–33
Gilbert, Richards C., 99
glass:
 American, 16, 200–201
 art, 194
Glover, Jack, 124
Goldschmidt, Lucien, 63
Grendey, Giles, 15
Guardi, Francesco, 147
Guide Book of United States Coins, A (Yeoman), 66, 176
Guimard, Hector, 75–76

"Hagar and the Angel" (Vignali), 23, 156
Hamilton, Charles, 59, 129
Hanson, Duane, 190
Harmers, 59
Harris Reference Catalog, 67
Hassam, Childe, 29–30
Hatie, George D., 106n
Heade, Martin Johnson, 21
Heim, François, 126
Hemmings Motor News, 119–120, 165, 175
Heublein, Inc., 60
Hicks, Edward, 193
Hislop, Richard, 40
house auctions, 96–99, 177
house sales, 95–96
Hudson, Kenneth, 149
Hudson River School, 13

"Icebergs" (Church), 27, 29, 30, 58, 141
income tax, 6, 82, 125–127, 137–139, 144

Index

Internal Revenue Service, 82, 126, 137–139
 Publication 561 (*Valuation of Donated Property*) of, 128, 129, 136–137, 139, 141
International Art Market, 39–40
International Barbed Wire Gazette, 124
Investments You Can Live with and Enjoy (Rush), 3
Israel Sack, Inc., 76, 158

Jaroslawicz, Isaac, 9–10
jewelry, 18–19
John C. Edelmann Galleries, 59–60
Johns, Jasper, 178–180
Jones, Jennifer, 47
"Juliet and Her Nurse" (J. M. W. Turner), 1n, 2, 64

Kelly, Ellsworth, 189
Kennedy Galleries, 74
Ketchum, William C., 203
Kleeman, Ron, 185
Kluge, Constantin, 188
Kovel, Ralph and Terry, 203–204
Kovels' Complete Antiques Price List, The, 39
Kruse International, 62
Künstler Lexikon (Thieme and Becker), 153–154
Kuntz, Joseph, 36

Lafite-Rothschild, 10, 16
Lamborghini, 5–6, 101–102, 104, 117
"Landscape" (Matulka), 187
Lash, Stephen S., 98–99
Lehrer, Jim, 4
Leo Castelli Gallery, 178–180
Levitt, Andrew, 161–162
Lichtenstein, Roy, 189
Liebermann, Max, 152
Linn's Stamp News, 122
liquidity, as investment factor, 4–5, 22, 184, 191
locomotives, as collectibles, 4–5
Louvre, 140
"Luck of Yunnan, The," 55
Lyle Official Antiques Review, The, 203

McFarland, Grace, 39, 203
McLean, Richard, 185
MacNeil, Robert, 111
MacNeil/Lehrer Report, 4, 111
"Madonna and Child with Two Saints" (Palmezzano), 125
"Magdalena River, Ecuador" (Church), 27

Manning, Robert, 12
Marinello, Sal, 5–6, 165
Marion, John, 19
markets for art, 178–192
 auction, 23–24, 178, 184–191
 international, 24, 178, 188–191
 national, 178, 183–188
market value, 27–42
 appraisers and, 37–38
 artist or maker and, 29
 beauty and, 30–31
 books and catalogs and, 31, 38–42
 of coins, 34
 condition and, 31–32
 determination of, 22–24, 34–37
 elaborateness and, 30
 exhibitions and, 31
 fads and, 28–29
 fair, IRS definition of, 128
 price history and, 33–34
 provenance and, 31
 rarity and, 32–33
 size and, 29
 of stamps, 34
Mart, The, 110
Martin, Gregory, 126, 153
Maserati Information Exchange, 102–103
Massey, Douglas, 63
Massey, Stephen C., 63
Matulka, Jan, 187–188
Medici, Francesco de', 36
Melina, Umberto, 150–152, 153
memorabilia, as collectibles, 4
Mercedes-Benz, 1, 14, 15, 30, 104, 116
Metropolitan Museum of Art, 10, 142, 143–144, 145, 148
Miller, Flora Whitney, 1, 64
Modern Classics, 106
"Mona Lisa" (Vinci), 30, 78
Monet, Claude, 44
Moran, Thomas, 13, 28
Moro, Francis, 125
Morris, William, 194
Motherwell, Robert, 189
"Movement in Space" (Rice-Pereira), 186
Munves, Edward, 81
Murray, Arthur, 76, 183
museums, 140–149
 acquisitions criteria of, 140–141, 147–149
 list of, 140
 reached by dealers, 141–143
 see also specific museums

Museums of the World, 149
Mustang, 10, 163

NADA (National Automobile Dealers) book, 68
"Napoleon Banner" (Rivers), 186
Nassau, Lillian, 16, 75
National Antique & Art Dealers Association of America, 80–81
National Association of Watch and Clock Collectors, 109–110
National Gallery (London), 145
National Gallery of Art (Washington, D.C.), 145
New York Annual Antique Conference, 84
New York Diamond Exchange, 9–10
New York Times, 34, 104, 114, 116–117, 118–119, 122–123, 175
Nicholls, Ann, 149
Niederländischen Maler des 17. Jahrhunderts, Die (Bernt), 155
Numismatic News, 123
Numismatist, 106, 108

Official Price Guide to Antiques and Other Collectibles (McFarland), *The,* 38–39, 203, 204
Old Cars Weekly, 121
Optical Art, 191
Oriental Rugs (Denny), 166
Orientals (carpets), 16

paintings:
 American, 11, 12, 13, 21, 27–28, 74, 145, 146–147, 174, 195
 attribution of, 27–28, 143, 152–154, 155–156
 Color Field, 190–191
 consignment of, 73
 contemporary, 178–192
 directories of, 153–154, 155
 Dutch, 155, 173–174
 English, 12, 145
 European, 12–13, 31–32, 140, 145, 150–152
 folk art, 193–194
 by Hudson River School, 13
 Impressionist, 5, 11
 markets for, 173–174
 nineteenth-century, 12–13, 27, 150–152
 Old Master, 23, 76, 77–78, 82, 125, 145, 146, 147, 148, 153, 156, 173–174
 Photo Realist, 185, 187, 191
 preparation for sale of, 150–156

paintings *(cont'd)*
 restoration of, 154–156, 161
 schools of, 190–191
 see also specific artists and titles
Palmezzano, Marco, 125
Pardo, Lloyd, 147, 169, 171
Pardo Galleries, 147
"Parisian Street Scene" (Kluge), 188
Patterson, Jerry E., 172
pewter, 201
Phillips, Ammi, 194
Phillips Fine Art Auctioneers, 1, 7, 62
"Phonograph, The" (Matulka), 187
photographing collectibles, 36, 51–52, 153
Photo Realism, 185, 187, 190
Picasso, Pablo, 17
"Polarity of Light, The" (Rice-Pereira), 186
Pollock, Jackson, 178, 188, 190
Pop Art, 190
porcelain, 7, 32, 168–172
Porcelain (Patterson), 172
pottery, 194, 201–202
 see also ceramics
Potwine, John, 54
prices:
 auction, 23–24, 25, 33
 auction vs. dealer, 25, 167
 guidebooks to, 38–42
 international market, 24
 market, *see* market value
 record, 1, 2, 13, 17, 18–19, 20, 21, 30, 36, 44, 58, 61, 170, 179, 189, 190
 rising, 1, 3, 9–10, 11–21
Prices of Victorian Paintings, Drawings and Watercolors, 40–41
proof, defined, 65
Putter, Pieter de, 155

"Quai des Orfèvres, Le" (Kluge), 188
Quaritsch, Bernard, 63
"Queen Elizabeth II" (Annigoni), 184
"quilts, 202

Ray, Man, 190
Reagan, Ronald, 61
records, phonograph, 195
Rembrandt, 17, 27, 29, 33, 73, 142, 143
Remington, Frederic, 13
Renoir, Pierre Auguste, 5, 148
restoration:
 of antique furniture, 156–158
 of automobiles, 163–165

Index

restoration *(cont'd)*
 of carpets and rugs, 167
 of paintings, 154–156, 161
 of porcelain, 168–171
 of silver, 158–161
Revere, Paul, 20, 29
Rice-Pereira, Irene, 186, 189
Richards Gilbert auction house, 99
Rivers, Herbert, 178
Rivers, Larry, 186–187
Road and Track, 104, 106, 112–113, 120
Robert Scull Collection of Pop Art, 24, 181
Rolls-Royce, 2–3, 32, 68, 162, 163–165
Roman, Herbert, 125, 131
Rosen Foundation, 15
Rothko, Mark, 189
Rousseau, Theodore, 145, 146
Rubens, Peter Paul, 145
rugs, *see* carpets and rugs
Rush, Julie, 192
Russell, Charles, 11
Rust, David, 10

Sack, Albert, 30
Sack, Robert, 33, 76
"Samson and Delilah" (Rubens), 145
Savage, George, 172
Scott's, 67–68
scrimshaw, 198
Scull, Robert, 24, 181, 185
"Scullduggery Series, Prototype for the Dragging Sculls" (Kleeman), 185
Sellaio, Jacopo del, 76, 146
Seventh Regiment Armory, sales at, 84–86
silver:
 American, 19–20, 160
 Georgian, 79, 159–160
 guidebooks to, 159–160
 polishing of, 161
 preparation for sale of, 158–161
 restoration of, 158–161
Silver, 124
Simon, Norton, 47
Sloan, John, 74
Smithsonian Institution, 145
Sotheby Parke Bernet (Sotheby's), 1, 2, 3, 13, 35, 36, 59, 60, 62, 64–65
 appraisal service of, 135
 Art at Auction published by, 41
 Garbisch estate sold by, 44, 64, 98, 157
 P.B.84 at, 12
 Robert von Hirsch Collection sale at, 17

Sotheby Parke Bernet's Price Guide to Antiques and Decorative Arts, 39
Spinning Wheel Antiques and Crafts, 115
Stacks, 59
Stamp Collector, 122
stamps, 67–68
 advertisements for sale of, 122–123
 auctions of, 57–59, 176
 collectors' clubs for, 109
 market value of, 34
 preparation for sale of, 161, 162
Stamps, 122
Stamp Show News and Philatelic Review, 122
Stamp Trade International, 122
Storm, Alex, 66
Stuart, Gilbert, 145
Swann Galleries, 63

tag sales, 95–98, 177
taxes, *see* income tax
Teichman, Sabina, 183
telephone directories, "Antique Dealers Guide" in, 89–90
"Tequila Sunrise" (Blackwell), 187
Thieme, Ulrich, 153
"Three Flags" (Johns), 178–180
Tierney, Joseph, 20
Tiffany lamps, 16, 28, 194
Titian, 32–33, 143, 145
"Toro III" (de Kooning), 187
toys, 194–195, 199–200
Trans-Mississippi $1 black (1898), 58
treasures, defined, 66
Turner, Joseph Mallord Wilson, 1, 2, 18, 64

Ulrich's International Periodicals Directory, 110, 123
U.S. News & World Report, 161, 168

Valuation of Donated Property, 128
van Dyck, Peter, 20
Velasquez, Diego, 145
Veterans Motor Club of America, 121
Vignali, Jacopo, 23, 156
Vinci, Leonardo da, 30, 78, 145
Vouet, Simon, 143

Wall Street Journal, 119
Washington, D.C., Antiques Show, 84
watches, collectors' clubs for, 109–110
Weitzner, Julius, 32–33, 78, 143, 178
Weschler's (Adam A. Weschler & Sons), 18

Whitney Museum of American Art, 178–180
wines:
 auctions of, 45, 60, 175
 as collectibles, 10, 16
 prices of, 41–42
Winter Antiques Show, 84–86
Wishart, Hugh, 20
Wolpe, Robert N., 5, 68

World Art Market Conference March 1980, 2
World Coin News, 123
World Collectors Annuary, 40

Yeoman, R. S., 66, 176

Zagorski, Stanislaw, 5–6, 117